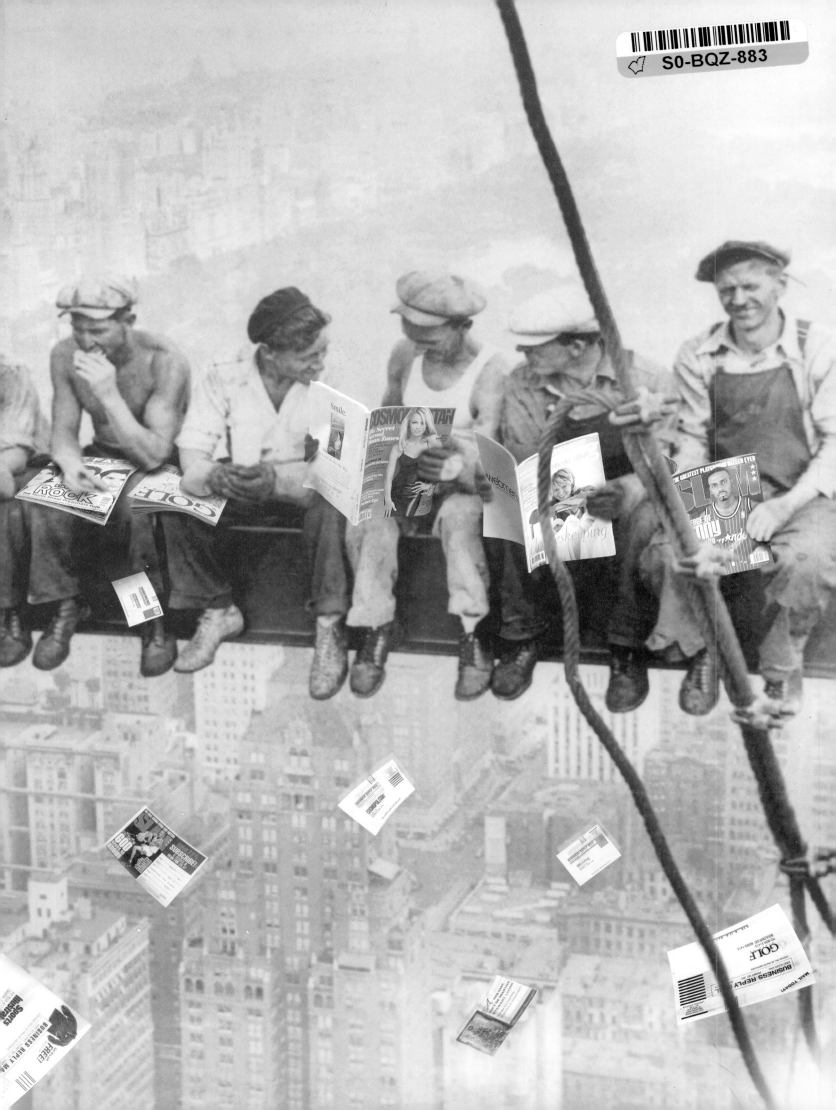

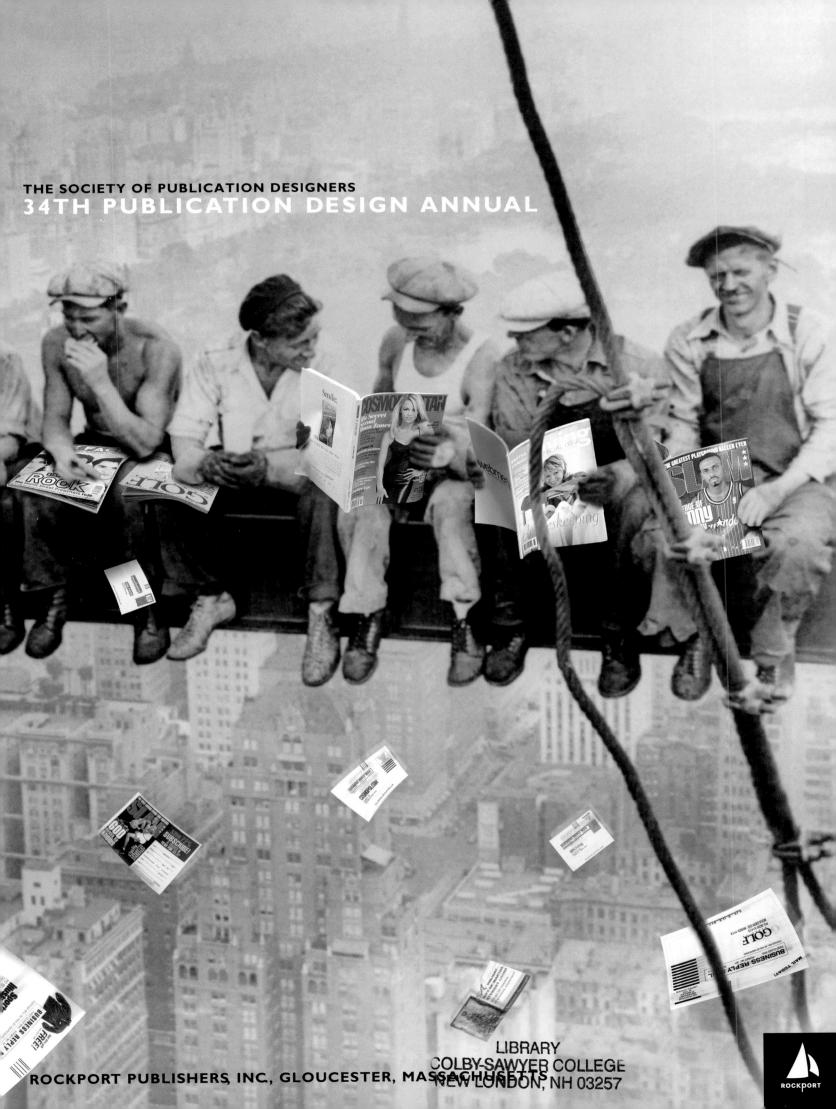

THE SOCIETY OF PUBLICATION DESIGNERS
34TH PUBLICATION DESIGN ANNUAL

ROCKPORT PUBLISHERS, INC., GLOUCESTER, MASSACHUSETTS

ROCKPORT

acknowledgements

The Gala
The Society wishes to thank The New York Times Company Foundation for its generosity to the New York Public Library, which has enabled the Society of Publication Designers to hold its annual awards Gala in this very special place.

The Sponsors
The Society thanks its corporate sponsors for their continuing support:

American Express Publishing
Apple Computers, Inc.
Condé Nast Publications, Inc.
Dow Jones & Company, Inc.
Eusy Printers
Hachette Filipacchi Magazines, Inc.
Hearst Magazines
McGraw Hill, Inc.
Meredith Corporation
The New York Times
Newsweek
Quebecor Printing
Wenner Media
Time Inc.
U.S. News & World Report
Westvaco Corporation

Pub 34 Competition
The Co-Chairs, Ina Salz and Steven Hoffman, would like to extend special thanks to David Baer, Steve Beispel, Delgis Canahuate, Alexandra Conley, Robin Hellman, Kory Kennedy, Mimi Park, Michael Picon, Linda Root, Maura Scanlon, Sven Travis, Irene Vandervoort, Brad Wallick and most especially to all the volunteers who worked so long and hard to make the judging a successful and exciting event.

Call for Entries Design:
Steven Hoffman and Kory Kennedy
Separations: Sport Illustrated Imaging Department
Paper: Westvaco Corporation
Printing: Quebecor Printing

The Gala
Program Design: Kory Kennedy
Separations: Sport Illustrated Imaging Department
Slide Presentation & Audio Visual Program:
Show & Tell Anagraphics
Technical Support: David Solin

Student Competition
Co-Chairs: Gail Anderson and Paul Roelofs
Poster Design: Gail Anderson
Separations: Time Inc. People Imaging
Paper: Westvaco Corporation
Printing: Perry-Judd's Inc.

Spots Competition
The Chairperson Christine Curry would like to extend a special thanks to Barry Blitt for the wonderful illustration of our judges in action. And to Suzanne Bennett, Erin Whelan, Bob Newman. and, of course, Bride Whelan for keeping us in line and helping us tally up the ratings for the hundreds and hundreds of entries.

Call for Entries Design:
Laurent Ciluffo and Florian Bachleda
Separations: Gary Van Dis of Conde Nast Publications, Inc.
Paper: Westvaco Corporation
Printing: Seiple Lithograph
Program Design: Mimi Park and Laurent Ciluffo

The Society of Publication Designers, Inc.
60 East 42nd Street, Suite 721
New York, NY 10165
Telephone: (212) 983-8585
Fax: (212) 983-6043
Email: SPDNYC@aol.com
Web site: HTTP://www.SPD.ORG

The SPD 34th Publication Design Annual
Book produced and designed by Mimi Park Design Park, Inc., Hoboken, NJ

Jacket Photo Illustration by Joe Zeff

The Society of Publication Designers has been granted permission to use the image on the 34th Publication Design Annual by FPG International LLC in accordance with their policy pertaining to photo illustration.

First published
in the United States of America by:
Rockport Publishers, Inc.
33 Commercial Street
Gloucester, Massachusetts 01930
Telephone: (978) 282-9590
Fax: (978) 283-2742

Distributed to the book trade and art trade in the U.S. and Canada by:
North Light, an imprint of F & W Publications
1507 Dana Avenue
Cincinnati, OH 45207
Telephone: (800) 289-0963

Other Distribution by:
Rockport Publishers, Inc.
Gloucester, Massachusetts 01930

ISBN 1-56496-621-6

Printed in China

contents

hen reviewing the work submitted for Pub34, I realized that the computer revolution was officially over," says Chris Garcia, art director of Popular Science magazine and one of the 36 judges of the SPD competition. "So now we can concentrate on typography and not just fun tricks!"

With less gratuitous visual fillips, less overlapping tchotchkes, and less Photoshop gimmicks—less of what Laura Baer from PC magazine calls "eye candies"—this year's entries looked suddenly very contemporary. Most of the judges now admit that they were taken by surprise by this unexpected display of self-control. "It wasn't a year of exuberant invention or distinctive voices," says Bruce Ramsay, who art directs the Newsweek covers. "The stuff was restrained and fairly direct. But on the other hand, I saw a lot of solid, gorgeous work."

After a decade of hyperlink-inspired complexity, it's actually a relief not to be held hostage by the hard-wired generation. Could it be that technoids, mouse potatoes, and cybertots are no longer wowed by their own dexterity? "The show was underwhelming rather than overwhelming," says Malcolm Frouman, Business Week's art director. "Which ain't bad. A lot of the usual suspects won the awards. But let's face it: As usual, the usual suspects did their usual first-rate best."

This year, novelty wasn't the thing. Designers with a lot of experience and a confirmed track record captured the attention of the judges who found their elegant handling of typography and their well-tempered image-making right out refreshing. "Sure, they were some interesting layouts by newcomers," says Baer, "but the folks who continue to get the gold medals are those who honed their skills year after year after year."

This drift toward temperance and moderation is not some sort of Y2K backlash. On the contrary: The pendulum swung away from Rasterbator style—compulsive manipulation of digital images and type—as a direct result of our greater understanding of what the digital media is all about.

Melanie McLaughin, art director of Time Inc. New Media, and one of the judges of the online segment of Pub34, helps explain the phenomenon. "There are new criteria for judging good website design: readability, navigation and speed of download," she tells. For her and for her group, intricate layouts that take forever to come up on the screen are simply not acceptable. What counts is how quickly visitors to the web pages get the picture, understand their options, and are able to access the next level of information. A measure of success for online art directors is how well they manage their onscreen readers' time.

The same is true today for ink-based publications. Time is also the most precious commodity for their readers. Magazines that communicate their ideas clearly and intelligently are leaders in their field. It's that simple. "There is a sense that the overall design of the magazine is now essential to its editorial and business success," says Robert Newman, Details magazine's design director.

"Believe it or not, there were fewer cover lines," remarked Alex Isley, who is currently redesigning How magazine. "Somehow, editors and circulation directors are realizing that more is not better. That a simple, direct and forceful image, coupled with a well-chosen line, can encourage readers to pick-up an issue." Less is more—but not necessarily smaller. "Coverlines seem to have reached epic proportions," quips David Harris, art director at Vanity Fair.

The overall impression was one of great control, with something athletic about the best entries—almost as if the visuals had been pumping iron. More than ever, you got a sense that words and images were team players. The typography was muscular—but so was white space. Both photographs and illustrations had a hearty quality. This was the year of the red-blooded layout.

No wonder sports magazines made a great impression on the judges. Whereas in the past music as a theme was the driving force for graphic excellence and innovations, today, sports is the inspiring metaphor. "One of the most interesting trends for me was the new focus on sports as a platform for well designed magazines and visual pleasure," notes Françoise Mouly, art editor at the New Yorker. Ina Saltz, design director of Golf Magazine, and co-chairman of the Pub34 event, was awed by this overall display of energy, vitality and focus. "It was inspirational and daunting, simultaneously," she says. —Veronique Vienne

● About the Society

Established in 1965, the Society of Publication Designers was formed to acknowledge the role of the art director/designer in the visual understanding of the printed word. The art director as journalist brings a unique skill to the editorial mission of the publication and clarifies the editorial message. The specialized skills of the designer confront the challenges of technology within a constantly expanding industry.

The Society provides for its members Speaker Luncheons and Evenings, the monthly newsletter GRIDS, the publication design annual, the Design Exhibition and the annual SPOTS Competition and Exhibition for illustrators, and the SPD Auction and Awards Gala. It has developed a working network of opportunities for job seekers and student interns. It actively participates in related activities that bring together members of the numerous design communities in the New York area.

SPD WEST was formed in 1997 to represent the many members and publications in California and the West Coast.

Bride Whelan
Executive Director
The Society of Publication Designers

Robert Newman
President
The Society of Publication Designers

● The Pub 34 Competition

The judging this year was one of the most spirited in memory. Over 40 design professionals spent two days viewing 8,345 submissions. The show, with 696 merit awards, 36 silver awards, 16 gold awards, and the Magazine of the Year, is the result of their efforts.

This judging represents those many viewpoints. It is a subjective process, affected by style and contemporary taste, but we hope that certain universal values prevail, and that over time the work this group of judges has chosen will continue to represent high journalistic standards, innovative problem solving, and the pure pleasure of design.

Competition Co-chairs
Ina Saltz
Design Director, Golf Magazine

Steven Hoffman
Creative Director, Sports Illustrated

● The Judges
*Group Leaders

Top, Clockwise
1
Mirko Ilíc
Principal, Mirko Ilíc Corp.
Laura Baer
Art Director, PC
***Robert Priest**
Art Director, Esquire
Carol Layton
Art Director, Bloomberg Personal
Chris Garcia
Art Director, Popular Science
Gail Anderson
Senior Art Director, Rolling Stone

2
Jonathan Hoefler
Principal, The Jonathan Hoefler Type Foundry
Elizabeth Betts
Art Director, Men's Health
***John Korpics**
Design Director, Entertainment Weekly
Anna Demchick
Creative Director, Ladies Home Journal and More
Alex Isley
Principal, Alexander Isley Design
Florian Bachleda
Art Director, P.O.V.

3
Robb Allen
Creative Director,
Hachette Filipacchi Custom Publishing
Lee Swillingham
Art Director, The Face
***Malcolm Frouman**
Art Director, BusinessWeek
Mark Michaelson
Design Director, New York
Sharon Okamoto
Art Director, Civilization
Lou DiLorenzo
Art Director, Food & Wine

4
Dwayne Shaw
Art Director, Vibe
Tina Strasberg
Art Director, Nickelodeon
Luke Hayman
Design Director, I.D.
Jay Kennedy
Editor-in-Chief, King Syndicate
Marilu Lopez
Creative Director, Redbook
***David Harris**
Art Director, Vanity Fair

7
Kathy Nenneker
Associate Publisher/Creative Director,
Women's Publishing Group
Weider Publications
Eric Pike
Art Director, Martha Stewart Living
Lori Ende
Art Director, Cigar Aficianado
***David Armario**
Art Director, Los Angeles
Françoise Mouly
Art Editor, The New Yorker
Barry Deck
Art Director, Ray Gun

6
Jane Mount
Creative Director, Concrete Design
***Ronnie Peters**
Creative Director,
Bertelsmann New Media
Melanie McLaughlin
Art Director, Time Inc. New Media
Adam Moore
Principal, MC Squared Creative Solutions
Jim Anderson
Associate, Pentagram Design
Thomas Muller
Design Director, Razorfish

5
Paul Roelofs
Art Director, InStyle
***Janet Froelich**
Art Director,
The New York Times Magazine
Donald Morris
Art Director, Slam and XXL
Bruce Ramsay
Art Director (Covers), Newsweek
Patrick Mitchell
Art Director, Fast Company
Margery Peters
Art Director, Fortune

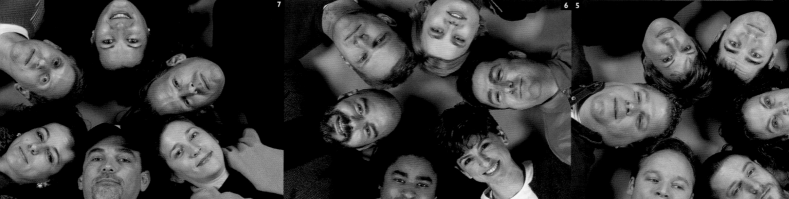

design

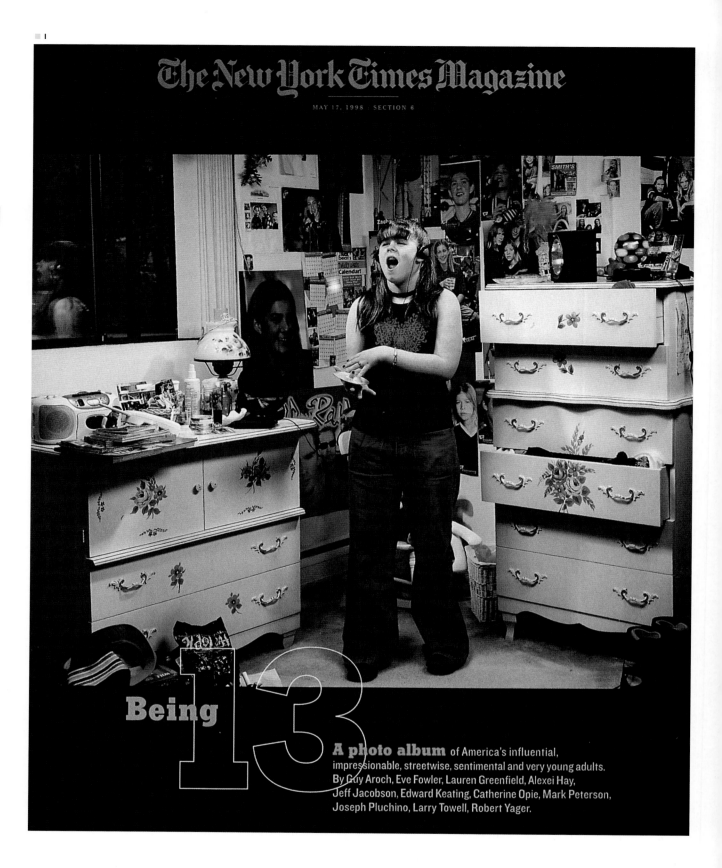

The New York Times Magazine

MAY 17, 1998 · SECTION 6

Being **13**

A photo album of America's influential, impressionable, streetwise, sentimental and very young adults. By Guy Aroch, Eve Fowler, Lauren Greenfield, Alexei Hay, Jeff Jacobson, Edward Keating, Catherine Opie, Mark Peterson, Joseph Pluchino, Larry Towell, Robert Yager.

Publication The New York Times Magazine
Art Director Janet Froelich
Designers Catherine Gilmore-Barnes, Nancy Harris, Joele Cuyler, Andrea Fella, Claude Martel
Photo Editor Kathy Ryan
Photographers Alexei Hay, Jake Chessum, Tom Schierlitz, Larry Towell, Lauren Greenfield
Publisher The New York Times
Issues May 17, September 20, December 13, 1998
Category Magazine of the Year

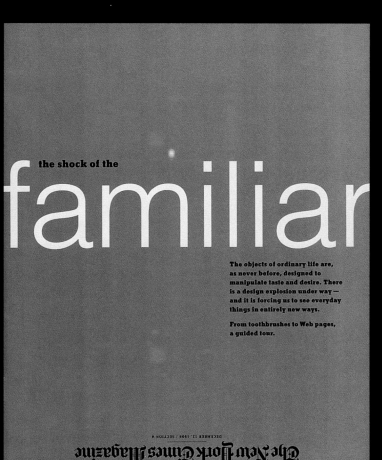

the shock of the

familiar

The objects of ordinary life are, as never before, designed to manipulate taste and desire. There is a design explosion under way — and it is forcing us to see everyday things in entirely new ways.

From toothbrushes to Web pages, a guided tour.

DECEMBER 13, 1998 / SECTION 6
The New York Times Magazine

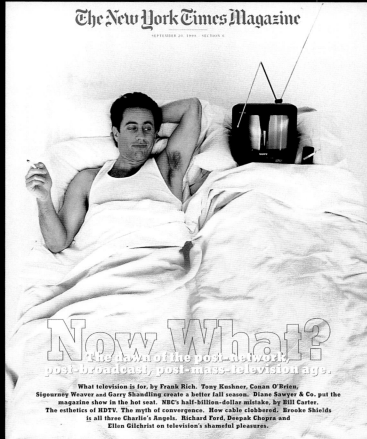

The New York Times Magazine

SEPTEMBER 20, 1998 · SECTION 6

Now What?

The dawn of the post-network, post-broadcast, post-mass-television age.

What television is for, by Frank Rich. Tony Kushner, Conan O'Brien, Sigourney Weaver and Garry Shandling create a better fall season. Diane Sawyer & Co. put the magazine show in the hot seat. NBC's half-billion-dollar mistake, by Bill Carter. The esthetics of HDTV. The myth of convergence. How cable clobbered. Brooke Shields is all three Charlie's Angels. Richard Ford, Deepak Chopra and Ellen Gilchrist on television's shameful pleasures.

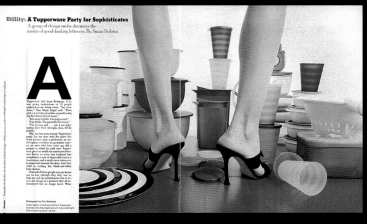

Utility: A Tupperware Party for Sophisticates
A group of design snobs discusses the merits of good-looking leftovers. By Susan Bolotin

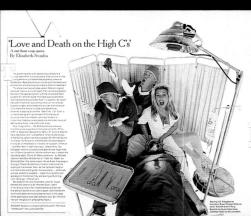

'Love and Death on the High C's'
A one-hour soap opera. By Elizabeth Swados

'Bill and Bill'
A half-hour semi-erotic situation comedy. By Garry Shandling

American Pastoral
Photograph by Larry Towell

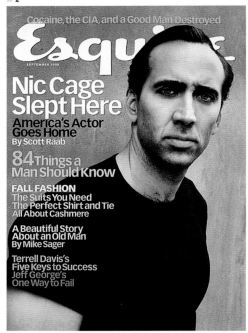

Cocaine, the CIA, and a Good Man Destroyed

Esquire
SEPTEMBER 1998

Nic Cage Slept Here
America's Actor Goes Home
By Scott Raab

84 Things a Man Should Know

FALL FASHION
The Suits You Need
The Perfect Shirt and Tie
All About Cashmere

A Beautiful Story About an Old Man
By Mike Sager

Terrell Davis's Five Keys to Success
Jeff George's One Way to Fail

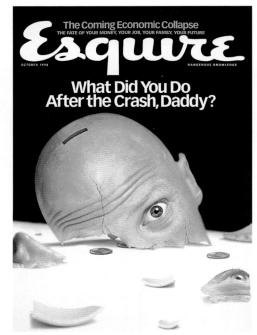

The Coming Economic Collapse
THE FATE OF YOUR MONEY, YOUR JOB, YOUR FAMILY, YOUR FUTURE

Esquire
OCTOBER 1998 DANGEROUS KNOWLEDGE

What Did You Do After the Crash, Daddy?

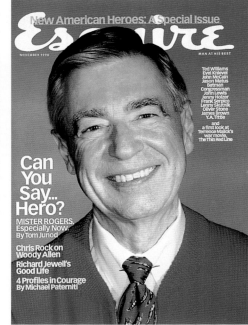

New American Heroes: A Special Issue

Esquire
NOVEMBER 1998 MAN AT HIS BEST

Ted Williams
Evel Knievel
John McCain
Jason Matus
Batman
Congressman
John Lewis
Jenny Holzer
Frank Serpico
Lenny Skutnik
Oliver Stone
James Brown
Y.A. Tittle
and a first look at
Terrence Malick's
new movie,
The Thin Red Line

Can You Say... Hero?
MISTER ROGERS.
Especially Now.
By Tom Junod

Chris Rock on Woody Allen
Richard Jewell's Good Life
4 Profiles in Courage
By Michael Paterniti

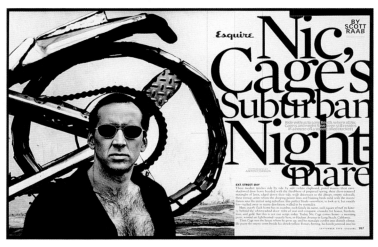

Esquire
BY SCOTT RAAB
Nic, Cage's Suburban Nightmare

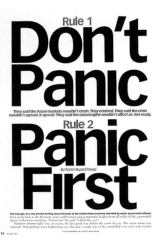

Rule 1
Don't Panic

They said the Asian markets wouldn't crash. They crashed. They said the crisis wouldn't spread. It spread. They said the catastrophe wouldn't affect us. Get ready.

Rule 2
Panic First
By Walter Russell Mead

92 ESQUIRE

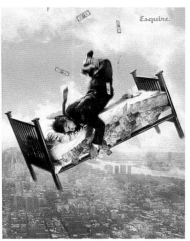

Esquire

RICHARD JEWELL IS ON THE WAY

BY SARA CORBETT

PHOTOGRAPHS BY HARRY BENSON

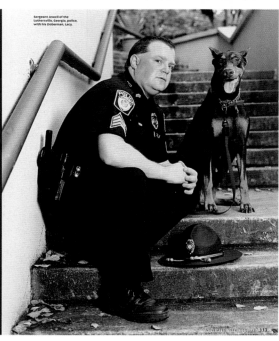

Sergeant Jewell of the Luthersville, Georgia, police, with his Doberman, Lacy.

■ 2
Publication Esquire
Design Director Robert Priest
Art Director Rockwell Harwood
Designer Joshua Liberson
Photo Editor Patti Wilson
Photographers Dan Winters, Matt Mahurin,
Brian Velenchenko, Anton Corbijn, Harry Benson
Publisher The Hearst Corporation-Magazines Division
Issues September, October, November 1998
Category Magazine of the Year

STORIES ON THE STATE OF THE AMERICAN RIDE

One Man, One Car

Where are we going?
Out.

The world explodes when we get our hands around a wheel. We grow large. It is not an unmixed blessing. But it is, surely, a blessing.

As we greet the final new-model year of the millennium and mark the one hundredth anniversary of the first used-car sale, and as tail fins and chrome fenders recede into memory and the roads fill with leased paragons of Eurobox reliability and mall-bound 4x4 SUVs, some timeless truths remain:

Liberty depends upon our right to hit the road.
Movement is the soul of being.
Freedom means striking out for parts unknown.

We are, for better and worse, heirs of immigrants, sons of pioneers steeped in nation-building notions of manifest destiny and eminent domain. We'd rather stop for another tank of gas than ask for directions.

So welded is the car to American culture that it is easy to mistake semiotics for substance here. The sounds and images repeat and accrue. Car chases. Drag races. The getaway. The backseat tryst. The Batmobile. The pimpmobile. The Popemobile. And Herbie. The infinitely rich mix of El Producto cigars, Old Spice aftershave, and the sad effluvium—part beer, part sweat, part quiet desperation—of young men saddled to husbandhood, fatherhood, and dead-end jobs, driving models whose names were the poetry of wandering.

Fury, Tempest, Coronet
Cutlass, Barracuda, 'Vette
Imperial, LeSabre, LTD
El Camino, Eldorado
Riviera, Toronado
Continental, Coupe de Ville
Country Squire, Bonneville
Biscayne, Bel Air, Malibu
Grand Prix

For us, the automobile is more than a symbol of freedom. It *is* freedom. It is not just a means of physical transportation: It is *spiritual* transport, too, the vehicle of American manhood, the dream of American boyhood. Wed to a man's will to go—even if he's driving to the office—the car is no mere totem. It is the essence of his force, four-cylinder or eight-, automatic or stick, destination charges not included.

Split open a seventeen-year-old boy's heart and you'll smell hot vinyl, sex, and gasoline.

When will we be back?
Later.

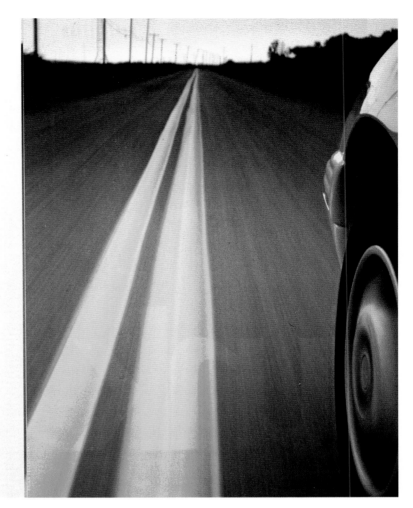

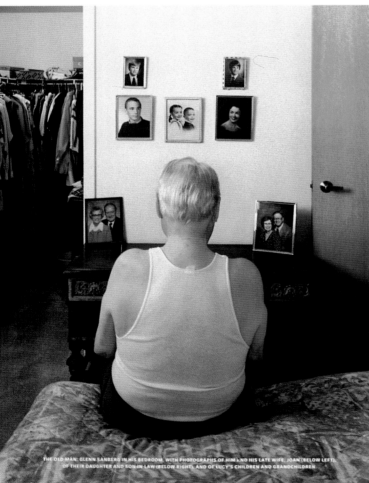

THE OLD MAN: GLENN SANBERG IN HIS BEDROOM, WITH PHOTOGRAPHS OF HIM AND HIS LATE WIFE, JOAN (BELOW LEFT), OF THEIR DAUGHTER AND SON-IN-LAW (BELOW RIGHT), AND OF LUCY'S CHILDREN AND GRANDCHILDREN.

PHOTOGRAPHS BY DAN WINTERS

Old

BY MIKE SAGER

Boy, oh boy, oh boy, Sanberg. You're 92. And you've been old longer than you've been anything else.

MORNING FILTERS THROUGH THE BEDROOM WINDOW IN DELICATE, SLANTED rays, dust motes and sounds and memories drifting in the air. Doves coo, a horseshoe clangs, quails skitter across the rain gutter. The clock radio on the night table whirs and vibrates, the number card flops: 6:33.

The old man sleeps on his left shoulder on the right side of the bed. His name is Glenn Brown Sanberg. He is ninety-two. He is peaceful in repose in plaid pajamas, a colorful floral spread pulled snugly to his neck. He has white, flyaway hair and bushy eyebrows, a flaky irritation at the point on his forehead from which his pompadour once issued. His cheeks are soft and deeply furrowed, speckled here and there with brown spots. His mouth is open, top lip buckled a bit over the gum line, chin stubbled with fine white whiskers. His left hand rests upon the pillow on the unmussed side of the bed, a queen.

Starlings chatter. Water gurgles in an ornamental pond. A draft horse pulls a wagon full of housewares down a cobblestone street. Glenn stirs, sighs, floats toward wakefulness. He thinks of the lake cabin he once built. Laying the foundation, he used a pancake turner for a trowel. He

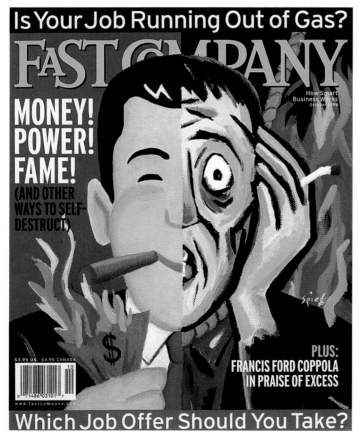

3
Publication Fast Company
Art Director Patrick Mitchell
Designers Gretchen Smelter, Emily Crawford, Rebecca Rees, Patrick Mitchell
Illustrators Barry Blitt, Douglas Fraser, Art Spiegelman
Photographers Chris Buck, David Barry
Publisher Fast Company
Issues October, November, December 1998
Category Magazine of the Year

How to Hire the Next Michael Jordan

IF YOU WANT TO RECRUIT SUPERSTARS—THE BEST OF THE BEST—
THEN YOU HAVE TO FIND THEM DIFFERENTLY, EVALUATE THEM DIFFERENTLY, AND OFFER
THEM JOBS DIFFERENTLY. HERE'S A SHORT COURSE
FROM **JOHN SULLIVAN,** THE MICHAEL JORDAN OF HIRING.

BY GINA IMPERATO ILLUSTRATIONS BY BARRY BLITT

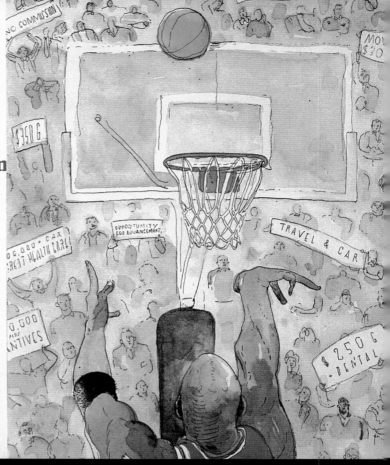

LEADERSHIP

"I NEVER FORGET THAT I AM PARKING THE CARS, AND THEY ARE DRIVING. WHAT'S IMPORTANT IS THAT GUESTS GET WHAT THEY EXPECT."
Hans Willimann

Title General Manager
Company Four Seasons Hotel
Location Chicago
Age 52

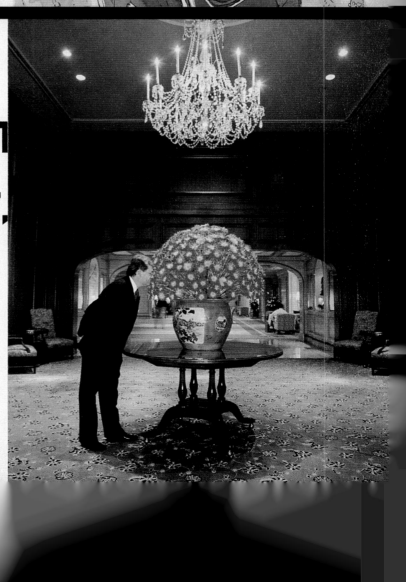

By Charles Fishman Photograph by David Barry

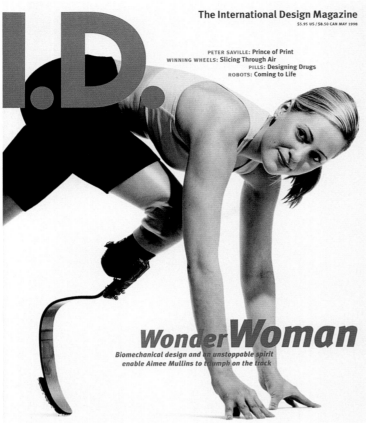

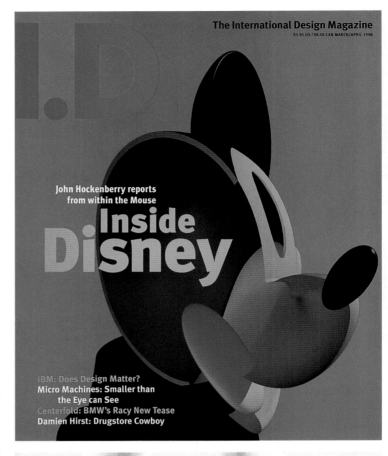

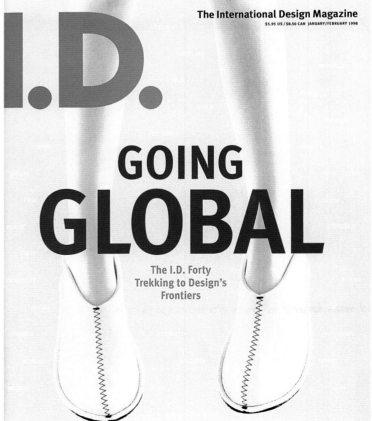

■ 4
Publication I. D.
Design Director Luke Hayman
Designers Miranda Dempster, Darren Ching
Illustrators Antoine Bordier, Lex Curtiss, J. J. Gifford
Photographers Annabel Elston, Graham MacIndoe, James Wojcik, Nick Knight,
Mikako Koyama, Davies + Starr, Jay Zuckerkorn, Steve Richter, John Holderer
Publisher F&W Publications
Issues March/April, May, September/October 1998
Category Magazine of the Year

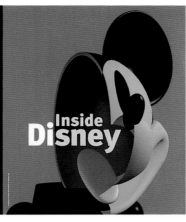

KEN WONG IS TALKING ABOUT THE WEENIE. *The president of the world's largest design firm sits in a conference room accented with stylishly dimmed track lighting. He's wearing an immaculately tailored suit and having a discussion with an employee named Dave in T-shirt and sneakers. It is a discussion Walt Disney might have engaged in a half century ago.*

"Walt came up with the Weenie and the Big Wow," Wong explains to me. "Every attraction in the parks has one of each—has to, in fact." He thinks a moment. He's worked through this particular riddle before. "The Big Wow is easy. The 13-story drop in the Tower of Terror in Orlando is a Big Wow." Dave nods enthusiastically. "And the Weenie?" I ask. "The Weenie is harder," Dave offers. "The Weenie is a real Walt term," says Wong, as though he's talking about the Doric columns of the Parthenon. "It's the thing that puts the whole attraction together, that makes it like home for the guests. The castle at Disneyland is the Weenie," says Wong of the architectural icon that has come to symbolize America's highest-grossing escapist fantasy.

Inside Disney

BY JOHN HOCKENBERRY

 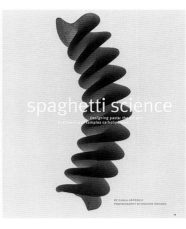

spaghetti science

Designing pasta: the art
engineering of complex carbohydrates

BY PAULA ANTONELLI
PHOTOGRAPHY BY MIKAKO KOYAMA

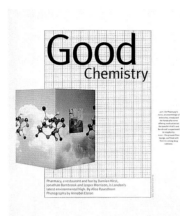

Good
Chemistry

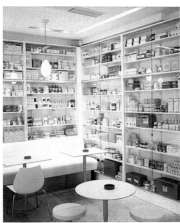

Pharmacy, a restaurant and bar by Damien Hirst, Jonathan Barnbrook and Jasper Morrison, is London's latest environmental high. By Alice Rawsthorn
Photography by Annabel Elston

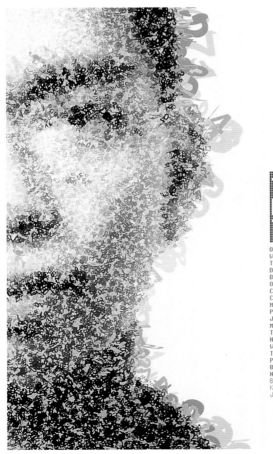

THE MAEDA TOUCH

OBSESSED
WITH
THE
DEEP
BEAUTY
OF
COMPUTER
CODE,
MIT
PROFESSOR
JOHN
MAEDA
TEACHES
NEW
WAYS
TO
PAINT
BY
NUMBERS.
BY
KARRIE
JACOBS

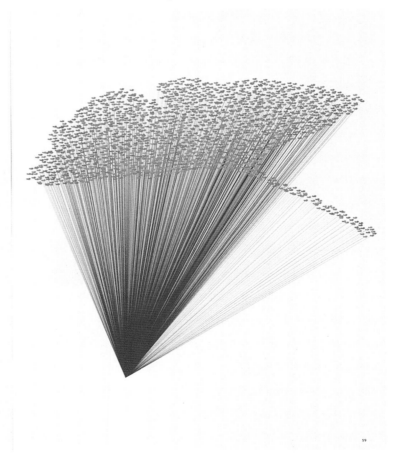

59

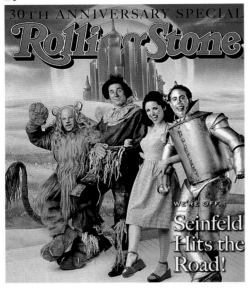

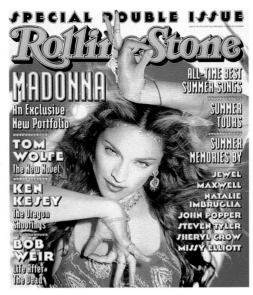

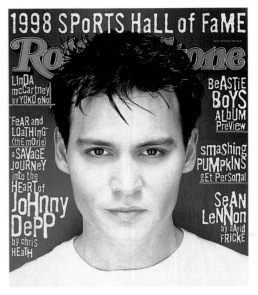

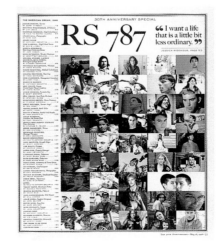

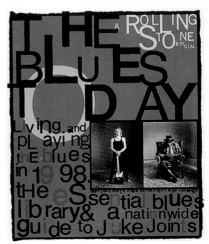

■ 5
Publication Rolling Stone
Art Director Fred Woodward
Designers Fred Woodward, Gail Anderson,
Siung Tjia, Eric Siry, Hannah McCaughey
Photo Editors Rachel Knepfer, Fiona McDonagh
Photographers Dan Winters, David LaChapelle,
Mark Seliger, Mary Ellen Mark
Publisher Straight Arrow Publishers
Issues May 28, June 11, July 9, 1998
Category Magazine of the Year

THE STAR OF "FEAR AND
LOATHING IN LAS VEGAS"
GOES GONZO INTO
THE PSYCHE OF
HUNTER S. THOMPSON
AND LIVES
TO TELL ABOUT IT

JOHNNY DEPP'S SAVAGE JOURNEY

BY CHRIS HEATH

PHOTOGRAPHS BY DAN WINTERS

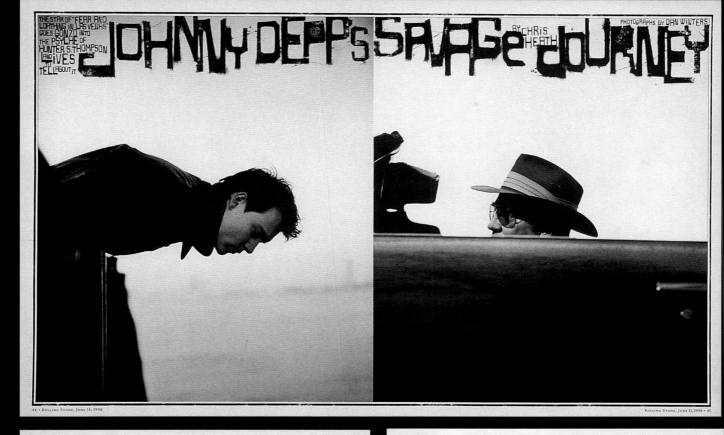

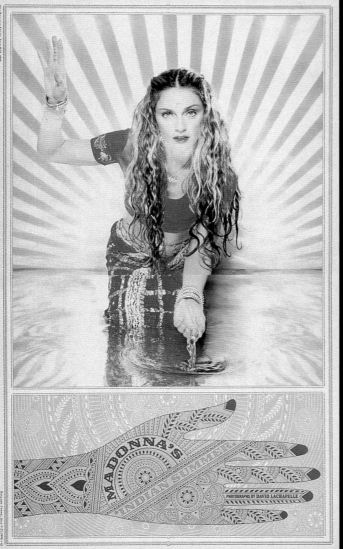

MADONNA'S INDIAN SUMMER

PHOTOGRAPHS BY DAVID LACHAPELLE

The End

The 180th and final episode of "Seinfeld," to be broadcast on May 14th, was scheduled to be filmed over nine days, from March 31st to April 8th. ROLLING STONE was there the whole time – for more than 100 hours on set – watching. Hiding in corners. Being nosy. All Jerry Seinfeld asked in return was that the ensuing story not reveal anything. This is that story.

BY CHRIS HEATH

PHOTOGRAPHS BY MARK SELIGER

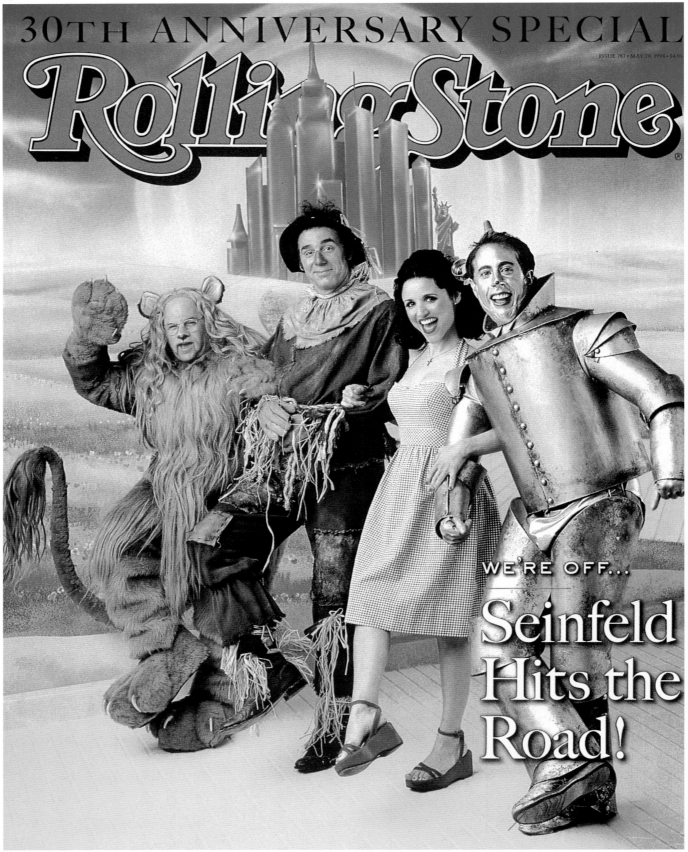

30TH ANNIVERSARY SPECIAL

ISSUE 787 • MAY 28, 1998 • $4.95

Rolling Stone

WE'RE OFF...

Seinfeld Hits the Road!

■ 6
Publication Rolling Stone
Art Director Fred Woodward
Designer Fred Woodward
Photo Editor Rachel Knepfer
Photographer Mark Seliger
Publisher Straight Arrow Publishers
Issue May 28, 1998
Category Cover

■ 7
Publication Rolling Stone
Art Director Fred Woodward
Designers Fred Woodward, Gail Anderson,
Siung Tjia, Eric Siry, Hannah McCaughey
Photo Editors Rachel Knepfer, Fiona McDonagh
Photographers Mark Seliger, Dan Winters
Publisher Straight Arrow Publishers
Issue May 28, 1998
Category Entire Issue

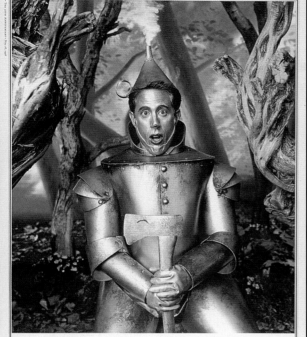

The End

The 180th and final episode of "Seinfeld," to be broadcast on May 14th, was scheduled to be filmed over nine days, from March 31st to April 8th. ROLLING STONE was there the whole time – for more than 100 hours on set – watching. Hiding in corners. Being nosy. All Jerry Seinfeld asked in return was that the ensuing story not reveal anything. This is that story. BY CHRIS HEATH

PHOTOGRAPHS BY MARK SELIGER

30TH ANNIVERSARY SPECIAL

RS 787

"I want a life that is a little bit less ordinary."

JESSICA RIDENOUR, PAGE 93

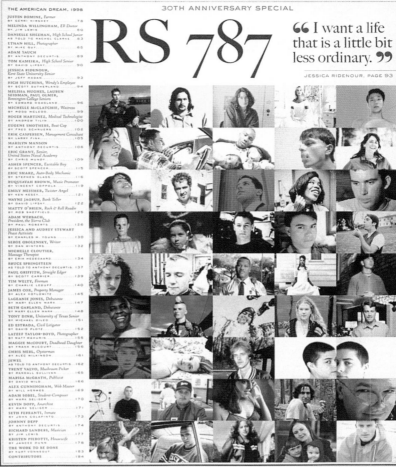

me. My close friends are also involved in resistance."

Returning to formal education at fifteen – Jessica at the College of the Atlantic in Bar Harbor, Maine, Audrey at the University of Maine at Orono – they continued to pursue their own agenda of feminism, psychology, ecology and the history of nonviolence. Under the influence of books of New Age anti-hierarchical thought such as *Chalice and the Blade*, by Riane Eisler, and *Dreaming the Dark*, by Starhawk, they turned eighteen and discovered that, as adults, getting arrested for civil disobedience entails less hassle than it used to – because as minors they could only be released to the custody of parents or guardians. So they dropped out and got arrested eight times in less than a year. Their crimes have ranged from dumping baby bottles of their own blood on an Aegis destroyer in Bath to sitting in at the U.S. Army School of the Americas, in Fort Benning, Georgia, an institution known on the left as the School of the Assassins for its training of death squads and torturers all over the Third World.

"It's not always a pleasant thing to be involved with the legal system," says Audrey, who has a habit of defying judges. "You can't go to the bathroom in any privacy; you get strip-searched. The rituals are endless and pointless, except to demonstrate that the guard is the boss and you aren't. The structures of domination that are normally masked in society become really, really visible in jail, so it's a consciousness-raising experience."

"You realize the prison system is bigger than anybody who's involved," says Jessica, "and it's out of everybody's control. It's not designed to help anyone. It's just vicious. There's always a punishment they can inflict and a reward they can dangle. Society operates the same way, only more subtly, so people from the white middle class don't notice."

In one memorable episode last December, they were arrested for praying in front of the White House. On the day of their status hearing in Washington in the middle of January, Jessica got caught in

the worst ice storm in Maine history. When the weather warmed up, the federal marshals hauled her off in manacles and, in a two-week period, flew her first to a prison in Rhode Island, then to a federal transfer center in Oklahoma City, back to Maine, then to Washington again, where a federal judge sentenced her to six weeks in a halfway house.

"While you're getting on and off the plane, they point machine guns at you," Jessica says with a giggle. "It's quite interesting. They do call it Con Air, like the movie. It's these decrepit old airplanes that look like they're going to fall apart. And fifteen men six and a half feet tall guarding me, in chains. Just your tax dollars at work. If there are fifty ways to do something, the legal system will choose the most inefficient."

"I think they would do all fifty and then settle on the slowest," says Audrey.

Jessica is currently living in Maine on "self report," meaning she is waiting for a phone call telling her to report in two days to a halfway house, which may or may not be in Maine. Last December, Audrey moved to Jonah House, a resistance community in Baltimore associated with the Plowshares, a pacifist organization whose daring acts of civil disobedience have inspired both legend and long prison sentences. Neither Stewart makes enough money from the occasional odd job to be taxed, and neither would pay if she did. Apart from a few cassettes by Ani DiFranco and Sweet Honey in the Rock,

they shun popular culture. They view sex as overrated and have no plans to start families or traditional careers.

"It seems like the government is coming down on people with greater severity," says Audrey. "All these new prisons they're building. Even what happened to my sister, getting a month and a half for a White House vigil, is unheard of. At the School of the Americas demonstration, 601 people got arrested. Twenty-eight of them had been arrested for trespass before, and they got six months. I saw children arrested in Plymouth, Massachusetts. Where I live, in the inner city of Baltimore, the DEA [Drug Enforcement Administration] flies black helicopters over the projects all

the time. It's bizarre, and it's frightening. But it's also a sign that something is working. We must be doing something right, or the government wouldn't bother."

"I would like to start a self-sustaining, nonviolent-resistance community like Jonah House here in Maine," says Jessica. "It's really difficult to do this work unless you have a support group to take care of things while you're locked up. The prospect of prison doesn't excite me, but it will probably happen." I ask Jessica whether her activism is motivated by some sort of patriotism. "No, I can't use that word in any sense," she says. "I don't believe in national boundaries. I reject every aspect of the American dream. The goal is nonviolent revolution."

SERGE OBOLENSKY | 21 | Writer | Los Angeles

"I was struck by a sense of inspiration just watching him do things we all take for granted."

PHOTOGRAPH BY DAN WINTERS

TWO YEARS AGO, AT AGE nineteen, Serge Obolensky was grievously injured when he and his brother were playing with firecrackers. It was an adolescent game, the kind of boredom-chasing activity that many boys engage in and get away with.

Serge's life basically froze from that point on. He is learning to live without hands, and he is able to find beauty in his daily existence. "Once a day," he says, "I walk through a nursery with beautiful fruit trees. They give me a tingly feeling in my brain. I always think that if I could make the rest of the day as high-quality as that walk, I could have perfection in my life."

Serge is clear about his aspirations. "As long as I'm on earth living like this," he says,

"I want to do what's *right*, to show God I love him. I also have a dream to sing. When I'm alone, I can sing, and it makes me really happy. Oh, and I would also like to get married." He reads books on astronautical sciences, loves "trance" music – "It's like an electronic paradise" – and frequently goes to raves.

Serge feels that he can cause cathartic responses when he encounters strangers who are curious about how he accomplishes simple daily tasks. I met him in a Hollywood diner as one of those strangers. I was immediately struck by a sense of hope and inspiration just watching Serge do the things we all take for granted. We have since formed a bond and a friendship.

Serge, unable to pursue his passion for drawing, told me he plans to write a book. If his written word has the same effect on people as his physical presence, it could be one powerful piece of work. —D.W.

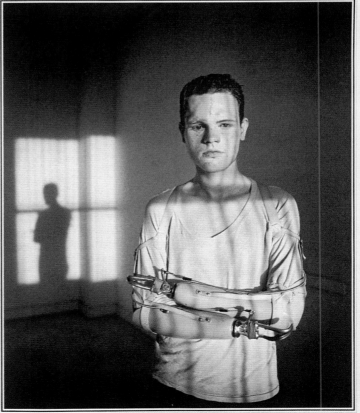

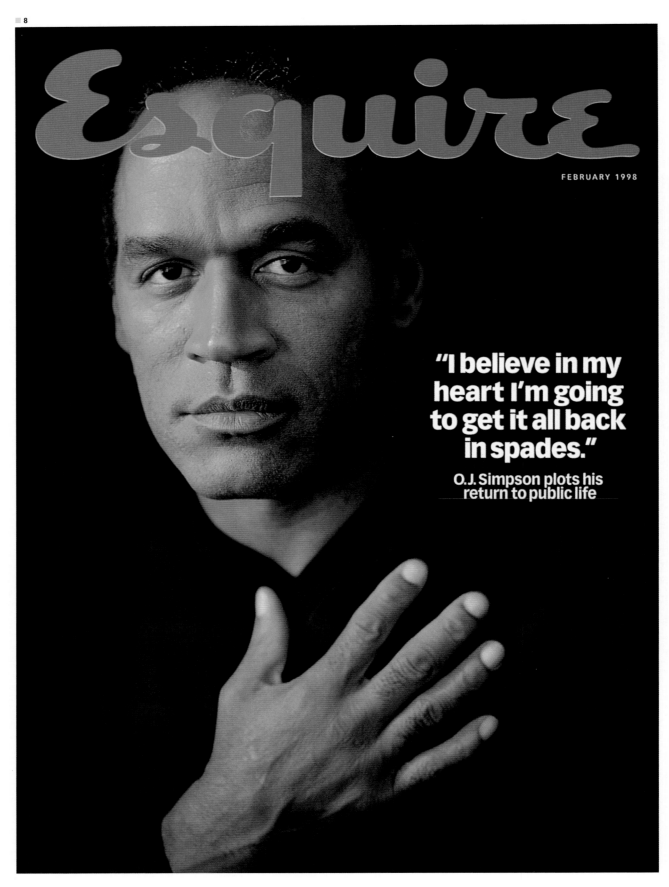

Esquire

FEBRUARY 1998

"I believe in my heart I'm going to get it all back in spades."

O.J. Simpson plots his return to public life

8
Publication Esquire
Design Director Robert Priest
Art Director Rockwell Harwood
Designer Joshua Liberson
Photo Editor Patti Wilson
Photographer Gregory Heisler
Publisher The Hearst Corporation-Magazines Division
Issue February 1998
Category Cover

9
Publication Esquire
Design Director Robert Priest
Art Director Rockwell Harwood
Designer Joshua Liberson
Photo Editor Patti Wilson
Photographer Matt Mahurin
Publisher The Hearst Corporation-Magazines Division
Issue October 1998
Category Cover

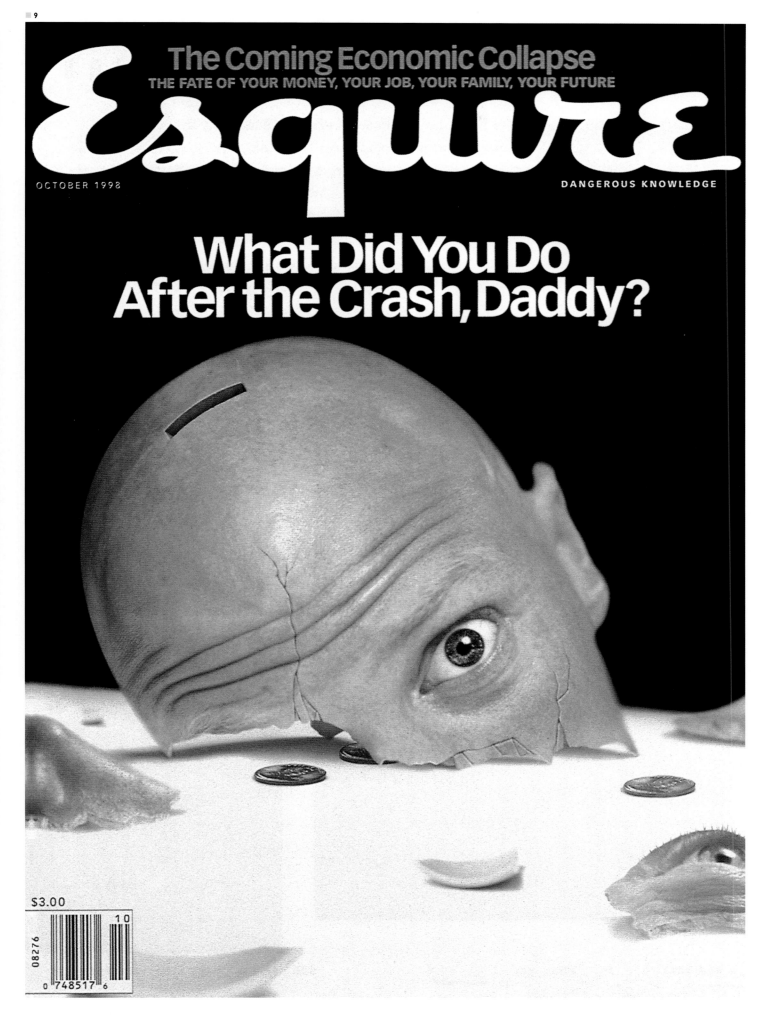

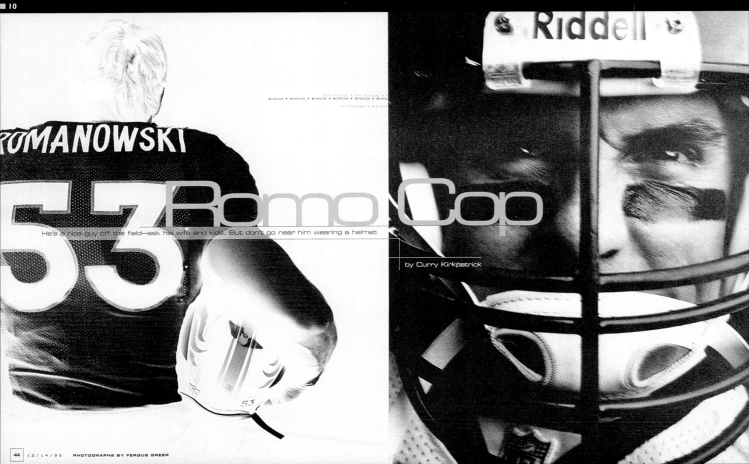

ROMANOWSKI

53 Robo Cop

He's a nice guy off the field—ask his wife and kids. But don't go near him wearing a helmet

by Curry Kirkpatrick

Riddell

MENTORING—WOMEN DO IT DIFFERENT

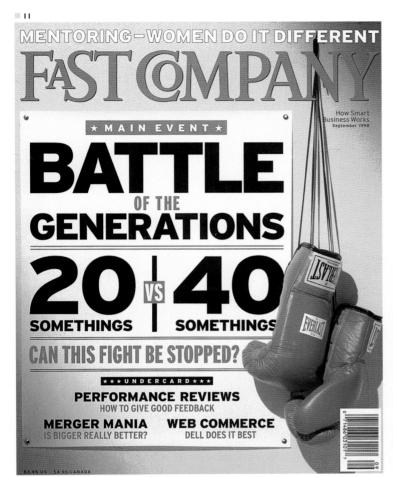

FAST COMPANY

How Smart
Business Works
September 1998

★ MAIN EVENT ★

BATTLE
OF THE
GENERATIONS

20 VS 40
SOMETHINGS | SOMETHINGS

CAN THIS FIGHT BE STOPPED?

★ ★ ★ UNDERCARD ★ ★ ★

PERFORMANCE REVIEWS
HOW TO GIVE GOOD FEEDBACK

MERGER MANIA
IS BIGGER REALLY BETTER?

WEB COMMERCE
DELL DOES IT BEST

$3.95 US $4.95 CANADA

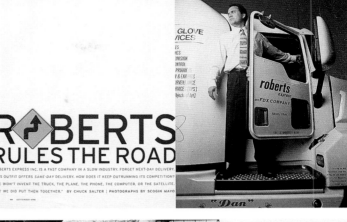

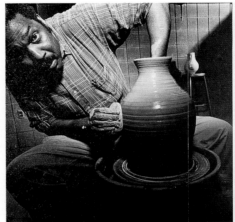

ROBERTS
RULES THE ROAD

ROBERTS EXPRESS INC. IS A FAST COMPANY IN A SLOW INDUSTRY. FORGET NEXT-DAY DELIVERY.
THIS OUTFIT OFFERS *SAME-DAY* DELIVERY. HOW DOES IT KEEP OUTRUNNING ITS COMPETITION?
"WE DIDN'T INVENT THE TRUCK, THE PLANE, THE PHONE, THE COMPUTER, OR THE SATELLITE,
BUT WE DID PUT THEM TOGETHER." BY CHUCK SALTER | PHOTOGRAPHS BY SCOGIN MAYO

genius at work

WITH HIS POTTER'S HANDS, BILL STRICKLAND IS RESHAPING THE
BUSINESS OF SOCIAL CHANGE. HIS PITTSBURGH-BASED PROGRAM
OFFERS A NATIONAL MODEL FOR EDUCATION, TRAINING—AND HOPE.
BY SARA TERRY PHOTOGRAPHS BY MARY ELLEN MARK

AMF HAS MOVED BOWLING OUT OF ITS OLD ALLEYS AND INTO TECHNOTAINMENT. BY LISA CHADDERDON

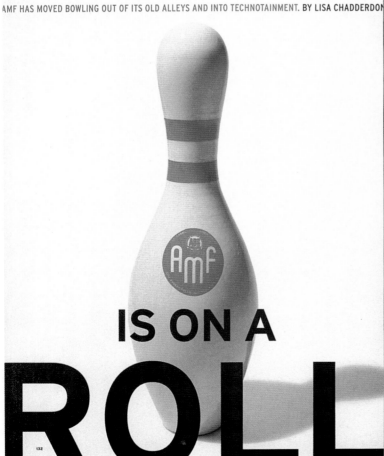

IS ON A
ROLL

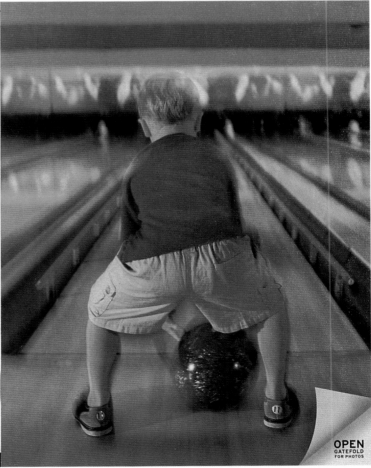

OPEN
GATEFOLD
FOR PHOTOS

23

HEAL SICK TEAMS » GET A LEADERSHIP CHECKUP » OPERATE ON BRAINS

FAST COMPANY

Second Anniversary Issue

How Smart Business Works
February : March 1998

YOU DECIDE

["LOOK, WE NEVER SAID THIS NEW ECONOMY STUFF WAS EASY!"]

IS YOUR JOB YOUR CALLING?

IS YOUR COMPANY SELLING OUT?

IS GIVING AWAY POWER THE WAY TO LEAD?

$3.95 US / $4.95 CANADA

0 71486 03101 7 03

■ 12
Publication Fast Company
Art Director Patrick Mitchell
Designer Patrick Mitchell
Publisher Fast Company
Issue February/March 1998
Category Cover

13

Print

$35
AMERICA'S GRAPHIC DESIGN MAGAZINE
SEPTEMBER/OCTOBER 1998
PRINT LII:V

Print's Regional Design Annual 1998

50% 50% 25% 75% B Kreuzt M B Balance Kreuzmiren C 50%

(see inside for details)

13
Publication Print
Art Director Andrew Kner
Designer Michael Ian Kaye
Publisher RC Publications
Issue September 1998
Category Cover

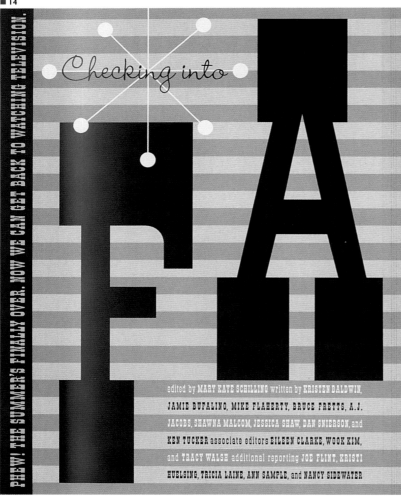

Checking into

FALL

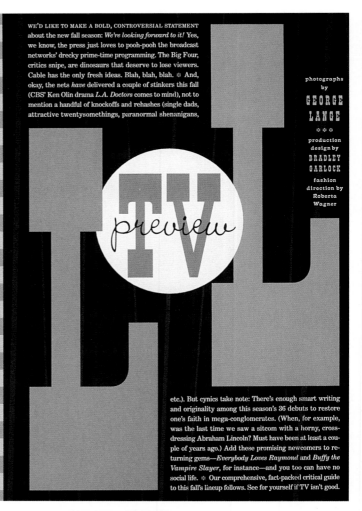

TV

preview

WE'D LIKE TO MAKE A BOLD, CONTROVERSIAL STATEMENT about the new fall season: *We're looking forward to it!* Yes, we know, the press just loves to pooh-pooh the broadcast networks' drecky prime-time programming. The Big Four, critics snipe, are dinosaurs that deserve to lose viewers. Cable has the only fresh ideas. Blah, blah, blah. ❋ And, okay, the nets *have* delivered a couple of stinkers this fall (CBS' Ken Olin drama *L.A. Doctors* comes to mind), not to mention a handful of knockoffs and rehashes (single dads, attractive twentysomethings, paranormal shenanigans,

photographs by
GEORGE LANGE
❋ ❋ ❋
production design by
BRADLEY GARLOCK
fashion direction by
Roberta Wagner

etc.). But cynics take note: There's enough smart writing and originality among this season's 36 debuts to restore one's faith in mega-conglomerates. (When, for example, was the last time we saw a sitcom with a horny, cross-dressing Abraham Lincoln? Must have been at least a couple of years ago.) Add these promising newcomers to returning gems—*Everybody Loves Raymond* and *Buffy the Vampire Slayer*, for instance—and you too can have no social life. ❋ Our comprehensive, fact-packed critical guide to this fall's lineup follows. See for yourself if TV isn't good.

edited by MARY KAYE SCHILLING written by KRISTEN BALDWIN, JAMIE BUFALINO, MIKE FLAHERTY, BRUCE FRETTS, A.J. JACOBS, SHAWNA MALCOM, JESSICA SHAW, DAN SNIERSON, and KEN TUCKER associate editors EILEEN CLARKE, WOOK KIM, and TRACY WALSH additional reporting JOE FLINT, KRISTI HUELSING, TRICIA LAINE, ANN SAMPLE, and NANCY SIDEWATER

PHEW! THE SUMMER'S FINALLY OVER. NOW WE CAN GET BACK TO WATCHING TELEVISION.

Wednesday

the SOPHOMORE the MERRIER

————
DAWSON'S CREEK
THE WB, 8-9 PM
STARTS OCT. 7

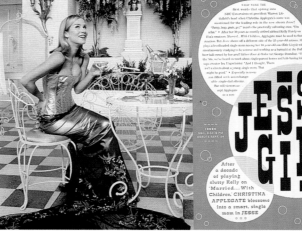

Thursday

JESSE'S GIRLS

After a decade of playing slutty Kelly on *Married... With Children*, CHRISTINA APPLEGATE blossoms into a smart, single mom in JESSE
❋ ❋ ❋

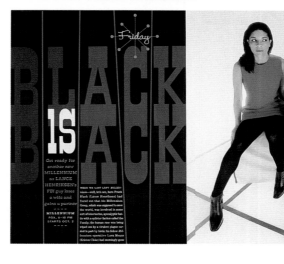

Friday

BLACK IS BLACK

————
MILLENNIUM
FOX, 9-10 PM
STARTS OCT. 2

■ 14
Publication Entertainment Weekly
Design Director John Korpics
Art Director Geraldine Hessler
Designer Geraldine Hessler
Photo Editor Alice Babcock
Photographer George Lange
Publisher Time Inc.
Issue September 11, 1998
Category Feature Story

■ 15

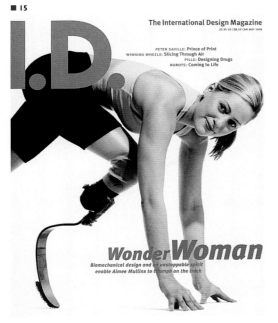
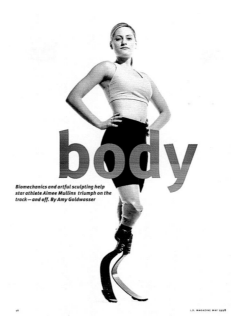
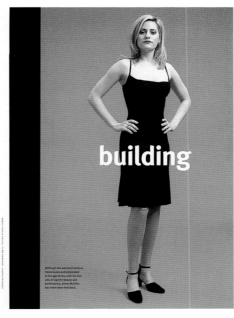

body building

Biomechanics and artful sculpting help star athlete Aimee Mullins triumph on the track — and off. By Amy Goldwasser

Wonder Woman
Biomechanical design and an unstoppable spirit enable Aimee Mullins to triumph on the track

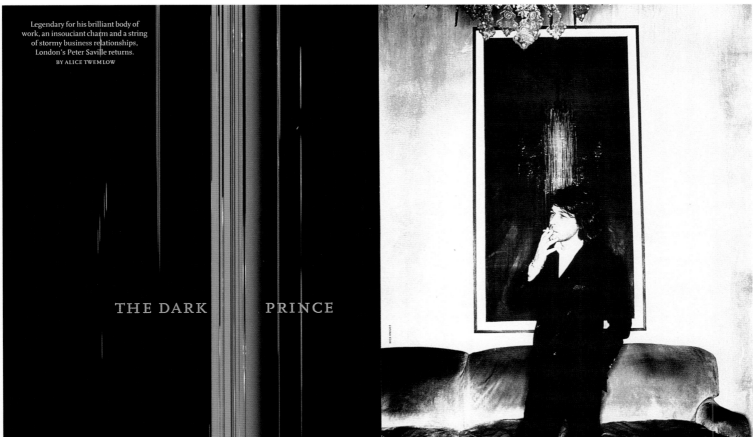

Legendary for his brilliant body of work, an insouciant charm and a string of stormy business relationships, London's Peter Saville returns.
BY ALICE TWEMLOW

THE DARK PRINCE

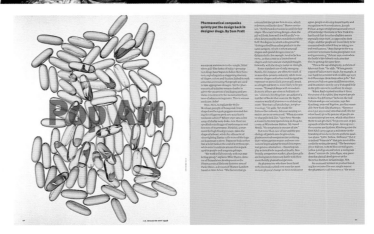

Pharmaceutical companies quietly put the design back in designer drugs. By Sam Pratt

POP ART

■ 15
Publication I. D.
Design Director Luke Hayman
Designer Miranda Dempster
Illustrator J. J. Gifford
Photographers Graham MacIndoe, James Wojcik, Nick Knight
Publisher F&W Publications
Issue May 1998
Category Entire Issue

27

ITC TYPEFACE COLLECTION

SPIDER PRESS : 3317-18TH AVENUE SOUTH

UPPER AND LOWER CASE : THE INTERNATIONAL JOURNAL OF GRAPHIC DESIGN AND DIGITAL MEDIA
PUBLISHED BY INTERNATIONAL TYPEFACE CORPORATION : VOL.25 NO.2 : FALL 1998 : $5 US $9.90 AUD £4.95

U&lc

ALL MERCHANDISE — GUARANTEED AOK

Customs Inspector: Contains Printed Matter

WORK::TITLE

SOLD TO:

MESSAGE:

FOR

COPYRIGHT N₀:

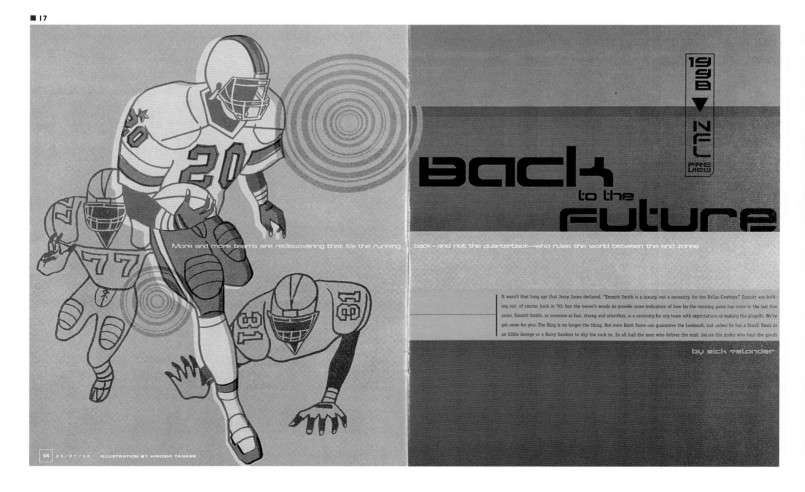

1998 ▼ NFL PREVIEW

back to the future

More and more teams are rediscovering that it's the running back—and not the quarterback—who rules the world between the end zones

It wasn't that long ago that Jerry Jones declared, "Emmitt Smith is a luxury, not a necessity, for the Dallas Cowboys." Emmitt was holding out, of course, back in '93, but the owner's words do provide some indication of how far the running game has come in the last five years. Emmitt Smith, or someone as fast, strong and relentless, is a necessity for any team with expectations of making the playoffs. We've got news for you: The fling is no longer the thing. Not even Brett Favre can guarantee the Lombardi, not unless he has a Terrell Davis or an Eddie George or a Barry Sanders to slip the rock to. So all hail the men who deliver the mail. Salute the dudes who haul the goods

by rick telander

54 05/07/98 ILLUSTRATION BY HIROSHI TANABE

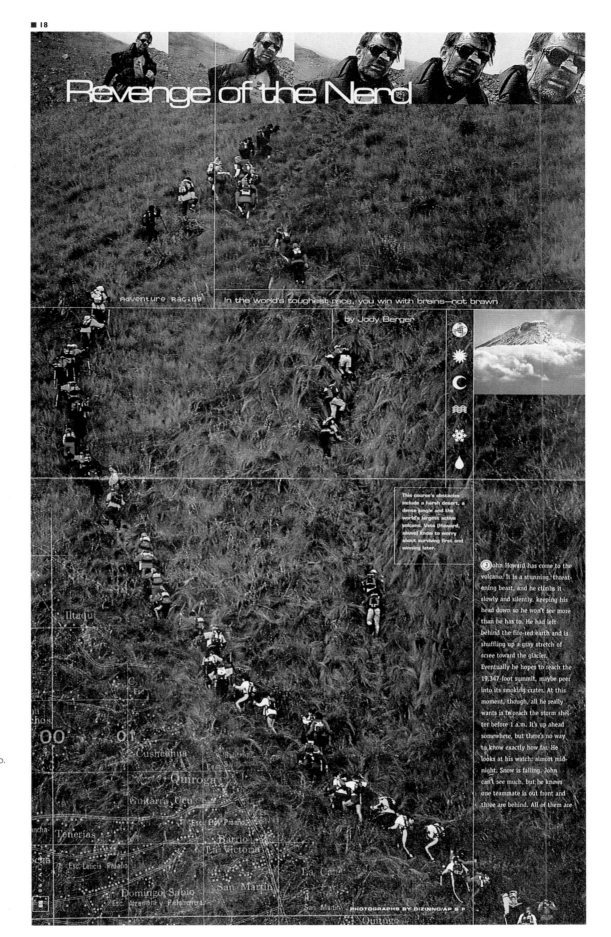

■ 18

Revenge of the Nerd

Adventure Racing In the world's toughest race, you win with brains—not brawn

by Jody Berger

This course's obstacles include a harsh desert, a dense jungle and the world's largest active volcano. Vets (Howard, above) know to worry about surviving first and winning later.

John Howard has come to the volcano. It is a stunning, threatening beast, and he climbs it slowly and silently, keeping his head down so he won't see more than he has to. He had left behind the fire-red earth and is shuffling up a gray stretch of scree toward the glacier. Eventually he hopes to reach the 19,347-foot summit, maybe peer into its smoking crater. At this moment, though, all he really wants is to reach the storm shelter before 1 a.m. It's up ahead somewhere, but there's no way to know exactly how far. He looks at his watch: almost midnight. Snow is falling. John can't see much, but he knows one teammate is out front and three are behind. All of them are

PHOTOGRAPHS BY DIZINNO/AP & F

■ 16
Publication U&lc
Creative Director John D. Berry
Design Director Clive Chiu
Art Director Mark van Bronkhorst
Designer Mark van Bronkhorst
Illustrators C. Christopher Stern, Jules Remedios Faye
Publisher International Typeface Corp.
Issue Fall 1998
Category Cover

■ 17
Publication ESPN
Design Director F. Darrin Perry
Art Director Peter Yates
Illustrator Hiroshi Tanabe
Publisher Disney
Issue September 7, 1998
Category Feature Spread

■ 18
Publication ESPN
Design Director F. Darrin Perry
Art Director Christopher Rudzik
Photo Editor Gladees Prieur
Photographer Dizinno
Publisher Disney
Issue December 14, 1998
Category Feature Spread

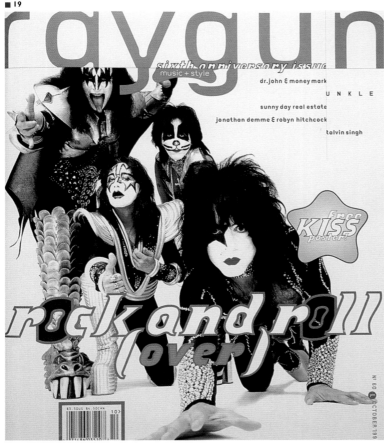

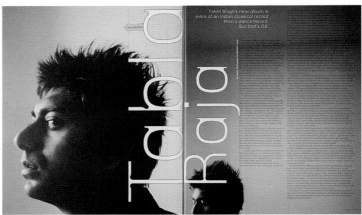

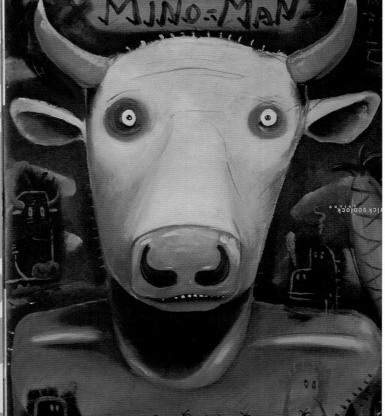

■19
Publication Ray Gun
Art Directors Barry Deck, Warren Corbitt
Designers Barry Deck, Warren Corbitt
Illustrator Rick Sealock
Photo Editor Robyn Forest
Photographer Dewey Nicks, Elizabeth Young
Publisher Ray Gun Publishing
Issue October 1998
Category Entire Issue

■20
Publication Ray Gun
Art Director Barry Deck
Designer Warren Corbitt
Photo Editor Robyn Forest
Photographer Dana Menussi
Publisher Ray Gun Publishing
Issue October 1998
Category Feature Spread

■21
Publication Rolling Stone
Art Director Fred Woodward
Designer Gail Anderson
Photo Editor Rachel Knepfer
Photographer Dan Winters
Publisher Straight Arrow Publishers
Issue September 3, 1998
Category Feature Spread

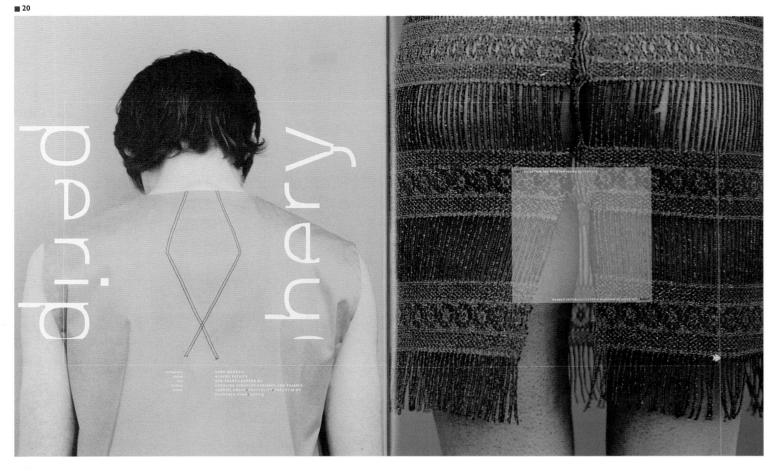

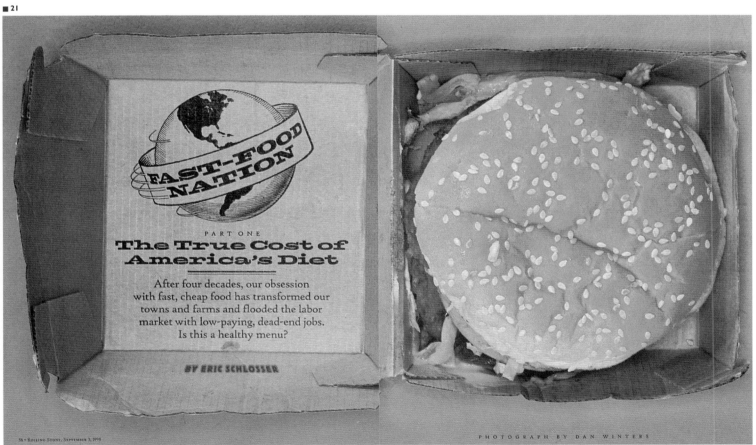

FAST-FOOD NATION

PART ONE

The True Cost of America's Diet

After four decades, our obsession
with fast, cheap food has transformed our
towns and farms and flooded the labor
market with low-paying, dead-end jobs.
Is this a healthy menu?

BY ERIC SCHLOSSER

PHOTOGRAPH BY DAN WINTERS

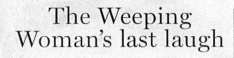

B10

NATIONAL POST, TUESDAY, OCTOBER 27, 1998

B11

AVENUE
Arts, Culture & Society

SWISS WATCHMAKER ATTEMPTS TO SYNCHRONISE THE WORLD

SHORTAGE OF GIFTS AS FEAR OF ANGELS DISCOURAGES GOOD DEEDS

HOW HINDU HOUDINIS HOODWINK

By TAHIR SHAH

The Weeping Woman's last laugh

WHO'D ABUSE A MUSE?

BY LIESL SCHILLINGER

DORA MAAR

A TOME WITH A VIEW TO TOMBS

By KEN BAKER

> WHEN SHE STRODE UP TO TAKE HER PLACE AT THE SURREALISTS' TABLE, HER DARK HAIR STREAMING OUT UNCOMBED AND SPILLING MESSILY DOWN HER NECK, HER FRIENDS SHOUTED ADMIRATION FOR HER SOCIAL TRANSGRESSIVENESS

> THE EASIEST PROOF THAT SOMEONE IS A LEGITIMATE SURREALIST IS THAT HE (OR SHE) IS KNOWN TO HAVE SLEPT WITH ANOTHER SURREALIST; OR TO HAVE SLEPT WITH SOMEONE WHO SLEPT WITH A SURREALIST.

> *Artifacts auctioned today in Paris are both a record of a life and a definition of surrealism.*

22
Publication National Post
Creative Director Leanne M. Shapton
Design Directors Lucie Lacava, Roland-Yves Carignan, Gayle Grin
Designer Leanne M. Shapton
Illustrator Andreas Ventura
Issue October 27, 1998
Category Feature Spread

THEASSASSINATIONAT
35

Why we still care.

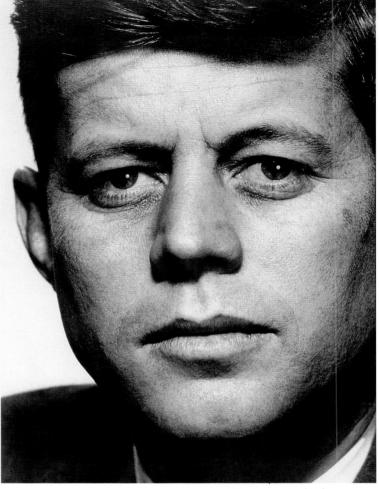

WE THINK THE MILLENNIUM IS CHANGING IN 2000, BUT SINCE eras change by events and not by the calendar, the new millennium actually began 35 years ago, on November 22, 1963. That was when the confidence and the security of the years following World War II were abruptly destroyed and replaced by suspicion and insecurity. Immediately afterward came the unthinkable—the assassinations of Martin Luther King, Jr., and Robert Kennedy, a losing war, Watergate, and Iran-Contra. Belief in conspiracy and powerful forces working against us became part of the national consciousness, reaching its apotheosis in the 1991 film *JFK*. One gauge of how much we've changed: In 1964 three fourths of the American people had a great deal of confidence in the government; today that number is one fifth.

In this issue we look closely at that singular event, the assassination. We explain the strengths and weaknesses of the best-known conspiracy theories. Research along these lines, so often misguided, seems from today's perspective to be a form of grieving. We talk with witnesses to the assassination. They are all certain of what they saw and experienced, yet their stories often conflict. That shows how difficult it is to find the truth. We show evidence of the crime in stark photographs from the National Archives. We try to explain how the loopiest assassination theory of all can have rational adherents. And we make the case that one man alone did the deed and try to show how knowing that can be a kind of solace. But we have not answered—and cannot answer—when or whether that solace will come.

TEXAS MONTHLY **124** November 1998

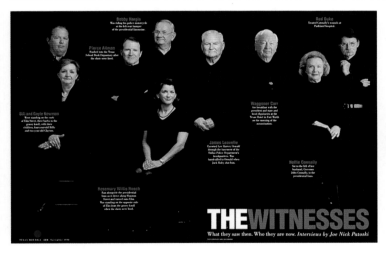

THEWITNESSES
What they saw then. Who they are now. *Interviews by Joe Nick Patoski*

THEEVIDENCE
Bullets, bloody clothes, a camera, and other assassinationalia from the National Archives.

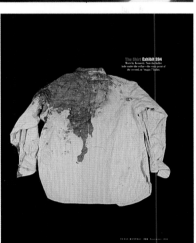

The Jacket Exhibit 393

The Shirt Exhibit 394

THELONE
GUNMAN

Lee Harvey Oswald killed
John F. Kennedy. End of Story.

by Gregory Curtis

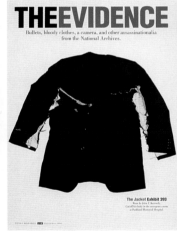

■ 23
Publication Texas Monthly
Creative Director D. J. Stout
Designers D. J. Stout, Nancy McMillen
Photo Editor D. J. Stout
Photographer Phillippe Halsman, Greg Watermann
Publisher Emmis Communications Corp.
Issue November 1998
Category Feature Story

Ethan HAWKE

*He left the big screen for
two years to pen his first novel.
Now the actor starts a
new chapter of his life with
'Great Expectations'*

by DAVID LIPSKY

portfolio by MARK SELIGER

meg
Ryan

By Johanna Schneller

PHOTOGRAPHS BY

Matthew Rolston

Fire 'n' nice: Behind
the angelic grin
lies a woman who
has learned the
hard way where to
find strength and
how to be happy

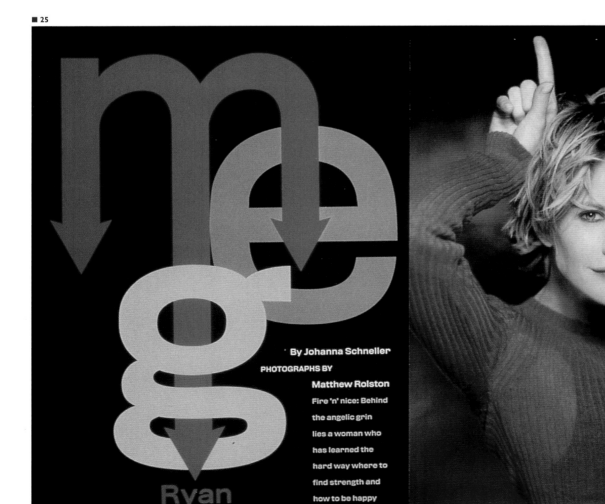

DEVILED
MEG
Red ribbed
split-knit
sweater by
John
Bartlett

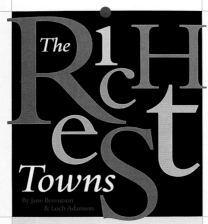

The RiCHeSt Towns

By Jane Berentson & Loch Adamson

OUR ANNUAL RANKING of the PLACES
WHERE MONEY FINDS COMPANY

MAY 1998 | WORTH 57

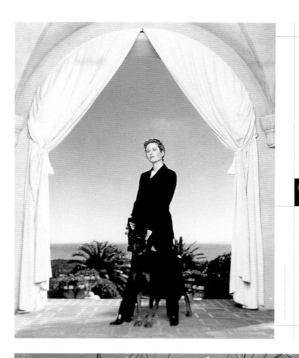

#28

"THERE ARE INCREDIBLE...

#182

ILLUSTRATION BY MARK ULRIKSEN

PHOTOGRAPH BY
NATHANIEL WELCH

#224

PHOTOGRAPH BY
DANNY CLINCH

■ 24
Publication US
Art Director Richard Baker
Designer Rina Migliaccio
Photo Editor Jennifer Crandall
Photographer Mark Seliger
Publisher US Magazine Co., L. P.
Issue January 1998
Category Feature Spread

■ 25
Publication US
Art Director Richard Baker
Photo Editor Jennifer Crandall
Photographer Matthew Rolston
Publisher US Magazine Co., L. P.
Issue April 1998
Category Feature Spread

■ 26
Publication Worth
Art Director Philip Bratter
Designer Deanna Lowe
Illustrators Robert de Michiell, Mark Gagnon,
Mark Ulriksen, Tim Carroll, John Cuneo
Photo Editor Sabine Meyer
Photographers Nathaniel Welch,
Mathew Gilson, Danny Clinch, Timothy Archibald
Publisher Capital Publishing L. P.
Issue May 1998
Category Feature Story

HOME OF THE MOAN

'The Vagina Monologues' Seizes the Means of Production

By Blanche McCrary Boyd

As President Clinton's recent troubles have demonstrated, it's not the economy, it's the body, stupid. And like his alleged fondness for blowjobs, vaginas are going public.

On V-Day (formerly Valentine's Day), a host of big muthas will perform Eve Ensler's Obie-Award-winning *The Vagina Monologues* at the Hammerstein Ballroom Theater. The usual suspects—Whoopi Goldberg, Lily Tomlin, Susan Sarandon, and Gloria Steinem—will join less obvious candidates like Barbara Walters, Glenn Close, and Winona Ryder in the most outrageous and important feminist event since the bra burnings at the Miss America pageant in 1968.

While Clinton has encountered the karma of "don't ask, don't tell,"

[Continued on page 38]

Michael S. Roth, curator of the hotly contested, long-delayed Sigmund Freud exhibition that opens this week at the Library of Congress, is talking with me about the hoary old Oedipus complex. In passing, I describe it as "wanting to sleep with your father and kill your mother." A flicker of surprise passes across Roth's face as he reminds me, "It's the opposite." So it is, I reply, startled and sheepish. Then I let Roth in on the fact that I'm gay. So was my Oedipus mistake a meaningless mix-up or a classic Freudian slip?

Freud bashers would insist such gaffes tell us nothing of the psyche. But even they couldn't help but suspect that such mistakes reveal *something*. And so, "We are all Freudians in our everyday thought," the psychiatrist Peter Kramer writes in the exhibition catalogue. Yes, the author of *Listening to Prozac* confesses that it was Freud who inspired him to go into psychiatry and Freud who continues to shape our conception of the psyche. "We worry," Kramer says, "about unconscious aggression, mother complexes, sexual repression, Freudian slips, and the like." The exhibition demonstrates how completely Freud pervades our culture by showing a delightful collection of video clips, from Popeye to the Simpsons, Dick Van Dyke to Murphy Brown.

Now is the perfect moment for an exhibition on Freud, not only because Monicagate is forcing everyone to ponder when a cigar is not just a cigar, but also because a new understanding of the mind is giving Freud his most serious competition ever: Roth has noticed that his 11-year-old son Max will make psychological jokes—but not Freudian ones. If someone is acting odd, he might say, "What, did you

freud vs. prozac: the architect of the unconscious faces his greatest challenge by mark schoofs

forget your medication today?" Freud, with his theories of libido and id and repression, has been forced to make room for the Prozac philosophy of mind as a soup of neurotransmitters.

Of course, Freud has long been under attack from many sides. Roth's exhibition, called "Sigmund Freud: Conflict and Culture," was scheduled to open two years ago. But more than 50 prominent figures, ranging from Gloria Steinem to Oliver Sacks, signed a petition protesting it as too laudatory. Biographers have shown that Freud lied, as in claiming to have cured patients when he hadn't. Freudian concepts such as as ego, id, and superego are dismissed by most brain researchers, and the idea that mental illness arises from infantile trauma—the centerpiece of Freudian theory—has, to put it charitably, not been validated. So from a medical and scientific standpoint, says Roth, there are "perfectly good questions about, well, does psychoanalysis work?"

But for most of Freud's readers, this question misses the point. Even for Freud himself, neurosis was the royal road to understanding *normal* life, and that, not a treatment model, is his lasting legacy. So while the attacks on Freud diminished him, they didn't replace his basic philosophy that humans are driven by unconscious desires that conflict with reality. Witness the feminist turnaround: in the 1960s and '70s women writers lacerated Freud for his misogyny, but now many younger feminists have reappropriated his ideas, spawning a vibrant feminist psychoanalytic movement.

Prozac and neurobiology, however, have succeeded where other challenges

[continued on page XX]

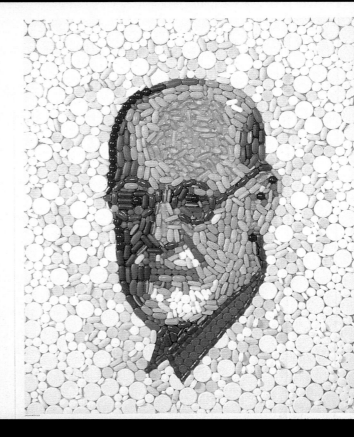

27
Publication The Village Voice
Design Director Ted Keller
Art Director Minh Uong
Designer Nicole Szymanski
Illustrator Jeff Crosby
Publisher VV Publishing Corp.
Issue February 17, 1998
Category Feature Spread

28
Publication The Village Voice
Design Director Ted Keller
Art Directors Keith Campbell, Minh Uong
Designer Jen Graffam Wink
Illustrator Jason Mecier
Publisher VV Publishing Corp.
Issue October 20, 1998
Category Feature Spread

■ 29

■ 30

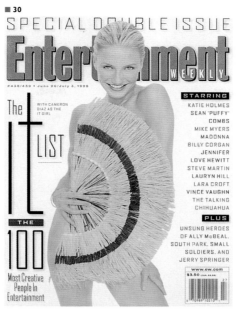

■ 31

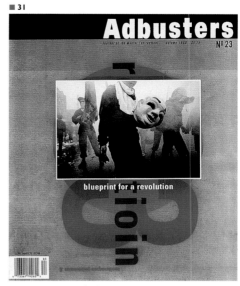

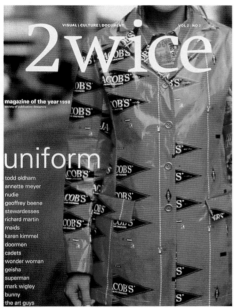

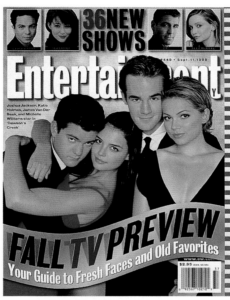

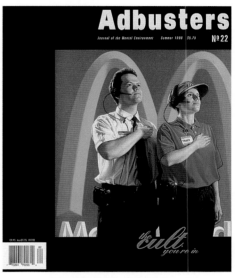

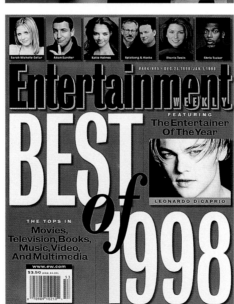

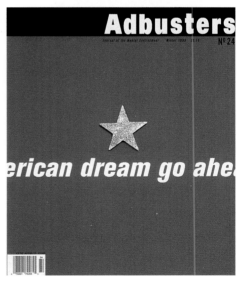

■ 29
Publication 2wice
Art Director J. Abbott Miller
Designers Paul Carlos, Scott Devendorf
Photographers Jeff Mitchell, Graham MacIndoe
Studio Design Writing Research
Publisher 2wice Arts Foundation
Issues Vol. 2, No. 1 & Vol. 2, No. 2 1998
Category Magazine of the Year

■ 30
Publication Entertainment Weekly
Design Director John Korpics
Art Directors Geraldine Hessler,
Joe Kimberling, John Walker
Designers George McCalman, Lilian Vilmenay,
Jennifer Procopio, Ellen Wundrok, Erin Whelan
Photo Editors Mary Dunn, Sarah Rozen,
Doris Brautigan, Alice Babcock, Michele Romero
Photographers Andrew Southam, George Lange,
Firooz Zahedi, Norman Jean Roy, Todd Eberle
Publisher Time Inc.
Issues June 6, September 11, December 25, 1998
Category Magazine of the Year

■ 31
Publication Adbusters
Art Director Chris Dixon
Designer Chris Dixon
Illustrator Chris Woods
Photographer Chien-Chi Chang
Publisher The Media Foundation
Issues Summer, Autumn, Winter 1998
Category Magazine of the Year

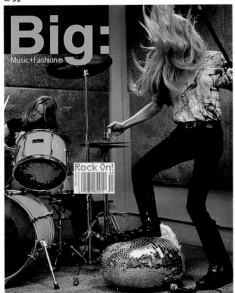

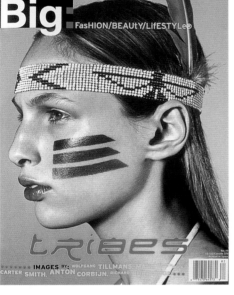

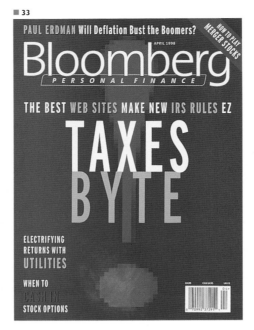

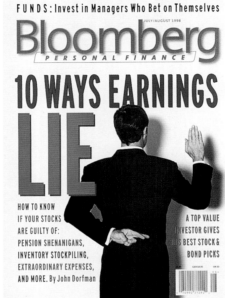

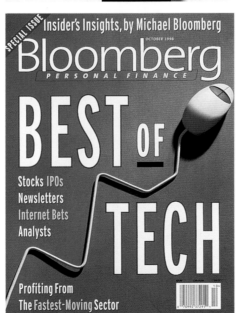

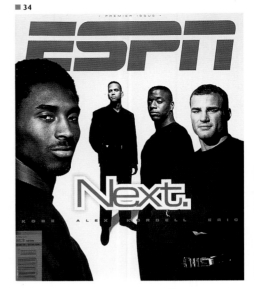

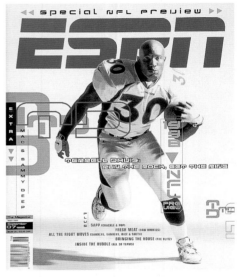

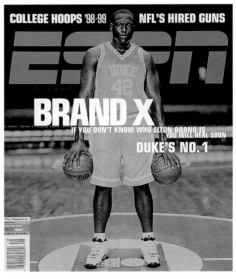

■ 32
Publication Big
Creative Director Marcelo Jünemann
Art Directors Douglas Lloyd, Tycoon Graphics
Designers Lloyd & Co., Anthony Yumul, Tycoon Graphics
Photographers Higashi Ishida, Richard Burbridge, Alexie Hay
Studio Lloyd & Co., & Tycoon Graphics
Publisher Big Magazine, Inc.
Issues July, September, December 1998
Category Magazine of the Year

■ 33
Publication Bloomberg Personal Finance
Art Director Carol Layton
Designers Carol Layton, Frank Tagariello, Owen Edwards, Evelyn Good
Photo Editors Mary Shea, Carrie Guenther
Photographers Fredrik Brodén
Publisher Bloomberg L. P.
Issues April, July/August, October1998
Category Magazine of the Year

■ 34
Publication ESPN
Design Director F. Darrin Perry
Art Directors Peter Yates, Yvette L. Francis
Designers Bruce D. Glase, Christopher Rudzik, Gabe Kuo
Photographers James Porto, Davis Factor, Barron Claiborne
Publisher Disney
Issues March 23, September 7, November 30, 1998
Category Magazine of the Year

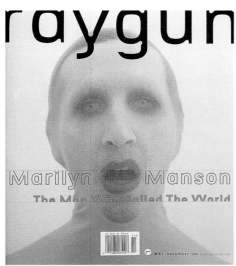

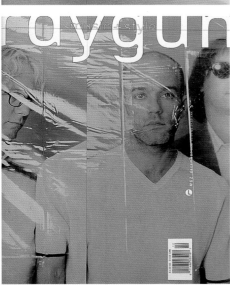

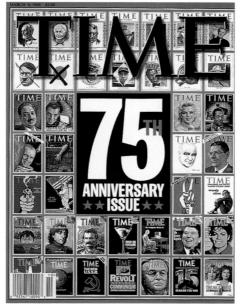

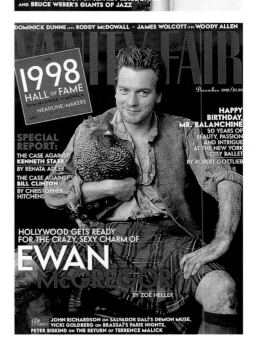

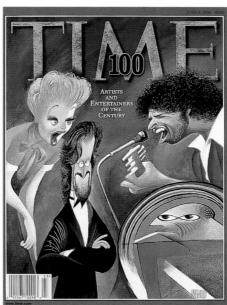

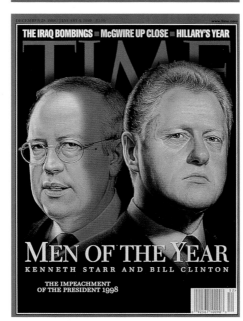

■ 35
Publication Ray Gun
Art Directors Barry Deck, Warren Corbitt
Designers Barry Deck, Warren Corbitt, Hwee Min
Photo Editor Robyn Forest
Photographers Steve Gullick, Dana Menussi, Christian Witkin
Publisher Ray Gun Publishing
Issues August, October, November 1998
Category Magazine of the Year

■ 36
Publication TIME
Art Director Arthur Hochstein
Illustrators Al Hirschfeld, Tim O'Brien
Photo Editor Michele Stephenson
Publisher Time Inc.
Issues March 9, June 8, December 7, 1998
Category Magazine of the Year

■ 37
Publication Vanity Fair
Design Director David Harris
Art Directors Gregory Mastrianni, Julie Weiss, Mimi Dutta
Designers Lisa Kennedy, Lee Ruelle
Photo Editor Susan White
Photographers Harry Benson, Annie Leibovitz
Publisher Condé Nast Publications Inc.
Issues April, July, December 1998
Category Magazine of the Year

■ 43

■ 44

■ 46
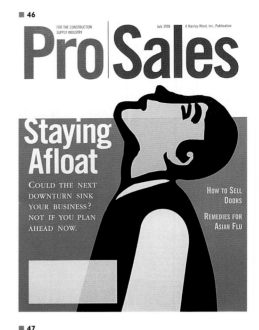

■ 45
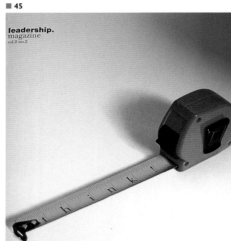

■ 47
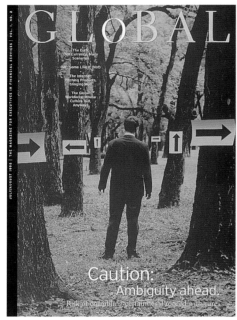

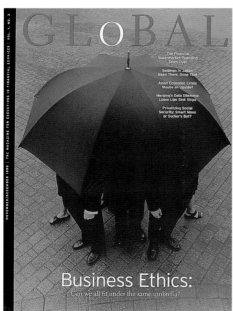

■ 43
Publication Global
Creative Director Sarah Vinas
Art Director Tom Brown
Designers Sarah Vinas, Tom Brown
Photographer Fredrik Brodén
Publisher Deloitte & Touche
Issues February/March, July/August,
November/December 1998
Category Magazine of the Year

■ 44
Publication Think Leadership
Creative Director Stephen Doyle
Designers Naomi Mizusake, Stephen Doyle
Photographer Victor Schrager
Studio Doyle Partners
Client IBM
Issue Fall 1998
Category Cover

■ 45
Publication Think Leadership
Creative Director Stephen Doyle
Designers Naomi Mizusake, Stephen Doyle
Photographer Victor Schrager
Studio Doyle Partners
Client IBM
Issue Winter 1998
Category Cover

■ 46
Publication ProSales
Art Director Brian J. Walker
Designer Peter Morelewicz
Illustrator Alison Seiffer
Publisher Hanley-Wood, Inc.
Issue July 1998
Category Cover

■ 47
Publication Silver & Blue
Art Director Camille C. Mansfield
Photographer Jeff B. Ross
Studio Mansfield Studios
Client University of Nevada, Reno
Issue May/June 1998
Category Cover

■ 38

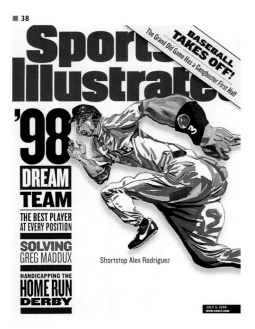

■ 40

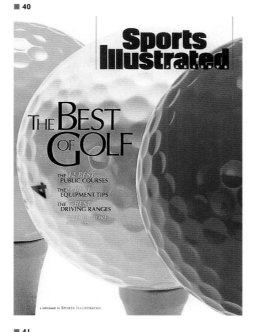

■ 42

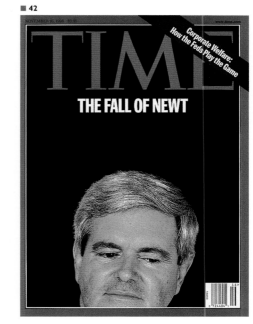

■ 39

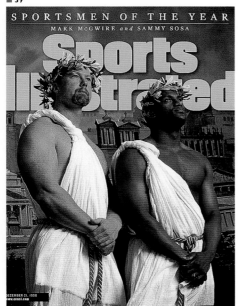

■ 41

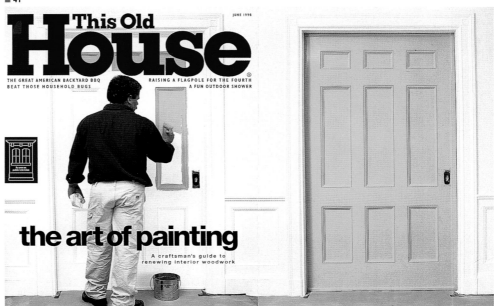

■ 38
Publication Sports Illustrated
Creative Director Steven Hoffman
Designers Steven Hoffman, Edward P. Truscio
Illustrator Phillip Burke
Publisher Time Inc.
Issue July 6, 1998
Category Cover

■ 39
Publication Sports Illustrated
Creative Director Steven Hoffman
Designer Edward P. Truscio
Photographer Walter Ioss Jr.
Publisher Time Inc.
Issue December 21, 1998
Category Cover

■ 40
Publication Sports Illustrated Presents
Art Director Craig L. Gartner
Photographer Brett Wills
Publisher Time Inc.
Issue April 1998
Category Cover

■ 41
Publication This Old House
Design Director Matthew Drace
Photographer Matthew Benson
Publisher Time Inc.
Issue June 1998
Category Cover

■ 42
Publication TIME
Art Director Arthur Hochstein
Photo Editor Michele Stephenson
Photographer Gregory Heisler
Publisher Time Inc.
Issue November 16, 1998
Category Cover

 48

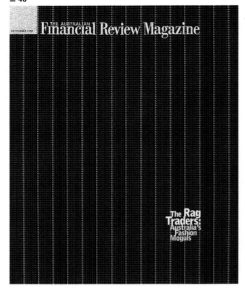

■ 49

■ 50

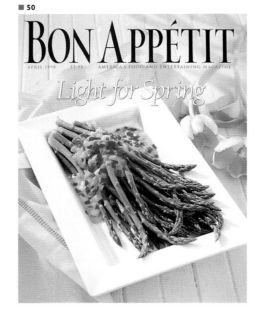

■ 51

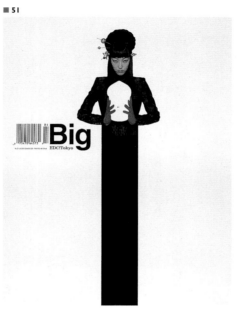

■ 52

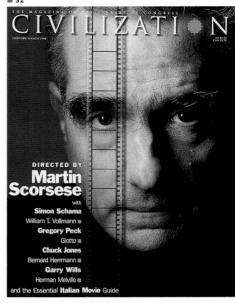

■ 53

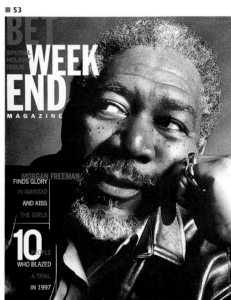

■ 48
Publication Australian Financial Review
Creative Director Andy Foster
Designers Christopher Roseby, Andy Foster
Publisher John Fairfax Publications
Issue September 1998
Category Cover

■ 49
Publication Computerwoche Extra
Creative Director Horst Moser
Designer Horst Moser
Illustrator Hans-Jürgen Lamb
Photo Editor Horst Moser
Photographer Stefan Bohrer
Publisher Computerwoche Verlag
Issue April 24, 1998
Category Cover

■ 50
Publication Bon Appétit
Art Director Campion Primm
Designer Campion Primm
Photo Editor Jodi Nakatsuka
Photographer Brian Leatart
Publisher Condé Nast Publications Inc.
Issue April 1998
Category Cover

■ 51
Publication Big
Creative Director Marcelo Jünemann
Art Director Tycoon Graphics
Designer Tycoon Graphics
Photographer Higashi Ishida
Studio Tycoon Graphics
Publisher Big Magazine, Inc.
Issue December 1998
Category Cover

■ 52
Publication Civilization
Design Director Mimi Park
Designers Mimi Park, Steve Walkowiak
Photo Editor Alison Morley
Photographer Michael O'Neill
Publisher Capital Publishing L. P.
Studio Desgin Park Inc.
Issue February/March 1998
Category Cover

■ 53
Publication BET Weekend
Creative Director Lance A. Pettiford
Designer Lance A. Pettiford
Photographer Davis Factor
Publisher BET Publishing
Issue January 1998
Category Cover

■ 54

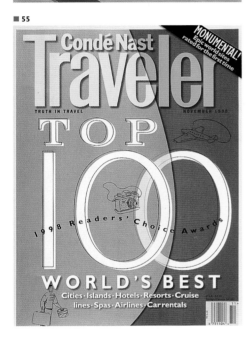

■ 55

■ 56

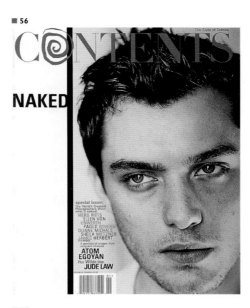

■ 57

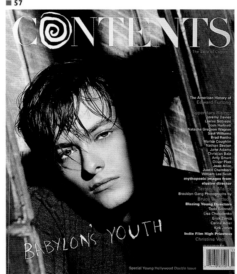

■ 58

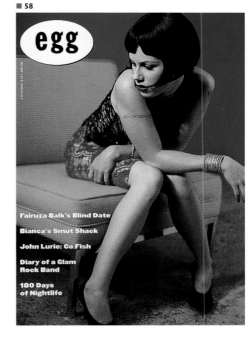

■ 59

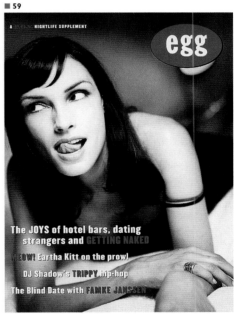

■ 54
Publication Condé Nast Traveler
Design Director Robert Best
Art Director Carla Frank
Designer Robert Best
Illustrator Terry Allen
Photo Editor Kathleen Klech
Publisher Condé Nast Publications Inc.
Issue August 1998
Category Cover

■ 55
Publication Condé Nast Traveler
Design Director Robert Best
Art Director Carla Frank
Designer Robert Best
Illustrator Ward Schumaker
Photo Editor Kathleen Klech
Publisher Condé Nast Publications Inc.
Issue November 1998
Category Cover

■ 56
Publication Contents
Creative Director Joseph Alfieris
Art Director Frederico Guiterrez
Designer Julius Finley
Photo Editor James Crump
Photographer Bob Frame
Publisher Waxing Moon Communications, Inc.
Issue Spring/Summer1998
Category Cover

■ 57
Publication Contents
Creative Director Joseph Alfieris
Art Director Christopher Brooks
Designers Ching Keo Pua, Winny Sutanto
Photo Editor Jameson West
Photographer Greg Gorman
Publisher Waxing Moon Communications, Inc.
Issue December 1998/January 1999
Category Cover

■ 58
Publication egg
Art Director Modino Design
Photo Editor Ron Beinner
Photographer Stephen Danelian
Studio Modino Design
Publisher BYOB/Freedom Ventures Inc.
Issue One/1998
Category Cover

■ 59
Publication egg
Design Director Lynette Cortez
Art Director Tonya Hudson
Designers Jennie Chang, Amy Smith
Photographer Art Streiber
Studio Divine Design Studio, Inc.
Publisher BYOB/Freedom Ventures Inc.
Issue November 1998
Category Cover

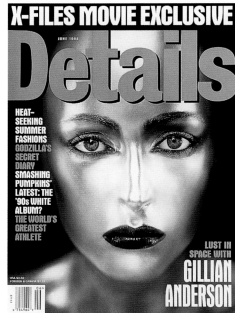

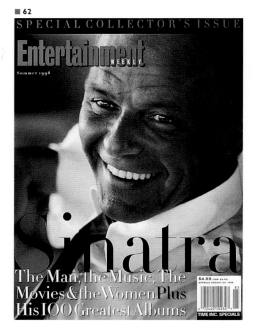

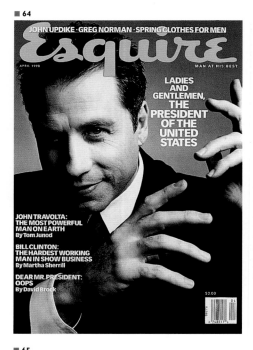

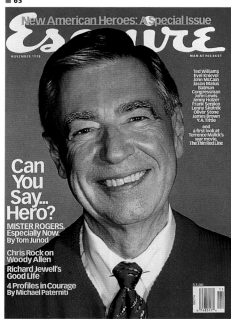

Publication Details
Design Director Robert Newman
Photo Editors Greg Pond, Halla Timon
Photographer Seb Jeniak
Stylist William Mullen
Publisher Condé Nast Publications Inc.
Issue June 1998
Category Cover

Publication Metropoli
Creative Director Rodrigo Sanchez
Design Director Carmelo Caderot
Designer Rodrigo Sanchez
Publisher Unidad Editorial S.A.
Client El Mundo
Issue July 17, 1998
Category Cover

Publication Entertainment Weekly
Design Director John Korpics
Designer John Korpics
Photo Editor Sarah Rozen
Photographer William Read Woodfield
Publisher Time Inc.
Issue Summer 1998
Category Cover

Publication Entertainment Weekly
Design Director John Korpics
Art Director Geraldine Hessler
Designer George McCalman
Photo Editor Michele Romero
Photographer Alison Dyer
Publisher Time Inc.
Issue Fall 1998
Category Cover

Publication Esquire
Design Director Robert Priest
Art Director Rockwell Harwood
Designer Joshua Liberson
Photo Editor Patti Wilson
Photographer Patrick Demarchelier
Publisher The Hearst Corporation-Magazines Division
Issue April 1998
Category Cover

Publication Esquire
Design Director Robert Priest
Art Director Rockwell Harwood
Designer Joshua Liberson
Photo Editor Patti Wilson
Photographer Dan Winters
Publisher The Hearst Corporation-Magazines Division
Issue November 1998
Category Cover

■ 66

■ 68

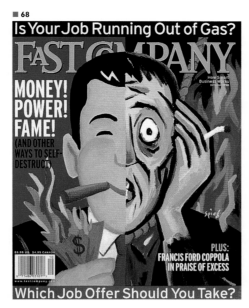

■ 70

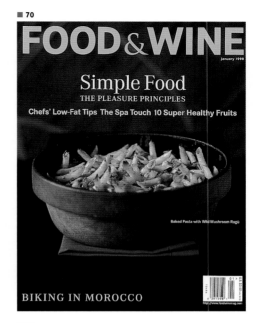

■ 67

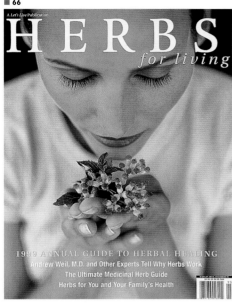

■ 69

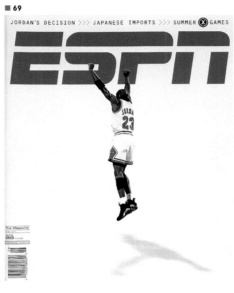

■ 71

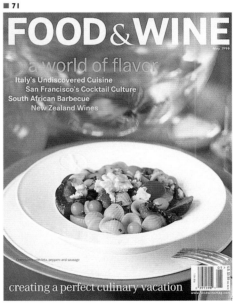

■ 66
Publication Herbs for Living
Creative Director Heidi L. Larsen
Designer Heidi L. Larsen
Photographer Tom Rafalovich
Publisher Franklin Publications
Issue September 1998
Category Cover

■ 67
Publication Folio
Creative Director Vickie Perez de Tagle
Art Director Bennett Peji
Designers Bennett Peji, Ben Cavalcanti
Illustrator Ben Cavalcanti
Photographer Volkmann
Studio Bennett Peji Design
Publisher Letras Filipinas
Issue August 1998
Category Cover

■ 68
Publication Fast Company
Art Director Patrick Mitchell
Designer Patrick Mitchell
Illustrator Art Spiegelman
Publisher Fast Company
Issue October 1998
Category Cover

■ 69
Publication ESPN
Design Director F. Darrin Perry
Photo Editor Simon P. Barnett
Photographer Andrew Bernstein
Publisher Disney
Issue June 29, 1998
Category Cover

■ 70
Publication Food & Wine
Creative Director Stephen Scoble
Designer Stephen Scoble
Photo Editor Kim Gougenheim
Photographer Maria Robledo
Publisher American Express Publishing Co.
Issue January 1998
Category Cover

■ 71
Publication Food & Wine
Creative Director Stephen Scoble
Designer Stephen Scoble
Photo Editor Kim Gougenheim
Photographer Quentin Bacon
Publisher American Express Publishing Co.
Issue May 1998
Category Cover

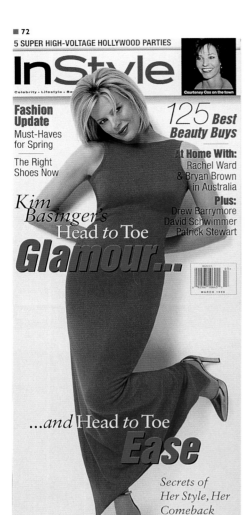

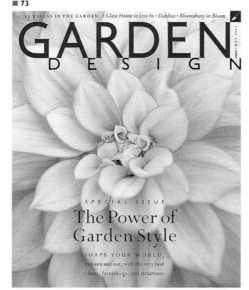

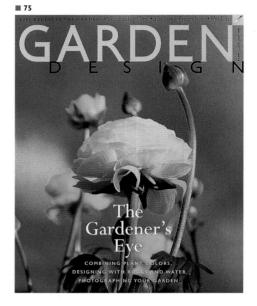

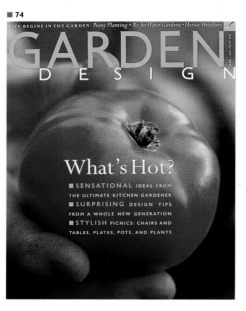

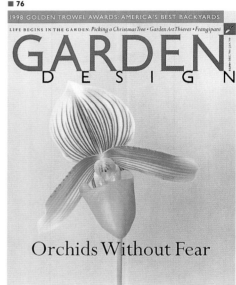

■ 72
Publication InStyle
Art Director Paul Roelofs
Designer Paul Roelofs
Photo Editor Laurie Kratochvil
Photographer Sante D'Orazio
Publisher Time Inc.
Issue March 1998
Category Cover

■ 73
Publication Garden Design
Creative Director Michael Grossman
Art Director Christin Gangi
Designer Michael Grossman
Photo Editor Lauren Hicks
Photographer Susan Seubert
Publisher Meigher Communications
Issue May 1998
Category Cover

■ 74
Publication Garden Design
Creative Director Michael Grossman
Art Director Christin Gangi
Designer Michael Grossman
Photo Editor Lauren Hicks
Photographer Matthew Benson
Publisher Meigher Communications
Issue August/September 1998
Category Cover

■ 75
Publication Garden Design
Creative Director Michael Grossman
Art Director Christin Gangi
Designer Michael Grossman
Photo Editor Lauren Hicks
Photographer Ron Van Dongen
Publisher Meigher Communications
Issue June/July 1998
Category Cover

■ 76
Publication Garden Design
Creative Director Michael Grossman
Art Director Christin Gangi
Designer Michael Grossman
Photo Editor Lauren Hicks
Photographer Evan Sklar
Publisher Meigher Communications
Issue December 1998/January 1999
Category Cover

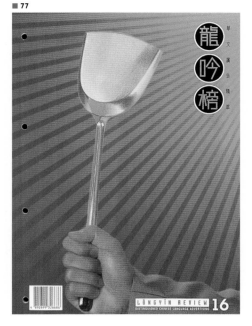

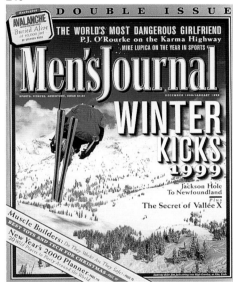

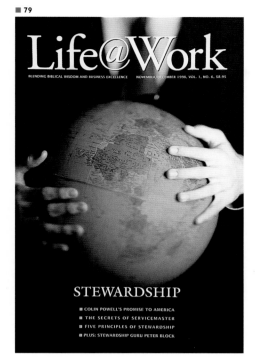

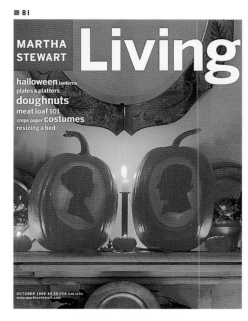

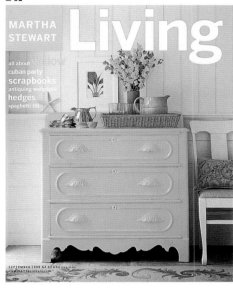

■ 77
Publication Longyin Review 16
Creative Director Benny Cheng
Designer Raymond Fu
Studio Gallery Ltd.
Publisher Longyin Review Ltd.
Issue October 1998
Category Cover

■ 78
Publication Men's Journal
Art Director Michael Lawton
Designer Michael Lawton
Photo Editors M. C. Marden, Lisa Bentivegna
Photographer Lee Cohen
Publisher Wenner Media
Issue December 1998/January 1999
Category Cover

■ 79
Publication The Life@Work Journal
Creative Directors Tim Walker, Sean Womack
Designer Tim Walker
Photographer Mark Jackson
Studio Walker Creative, Inc.
Publisher The Life@Work Company
Issue November/December 1998
Category Cover

■ 80
Publication The Life@Work Journal
Creative Directors Tim Walker, Sean Womack
Designer Tim Walker
Photographer Mark Jackson
Studio Walker Creative, Inc.
Publisher The Life@Work Company
Issue July 1998
Category Cover

■ 81
Publication Martha Stewart Living
Design Director Eric A. Pike
Art Director James Dunlinson
Designers James Dunlinson, Jodi Levine
Photo Editor Heidi Posner
Photographer Victor Schrager
Publisher Martha Stewart Living Omnimedia
Issue October 1998
Category Cover

■ 82
Publication Martha Stewart Living
Design Director Eric A. Pike
Art Director Scot Schy
Designers Scot Schy, Stephen Earle
Photo Editor Heidi Posner
Photographer Dana Gallagher
Publisher Martha Stewart Living Omnimedia
Issue September 1998
Category Cover

■ 83

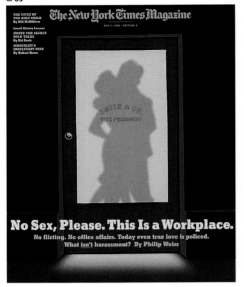

■ 85

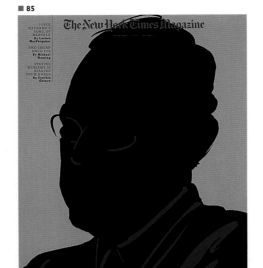

■ 87

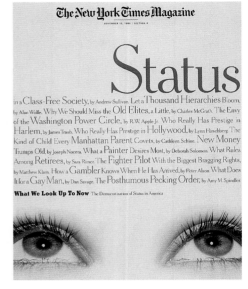

■ 84

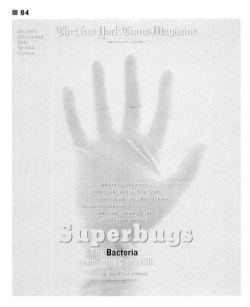

■ 86

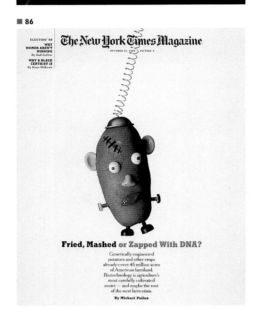

■ 88

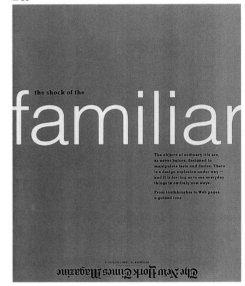

■ 83
Publication The New York Times Magazine
Art Director Janet Froelich
Designer Catherine Gilmore-Barnes
Illustrator Christoph Niemann
Publisher The New York Times
Issue May 3, 1998
Category Cover

■ 84
Publication The New York Times Magazine
Art Director Janet Froelich
Designer Joele Cuyler
Photo Editor Kathy Ryan
Photographer Tom Schierlitz
Publisher The New York Times
Issue August 2, 1998
Category Cover

■ 85
Publication The New York Times Magazine
Art Director Janet Froelich
Designer Andrea Fella
Illustrator Christoph Niemann
Publisher The New York Times
Issue September 6, 1998
Category Cover

■ 86
Publication The New York Times Magazine
Art Director Janet Froelich
Designer Claude Martel
Photo Editor Kathy Ryan
Photographer Davies + Starr
Publisher The New York Times
Issue October 25, 1998
Category Cover

■ 87
Publication The New York Times Magazine
Art Director Janet Froelich
Designer Nancy Harris
Photo Editor Kathy Ryan
Photographer James Wojcik
Publisher The New York Times
Issue November 15, 1998
Category Cover

■ 88
Publication The New York Times Magazine
Art Director Janet Froelich
Designer Jennifer Morla
Publisher The New York Times
Issue December 13, 1998
Category Cover

■ 89
Publication The New York Times Magazine
Art Director Janet Froelich
Designer Catherine Gilmore-Barnes
Photo Editor Kathy Ryan
Photographer Michael O'Neill
Publisher The New York Times
Issue October 18, 1998
Category Cover

The New York Times Magazine

OCTOBER 18, 1998 / SECTION 6

For the Murdochs
and the Disneys,
sports is no game.
It's a hot, global
entertainment product
— and that's changing
all the rules.

Bizball

*Curtis Martin,
New York Jets*

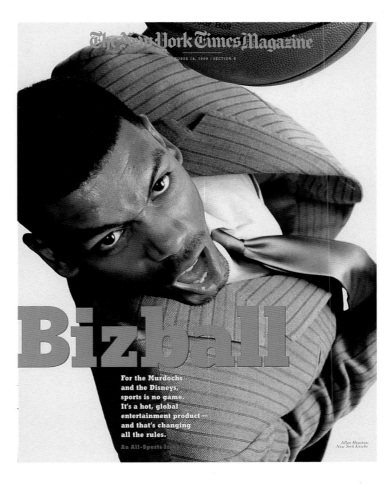

The New York Times Magazine

OCTOBER 18, 1998 / SECTION 6

Bizball

For the Murdochs
and the Disneys,
sports is no game.
It's a hot, global
entertainment product —
and that's changing
all the rules.

An All-Sports Issue

*Allan Houston,
New York Knicks*

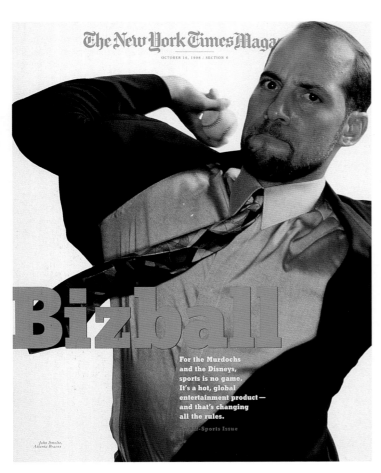

The New York Times Magazine

OCTOBER 18, 1998 / SECTION 6

Bizball

For the Murdochs
and the Disneys,
sports is no game.
It's a hot, global
entertainment product —
and that's changing
all the rules.

An All-Sports Issue

*John Smoltz,
Atlanta Braves*

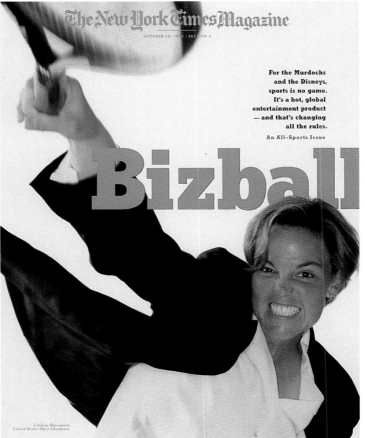

The New York Times Magazine

OCTOBER 18, 1998 / SECTION 6

For the Murdochs
and the Disneys,
sports is no game.
It's a hot, global
entertainment product
— and that's changing
all the rules.

An All-Sports Issue

Bizball

*Lindsay Davenport,
United States Open Champion*

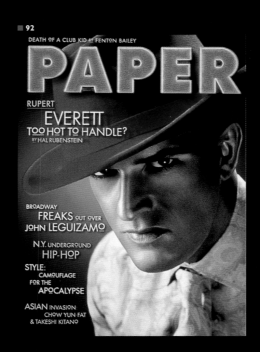

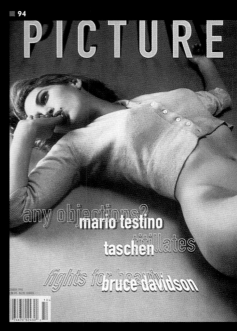

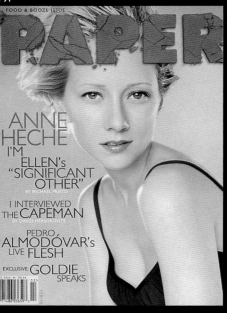

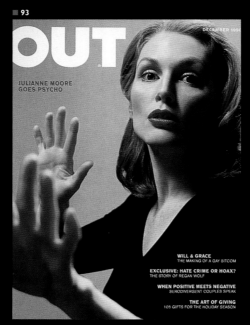

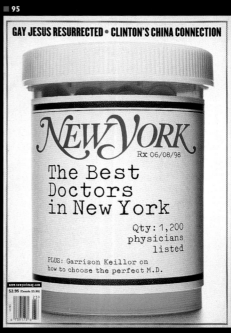

■ 77
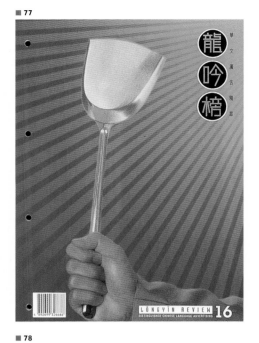

■ 78
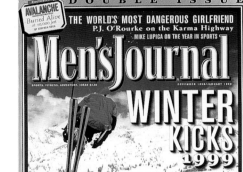

■ 79
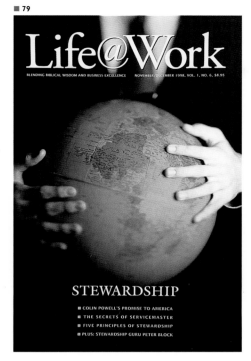

■ 80
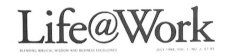

■ 81
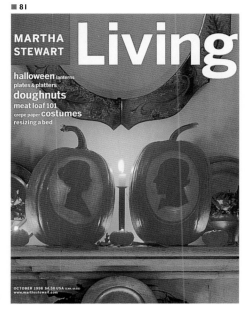

■ 82
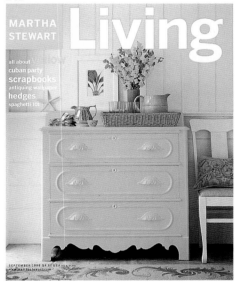

■ 77
Publication Longyin Review 16
Creative Director Benny Cheng
Designer Raymond Fu
Studio Gallery Ltd.
Publisher Longyin Review Ltd.
Issue October 1998
Category Cover

■ 78
Publication Men's Journal
Art Director Michael Lawton
Designer Michael Lawton
Photo Editors M. C. Marden, Lisa Bentivegna
Photographer Lee Cohen
Publisher Wenner Media
Issue December 1998/January 1999
Category Cover

■ 79
Publication The Life@Work Journal
Creative Directors Tim Walker, Sean Womack
Designer Tim Walker
Photographer Mark Jackson
Studio Walker Creative, Inc.
Publisher The Life@Work Company
Issue November/December 1998
Category Cover

■ 80
Publication The Life@Work Journal
Creative Directors Tim Walker, Sean Womack
Designer Tim Walker
Photographer Mark Jackson
Studio Walker Creative, Inc.
Publisher The Life@Work Company
Issue July 1998
Category Cover

■ 81
Publication Martha Stewart Living
Design Director Eric A. Pike
Art Director James Dunlinson
Designers James Dunlinson, Jodi Levine
Photo Editor Heidi Posner
Photographer Victor Schrager
Publisher Martha Stewart Living Omnimedia
Issue October 1998
Category Cover

■ 82
Publication Martha Stewart Living
Design Director Eric A. Pike
Art Director Scot Schy
Designers Scot Schy, Stephen Earle
Photo Editor Heidi Posner
Photographer Dana Gallagher
Publisher Martha Stewart Living Omnimedia
Issue September 1998
Category Cover

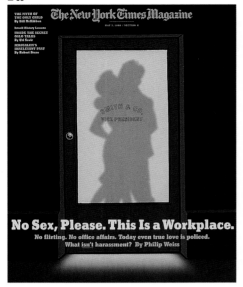

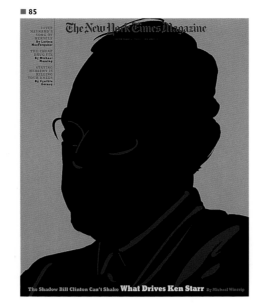

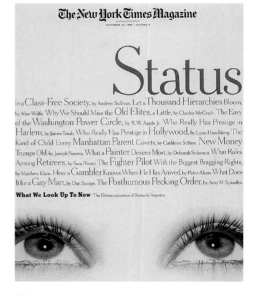

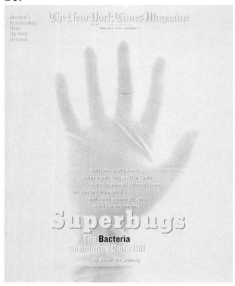

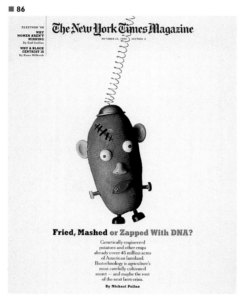

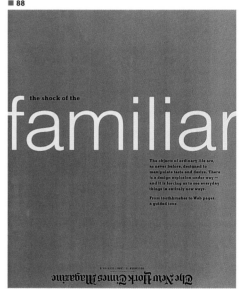

■ 83
Publication The New York Times Magazine
Art Director Janet Froelich
Designer Catherine Gilmore-Barnes
Illustrator Christoph Niemann
Publisher The New York Times
Issue May 3, 1998
Category Cover

■ 84
Publication The New York Times Magazine
Art Director Janet Froelich
Designer Joele Cuyler
Photo Editor Kathy Ryan
Photographer Tom Schierlitz
Publisher The New York Times
Issue August 2, 1998
Category Cover

■ 85
Publication The New York Times Magazine
Art Director Janet Froelich
Designer Andrea Fella
Illustrator Christoph Niemann
Publisher The New York Times
Issue September 6, 1998
Category Cover

■ 86
Publication The New York Times Magazine
Art Director Janet Froelich
Designer Claude Martel
Photo Editor Kathy Ryan
Photographer Davies + Starr
Publisher The New York Times
Issue October 25, 1998
Category Cover

■ 87
Publication The New York Times Magazine
Art Director Janet Froelich
Designer Nancy Harris
Photo Editor Kathy Ryan
Photographer James Wojcik
Publisher The New York Times
Issue November 15, 1998
Category Cover

■ 88
Publication The New York Times Magazine
Art Director Janet Froelich
Designer Jennifer Morla
Publisher The New York Times
Issue December 13, 1998
Category Cover

■ 89
Publication The New York Times Magazine
Art Director Janet Froelich
Designer Catherine Gilmore-Barnes
Photo Editor Kathy Ryan
Photographer Michael O'Neill
Publisher The New York Times
Issue October 18, 1998
Category Cover

■ 96

■ 97

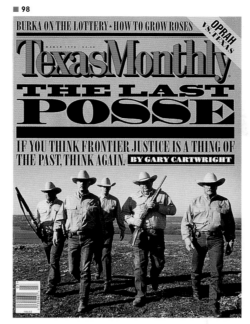

■ 98

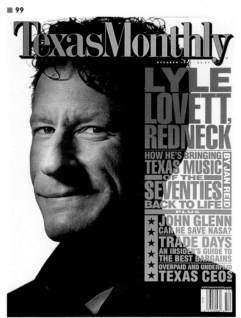

■ 99

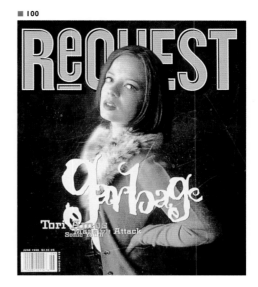

■ 100

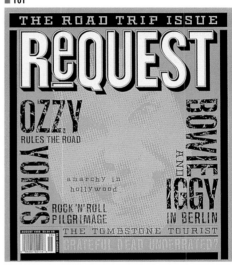

■ 101

■ 96

Publication Saveur
Creative Director Michael Grossman
Art Director Jill Armus
Designers Michael Grossman, Jill Armus
Photo Editor Maria Millan
Photographer Michael Grimm
Publisher Meigher Communications
Issue January/February 1998
Category Cover

■ 97

Publication Saveur
Creative Director Michael Grossman
Art Director Jill Armus
Designers Michael Grossman, Jill Armus
Photo Editor Maria Millan
Photographer Christopher Hirsheimer
Publisher Meigher Communications
Issue September/October 1998
Category Cover

■ 98

Publication Texas Monthly
Creative Director D. J. Stout
Designers D. J. Stout, Nancy McMillen
Photo Editor D. J. Stout
Photographer Laura Wilson
Publisher Emmis Communications Corp.
Issue March 1998
Category Cover

■ 99

Publication Texas Monthly
Creative Director D. J. Stout
Designers D. J. Stout, Nancy McMillen
Photo Editor D. J. Stout
Photographer Albert Watson
Publisher Emmis Communications Corp.
Issue October 1998
Category Cover

■ 100

Publication Request
Art Director David Yamada
Designer David Yamada
Photographer Myriam Santos-Kayda
Publisher Request Media
Issue June 1998
Category Cover

■ 101

Publication Request
Art Director David Yamada
Designers David Yamada, David Simpson
Photographer Tom Stratton
Publisher Request Media
Issue August 1998
Category Cover

■ 102
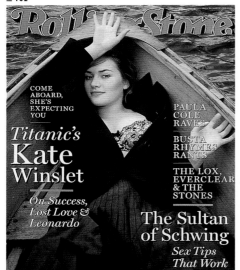

■ 104
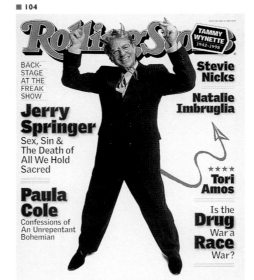

■ 106
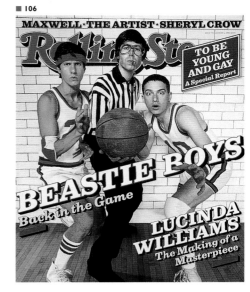

■ 103
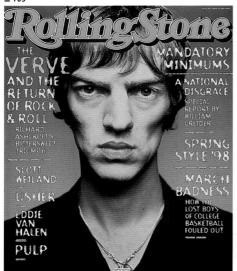

■ 105
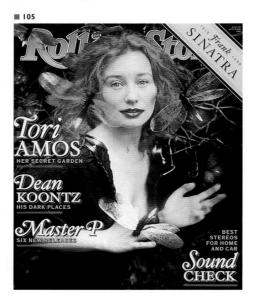

■ 107
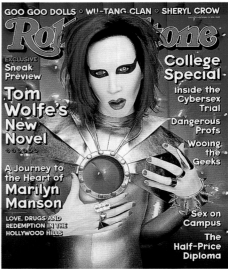

■ 102
Publication Rolling Stone
Art Director Fred Woodward
Designer Fred Woodward
Photo Editor Rachel Knepfer
Photographer Peggy Sirota
Publisher Straight Arrow Publishers
Issue March 5, 1998
Category Cover

■ 103
Publication Rolling Stone
Art Director Fred Woodward
Designers Fred Woodward, Gail Anderson
Photo Editor Rachel Knepfer
Photographer Mark Seliger
Publisher Straight Arrow Publishers
Issue April 16, 1998
Category Cover

■ 104
Publication Rolling Stone
Art Director Fred Woodward
Photo Editor Rachel Knepfer
Photographer Mark Seliger
Publisher Straight Arrow Publishers
Issue May 14, 1998
Category Cover

■ 105
Publication Rolling Stone
Art Director Fred Woodward
Photo Editor Rachel Knepfer
Photographer David LaChapelle
Publisher Straight Arrow Publishers
Issue June 25, 1998
Category Cover

■ 106
Publication Rolling Stone
Art Director Fred Woodward
Designer Fred Woodward
Photo Editor Rachel Knepfer
Photographer Mark Seliger
Publisher Straight Arrow Publishers
Issue August 6, 1998
Category Cover

■ 107
Publication Rolling Stone
Art Director Fred Woodward
Photo Editor Rachel Knepfer
Photographer Mark Seliger
Publisher Straight Arrow Publishers
Issue October 15, 1998
Category Cover

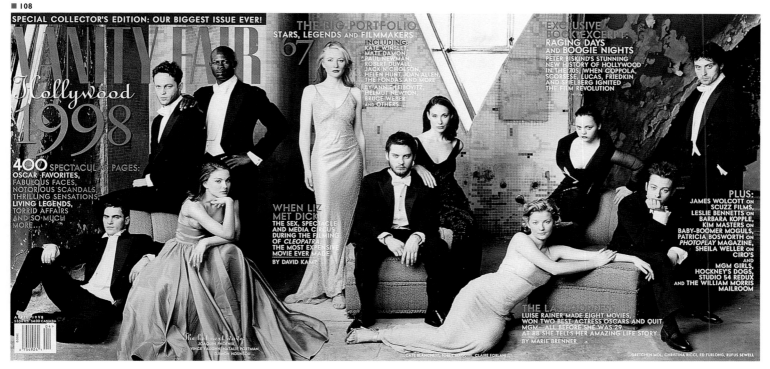

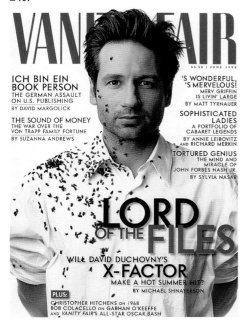

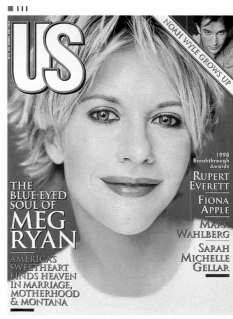

108
Publication Vanity Fair
Design Director David Harris
Art Director Gregory Mastrianni
Designer Gregory Mastrianni
Photographer Annie Leibovitz
Publisher Condé Nast Publications Inc.
Issue April 1998
Category Cover

109
Publication Vanity Fair
Design Director David Harris
Art Director Gregory Mastrianni
Designer Gregory Mastrianni
Photographer Annie Leibovitz
Publisher Condé Nast Publications Inc.
Issue June 1998
Category Cover

110
Publication Vanity Fair
Design Director David Harris
Art Director Gregory Mastrianni
Designer Gregory Mastrianni
Photographer Annie Leibovitz
Publisher Condé Nast Publications Inc.
Issue September 1998
Category Cover

111
Publication US
Art Director Richard Baker
Photo Editor Jennifer Crandall
Photographer Matthew Rolston
Publisher US Magazine Co., L. P.
Issue April 1998
Category Cover

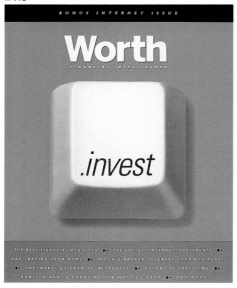

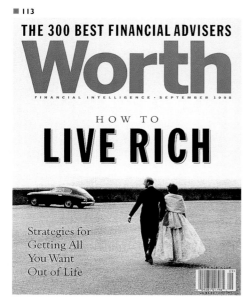

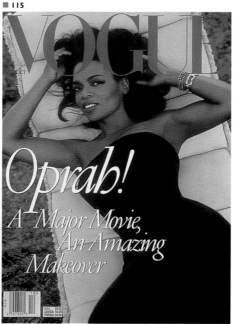

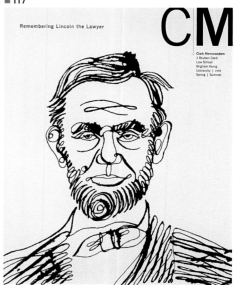

■ 112
Publication Worth
Art Director Philip Bratter
Designers Deanna Lowe, Philip Bratter
Photo Editor Sabine Meyer
Photographer Steve Wisbauer
Publisher Capital Publishing L. P.
Issue August 1998
Category Cover

■ 113
Publication Worth
Art Director Philip Bratter
Designer Philip Bratter
Photo Editor Melanie Osterhout
Photographer Burt Glinn
Publisher Capital Publishing L. P.
Issue September 1998
Category Cover

■ 114
Publication Vibe
Art Director Dwayne N. Shaw
Designer Dwayne N. Shaw
Photo Editor George Pitts
Photographer Michael O'Neil
Publisher Vibe/Spin Ventures
Issue September 1998
Category Cover

■ 115
Publication Vogue
Design Director Charles R. Churchward
Designer Charles R. Churchward
Photographer Steven Meisel
Publisher Condé Nast Publications Inc.
Issue October 1998
Category Cover

■ 116
Publication Yahoo! Internet Life
Art Director Gail Ghezzi
Designer Gail Ghezzi
Photo Editor Gail L. Henry
Photographer Joshua McHugh
Publisher Ziff-Davis, Inc.
Issue May 1998
Category Cover

■ 117
Publication Clark Memorandum
Art Director Linda Sullivan
Designer Linda Sullivan
Illustrator Elvis Swift
Publisher Brigham Young University
Client J. Reuben Clark Law School
Issue Spring 1998
Category Cover

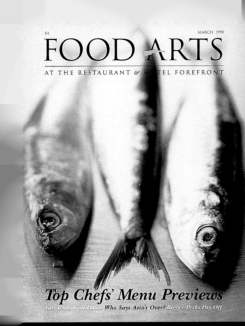

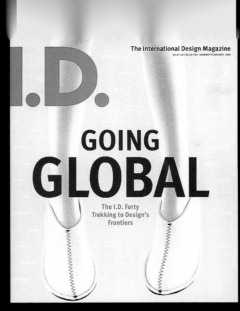

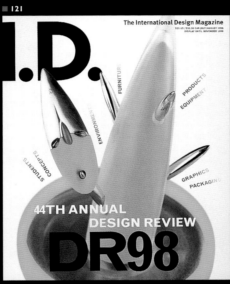

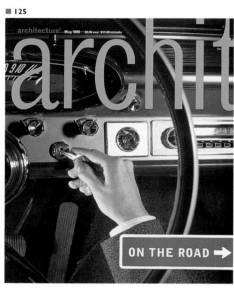

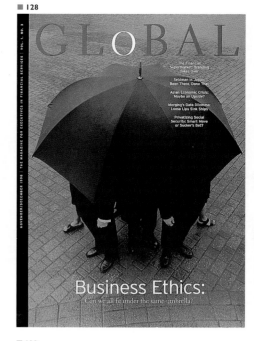

Print
AMERICA'S GRAPHIC DESIGN MAGAZINE
MAY/JUNE 1998
PRINT LII.III

"This is my best idea yet. No, wait! I've got a better one! First I'll blow up the logo huge to fit across the whole page, and put a drop shadow on it. Or get someone to redraw it. No. No. No. They'll never let me do that. At least I'll get to tweak that little spaghetti type at the top. OK, then I'll take a picture and do a Photoshop number on it. Not one of those OJ things, something hip. What a brilliant idea. This is my best idea yet. Oh man, maybe a type thing would be cooler. I need a headline that's just one short word, but they'll probably give me something that's way too long and doesn't fit. And then of course I'll get a sub-head that's as long as a novel. People aren't stupid! You don't have to tell them the whole story. I should run the type vertically up the side. I know it's hard to read, but so what. No, wait! I'll make the cover all one color, just black on white. This is my best idea yet. If they weren't so cheap I could get a fifth color and use it just for the period at the end of the sentence. This is definitely an award-winner if they let me do exactly what I want. But everybody wants to be an art director. Why did they even hire me? And after all this, the printer will probably mess up the separations and the registration anyway. What's pathetic is that the cover could be butt-ugly and people will still like it. What I need is a really cool illustrator who can come up with a great idea so I don't have to. This is my best idea yet."

Print
AMERICA'S GRAPHIC DESIGN MAGAZINE
NOVEMBER/DECEMBER 1998
PRINT LII.VI

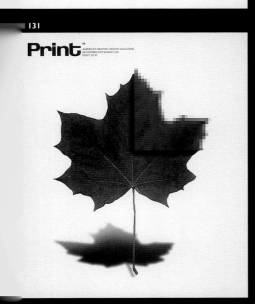

PUBLISHED BY THE AMERICAN INSTITUTE OF ARCHITECTS NEW YORK CHAPTER VOLUME 61, NUMBER 2, OCTOBER 1998

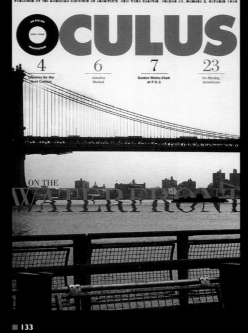

OCULUS

4	6	7	23
Libraries for the Next Century	Jamaica Market	Gordon Matta-Clark at P.S. 1	On Moving Downtown

ON THE
WATERFRONT

PUBLISHED BY THE AMERICAN INSTITUTE OF ARCHITECTS NEW YORK CHAPTER VOLUME 61, NUMBER 3, NOVEMBER 1998

OCULUS

6	8	16	22
Hospitals to Lift the Spirit	Houses for the 21st Century	Planning for Governors Island	1998 Design Awards Symposium

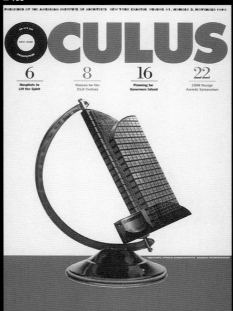

PUBLISHED BY THE AMERICAN INSTITUTE OF ARCHITECTS NEW YORK CHAPTER VOLUME 61, NUMBER 1, SEPTEMBER 1998

OCULUS

4	5	7	12
Offices for the Aesthete Elite	Getting Real on Times Square	Reassessing the Tower in the Park	Aging in Place in New York

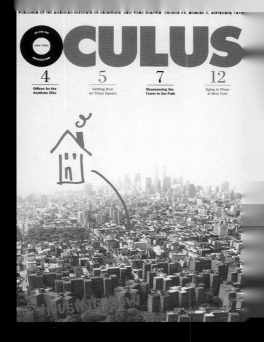

M
Volume 23, No. 4
July/August 1998
The Marsh & McLennan
Companies Magazine for
Employers and Retirees
Worldwide

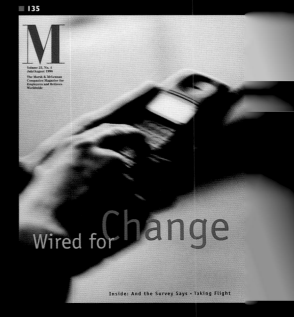

Wired for Change

Inside: And the Survey Says • Taking Flight

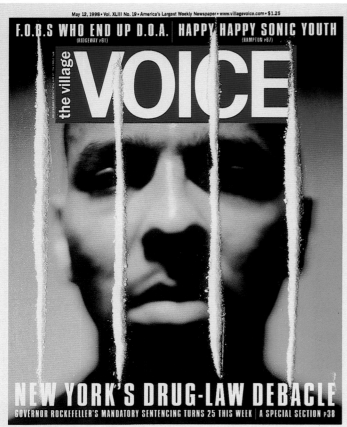

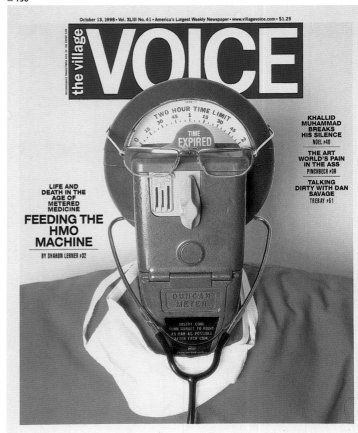

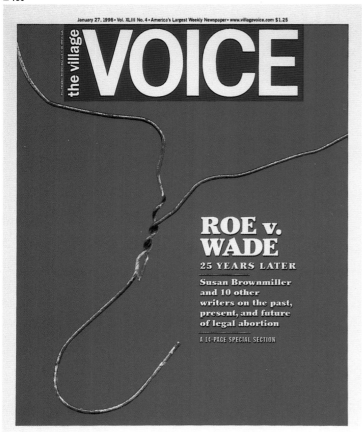

■ 136
Publication The Village Voice
Design Director Ted Keller
Art Director Minh Uong
Designer Nicole Szymanski
Illustrator Slow Hearth Studio
Publisher VV Publishing Corp.
Issue January 27, 1998
Category Front Page

■ 137
Publication The Village Voice
Design Director Ted Keller
Art Director Minh Uong
Designer Nicole Szymanski
Photo Editor Meg Handler
Photographer Clay Patrick McBride
Publisher VV Publishing Corp.
Issue May 12, 1998
Category Front Page

■ 138
Publication The Village Voice
Design Director Ted Keller
Art Directors Keith Campbell, Minh Uong
Designer Stacy Wakefield
Photo Editor Meg Handler
Photographer Adam Weiss
Publisher VV Publishing Corp.
Issue October 13, 1998
Category Front Page

■ 139
Publication The Village Voice
Design Director Ted Keller
Art Director Minh Uong
Designer Stacy Wakefield
Illustrator Mirko Ilíc
Publisher VV Publishing Corp.
Issue October 6, 1998
Category Front Page

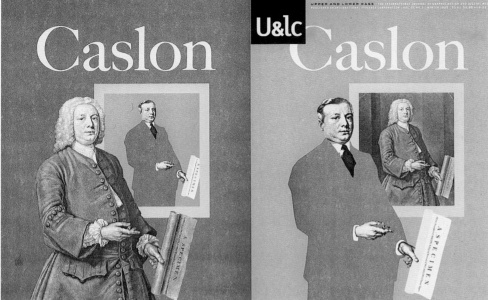

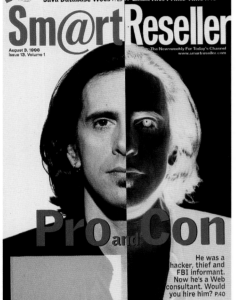

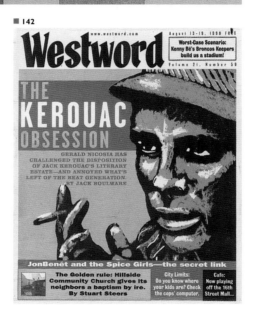

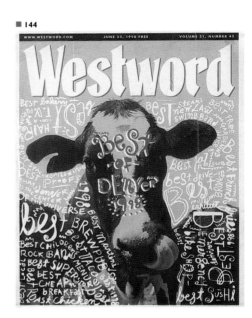

140
Publication U&lc
Creative Director John D. Berry
Design Director Clive Chiu
Art Director Mark van Bronkhorst
Designer Mark van Bronkhorst
Publisher International Typeface Corp.
Issue Winter 1998
Category Cover

141
Publication Smart Reseller
Design Director Nicole White
Art Director Annamaria Eason
Designer Simone Tieber
Photographer Howard Rosenberg
Publisher Ziff-Davis, Inc.
Issue August 13, 1998
Category Cover

142
Publication Westword
Art Director Dana Collins
Designer Dana Collins
Illustrator Dana Collins
Publisher New Times Inc.
Issue August 13, 1998
Category Front Page

143
Publication Westword
Art Director Dana Collins
Designer Dana Collins
Illustrator Dana Collins
Publisher New Times Inc.
Issue September 17, 1998
Category Front Page

144
Publication Westword
Art Director Dana Collins
Designer Dana Collins
Photographer Robin Clark
Publisher New Times Inc.
Issue June 25, 1998
Category Front Page

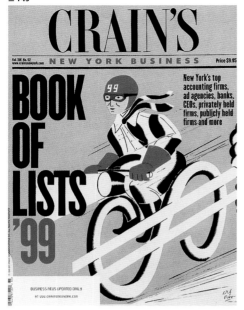

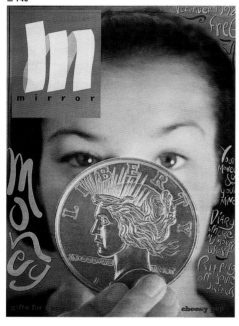

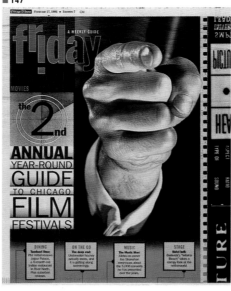

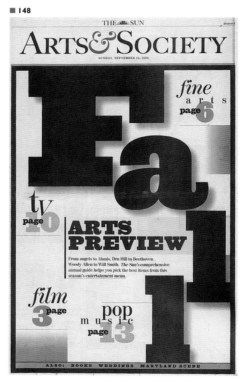

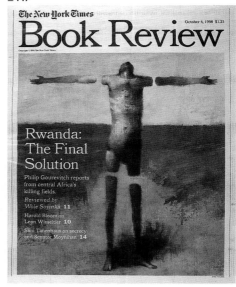

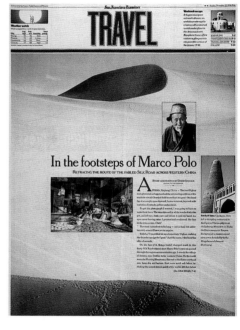

■ 145
Publication Crain's New York Business
Art Directors Steven Krupinski, Edward Levine
Designer Edward Levine
Illustrator Brian Cronin
Publisher Crain Communications
Issue December 28, 1998
Category Front Page

■ 146
Publication mirror
Art Director Andrew K. James
Designers Andrew K. James, Boo Davis
Photographer Karen Cammack
Publisher Seattle Times Publications
Issue December 1998
Category Front Page

■ 147
Publication Chicago Tribune
Design Director Therese Shechter
Art Director Joe Darrow
Publisher Chicago Tribune
Issue February 27, 1998
Category Front Page

■ 148
Publication The Baltimore Sun
Creative Director Joseph Hutchinson
Design Director Victor Panichkul
Designer Peter Yuill
Issue September 13, 1998
Category Front Page

■ 149
Publication The New York Times Book Review
Art Director Steven Heller
Illustrator Brad Holland
Publisher The New York Times
Issue October 4, 1998
Category Front Page

■ 150
Publication San Francisco Examiner
Designer Andrew Skwish
Photographer David Sanger
Issue November 22, 1998
Category Front Page

■ 151

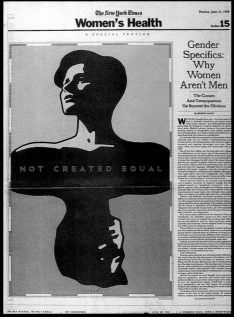

■ 152

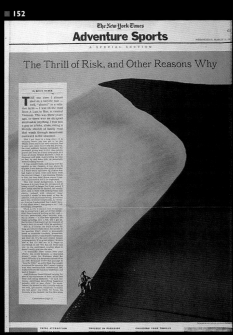

■ 153

■ 154

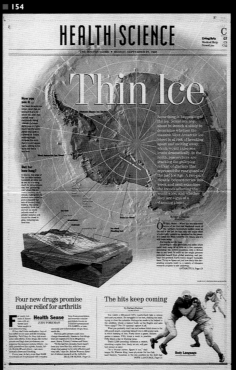

■ 155

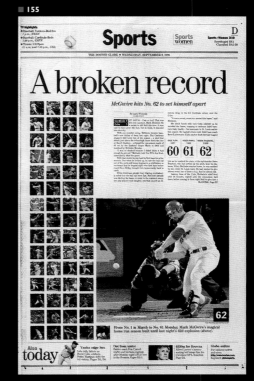

■ 156

■ 157

THE WALL STREET JOURNAL REPORTS.

© 1998 Dow Jones & Company, Inc. All Rights Reserved.

MONDAY, OCTOBER 19, 1998 THE WALL STREET JOURNAL **R1**

HEALTH & MEDICINE

PATIENT, TEACH THYSELF

The amount
of health-care
information available
to consumers is
exploding.
But how do you find
what you need?
And once you find it,
what do you do with it?

Taking matters
into your
own hands
PAGE 4

What drug ads
don't tell you
PAGE 6

Finding what
you need
on the Web
PAGE 10

The sometimes
useless
ratings game
PAGE 16

On-the-air
medical advice
PAGE 22

A patient and
her doctor hold
on to the past
PAGE 27

■ 158

■ 159

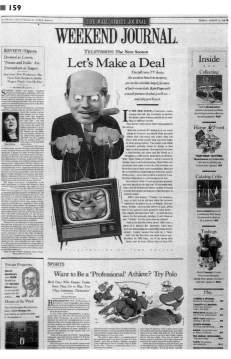

■ 157
Publication The Wall Street Journal Reports
Design Director Greg Leeds
Art Director Orlie Kraus
Designer Orlie Kraus
Illustrator Brian Cronin
Publisher Dow Jones & Co., Inc.
Issue October 19, 1998
Category Front Page

■ 158
Publication Weekend Journal-
The Wall Street Journal
Art Directors Joe Dizney, Stephen Fay
Designer Joe Dizney
Illustrator Michael Crawford
Photo Editor Elizabeth Williams
Photographer Jeremy Wolff
Publisher Dow Jones & Co., Inc.
Issue June 26, 1998
Category Front Page

■ 159
Publication Weekend Journal-
The Wall Street Journal
Art Directors Joe Dizney, Stephen Fay
Designer Joe Dizney
Illustrators John Ueland, Michael Witte
Photo Editor Elizabeth Williams
Publisher Dow Jones & Co., Inc.
Issue August 14, 1998
Category Front Page

M A R G A R E T F O R D

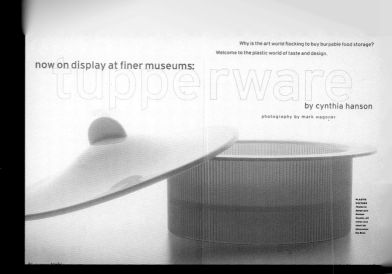

Why is the art world flocking to buy burpable food storage?
Welcome to the plastic world of taste and design.

now on display at finer museums:

tupperware

by cynthia hanson

photography by mark wagoner

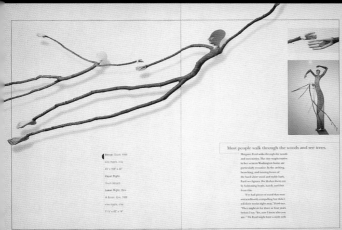

Most people walk through the woods and see trees.

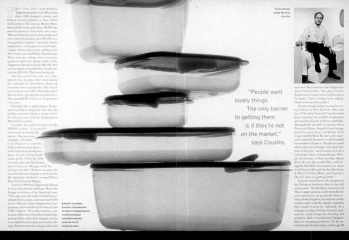
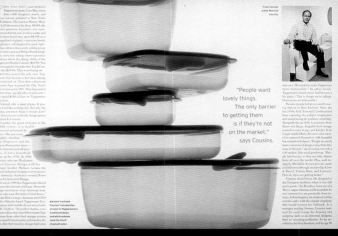

"People want
lovely things.
The only barrier
to getting them
is if they're not
on the market,"
says Cousins.

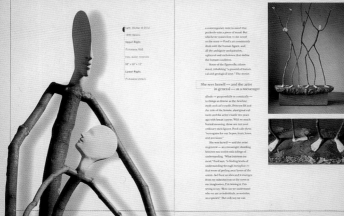
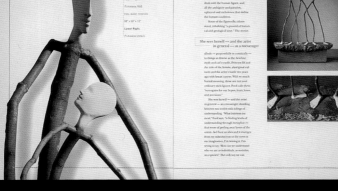

She sees herself — and the artist
in general — as a messenger.

To update Tupperware's look, Cousins introduced pure geometric shapes, bright white surfaces, and elegant lines.

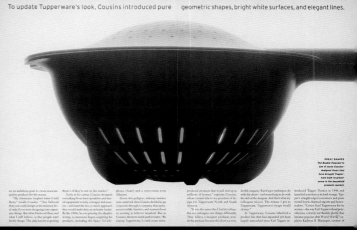

Cousins took the
camp out of Tupperware
and inspired a new
company slogan,
"Extraordinary design
for everyday living."

THESE ARE A FEW OF
HIS FAVORITE THINGS

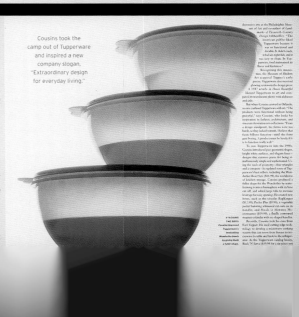

160
Publication American Way
Design Director Scott Feaster
Designer Charles Stone
Photographer Allen Kapahi
Publisher American Airlines Publishing
Issue March 15, 1998
Category Feature Story

161
Publication Attaché
Art Director Paul Carstensen
Designer Alana Smith
Photographer Mark Wagoner
Publisher Pace Communications
Client US Airways
Issue August 1998
Category Feature Story

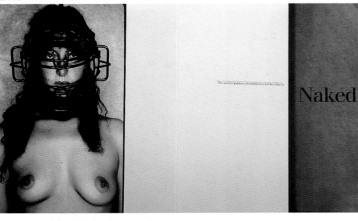

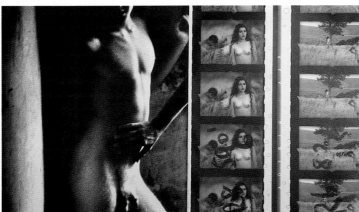

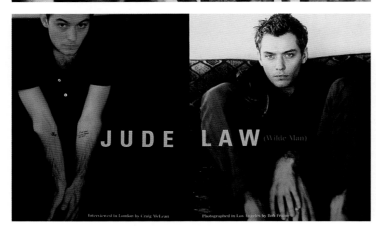

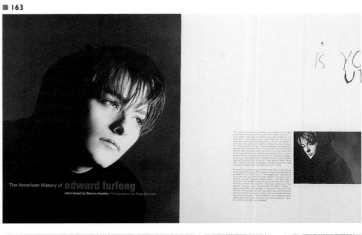

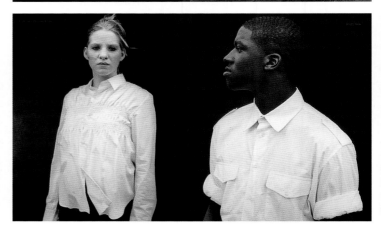

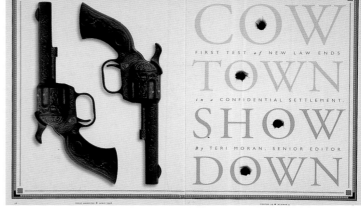

■ 162
Publication Contents
Creative Director Joseph Alfieris
Art Director Frederico Guiterrez
Designer Julius Finley
Photo Editor James Crump
Photographers Bob Frame, James Herbert
Publisher Waxing Moon Communications, Inc.
Issue Spring/Summer 1998
Category Entire Issue

■ 163
Publication Contents
Creative Director Joseph Alfieris
Art Director Christopher Brooks
Designers Ching Keo Pua, Winny Sutanto
Photo Editor Jameson West
Photographers Jasper James, Greg Gorman
Publisher Waxing Moon Communications, Inc.
Issue December 1998/January 1999
Category Entire Issue

■ 164
Publication Texas Medicine
Designer Kevin Goodbar
Studio Fuller Dyal & Stamper
Publisher Texas Medical Association
Issue April 1998
Category Feature Spread

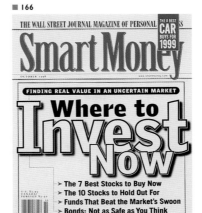

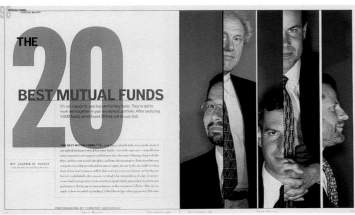

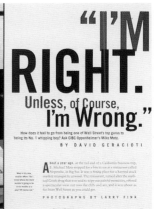

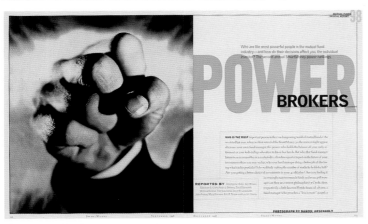

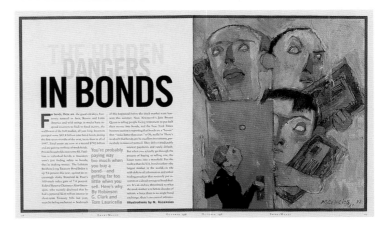

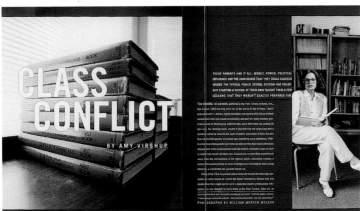

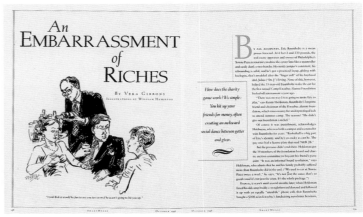

■ 165

Publication SmartMoney
Art Director Amy Rosenfeld
Designers Amy Rosenfeld, Donna Agajanian, Anna Kula, Julie Lazarus, Kandy Littrell
Illustrator Francisco Caceres
Photo Editors Jane Clark, Betsy Keating
Photographers Lizzie Himmel, Timothy Archibald, Rita Maas, Walter Smith, Daniel Arsenault, William Mercer Mcleod
Publisher Dow Jones & Hearst Corp.
Issue September 1998
Category Entire Issue

■ 166

Publication SmartMoney
Art Director Amy Rosenfeld
Designers Amy Rosenfeld, Donna Agajanian, Anna Kula, Julie Lazarus, Kandy Littrell
Illustrators Natalie Ascencios, William Hamilton
Photo Editors Jane Clark, Betsy Keating
Photographers Larry Fink, Erik Rank, Dudley Reed, Daniel Boris, Witold Krassowski
Publisher Dow Jones & Hearst Corp.
Issue October 1998
Category Entire Issue

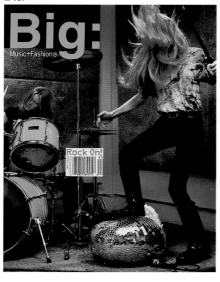

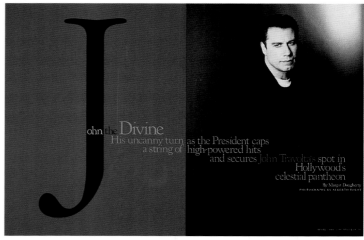

■ 167
Publication Big
Creative Director
Marcelo Jünemann
Art Director Douglas Lloyd
Designer Anthony Yumul
Illustrator Denis Erickson
Photographers Tom Munro,
Stephane Sednaoui,
Jesse Frohman, Alexie Hay,
Richard Burbridge
Studio Lloyd & Co.
Publisher Big Magazine, Inc.
Issue July 1998
Category Entire Issue

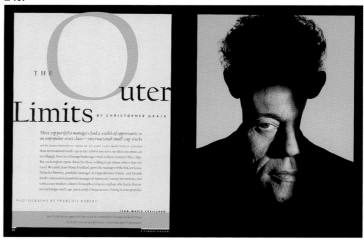

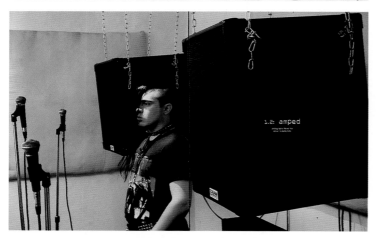

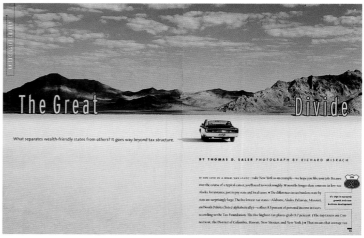

■ 168
Publication Los Angeles
Creative Director David Armario
Designer David Armario
Photo Editor Lisa Thackaberry
Photographer Alberto Tolot
Publisher Fairchild Publications
Issue April 1998
Category Feature Spread

■ 169
Publication Bloomberg Personal Finance
Art Director Carol Layton
Designer Carol Layton
Photo Editor Mary Shea
Photographer François Robert
Publisher Bloomberg L. P.
Issue January/February 1998
Category Feature Spread

■ 170
Publication Bloomberg Personal Finance
Art Director Carol Layton
Designer Carol Layton
Photo Editor Mary Shea
Photographer Richard Misrach
Publisher Bloomberg L. P.
Issue March 1998
Category Feature Spread

■ 171

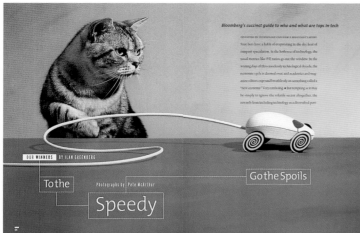

Bloomberg's succinct guide to who and what are tops in tech

OUR WINNERS BY ILAN GREENBERG

To the

Speedy

Photographs by Pete McArthur

Go the Spoils

■ 172

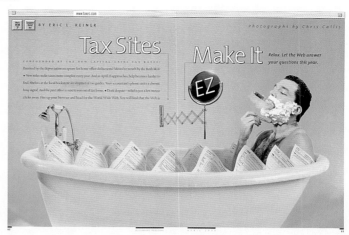

BY ERIC L. REINER

Photographs by Chris Callis

Tax Sites

Make It

EZ

Relax. Let the Web answer your questions this year.

■ 173

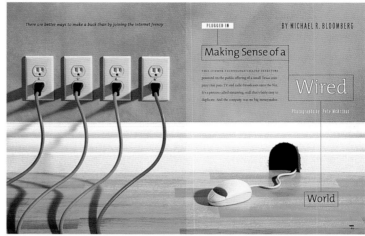

There are better ways to make a buck than by joining the internet frenzy

PLUGGED IN

BY MICHAEL R. BLOOMBERG

Making Sense of a

Wired

Photographs by Pete McArthur

World

■ 174

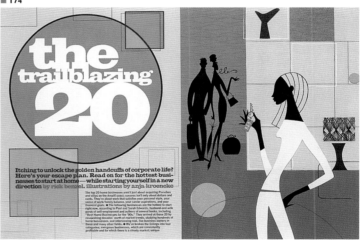

the trailblazing 20

Itching to unlock the golden handcuffs of corporate life? Here's your escape plan. Read on for the hottest businesses to start at home—while starting yourself in a new direction by rick benzel. illustrations by anja kroencke

Israel emerges as a high-tech powerhouse, generating huge stock gains

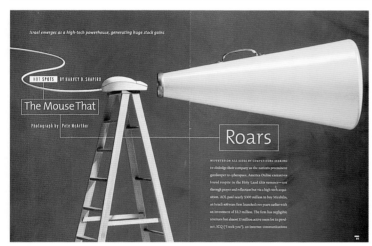

HOT SPOTS BY HARVEY D. SHAPIRO

The Mouse That

Photograph by Pete McArthur

Roars

For the brave, five steps for going gingerly after beaten-down tech companies

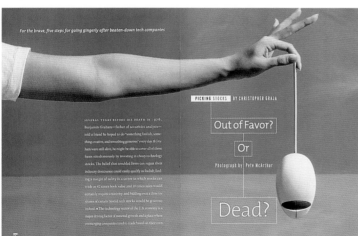

PICKING STOCKS BY CHRISTOPHER GRAJA

Out of Favor?

Or

Photograph by Pete McArthur

Dead?

Our panelists predict only companies with the quickest reflexes will survive

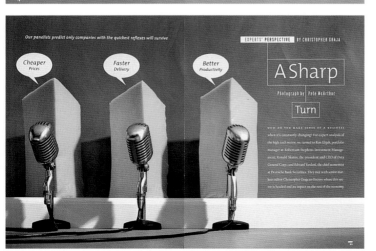

EXPERTS' PERSPECTIVE BY CHRISTOPHER GRAJA

Cheaper Prices

Faster Delivery

Better Productivity

A Sharp

Photograph by Pete McArthur

Turn

■ 171
Publication Bloomberg Personal Finance
Art Director Carol Layton
Designer Carol Layton
Photo Editor Mary Shea
Photographer Pete McArthur
Publisher Bloomberg L. P.
Issue October 1998
Category Feature Story

■ 172
Publication Bloomberg Personal Finance
Art Director Carol Layton
Designer Carol Layton
Photo Editor Mary Shea
Photographer Chris Callis
Publisher Bloomberg L. P.
Issue April 1998
Category Feature Spread

■ 173
Publication Bloomberg Personal Finance
Art Director Carol Layton
Designer Carol Layton
Photo Editor Mary Shea
Photographer Pete McArthur
Publisher Bloomberg L. P.
Issue October 1998
Category Feature Spread

■ 174
Publication Working at Home
Art Director David O'Connor
Designer Marcus Villaça
Illustrator Anja Kroencke
Publisher Success Holdings Co.
Issue Vol. 3, No. 3
Category Feature Spread

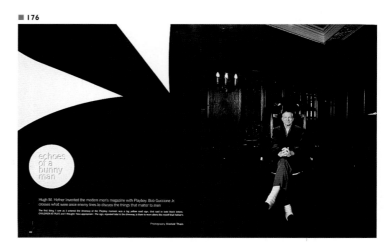

■ 175
Publication Condé Nast Traveler
Design Director Robert Best
Art Director Carla Frank
Designers Robert Best, Carla Frank, Devin Pedzwater
Illustrator Kam Hak
Photo Editor Kathleen Klech
Photographers Hakan Ludwigson, Macduff Everton
Publisher Condé Nast Publications, Inc.
Issue November 1998
Category Entire Issue

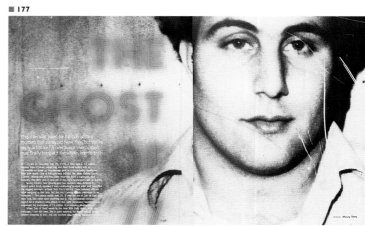

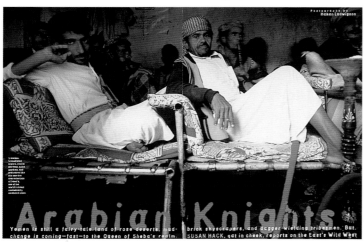

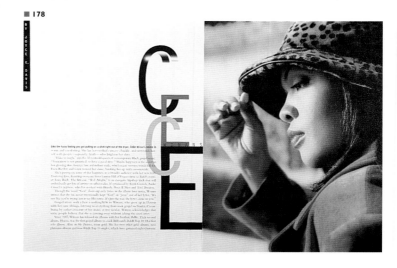

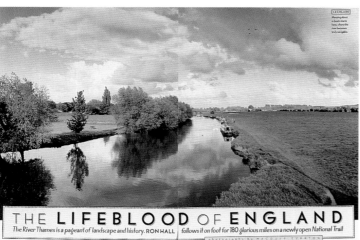

■ 176
Publication Gear
Art Director Matt Guemple
Photo Editor Anthea Paul
Photographer Alastair Thain
Publisher Guccione Media
Issue September/October 1998
Category Feature Spread

■ 178
Publication BET Weekend
Creative Director Lance A. Pettiford
Designer Lance A. Pettiford
Photographer Mario Castellanos
Publisher BET Publishing
Issue April 1998
Category Feature Spread

■ 177
Publication Gear
Art Director Matt Guemple
Photo Editor Anthea Paul
Publisher Guccione Media
Issue November/December 1998
Category Feature Spread

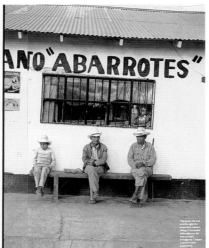

GRANDEUR AT TWILIGHT

ANO"ABARROTES"

RIDING THE RAILS ALONG MEXICO'S SPECTACULAR COPPER CANYON, ROBERT KAPLAN WITNESSES A NATIVE PEOPLE RUN OUT OF TIME, IN THE SHADOWS OF TOUR GROUPS, DRUGS, AND MONEY

Photographs by François Deconinck

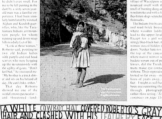
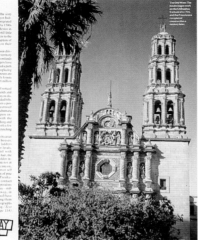

A WHITE COWBOY HAT COVERED ROBERTO'S GRAY HAIR AND CLASHED WITH HIS LEATHERY FACE

LOGGERS HAVE NOT JUST CLEARED AWAY FORESTS, BUT HAVE CLEARED A PATH FOR DRUG GANGS, TOO

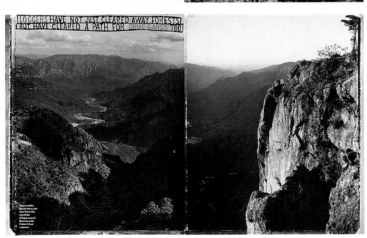

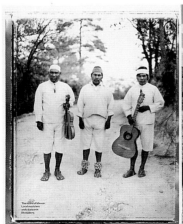

They called me *seaweed*

On Harbour Island it's a term used for visitors, meaning that you've been lucky enough to wash up on this exquisite beach from the real world. GULLY WELLS accepts the compliment and sings along with the Holy Rollers

Photographs by CHRIS SANDERS

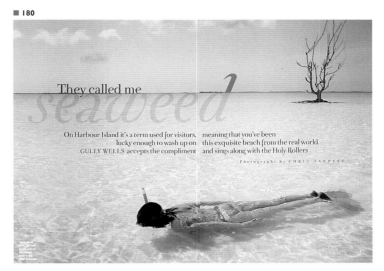

force of NATURE

It's June in the ARCTIC: the sun never sets, sea mammals in the millions hover against the melting ice, and the Inuit invite travelers into their fantastic world. WADE DAVIS goes where few have gone before

Photographs by ROB HOWARD

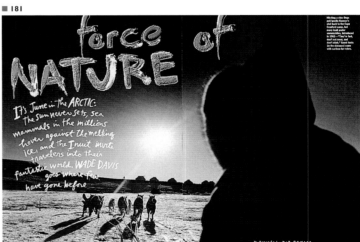

Patient HEAL THYSELF

STORY BY MOLLY GLENTZER

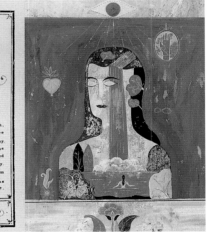

■ 179
Publication Condé Nast Traveler
Design Director Robert Best
Art Director Carla Frank
Designer Robert Best
Photo Editor Kathleen Klech
Photographer François Deconinck
Publisher Condé Nast Publications, Inc.
Issue June 1998
Category Feature Story

■ 180
Publication Condé Nast Traveler
Design Director Robert Best
Art Director Carla Frank
Designer Carla Frank
Photo Editor Kathleen Klech
Photographer Chris Sanders
Publisher Condé Nast Publications, Inc.
Issue October 1998
Category Feature Spread

■ 181
Publication Condé Nast Traveler
Design Director Robert Best
Art Director Carla Frank
Designer Carla Frank
Photo Editor Kathleen Klech
Photographer Rob Howard
Publisher Condé Nast Publications, Inc.
Issue January 1998
Category Feature Spread

■ 182
Publication Caring
Design Director Mark Geer
Designer Mark Geer
Illustrator Philippe Lardy
Studio Geer Design, Inc.
Client Memorial Healthcare System
Issue February 1998
Category Feature Spread

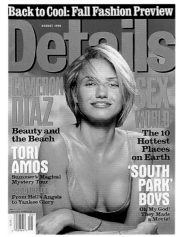

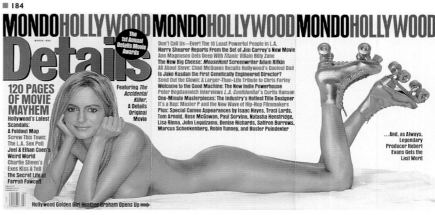

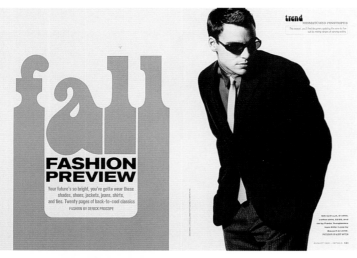

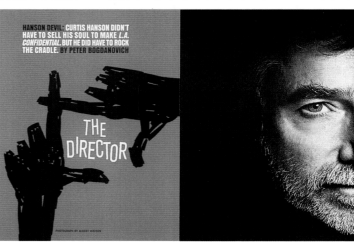

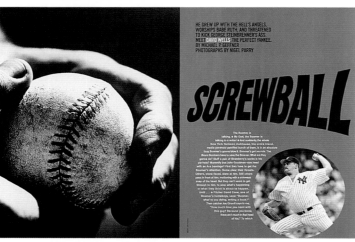

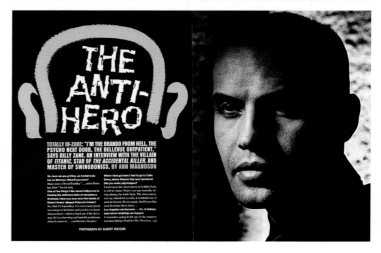

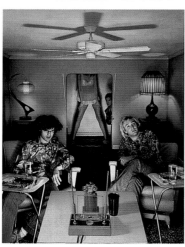

■ 183
Publication Details
Design Director Robert Newman
Designers John Giordani, Alden Wallace, Zoë Miller, Marlene Sezni, Andrea McNicol, Jesse Marinoff Reyes, Marcus Burrowes
Illustrator Charles Burns
Photo Editors Greg Pond, Halla Timon, Adam Woodward
Photographers Nigel Parry, Albert Watson, Dan Winters, Nigel Dickson
Publisher Condé Nast Publications, Inc.
Issue August 1998
Category Entire Issue

■ 184
Publication Details
Design Director Robert Newman
Designers John Giordani, Alden Wallace, Zoë Miller, Marlene Sezni, Ronda Thompson, Jesse Marinoff Reyes
Illustrators Drew Friedman, Mark Zingarelli, John Wilkinson
Photo Editors Greg Pond, Halla Timon, Adam Woodward
Photographers Albert Watson, Richard Burbridge, Dan Winters
Typography Norman Hathaway, David Coulson
Publisher Condé Nast Publications, Inc.
Issue March 1998
Category Entire Issue

■ 185

SINCE SHE DOVE INTO ACTING OPPOSITE JIM CARREY IN *THE MASK*, CAMERON DIAZ HAS PROVED SHE CAN SWIM WITH THE BIGGEST OF HOLLYWOOD SHARKS. THIS MONTH SHE MAKES WAVES WITH BOYFRIEND MATT DILLON IN *THERE'S SOMETHING ABOUT MARY*. BY PETER LEFCOURT. PHOTOGRAPHS BY ALBERT WATSON.

BEAUTY & THE BEACH

cameron diaz!!!!

■ 186

california dreamin'

No waves? No worry.
Seven surfers kick
out the jams, jackets,
and Hawaiian shirts.
Photographs by Dan Winters
Fashion by Derick Procope

DAVE KARSCH, 26
Polyester
tracksuit (pants
not shown)
by Tommy
Hilfiger, $150.
Cotton tank top
by Calvin Klein.
Underwear, $15.
Sunglasses from
Killer Loop by
Bausch & Lomb.

■ 187

ANTI-FREEZE

Nylon parka by Guess, $2,000.

SEARCHING FOR THE PERFECT
DEFROSTERS THIS WINTER?
YOU'RE GETTING WARM. THE
COOLEST EXTREME-WEATHER
GEAR IS HOODED PARKAS,
DOWN VESTS, AND SHEARLING
OUTERWEAR—LAYERS OF
STYLE YOU CAN ADJUST AS
EASILY AS A THERMOSTAT
PHOTOGRAPHS BY KEVIN DAVIES
FASHION BY DERICK PROCOPE

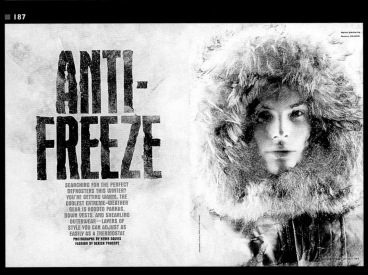

■ 188

Details

Suddenly,
this summer,
basic black
surrenders to
the new navy
Photographs by Richard Burbridge
Fashion by William Mullen

out of the blue

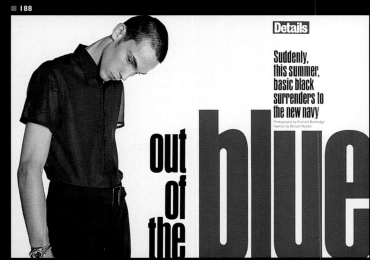

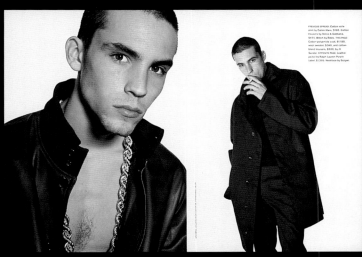

PREVIOUS SPREAD: Cotton voile
shirt by Calvin Klein, $195. Cotton
trousers by Dolce & Gabbana,
$475. Watch by Rolex. THIS PAGE:
Cotton-polyamide coat, $1,190,
wool sweater, $360, and cotton-
blend trousers, $360, by Jil
Sander. OPPOSITE PAGE: Leather
jacket by Ralph Lauren Purple
Label, $1,395. Necklace by Burger.

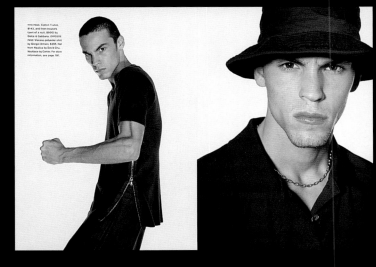

THIS PAGE: Cotton T-shirt,
$142, and linen trousers
(part of a suit, $900) by
Dolce & Gabbana. OPPOSITE
PAGE: Viscose polyester shirt
by Giorgio Armani, $295. Hat
from Nautica by David Chu.
Necklace by Carlos. For store
information, see page 191.

■ 185
Publication Details
Design Director Robert Newman
Designer Jesse Marinoff Reyes
Photo Editors Greg Pond, Halla Timon
Photographer Albert Watson
Publisher Condé Nast Publications, Inc.
Issue August 1998
Category Feature Spread

■ 186
Publication Details
Design Director Robert Newman
Designer Alden Wallace
Photo Editors Greg Pond, Halla Timon
Photographer Dan Winters
Publisher Condé Nast Publications, Inc.
Issue July 1998
Category Feature Spread

■ 187
Publication Details
Design Director Robert Newman
Designer Alden Wallace
Photo Editors Greg Pond, Halla Timon
Photographer Kevin Davies
Fashion Director Derick Procope
Publisher Condé Nast Publications, Inc.
Issue October 1998
Category Feature Spread

■ 188
Publication Details
Design Director Robert Newman
Designer Marlene Sezni
Photo Editors Greg Pond, Halla Timon
Photographer Richard Burbridge
Stylist William Mullen
Publisher Condé Nast Publications, Inc.
Issue April 1998
Category Feature Story

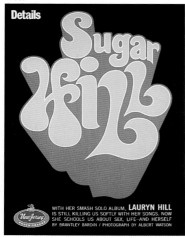
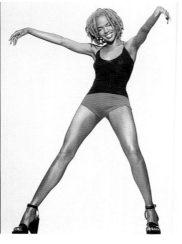

■ 189

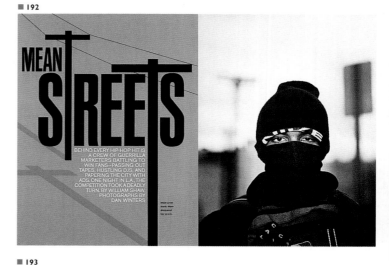

■ 192

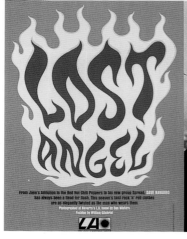
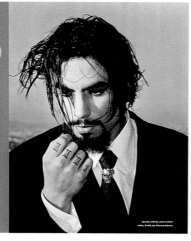

■ 190

■ 193

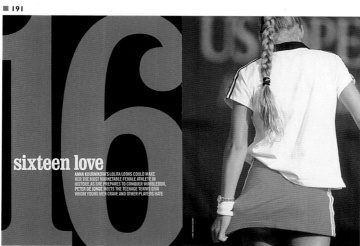
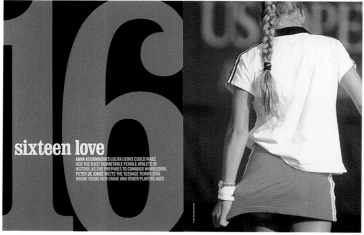

■ 191

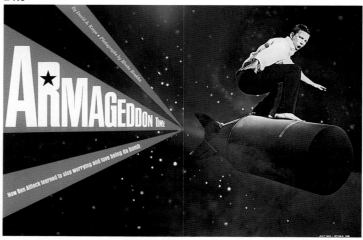

■ 189
Publication Details
Design Director Robert Newman
Photo Editors Greg Pond, Halla Timon
Photographer Albert Watson
Typography David Coulson
Logotype Chad Tomlinson
Publisher Condé Nast Publications, Inc.
Issue November 1998
Category Feature Spread

■ 190
Publication Details
Design Director Robert Newman
Designer John Giordani
Photo Editors Greg Pond, Halla Timon
Photographer Dan Winters
Typography House Industries
Stylist William Gilchrist
Logotype Chad Tomlinson
Publisher Condé Nast Publications, Inc.
Issue November 1998
Category Feature Spread

■ 191
Publication Details
Design Director Robert Newman
Designer Alden Wallace
Photo Editors Greg Pond, Halla Timon
Photographer Chris Trotman
Publisher Condé Nast Publications, Inc.
Issue July 1998
Category Feature Spread

■ 192
Publication Details
Design Director Robert Newman
Designer John Giordani
Photo Editors Greg Pond, Halla Timon
Photographer Dan Winters
Publisher Condé Nast Publications, Inc.
Issue July 1998
Category Feature Spread

■ 193
Publication Details
Design Director Robert Newman
Designer John Giordani
Photo Editors Greg Pond, Halla Timon
Photographer Moshe Brakha
Publisher Condé Nast Publications, Inc.
Issue July 1998
Category Feature Story

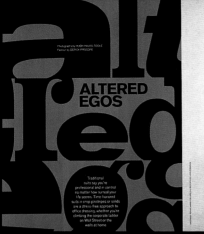

ALTERED EGOS

Traditional suits say you're professional and in control no matter how surreal your life seems. Time-honored suits in crisp pinstripes or solids are a stress-free approach to office dressing, whether you're climbing the corporate ladder on Wall Street or the walls at home.

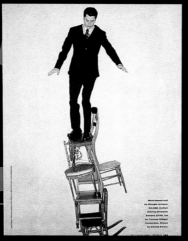

MAN ON THE STREET

Seven men-about-town hit the streets in this month's best casual city styles

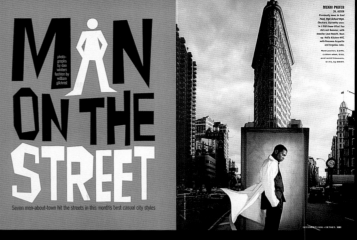

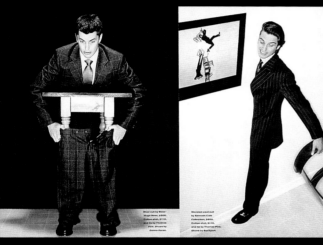

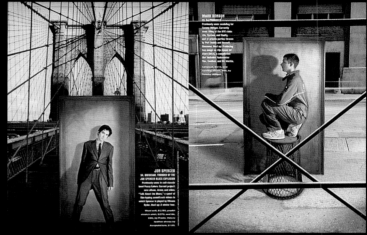

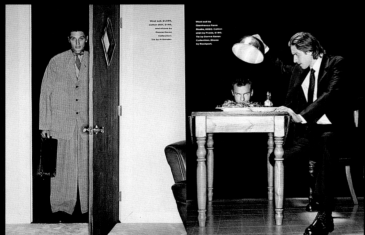

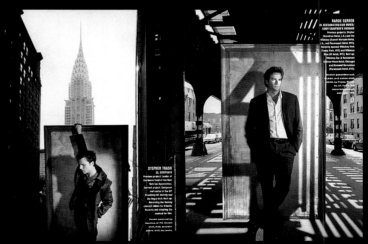

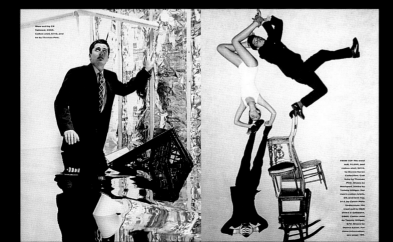

■ 194
Publication Details
Design Director Robert Newman
Designer Alden Wallace
Photo Editors Greg Pond, Halla Timon
Photographer Hugh Hales-Tooke
Fashion Director Derick Procope
Publisher Condé Nast Publications, Inc.
Issue October 1998
Categories Feature Story
A Spread

■ 195
Publication Details
Design Director Robert Newman
Designer John Giordani
Photo Editors Greg Pond, Halla Timon
Photographer Dan Winters
Stylist William Gilchrist
Publisher Condé Nast Publications, Inc.
Issue December 1998
Category Feature Story

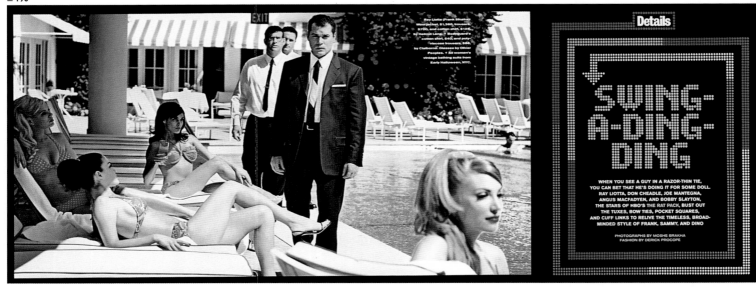

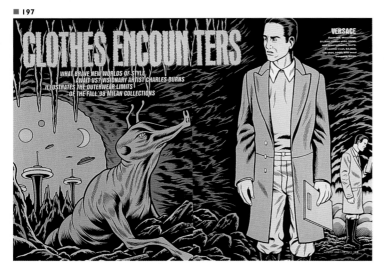

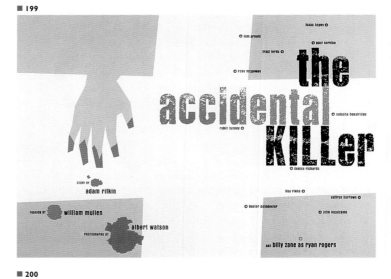

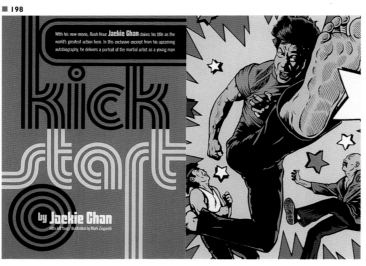

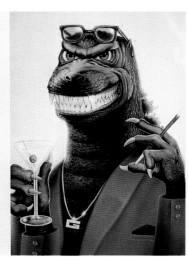

■ 196
Publication Details
Design Director
Robert Newman
Designer Alden Wallace
Photo Editors Greg Pond,
Halla Timon
Photographer Moshe Brakha
Fashion Director
Derick Procope
Publisher
Condé Nast Publications, Inc.
Issue September 1998
Category Feature Spread

■ 197
Publication Details
Design Director
Robert Newman
Designer Alden Wallace
Illustrator Charles Burns
Comix Editor Art Spiegelman
Publisher
Condé Nast Publications, Inc.
Issue August 1998
Category Feature Spread

■ 198
Publication Details
Design Director
Robert Newman
Designer Jesse Marinoff Reyes
Illustrator Mark Zingarelli
Publisher
Condé Nast Publications, Inc.
Issue October 1998
Category Feature Spread

■ 199
Publication Details
Design Director
Robert Newman
Art Director John Giordani
Designer Imaginary Forces
Publisher
Condé Nast Publications, Inc.
Issue March 1998
Category Feature Spread

■ 200
Publication Details
Design Director
Robert Newman
Designer John Giordani
Illustrator Tim O'Brien
Publisher
Condé Nast Publications, Inc.
Issue June 1998
Category Feature Spread

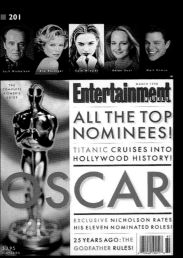
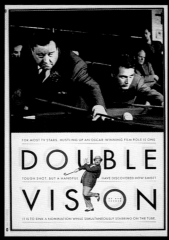

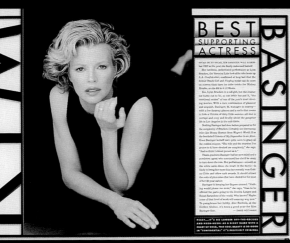

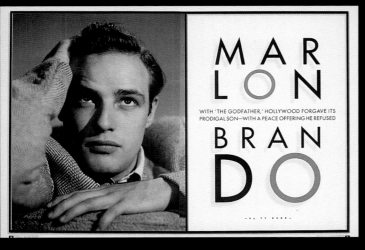

201
Publication Entertainment Weekly
Design Director John Korpics
Art Director Joe Kimberling
Designer Joe Kimberling
Photo Editors Sarah Rozen, Janene Outlaw
Photographers Mark Weiss, George Holz, Andrew Southam, Stephen Stickler, Andrew Eccles
Publisher Time Inc.
Issue March 1998
Category Entire Issue

202
Publication Entertainment Weekly
Design Director John Korpics
Art Director Joe Kimberling
Designer Joe Kimberling
Photo Editor Michele Romero
Photographer David Barry
Publisher Time Inc.
Issue April 17, 1998
Category Feature Spread

203
Publication Entertainment Weekly
Design Director John Korpics
Art Director Joe Kimberling
Designer Joe Kimberling
Illustrator Charles Spencer Anderson
Publisher Time Inc.
Issue July 17, 1998
Category Feature Spread

204
Publication Entertainment Weekly
Design Director John Korpics
Art Directors Geraldine Hessler, Joe Kimberling
Illustrator Mark Ryden
Publisher Time Inc.
Issue December 25, 1998
Category Contents

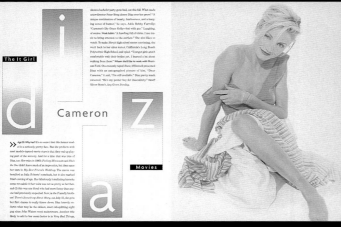

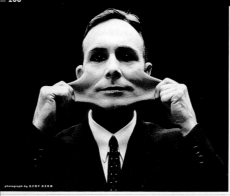

STRETCHiNG the BOUNDARiES

You can never be too rich, too young, or too thin. And if you happen to be all three—and talented to boot—you may find your name somewhere on the following pages of our ninth annual "Best of..." issue. Top entertainers have never made more money (even ADAM SANDLER may soon be a $20 million-a-picture man) and never looked so youthful (we wouldn't sell a six-pack to the BACKSTREET BOYS, CHRISTINA RICCI, or THE WOMEN OF THE WB). Lord knows they've never been skinnier (CALISTA FLOCKHART turned waifdom into a national debate, and *Bridget Jones* diarist HELEN FIELDING is surely the Samuel Pepys of calorie counting). Of course, if you happen to be all of the above— young, rich, trim, and wrapped up in one rebellious, baby-faced, steerage-class package— then you get EW's biggest prize. Which is why this year our choice for the No. 1 King of the Entertainment World is none other than...

photograph by GEOF KERN

the ENTERTAiNERS

EXiT STAGE LEFT

Remember Alice, whose idle nibbles on a mushroom blew her up to Brobdingnagian proportions, then made her downright Lilliputian? There was a lot of that going around in entertainment this year. On the upside, giants roamed the land in massive vehicles, be they three-hour movie juggernauts (yo, LEO, BRAD, and OPRAH), prolonged TV finales (goodbye already, JERRY), even gargantuan birthday parties (a big shout-out to PUFF DADDY). But as often as audiences embraced and thereby magnified the impact of monolithic entertainments, they cut many a Goliath down to size, as mega-music acts failed to sell records (PEARL JAM and VAN HALEN among them), 6-foot-9 MAGIC JOHNSON became a talk-TV casualty, and a large lizard and an overfed pig—both very expensive— were skewered at the box office. From the Beltway to Broadway to Hollywood Blvd., we loved to see the mighty rise high or fall hard. Join us in a pop-culture wonderland as we see who got big and who got small.

the YEaR that WaS

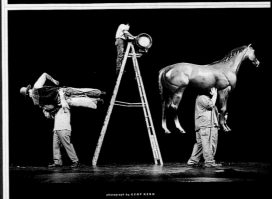

photograph by GEOF KERN

the BEST & WORST

TAKiNG MEASURE

Always in search of quality and innovation, always on guard against mediocrity and imitation, ENTERTAINMENT WEEKLY's critics summarize 1998 with their choices of the best and worst in movies, TV, books, music, video, and multimedia. As usual, the lists end up giving you a capsule analysis of the year's most striking moments in popular culture, from the fresh hell of war depicted in STEVEN SPIELBERG's *Saving Private Ryan* to the long-awaited release of still-explosive decades-old BOB DYLAN music. Whether it's taking the full measure of TOM WOLFE's *A Man in Full* or giving BUFFY THE VAMPIRE SLAYER her due, whether we come to praise the Japanese Walt Disney for KIKI'S DELIVERY SERVICE or to bury the most self-indulgent aspects of the Internet, EW's opinion polishers offer food for thought and argumentation. Chew over these picks.

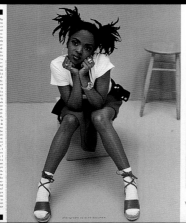

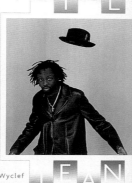

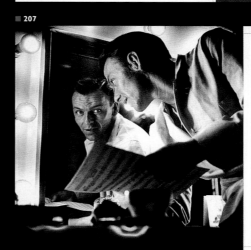

Contents

205
Publication Entertainment Weekly
Design Director John Korpics
Art Director Geraldine Hessler
Designer Geraldine Hessler
Illustrator Mark Matcho
Photo Editor Sarah Rozen
Photographers Andrew Southam, Cleo Sullivan, William Wegman
Publisher Time Inc.
Issue June 26, 1998
Category Feature Story

206
Publication Entertainment Weekly
Design Director John Korpics
Art Director Geraldine Hessler
Designer Geraldine Hessler
Photographer Geof Kern
Publisher Time Inc.
Issue December 25, 1998-January 1, 1999
Category Feature Story

207
Publication Entertainment Weekly
Design Director John Korpics
Designer John Korpics
Photo Editor Sarah Rozen
Photographer Bert Parry
Publisher Time Inc.
Issue Summer 1998
Category Contents

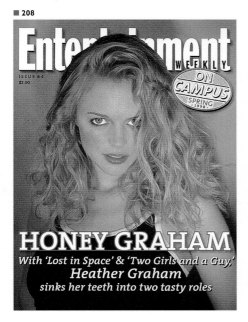

■ 208

Entertainment WEEKLY
ON CAMPUS
ISSUE #4
$2.00
SPRING 1998

HONEY GRAHAM

With 'Lost in Space' & 'Two Girls and a Guy,'
Heather Graham
sinks her teeth into two tasty roles

■ 208
Publication Entertainment Weekly
Design Director John Korpics
Art Director Geraldine Hessler
Designer George McCalman
Illustrator Geoffrey Grahn
Photo Editor Michele Romero
Photographers Frank W. Ockenfels 3,
Erin Patrice O'Brien, Patricia McDonough
Publisher Time Inc.
Issue Spring 1998
Category Entire Issue

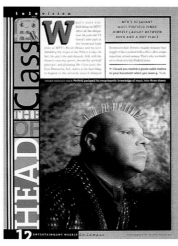

THE HEAD OF Class

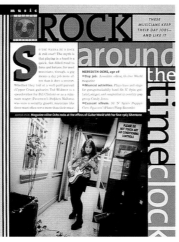

ROCK around the timeclock

THESE MUSICIANS KEEP THEIR DAY JOBS—AND LIKE IT

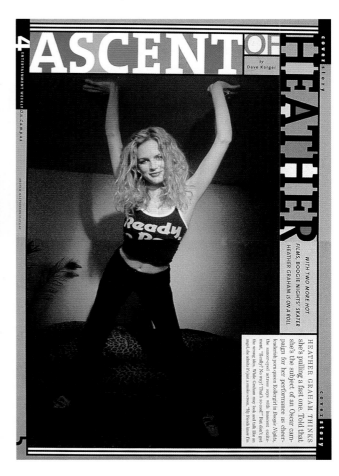

ASCENT OF HEATHER

by Dave Karger

WITH TWO MORE HOT FILMS, BOOGIE NIGHTS' SKATER HEATHER GRAHAM IS ON A ROLL

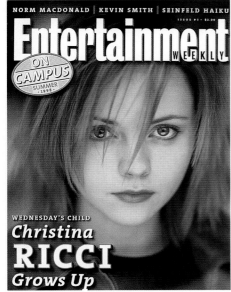

■ 209

NORM MACDONALD | KEVIN SMITH | SEINFELD HAIKU
ISSUE #5 · $2.00

Entertainment WEEKLY
ON CAMPUS
SUMMER 1998

WEDNESDAY'S CHILD
Christina
RICCI
Grows Up

■ 209
Publication Entertainment Weekly
Design Director John Korpics
Art Director Geraldine Hessler
Designer George McCalman
Illustrator Geoffrey Grahn
Photo Editor Michele Romero
Photographers Andrew Macpherson,
Joseph Pluchino, Patricia McDonough
Publisher Time Inc.
Issue Summer 1998
Category Entire Issue

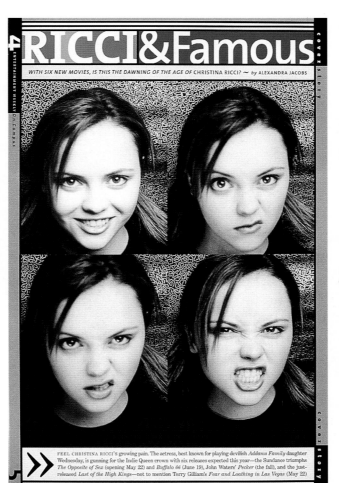

RICCI & Famous

WITH SIX NEW MOVIES, IS THIS THE DAWNING OF THE AGE OF CHRISTINA RICCI? — by ALEXANDRA JACOBS

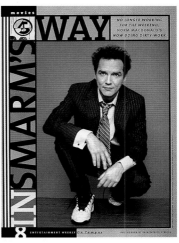

INSMARM'S WAY

NO LONGER WORKING FOR THE WEEKEND, NORM MACDONALD'S NOW DOING DIRTY WORK

THE GREAT UNKNOWNS

PRESENTING THREE OF THE BEST BANDS YOU'VE (PROBABLY) NEVER HEARD OF

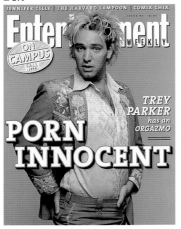

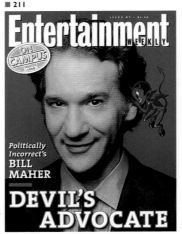

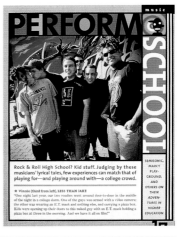

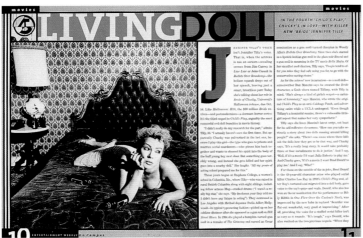

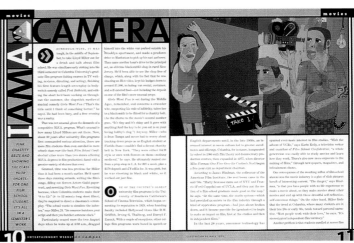

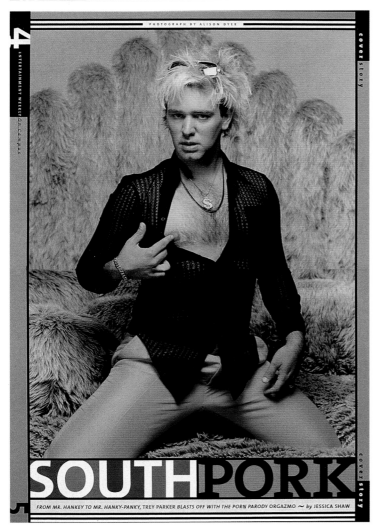

■ 210

Publication Entertainment Weekly
Design Director John Korpics
Art Director Geraldine Hessler
Designer George McCalman
Illustrators Geoffrey Grahn, Archer Prewitt
Photo Editor Michele Romero
Photographers Alison Dyer, Stephen Stickler, Eugene Pierce
Publisher Time Inc.
Issue Fall 1998
Category Entire Issue

■ 211

Publication Entertainment Weekly
Design Director John Korpics
Art Director Geraldine Hessler
Designer George McCalman
Illustrators Mark Todd, Christoph Niemann
Photo Editor Michele Romero
Photographers Alison Dyer, Joshua Kessler
Publisher Time Inc.
Issue Winter 1998
Category Entire Issue

■ 212

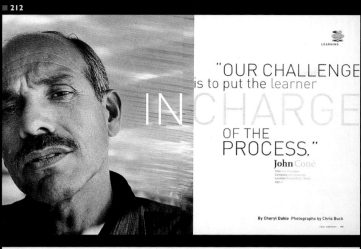

"OUR CHALLENGE
is to put the learner
IN CHARGE
OF THE
PROCESS."
John Coné

By Cheryl Dahle Photographs by Chris Buck

■ 213

REPORT
FROM THE FUTURE

Be Your Own Futurist

BY CURTIS SITTENFELD
ILLUSTRATIONS BY ANDERS WENNGREN

■ 214

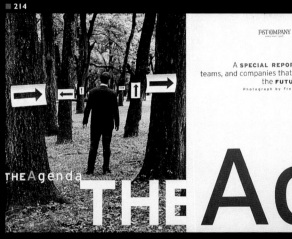

FAST COMPANY

A SPECIAL REPORT on the people,
teams, and companies that are creating
the FUTURE of BUSINESS.
Photograph by Fredrik Brodén

THE Agenda

THE Age

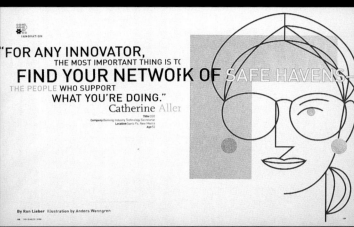

INNOVATION

"FOR ANY INNOVATOR,
THE MOST IMPORTANT THING IS TO
FIND YOUR NETWORK OF SAFE HAVENS.
THE PEOPLE WHO SUPPORT
WHAT YOU'RE DOING."
Catherine Allen

By Ron Lieber Illustration by Anders Wenngren

■ 215

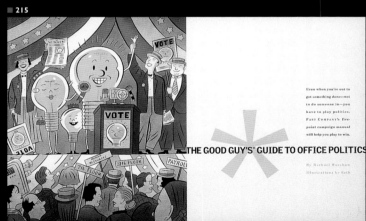

Even when you're out to
get something done—not
to do someone in—you
have to play politics.
FAST COMPANY's five-
point campaign manual
will help you play to win.

THE GOOD GUY'S GUIDE TO OFFICE POLITICS

By Michael Warshaw
Illustrations by Seth

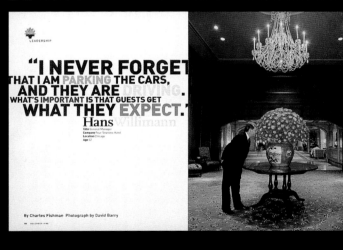

LEADERSHIP

"I NEVER FORGET
THAT I AM PARKING THE CARS,
AND THEY ARE DRIVING.
WHAT'S IMPORTANT IS THAT GUESTS GET
WHAT THEY EXPECT."
Hans Willimann

By Charles Fishman Photograph by David Barry

■ 212
Publication Fast Company
Art Director Patrick Mitchell
Designers Gretchen Smelter,
Emily Crawford, Rebecca Rees,
Patrick Mitchell
Illustrator Anders Wenngren
Photographers Chris Buck,
David Barry
Publisher Fast Company
Issue December 1998
Category Entire Issue

■ 213
Publication Fast Company
Art Director Patrick Mitchell
Designer Gretchen Smelter
Illustrator Anders Wenngren
Publisher Fast Company
Issue October 1998
Category Department

■ 214
Publication Fast Company
Art Director Patrick Mitchell
Designer Patrick Mitchell
Photographer Fredrik Brodén
Publisher Fast Company
Issue April/May 1998
Category Feature Spread

■ 215
Publication Fast Company
Art Director Patrick Mitchell
Designer Emily Crawford
Illustrator Seth
Publisher Fast Company
Issue April/May 1998
Category Feature Spread

IT'S A REVOLUTIONARY NOTION: TALENTED PEOPLE ARE JOINING UP WITH FAST COMPANIES TO CREATE "SOCIAL GLUE"—THE ESSENCE OF BOTH A WINNING BUSINESS AND A HUMANE WORKPLACE.

The Company of the Future

BY ROBERT B. REICH

ILLUSTRATIONS BY DOUGLAS FRASER
PHOTOGRAPHY BY LARRY FORD

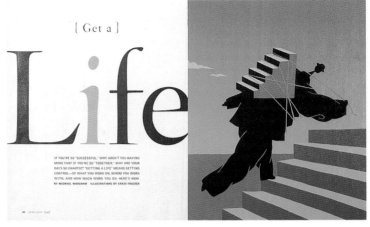

{ Get a }

Life

IF YOU'RE SO "SUCCESSFUL," WHY AREN'T YOU HAVING MORE FUN? IF YOU'RE SO "TOGETHER," WHY ARE YOUR DAYS SO CHAOTIC? "GETTING A LIFE" MEANS GETTING CONTROL—OF WHAT YOU WORK ON, WHOM YOU WORK WITH, AND HOW MUCH WORK YOU DO. HERE'S HOW.

BY MICHAEL WARSHAW ILLUSTRATIONS BY CRAIG FRAZIER

REPORT
FROM THE FUTURE

EDITED BY POLLY LABARRE

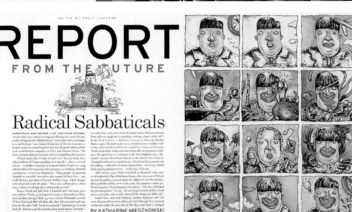

Radical Sabbaticals

BY KATHARINE MIESZKOWSKI
ILLUSTRATIONS BY KEVIN POPE

REPORT
FROM THE FUTURE

EDITED BY POLLY LABARRE

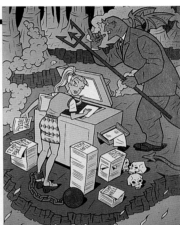

Don't Wanna Be Your (Temp) Slave!

BY KATHARINE MIESZKOWSKI
ILLUSTRATIONS BY STEVE WACKSMAN

By Alan M. Webber

HOW TO GET **THEM** TO SHOW **YOU** THE MONEY

LEIGH STEINBERG, THE MOST POWERFUL AGENT IN SPORTS, TELLS FREE AGENTS IN THE BUSINESS WORLD HOW TO NEGOTIATE GREAT DEALS—AND HOW TO DEAL WITH THEIR FEAR OF NEGOTIATION.

PHOTOGRAPHS BY EVERARD WILLIAMS JR.

AMF HAS MOVED BOWLING OUT OF ITS OLD ALLEYS AND INTO TECHNOTAINMENT. BY LISA CHADDERDON

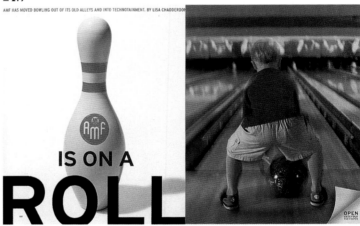

IS ON A ROLL

OPEN GATEFOLD FOR PHOTOS

■ 216
Publication Fast Company
Art Director Patrick Mitchell
Designers Gretchen Smelter, Emily Crawford, Rebecca Rees, Patrick Mitchell
Illustrators Douglas Fraser, Kevin Pope
Photographer Everard Williams, Jr.
Publisher Fast Company
Issue November 1998
Category Entire Issue

■ 217
Publication Fast Company
Art Director Patrick Mitchell
Designer Patrick Mitchell
Illustrator Craig Frazier
Publisher Fast Company
Issue June/July 1998
Category Feature Spread

■ 218
Publication Fast Company
Art Director Patrick Mitchell
Designer Gretchen Smelter
Illustrator Steve Wacksman
Publisher Fast Company
Issue September 1998
Category Feature Spread

■ 219
Publication Fast Company
Art Director Patrick Mitchell
Designer Emily Crawford
Photographer Burk Uzzle
Publisher Fast Company
Issue September 1998
Category Feature Spread

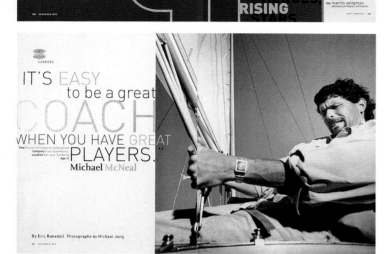

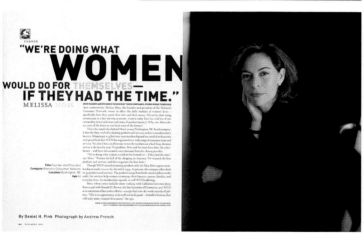

DESIGN MERIT ■

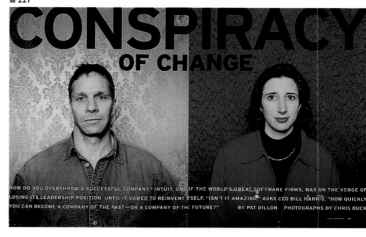

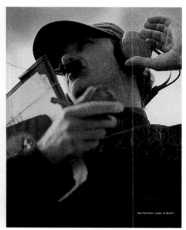

■ 220
Publication Fast Company
Art Director Patrick Mitchell
Designers Gretchen Smelter,
Emily Crawford, Patrick Mitchell
Illustrator Anders Wenngren
Photographers Michael Jang, Andrew French
Publisher Fast Company
Issue December 1998
Category Feature Story

■ 221
Publication Fast Company
Art Director Patrick Mitchell
Designers Gretchen Smelter, Emily Crawford,
Rebecca Rees, Patrick Mitchell
Photographers Chris Buck, Burk Uzzle
Illustrator Chip Wass
Publisher Fast Company
Issue October 1998
Categories Entire Issue
 A Department

Next

There is no path or recipe or design to greatness. There is no Will Hunting-like formula (Gift, plus Style minus Hype times Rings equals Impact) to explain Michael Jordan. ⊕ There is a feeling to greatness, though—a smile or even the tear we sometimes get when we witness it. We simply know it when we see it. And we've been seeing it a lot lately: LT, Montana, B. Sanders; Wayne, Mario, Messier; Bird, Magic, Michael; Gwynn, Griffey, Ripken. We shake our heads over the outrageous money they get and the ridiculous degree of celebrity they attain, yet the evidence is that they are actually thriving under the pressure and furthering the evolution of their sports. ⊕ This rush of brilliance should not only make us feel blessed, but should also teach us never to say, "There will never be another," because there almost always is. (Michael may be the exception.) Who's next? Nothing in sports is guaranteed—for every Tiger Woods, there is a Todd Marinovich. Still, here are four damn good bets on who will pull us out of our seats in the 21st century, four players to tell our grandchildren about, to lay down a challenge for the next generation, to give us that feeling.

Photographed by James Porto

A

Kobe Bryant

by Tom Friend

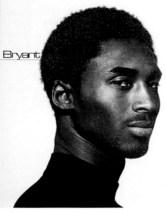

Alex Rodriguez

by Tim Kurkjian

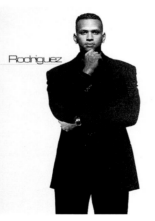

Eric Lindros

by Dan Shaughnessy

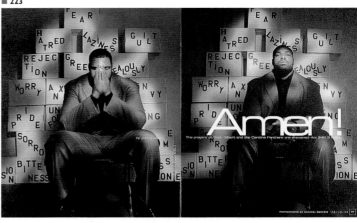

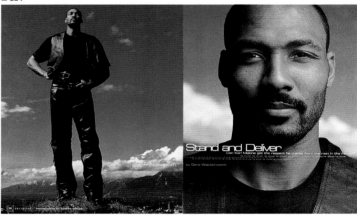

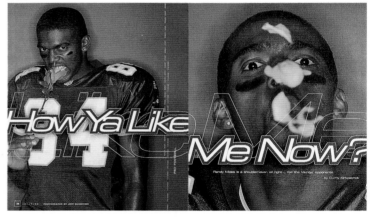

 226

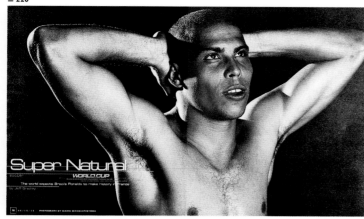

229

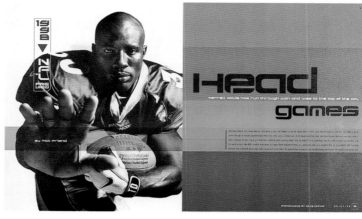

227

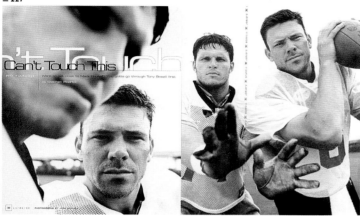

230

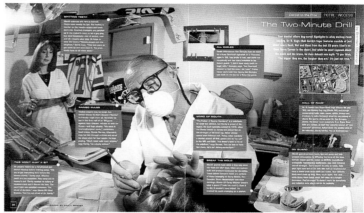

228

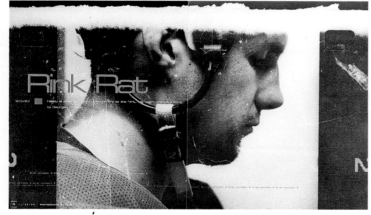

231

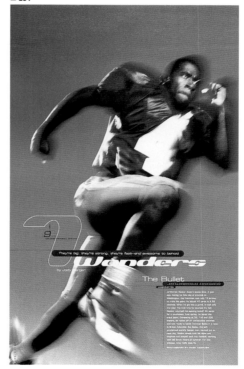

226
Publication ESPN
Design Director F. Darrin Perry
Art Director Yvette L. Francis
Photo Editor Simon P. Barnett
Photographer Giani Giansanti
Publisher Disney
Issue June 15, 1998
Category Feature Spread

227
Publication ESPN
Design Director F. Darrin Perry
Designer F. Darrin Perry
Photo Editor John Toolan
Photographer Jorg Badura
Publisher Disney
Issue November 2, 1998
Category Feature Spread

228
Publication ESPN
Design Director F. Darrin Perry
Designer F. Darrin Perry
Photo Editor Brenna Britton
Photographer Exum
Publisher Disney
Issue November 2, 1998
Category Feature Spread

229
Publication ESPN
Design Director F. Darrin Perry
Art Director Peter Yates
Photo Editor Marianne Butler
Photographer Davis Factor
Publisher Disney
Issue September 7, 1998
Category Feature Spread

230
Publication ESPN
Design Director F. Darrin Perry
Art Director Christopher Rudzik
Photo Editor John Toolan
Photographer Erica Berger
Publisher Disney
Issue December 14, 1998
Category Department

231
Publication ESPN
Design Director F. Darrin Perry
Art Director Yvette L. Francis
Photo Editor John Toolan
Photographer Mark Hanauer
Publisher Disney
Issue August 24, 1998
Category Feature Spread

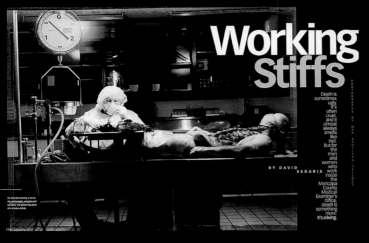

Working Stiffs

BY DAVID SEDARIS

Death is sometimes ugly. It's often cruel, and it almost always smells like hell. But for the men and women who work inside the Maricopa County Medical Examiner's Office, death is something more. It's a living.

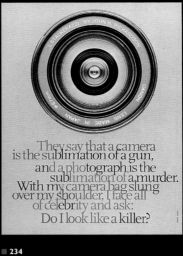

I STALKERAZZI. BY JOHN H. RICHARDSON

They say that a camera is the sublimation of a gun, and a photograph is the sublimation of a murder. With my camera bag slung over my shoulder, I face all of celebrity and ask: Do I look like a killer?

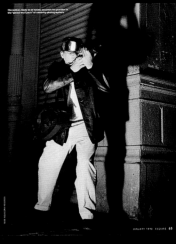

snapfiction

Quill

By Tony Earley

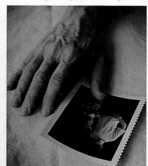

232
Publication Esquire
Design Director Robert Priest
Art Director Rockwell Harwood
Designer Joshua Liberson
Photo Editor Patti Wilson
Photographer Max Aguilera-Hellweg
Publisher The Hearst Corporation-
Magazines Division
Issue April 1998
Category Feature Story

233
Publication Esquire
Design Director Robert Priest
Art Director Rockwell Harwood
Designer Laura Harrigan
Photo Editor Patti Wilson
Photographers Gary Hush,
Max Aguilera-Hellweg
Publisher The Hearst Corporation-
Magazines Division
Issue January 1998
Category Feature Spread

234
Publication Esquire
Design Director Robert Priest
Art Director Rockwell Harwood
Designer Joshua Liberson
Photo Editor Patti Wilson
Photographer Dana Gallgher
Publisher The Hearst Corporation-
Magazines Division
Issue June 1998
Category Department

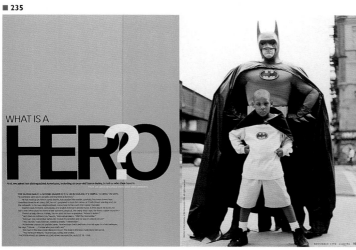

WHAT IS A HERO?

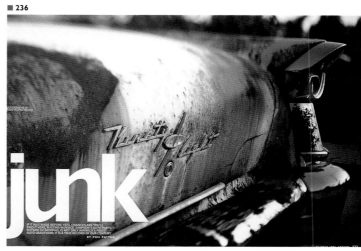

junk

IF IT WAS MADE BEFORE 1973, CHANCES ARE YOU'LL FIND IT HERE, RUSTING IN PEACE. SIMPSON'S AUTO PARTS, OUTSIDE OF MEMPHIS, IS NOT ONLY AMERICA'S FINEST AUTO GRAVEYARD, IT IS A TRUE RECORD OF OUR CENTURY. BY PHIL PATTON

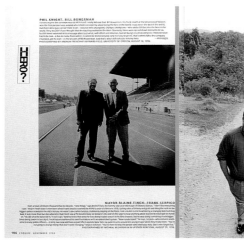

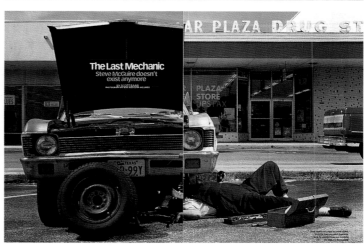

The Last Mechanic
Steve McGuire doesn't exist anymore

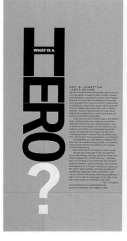

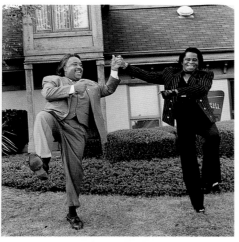

WHAT IS A HERO?

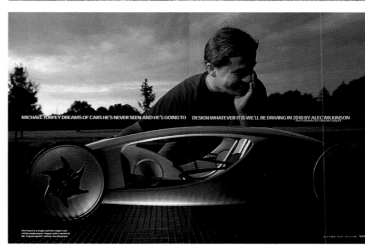

MICHAEL TORPEY DREAMS OF CARS HE'S NEVER SEEN AND HE'S GOING TO DESIGN WHATEVER IT IS WE'LL BE DRIVING IN 2010 BY ALEC WILKINSON

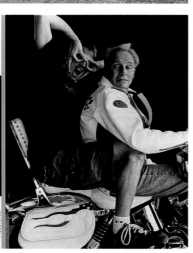

■ 235
Publication Esquire
Design Director Robert Priest
Art Director Rockwell Harwood
Designer Joshua Liberson
Photo Editor Patti Wilson
Photographers Brian Velenchenko, Andrew French, Michael McLaughlin, Nitin Vadukul, Kurt Markus, Harry Benson, Todd Eberle
Publisher The Hearst Corporation-Magazines Division
Issue November 1998
Category Feature Story

■ 236
Publication Esquire
Design Director Robert Priest
Art Director Rockwell Harwood
Designer Joshua Liberson
Photo Editor Patti Wilson
Photographers Brian Velenchenko, Phil Patton, Max Aguilera-Hellweg, Gregory Heisler
Publisher The Hearst Corporation-Magazines Division
Issue October 1998
Category Feature Story

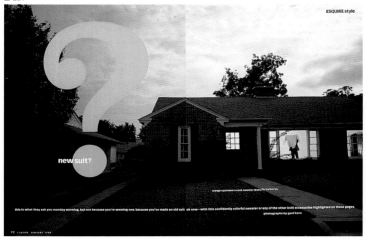

ESQUIRE style

new suit?

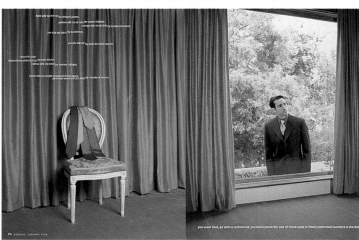

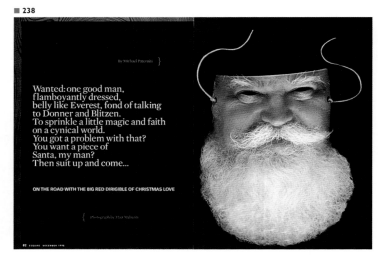

By Michael Paterniti }

Wanted: one good man,
flamboyantly dressed,
belly like Everest, fond of talking
to Donner and Blitzen.
To sprinkle a little magic and faith
on a cynical world.
You got a problem with that?
You want a piece of
Santa, my man?
Then suit up and come...

ON THE ROAD WITH THE BIG RED DIRIGIBLE OF CHRISTMAS LOVE

{ Photograph by Matt Mahurin }

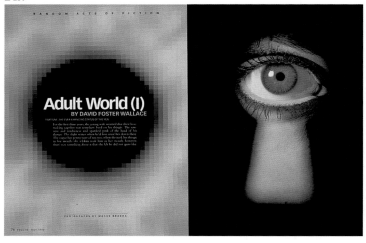

RANDOM ACTS OF FICTION

Adult World (I)
BY DAVID FOSTER WALLACE

(anamericanfamily)

(bydanielvoll)

Allen and Patty have four beautiful children. Allen and Patty are in love. But there's something sort of illegal about that. So Allen and Patty are in jail.

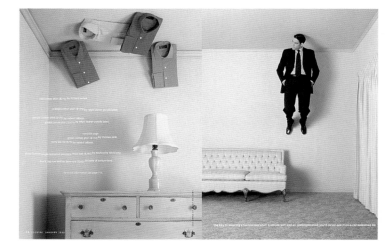

■ 237
Publication Esquire
Design Director Robert Priest
Art Director Rockwell Harwood
Designer Laura Harrigan
Photo Editor Patti Wilson
Photographer Geof Kern
Publisher The Hearst Corporation-Magazines Division
Issue January 1998
Category Feature Story

■ 238
Publication Esquire
Design Director Robert Priest
Art Director Rockwell Harwood
Designer Joshua Liberson
Photo Editor Patti Wilson
Photographer Matt Mahurin
Publisher The Hearst Corporation-Magazines Division
Issue December 1998
Category Feature Spread

■ 239
Publication Esquire
Design Director Robert Priest
Art Director Rockwell Harwood
Designer Joshua Liberson
Photo Editor Patti Wilson
Photographer Moshe Brakha
Publisher The Hearst Corporation-Magazines Division
Issue March 1998
Category Feature Spread

■ 240
Publication Esquire
Design Director Robert Priest
Art Director Rockwell Harwood
Designer Joshua Liberson
Photo Editor Patti Wilson
Photographer Moshe Brakha
Publisher The Hearst Corporation-Magazines Division
Issue July 1998
Category Department

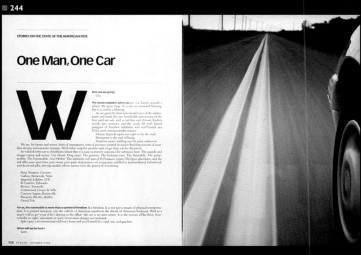

■ 241

LONG

LIVE THE

CAREER

SMOKER

BY DAVID EGGERS

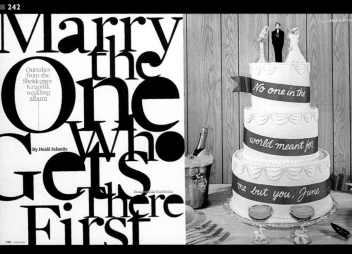

■ 242

Marry the One Who Gets There First

Outtakes from the Sheidegger-Krupnik wedding album

By Heidi Julavits

No one in the world meant for me but you, June

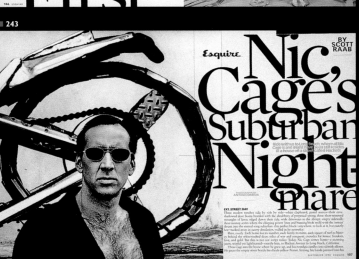

■ 243

BY SCOTT RAAB

Esquire

Nic Cage's Suburban Nightmare

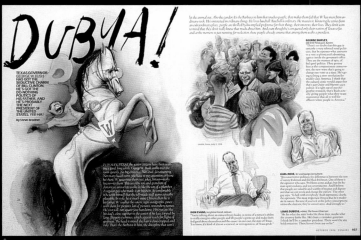

■ 244

STORIES ON THE STATE OF THE AMERICAN RIDE

One Man, One Car

W

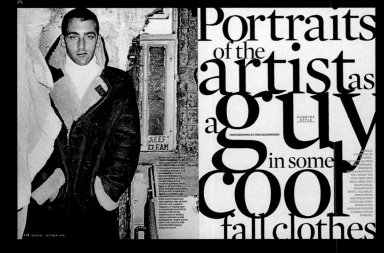

DUBYA!

TEXAS GOVERNOR GEORGE W. BUSH HAS GOT THE SEDUCTIVE CHARM OF BILL CLINTON. HE'S GOT THE DO-NOTHING POLITICS OF HIS FATHER. AND HE'S PROBABLY THE NEXT PRESIDENT OF THE UNITED STATES. YEE-HA!

By Steve Brodner

A

Portraits of the artist as a guy in some cool fall clothes

ESQUIRE STYLE

PHOTOGRAPHS BY BOB RICHARDSON

■ 241
Publication Esquire
Design Director Robert Priest
Art Director Rockwell Harwood
Designer Joshua Liberson
Photo Editor Patti Wilson
Photographer Geof Kern
Publisher The Hearst Corporation-Magazines Division
Issue April 1998
Category Feature Spread

■ 242
Publication Esquire
Design Director Robert Priest
Art Director Rockwell Harwood
Designer Joshua Liberson
Photo Editor Patti Wilson
Photographer Dan Winters
Publisher The Hearst Corporation-Magazines Division
Issue April 1998
Category Feature Spread

■ 243
Publication Esquire
Design Director Robert Priest
Art Director Rockwell Harwood
Designer Joshua Liberson
Photo Editor Patti Wilson
Photographer Anton Corbijn
Publisher The Hearst Corporation-Magazines Division
Issue September 1998
Category Feature Spread

■ 244
Publication Esquire
Design Director Robert Priest
Art Director Rockwell Harwood
Designer Joshua Liberson
Illustrator Steve Brodner
Photo Editor Patti Wilson
Photographers Bob Richardson, Brian Velenchenko
Publisher The Hearst Corporation-Magazines Division
Issue October 1998
Categories Entire Issue
A Spread

A NEW *age of* DISCOVERY

After 450 years as a Portuguese colony, magnetic Macau returns to Chinese rule in 1999 / Text by WW. Williams / Photography by James Whitlow Delano

'East is East, and West is West, and never the twain shall meet,' wrote Rudyard Kipling But he was wrong. Evidently he forgot about Macau

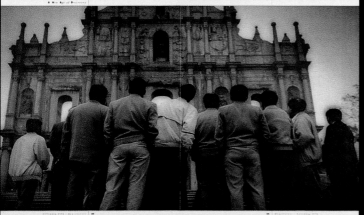

I pondered the lessons that Macau has taught me over the years. This unique cultural confluence has helped open my eyes to the world.

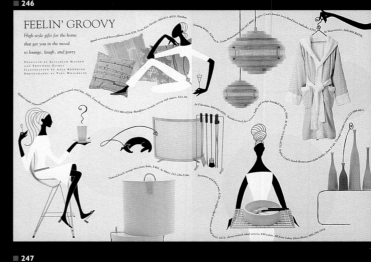

FEELIN' GROOVY

High-style gifts for the home
that get you in the mood
to lounge, laugh, and party

PRODUCED BY ELIZABETH WAGNER
AND FRONNIE GILBEY
ILLUSTRATION BY ANJA KROENCKE
PHOTOGRAPHED BY PAUL WHICHELOE

sex
can make you nervous

PHOTOGRAPHY BY TOM SCHIERLITZ

He's supposed to be the stiff one,
not you. If you've got performance
anxiety, turn the page and calm
yourself. By Suzan Colón

BODY BY

PHOTOGRAPHED BY LAUREN GREENFIELD
WRITTEN BY KEN WIBECAN

245
Publication Hemispheres
Design Director Jaimey Easler
Art Directors Jaimey Easler,
Jody Mustain, Kevin de Miranda
Photographer James Whitlow Delano
Publisher Pace Communications
Client United Airlines
Issue November 1998
Category Feature Story

246
Publication House Beautiful
Art Director Andrzej Janerka
Designer Victoria Beall Haemmerle
Illustrator Anja Kroencke
Photographer Paul Whicheloe
Publisher The Hearst Corporation-
Magazines Division

247
Publication Jane
Art Director Johan Svensson
Designer Amy Demas
Photo Editor Cary Estes Leitzes
Photographer Tom Schierlitz
Publisher Fairchild Publications
Issue November 1998
Category Feature Spread

248
Publication Modern Maturity
Design Director Cynthia J. Friedman
Art Director Gregory T. Atkins
Designer Gregory T. Atkins
Photo Editor Peter Howe
Photographer Lauren Greenfield
Publisher AARP

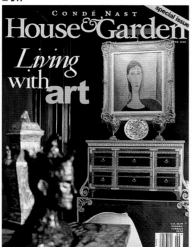

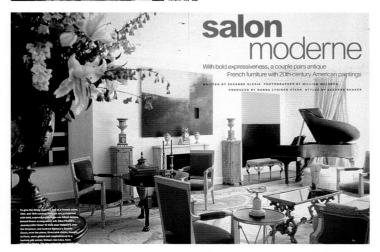

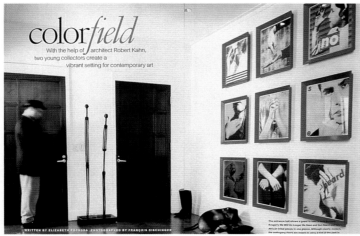

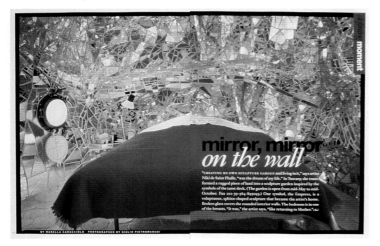

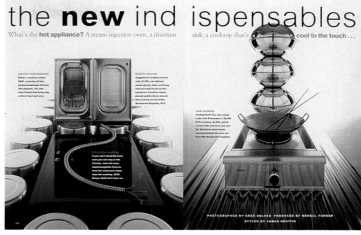

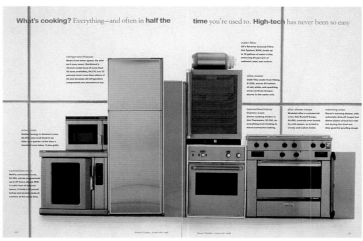

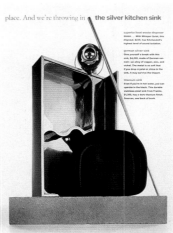

■ 249
Publication House & Garden
Art Director Diana LaGuardia
Photo Editor Dana Nelson
Photographers William Waldron,
François Dischinger, Giulio Pietromarchi
Publisher Condé Nast Publications, Inc.
Issue June 1998
Category Entire Issue

■ 250
Publication House & Garden
Art Director Diana LaGuardia
Designer Nancy Brooke Smith
Photo Editor Dana Nelson
Photographer Greg Delves
Publisher Condé Nast Publications, Inc.
Issue February 1998
Category Feature Story

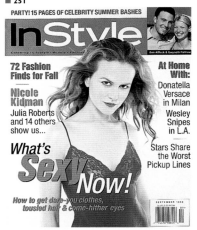

■ 251
Publication InStyle
Art Director Paul Roelofs
Designers Paul Roelofs,
Carol Pagliuco, Garrett Yankou,
Sharon Cowen, Elisabeth Mehary,
Jaime Ferrand, Lou Corredor
Photo Editors Laurie Kratochvil,
Maureen Griffin, Allyson M. Torrisi,
Angela Drexel, Elizabeth Popp,
Jean Cabacungan-Jarvis
Photographers Mark Liddell,
Art Streiber
Publisher Time Inc.
Issue September 1998
Category Entire Issue

■ 252
Publication Technology Review
Creative Director David Herbick
Art Director Kelly L. McMurray
Designers Kelly L. McMurray,
Margot Grisar
Illustrators Gene Greif,
Francisco Caceres
Photographers Anne Hamersky,
Max Aguilera-Hellweg, Jan Staller, Jana
Leon, Vito Alvia, David Zadig
Studio Kellydesign, inc. & David
Herbick Design
Client M. I. T.
Issue November/December 1998
Category Redesign

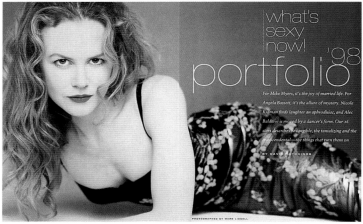

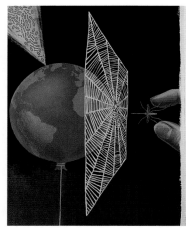

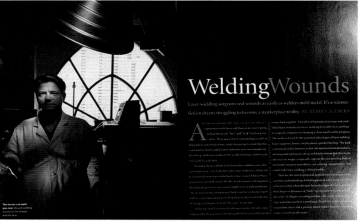

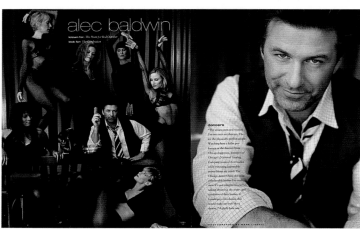

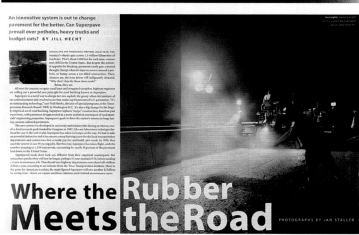

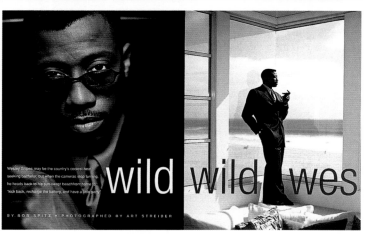

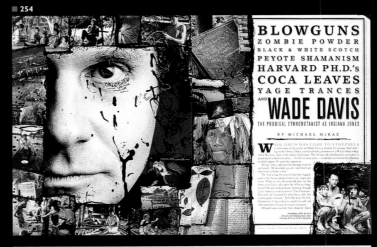

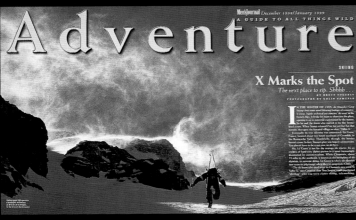

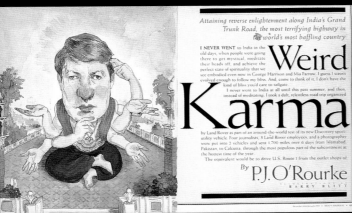

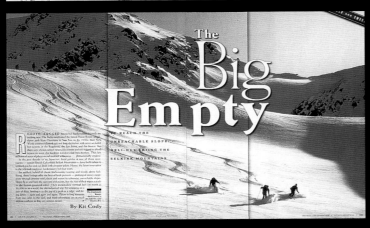

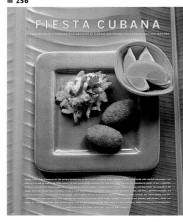

FIESTA CUBANA

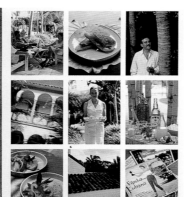

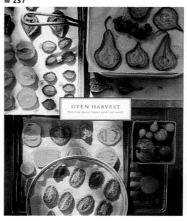

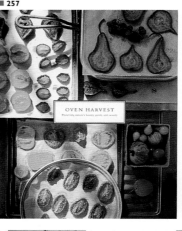

OVEN HARVEST

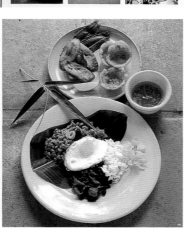

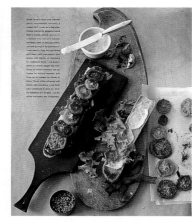

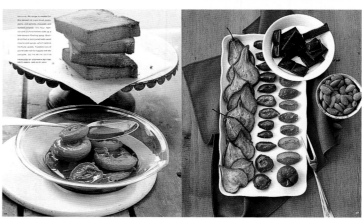

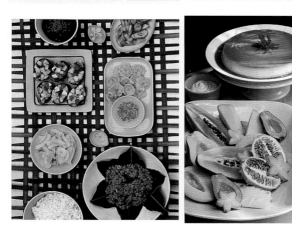

■ 256
Publication Martha Stewart Living
Design Director Eric A. Pike
Art Director James Dunlinson
Designers James Dunlinson, Susan Sugarman, Page Marchese
Photo Editor Heidi Posner
Photographer Gentl + Hyers
Publisher Martha Stewart Living Omnimedia
Issue September 1998
Category Feature Story

■ 257
Publication Martha Stewart Living
Design Director Eric A. Pike
Art Director Scot Schy
Designers Scot Schy, Fritz Karch, Stephana Bottom
Photo Editor Heidi Posner
Photographer Dana Gallagher
Publisher Martha Stewart Living Omnimedia
Issue September 1998
Category Feature Story

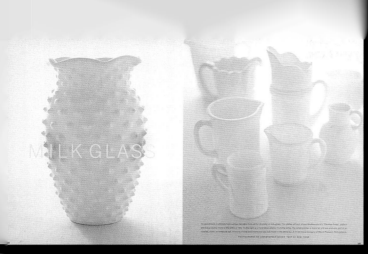

MILK GLASS

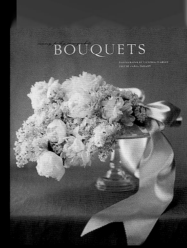
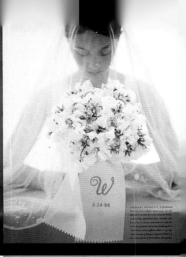

BOUQUETS

PHOTOGRAPHS BY VICTORIA PEARSON
TEXT BY CAROL PRISANT

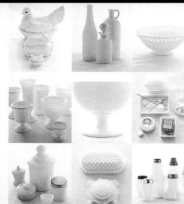

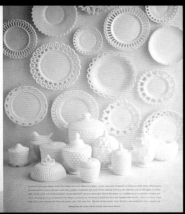

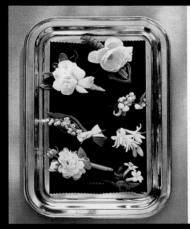
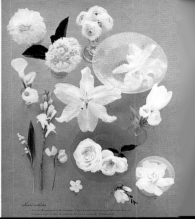

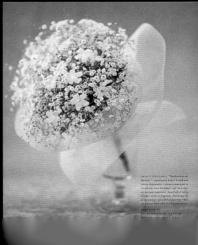
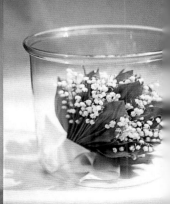

258
Publication Martha Stewart Living
Design Director Eric A. Pike
Art Director Agnethe Glatved
Designers Agnethe Glatved, Fritz Karch
Photo Editor Heidi Posner
Photographer Christopher Baker
Publisher Martha Stewart Living Omnimedia
Issue July/August 1998
Category Feature Story

259
Publication Martha Stewart Living
Design Director Eric A. Pike
Designers Eric A. Pike, Hannah Milman

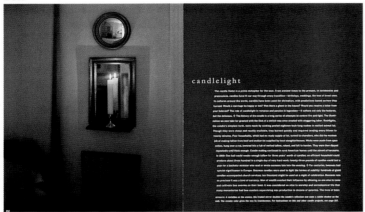

candlelight

The candle flame is a prime metaphor for the soul. From ancient times to the present, in ceremonies and processions, candles have lit our way through many transitions—birthdays, weddings, the loss of loved ones. In cultures around the world, candles have been used for divination, with predictions based on how they burned. Would a marriage be happy or sad? Was there a ghost in the house? Would you receive a letter from your beloved? The role of candlelight in romance and passion is legendary—it softens not only the features, but the defenses.

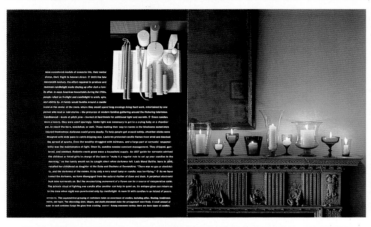

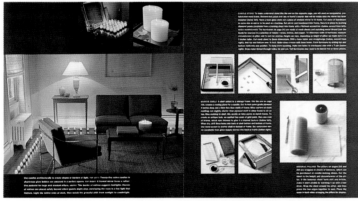

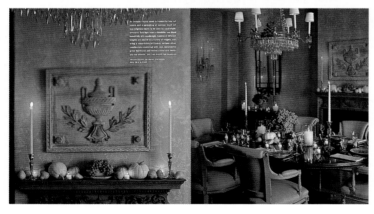

MARTHA STEWART Living

Caramel

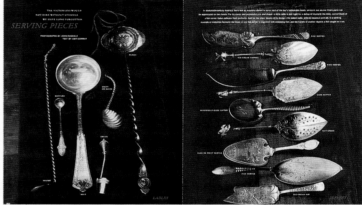

THE VICTORIAN WORLD
NOT DINE WITHOUT UTENSILS
WE HAVE LONG FORGOTTEN
SERVING PIECES

■ 261
Publication Martha Stewart Living
Design Director Eric A. Pike
Art Directors Scot Schy, Claudia Bruno, Agnethe Glatved, James Dunlinson
Designers Esther Bridavsky, Lilian Hough, Eva Spring, Stacey Dietz
Photo Editor Heidi Posner
Photographers John Dugdale, William Abranowicz, Gentl + Hyers, Maria Robledo
Publisher Martha Stewart Living Omnimedia
Issue November 1998
Category Entire Issue

■ 260
Publication Martha Stewart Living
Design Director Eric A. Pike
Designers Eric A. Pike, Anthony Cochran
Photo Editor Heidi Posner
Photographer William Abranowicz
Publisher Martha Stewart Living Omnimedia
Issue November 1998
Category Feature Story

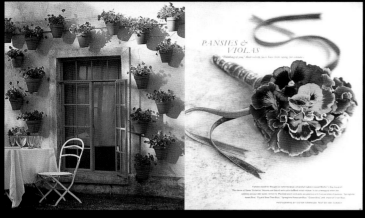

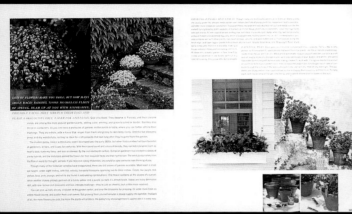

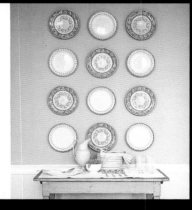

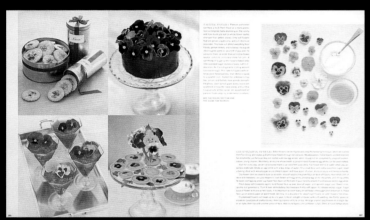

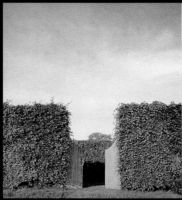

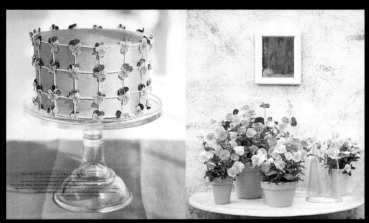

■ 263
Publication Martha Stewart Living
Design Director Eric A. Pike
Art Director Claudia Bruno
Designers Claudia Bruno, Susan Spungen
Photo Editor Heidi Posner
Photographer Dana Gallagher
Publisher Martha Stewart Living Omnimedia
Issue October 1998
Category Feature Spread

■ 264
Publication Martha Stewart Living
Design Director Eric A. Pike
Designers Eric A. Pike, Fritz Karch
Photo Editor Heidi Posner
Photographer Dana Gallagher
Publisher Martha Stewart Living Omnimedia
Issue October 1998
Category Feature Spread

■ 265
Publication Martha Stewart Living
Design Director Eric A. Pike
Art Director Robert Fisher
Designers Robert Fisher, Bill Shank
Photo Editor Heidi Posner
Photographer Jason Schmidt
Publisher Martha Stewart Living Omnimedia
Issue September 1998
Category Feature Spread

■ 262
Publication Martha Stewart Living
Design Director Eric A. Pike
Designers Eric A. Pike, Hannah Milman
Photo Editor Heidi Posner
Photographer Victor Schrager
Publisher Martha Stewart Living Omnimedia
Issue May 1998
Categories Feature Story
 A Spread

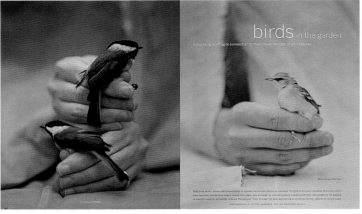

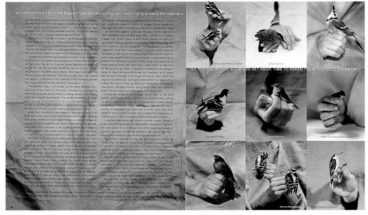

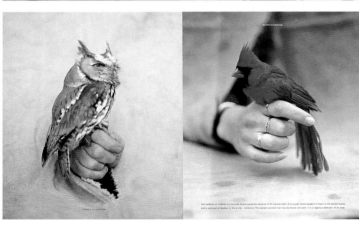

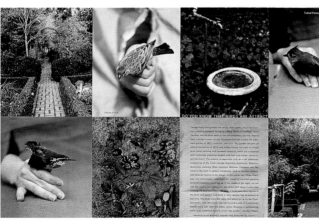

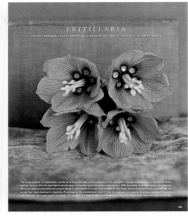

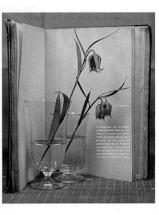

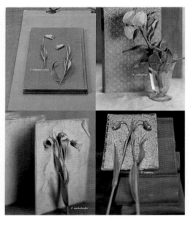

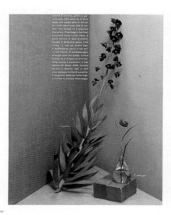

■ 266
Publication Martha Stewart Living
Design Director Eric A. Pike
Art Director Agnethe Glatved
Designers Agnethe Glatved, Michele Adams
Photo Editor Heidi Posner
Photographer Victor Schrager
Publisher Martha Stewart Living Omnimedia
Issue April 1998
Category Feature Story

■ 267
Publication Martha Stewart Living
Design Director Eric A. Pike
Art Director Claudia Bruno
Designers Claudia Bruno, Ayesha Patel
Photo Editor Heidi Posner
Photographer Victor Schrager
Publisher Martha Stewart Living Omnimedia
Issue March 1998
Category Feature Story

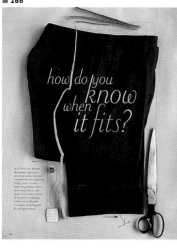

how do you know when it fits?

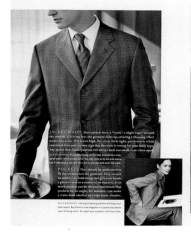

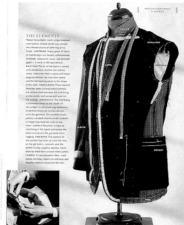

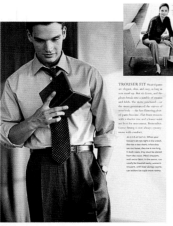

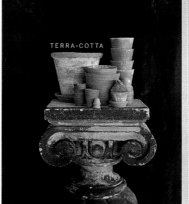

TERRA-COTTA

f-all '98

American sportswear has taken fashion by storm. Suits with a crisp white tee. A sweater set with a long A-line skirt. Sailor pants and Mary Janes. A cashmere coat paired with wing tips, white socks, and a sexy slip dress. The season's best clothing is beautifully tailored and fitted for your body. The styling? Think apple pie and champagne. Happy fall.

■ 268

Publication Martha Stewart Living
Creative Director Gael Towey
Design Director Eric A. Pike
Art Director Scot Schy
Designers Eric A. Pike,
Michele Outland
Photo Editor Heidi Posner
Photographer Anita Calero
Publisher Martha Stewart Living Omnimedia
Issue Clotheskeeping
Category Feature Story

■ 269

Publication Martha Stewart Living
Design Director Eric A. Pike
Art Director Scot Schy
Designers Scot Schy, Fritz Karch
Photo Editor Heidi Posner
Photographer Stephen Lewis
Publisher Martha Stewart Living Omnimedia
Issue February 1998
Category Feature Spread

■ 270

Publication Mode
Creative Director
Janine Weitenauer
Art Director Lynne Yeamans
Designers Suzanne Jennerich,
Janine Weitenauer
Photo Editor Bill Swan
Photographer Eran Offek
Studio 360 degrees, Inc
Publisher
Lewit & Lewinter/Freedom
Issue September 1998
Category Feature Single Page

■ 271

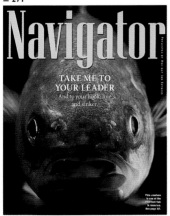

■ 271
Publication Navigator
Design Director Paul Carstensen
Designer Paul Carstensen
Illustrators Nigel Holmes,
Steve Stankiewicz, Bob Staake,
Jack Davis, Tom Garrett,
Max Seabaugh, Geoff Hunt
Photographers Joe Mehling,
Don Chambers, Troy House,
Kathleen Norris Cook,
Mark Wagoner, Clint Clemens
Publisher Pace Communications
Client Holiday Inn Express
Issue June/July 1998
Category Entire Issue

■ 272

■ 272
Publication Navigator
Design Director Paul Carstensen
Art Director Susan L. Bogle
Designer Susan L. Bogle
Illustrators Jane Sanders,
Nigel Holmes, Doreen Means,
Steve Stankiewicz, Barry Blitt,
Ross MacDonald, Brad Walker,
Max Seabaugh, Bob Staake
Photographers Don Chambers,
Kindra Clineff, Mark Wagoner,
Adrien Helé, Tim Pott, James Schnepf
Publisher Pace Communications
Client Holiday Inn Express
Issue August/September 1998
Category Entire Issue

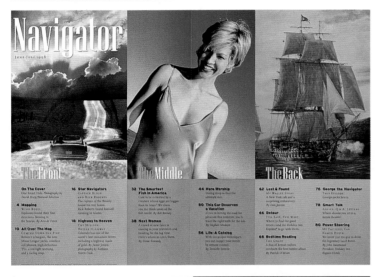

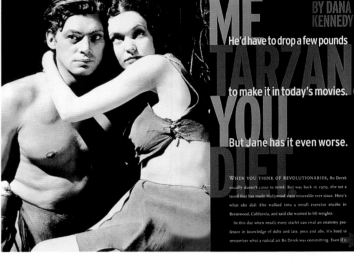

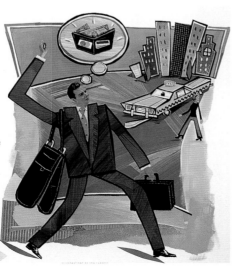

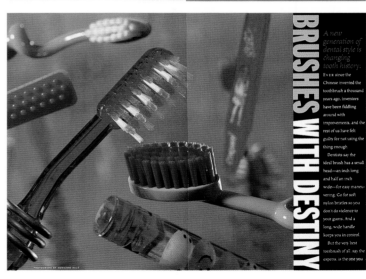

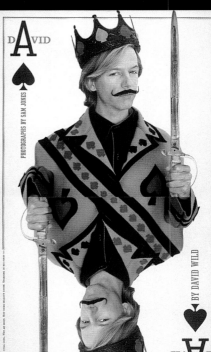

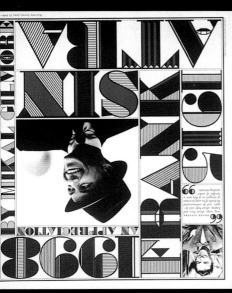

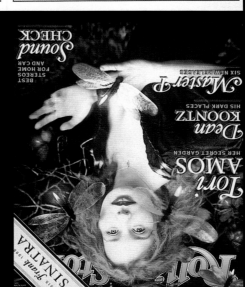

■ 279
Publication The New York Times Magazine
Art Director Janet Froelich
Designers Catherine Gilmore-Barnes,
Lisa Naftolin
Photo Editor Kathy Ryan
Photographers Alexei Hay, Edward Keating,
Jake Chessum, Lauren Greenfield
Publisher The New York Times
Issue May 17, 1998
Category Entire Issue

■ 280
Publication Request
Art Director David Yamada
Designer David Yamada
Photographer Ken Schles
Publisher Request Media
Issue May 1998
Category Feature Spread

■ 281
Publication Request
Art Director David Yamada
Designer David Yamada
Photographer Kevin Knight
Publisher Request Media
Issue July 1998
Category Feature Spread

■ 282
Publication Request
Art Director David Yamada
Designer David Yamada
Publisher Request Media
Issue December 1998
Category Feature Single Page

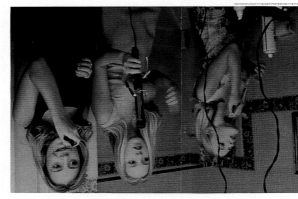

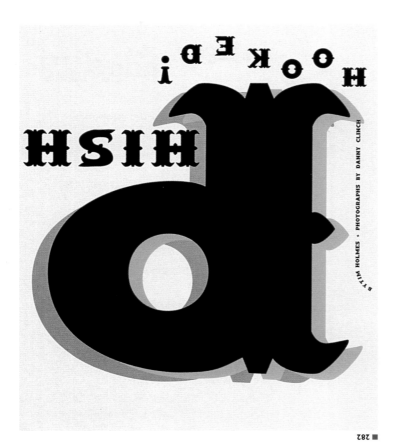

■ 282

HOOKED!
HISH

BY TIM HOLMES • PHOTOGRAPHS BY DANNY CLINCH

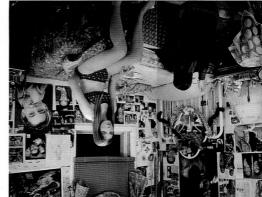

SONIC GENIUS or Butch Diva
Filanquye Has it Both Ways

■ 281

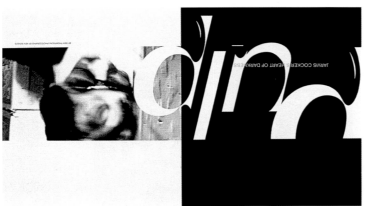

Pulp
JARVIS COCKER'S HEART OF DARKNESS

■ 280

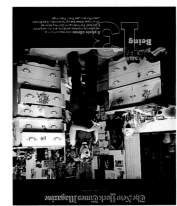

Being 13
The New York Times Magazine

■ 279

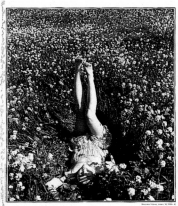

Photographs by Peggy Sirota

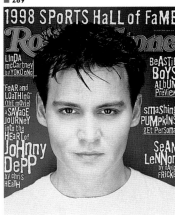

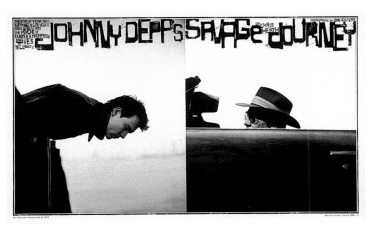

THE EVOLUTION OF

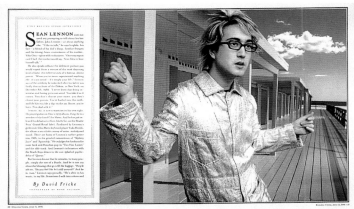

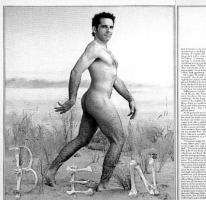

HIS JOURNEY
FROM NERDY NEW YORK KID
TO HIS HOLLYWOOD BONELESS PRESENT
THERE'S SOMETHING ABOUT BEN STILLER
By Chris Mundy

■ 287
Publication Rolling Stone
Art Director Fred Woodward
Photo Editor Rachel Knepfer
Photographer Peggy Sirota
Publisher Straight Arrow Publishers
Issue April 30, 1998
Category Feature Story

■ 288
Publication Rolling Stone
Art Director Fred Woodward
Designers Fred Woodward, Hannah McCaughey
Photo Editor Rachel Knepfer
Photographer Mark Seliger
Publisher Straight Arrow Publishers
Issue November 12, 1998
Category Feature Story

■ 289
Publication Rolling Stone
Art Director Fred Woodward
Designers Fred Woodward, Gail Anderson,
Siung Tjai, Hannah McCaughey, Eric Siry
Photo Editors Rachel Knepfer, Fiona McDonagh
Photographers Dan Winters, Mark Seliger, David LaChapelle
Publisher Straight Arrow Publishers
Issue June 11, 1998
Category Entire Issue

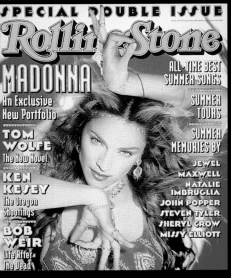

SPECIAL DOUBLE ISSUE
Rolling Stone

MADONNA
An Exclusive
New Portfolio

TOM WOLFE
The New Novel

KEN KESEY
The Oregon
Shootings

BOB WEIR
Life After
The Dead

ALL-TIME BEST
SUMMER SONGS

SUMMER
TOURS

SUMMER
MEMORIES BY

JEWEL
MAXWELL
NATALIE
IMBRUGLIA
JOHN POPPER
STEVEN TYLER
SHERYL CROW
MISSY ELLIOTT

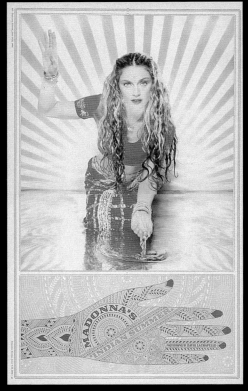

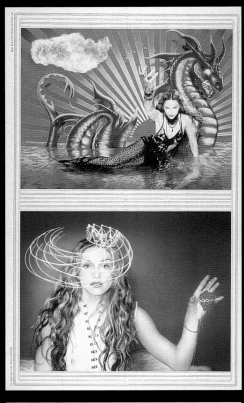

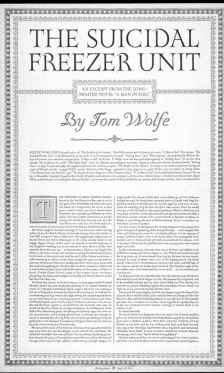

THE SUICIDAL
FREEZER UNIT

AN EXCERPT FROM THE LONG-
AWAITED NOVEL "A MAN IN FULL"

By Tom Wolfe

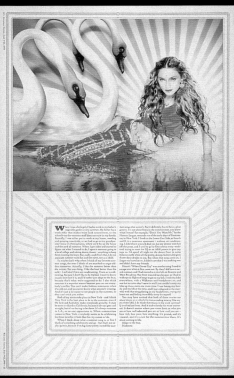

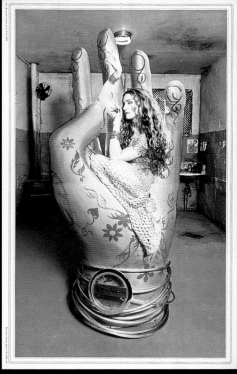

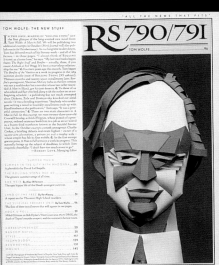

RS 790/791
TOM WOLFE

■ 290
Publication Rolling Stone
Art Director Fred Woodward
Designers Fred Woodward, Gail Anderson,
Siung Tjia, Hannah McCaughey, Eric Siry
Illustrator Edward Bryant
Photo Editors Rachel Knepfer, Fiona McDonagh
Photographer David LaChapelle
Publisher Straight Arrow Publishers
Issue July 9, 1998
Category Entire Issue

■ 291
Publication Rolling Stone
Art Director Fred Woodward
Designers Fred Woodward, Siung Tjia
Photo Editor Rachel Knepfer
Photographer David LaChapelle
Publisher Straight Arrow Publishers
Issue July 9, 1998
Category Feature Story

■ 292

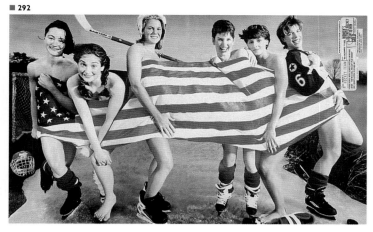

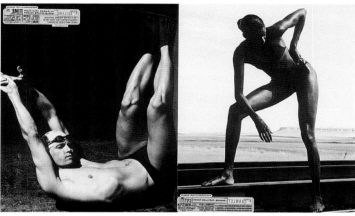

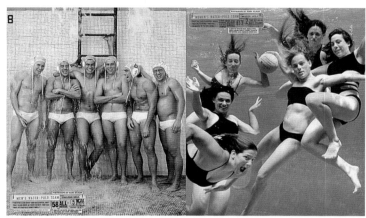

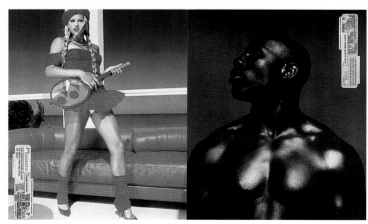

■ 293

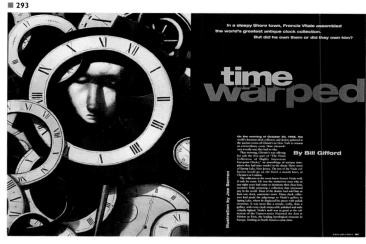

■ 294

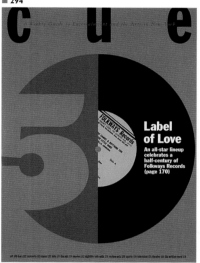

■ 295

■ 292
Publication Rolling Stone
Art Director Fred Woodward
Designer Hannah McCaughey
Photo Editors Rachel Knepfer, Fiona McDonagh
Photographers David LaChapelle, Kurt Markus, Mark Seliger, Ruven Afanador
Publisher Straight Arrow Publishers
Issue June 11, 1998
Category Feature Story

■ 293
Publication Philadelphia
Art Director Tim Baldwin
Designer John Goryl
Illustrator Joe Sorren
Publisher Metrocorp Publishing
Issue September 1998
Category Feature Spread

■ 294
Publication New York
Design Director
Mark Michaelson
Designer Anton Ioukhnovets
Illustrator Anton Ioukhnovets
Publisher Primedia Magazines Inc.
Issue May 4, 1998
Category Department

■ 295
Publication
The Life@Work Journal
Creative Directors
Tim Walker, Sean Womack
Designers Tim Walker,
Daniel Bertalotto
Studio Walker Creative, Inc.
Publisher
The Life@Work Company
Issue August 1998
Category Feature Spread

FROM BAD BOY TO BOY TOY TO HOLLYWOOD HOT
PROPERTY—HOW MARK WAHLBERG
BEAT THE ODDS

The CONTENDER

BY HOLLY MILLEA

PHOTOGRAPHED BY ANDREW MACPHERSON

IT APPEARS

in the distance, behind a silvery veil of light rain, a face full of rage, sweat, and sex. This man will not be beaten, will not go down. His fist, ten feet across, punches out the drivers passing below. He is the greatest.

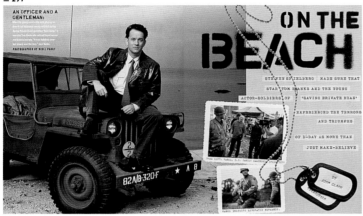

AN OFFICER AND A
GENTLEMAN:

PHOTOGRAPHED BY NIGEL PARRY

ON THE BEACH

STEVEN SPIELBERG MADE SURE THAT
STAR TOM HANKS AND THE YOUNG
ACTOR-SOLDIERS OF
'SAVING PRIVATE RYAN'
EXPERIENCED THE TERRORS
AND TRIUMPHS
OF D-DAY AS MORE THAN
JUST MAKE-BELIEVE

BY JOHN CLARK

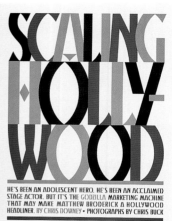

SCALING HOLLYWOOD

HE'S BEEN AN ADOLESCENT HERO, HE'S BEEN AN ACCLAIMED
STAGE ACTOR, BUT IT'S THE GODZILLA MARKETING MACHINE
THAT MAY MAKE MATTHEW BRODERICK A HOLLYWOOD
HEADLINER. BY CHRIS DOWNEY • PHOTOGRAPHS BY CHRIS BUCK

WITH SUDDEN FAME
COMES TEMPTATION. WILL
MINNIE DRIVER BITE?

BY EDWARD SUSSMAN • PHOTOGRAPHS BY ROBERT TRACHTENBERG

DRIVER'S EDUCATION

WILD CHILD

JOAQUIN
PHOENIX
HAS LED AN
UNCONVEN-
TIONAL A LIFE
AS POSSIBLE.
NOW HE'S
A RAGING
SUCCESS IN
HOLLYWOOD.
CAN TALENT
REALLY
CONQUER ALL?

BY EDWARD SUSSMAN
PHOTOGRAPHS BY ROBERT TRACHTENBERG

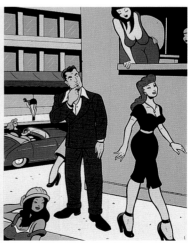

THE LANGUAGE OF WOMEN IS ONE
BREAKING OF THE
GREAT
MYSTE
RIES OF THE UNIVERSE. SOMETIMES
SHE'S SENDING THE RIGHT
SIGNALS, BUT YOUR RADAR'S **THE**
NOT PICKING THEM UP. OTHER
TIMES SHE'S TUNED OUT, BUT YOU'RE
CODE MOVING IN. MISSION
IMPOSSIBLE? NOT WITH
OUR SECRET DECODER.
BY ABBY ELLIN. ILLUSTRATION BY MARK MATCHO

SAVEUR

Savor a World of Authentic Cuisine

Pullout
BURGUNDY
POSTER
MAP & GUIDE
Inside

S P E C I A L I S S U E

BURGUNDY

THE GLORY OF REAL FRENCH FOOD

PLUS: *Pumpkins Galore • True Bagels • A Maryland Thanksgiving*

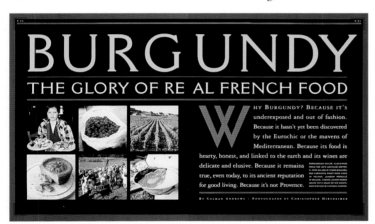

BURGUNDY

THE GLORY OF RE AL FRENCH FOOD

CHEFS & CARROTS

BURGUNDY'S CULINARY RAW MATERIALS
INSPIRE CUISINE BOTH HAUTE AND HOMEY

THE BEST OF BURGUNDY
ÉPOISSES

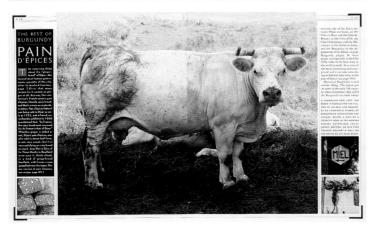

THE BEST OF BURGUNDY
PAIN D'ÉPICES

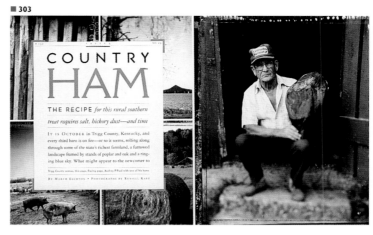

COUNTRY HAM

THE RECIPE *for this rural southern treat requires salt, hickory dust—and time*

IT IS OCTOBER in Trigg County, Kentucky, and every third barn is on fire—or so it seems, rolling along through some of the state's richest farmland, a furrowed landscape framed by stands of poplar and oak and a ringing blue sky. What might appear to the newcomer to

BY MARCH EGERTON • PHOTOGRAPHS BY RUSSELL KAYE

■ 304

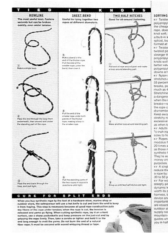

RO PE
THE POSTER

BY JILL CONNERS PHOTOGRAPHS BY ANTHONY COTSIFAS

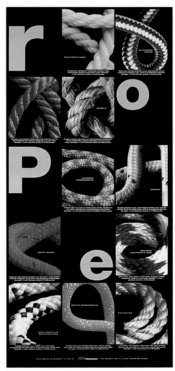

■ 302

Publication Saveur
Creative Director Michael Grossman
Art Director Jill Armus
Designers Michael Grossman,
Jill Armus, Toby Fox
Photo Editor Maria Millan
Photographer Christopher Hirsheimer
Publisher Meigher Communications
Issue November 1998
Category Entire Issue

■ 303

Publication Saveur
Creative Director Michael Grossman
Art Director Jill Armus
Designer Jill Armus
Illustrator Oliver Williams
Photo Editor Maria Millan
Photographer Russell Kaye
Publisher Meigher Communications
Issue September/October 1998
Category Feature Spread

■ 304

Publication This Old House
Design Director Matthew Drace
Art Director Diana Haas
Photographer Anthony Cotsifas
Publisher Time Inc.
Issue July/August 1998
Category Feature Story

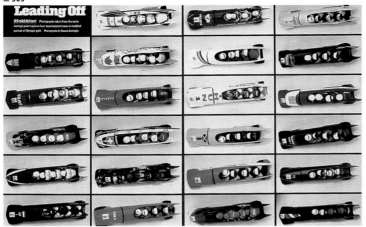

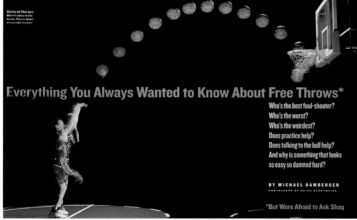

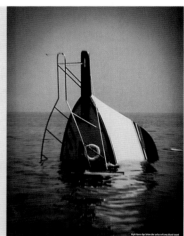

■ 305
Publication Sports Illustrated
Creative Director Steven Hoffman
Designers Steven Hoffman,
Meera Kothari
Photographer Nancie Battaglia
Publisher Time Inc.
Issue March 2, 1998
Category Department

■ 306
Publication Sports Illustrated
Creative Director Steven Hoffman
Designers Steven Hoffman,
Karen Meneghin
Photographer Brian Bahr
Publisher Time Inc.
Issue March 30, 1998
Category Department

■ 307
Publication Sports Illustrated
Creative Director Steven Hoffman
Designer Miki Sakai
Photographer Heinz Kluetmeier
Publisher Time Inc.
Issue April 13, 1998
Category Department

■ 308
Publication Sports Illustrated
Creative Director Steven Hoffman
Designer Rosanne Berry
Photographer Lynn Johnson
Publisher Time Inc.
Issue January 12, 1998
Category Feature Spread

■ 309
Publication Sports Illustrated
Creative Director Steven Hoffman
Designers Steven Hoffman, Judie Lilly
Photographer Bob Martin
Publisher Time Inc.
Issue June 8, 1998
Category Contents

■ 310
Publication Yachting
Art Director David Pollard
Designer David Pollard
Illustrator David Pollard
Photographer Dr. Dean Delladonne
Publisher Times Mirror Magazines
Issue March 1998
Category Feature Spread

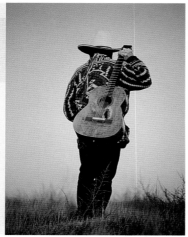

WHAT DO THE YEARS DO TO A REBEL? SOMETIMES THEY MAKE HIM EVEN WILDER. THE RED HEADED STRANGER LONG AGO WENT GRAY, BUT HIS PASSION—FOR MUSIC, THE ROAD, AND ADVENTURE—HASN'T GONE COLD.

at 65

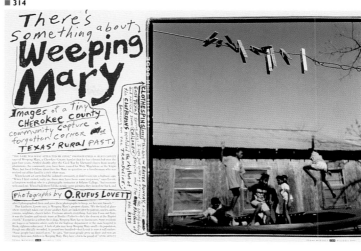

There's Something about Weeping Mary

Images of a tiny CHEROKEE COUNTY community capture a forgotten corner of TEXAS' RURAL PAST.

Photographs by O. RUFUS LOVETT

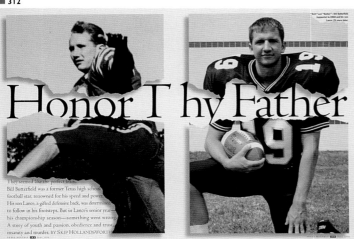

Honor Thy Father

They seemed like the perfect team. Bill Butterfield was a former Texas high school football star, renowned for his speed and power. His son Lance, a gifted defensive back, was determined to follow in his footsteps. But in Lance's senior year, his championship season—something went wrong. A story of youth and passion, obedience and trust, insanity and murder. BY SKIP HOLLANDSWORTH

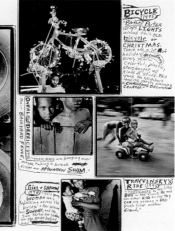

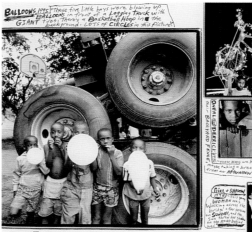

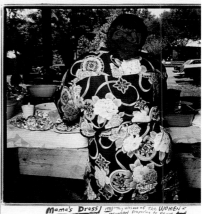

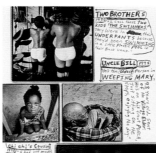

Can John Glenn Do It Again? Long ago he saved America from losing the space race to the Russians. Now the 77-year-old astronaut has a new mission: saving NASA. by Helen Thorpe

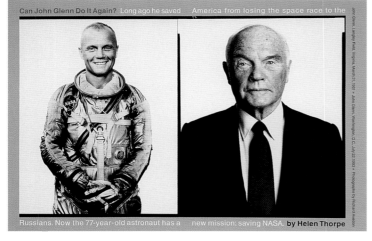

■ 311
Publication Texas Monthly
Creative Director D. J. Stout
Designers D. J. Stout,
Nancy McMillen
Photo Editor D. J. Stout
Photographer Dan Winters
Publisher
Emmis Communications Corp.
Issue April 1998
Category Feature Spread

■ 312
Publication Texas Monthly
Creative Director D. J. Stout
Designers D. J. Stout,
Nancy McMillen
Photo Editor D. J. Stout
Publisher
Emmis Communications Corp.
Issue June 1998
Category Feature Spread

■ 313
Publication Texas Monthly
Creative Director D. J. Stout
Designers D. J. Stout,
Nancy McMillen
Photo Editor D. J. Stout
Photographer Richard Avedon
Publisher
Emmis Communications Corp.
Issue October 1998
Category Feature Spread

■ 314
Publication Texas Monthly
Creative Director D. J. Stout
Designers D. J. Stout,
Nancy McMillen
Photo Editor D. J. Stout
Photographer O. Rufus Lovett
Publisher
Emmis Communications Corp.
Issue December 1998
Category Feature Story

THE NEW BERLIN

BY BILL VAN PARYS

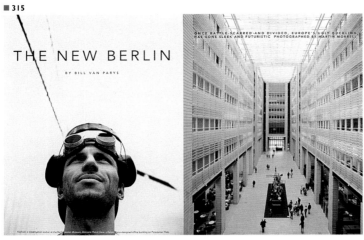

ONCE BATTLE-SCARRED AND DIVIDED, EUROPE'S UGLY DUCKLING HAS GONE SLEEK AND FUTURISTIC. PHOTOGRAPHED BY MARTIN MORRELL

Take five days, stir occasionally, and learn the secrets of the Tuscan kitchen at a cooking school outside Florence. BY HOLLY BRUBACH

FIORENTINA

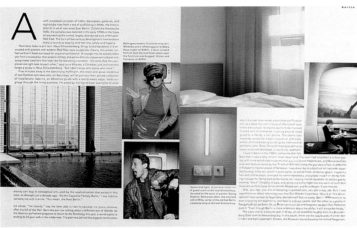

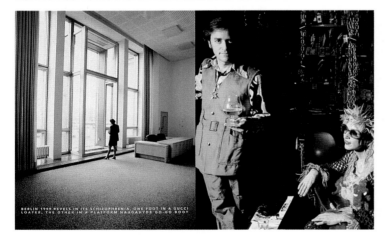

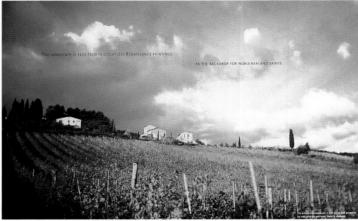

THE LANDSCAPE IS RENDERED IN COUNTLESS RENAISSANCE PAINTINGS

AS THE BACKDROP FOR NOBLEMEN AND SAINTS

BERLIN 1999 REVELS IN ITS SCHIZOPHRENIA, ONE FOOT IN A GUCCI LOAFER, THE OTHER IN A PLATFORM NAUGAHYDE GO-GO BOOT

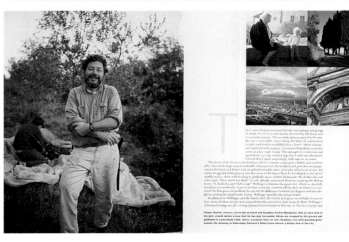

■ 315

Publication Travel & Leisure
Creative Director Pamela Berry
Designer Pamela Berry
Photo Editor Jim Franco
Photographer Martin Morrell
Publisher
American Express Publishing Co.
Issue January 1998
Category Feature Story

■ 316

Publication Travel & Leisure
Creative Director Pamela Berry
Art Director Dan Josephs
Designer Dan Josephs
Photo Editor Jim Franco
Photographer John Kernick
Publisher
American Express Publishing Co.
Issue September 1998
Category Feature Story

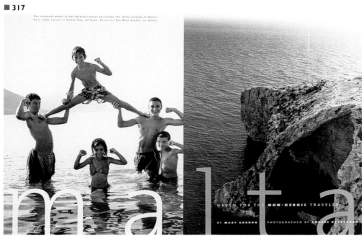

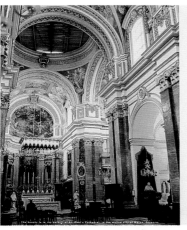

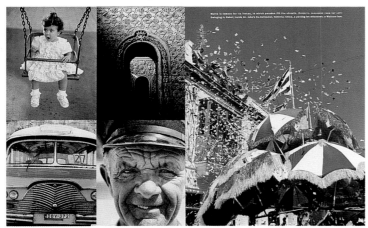

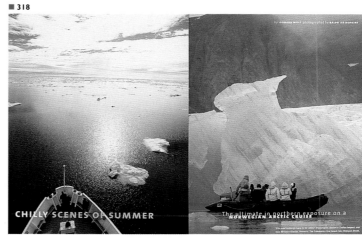

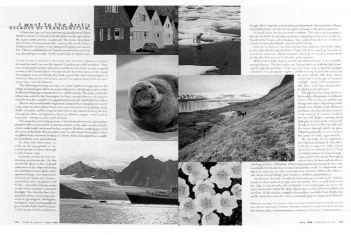

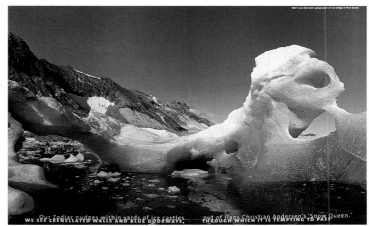

■ 317
Publication Travel & Leisure
Creative Director Pamela Berry
Designer Dan Josephs
Photo Editor Jim Franco
Photographer Anders Overgaard
Publisher
American Express Publishing Co.
Issue July 1998
Category Feature Story

■ 318
Publication Travel & Leisure
Creative Director Pamela Berry
Designer Dan Josephs
Photo Editor Jim Franco
Photographer Ralph Lee Hopkins
Publisher
American Express Publishing Co.
Issue July 1998
Category Feature Story

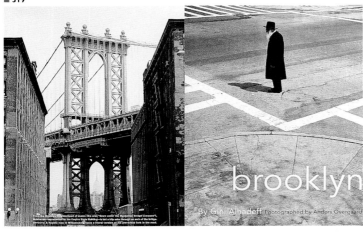

brooklyn

By Gini Alhadeff Photographed by Anders Overgaard

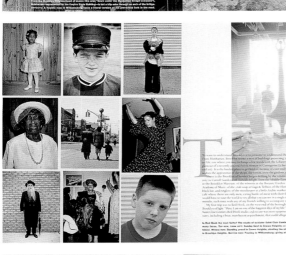

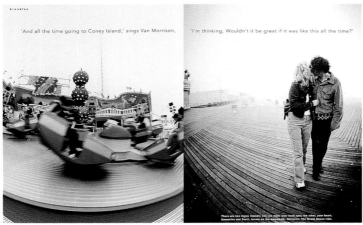

'And all the time going to Coney Island,' sings Van Morrison, 'I'm thinking, Wouldn't it be great if it was like this all the time?'

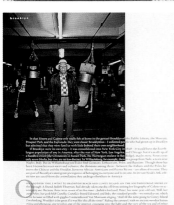

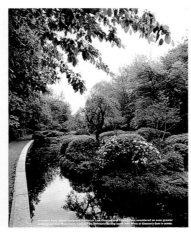

Ross Bleckner's Capri Sketchbook

The artist sets up his easel on Italy's
enchanted isle to capture the spirit of the Mediterranean

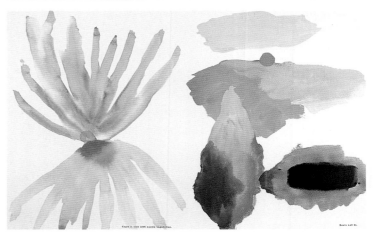

■ **319**
Publication Travel & Leisure
Creative Director Pamela Berry
Designer Pamela Berry
Photo Editor Jim Franco
Photographer Anders Overgaard
Publisher
American Express Publishing Co.
Issue September 1998
Category Feature Story

■ **320**
Publication Travel & Leisure
Creative Director Pamela Berry
Designer Pamela Berry
Illustrator Ross Bleckner
Publisher
American Express Publishing Co.
Issue March 1998
Category Feature Story

■ **321**
Publication Travel & Leisure
Creative Director Pamela Berry
Designer Pamela Berry
Photo Editor Jim Franco
Photographer Martin Morrell
Publisher
American Express Publishing Co.
Issue October 1998
Category Feature Story

■ **322**
Publication Travel & Leisure
Creative Director Pamela Berry
Designer Pamela Berry
Photo Editor Jim Franco
Photographer Magnus Marding
Publisher
American Express Publishing Co.
Issue April 1998
Category Feature Story

groovy!

There's a youthquake going on in the north of England.

Ground zero: Manchester and Liverpool

by philip watson photographed by martin morrell

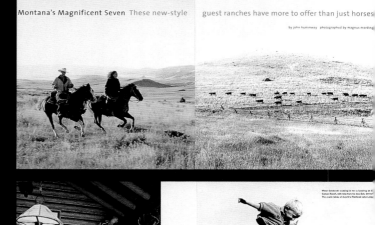

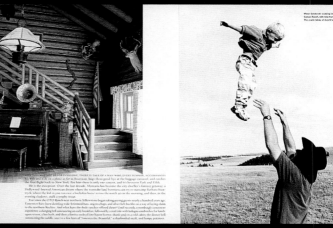

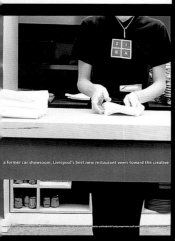

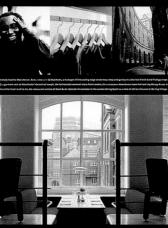

a former car showroom, Liverpool's best new restaurant veers toward the creative

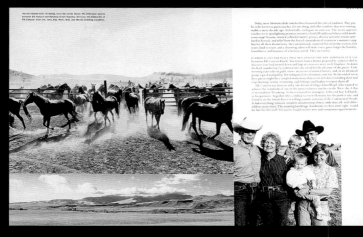

things have changed since the 1980's, when Manchester was known as Gunchester

montana

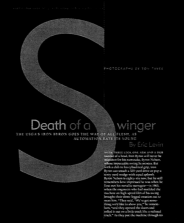

Death of a Swinger

THE USGA'S IRON BYRON GOES THE WAY OF ALL FLESH, AS AUTOMATION EATS ITS YOUNG

By Eric Levin

PHOTOGRAPHS BY TOM PAYNE

It's Too Easy, Being Green

For all that the Masters has done for the game of golf, there is cause to consider what Augusta National has done to the game as well

By Michael M. Thomas

ILLUSTRATIONS BY BRIAN CRONIN

Head Game: The Next Generation

A reissue of the classic Inner Game of Golf reminds us that the golfer's one great perennial, inescapable need: the scapegoat of his inner klutz

BY LEE EISENBERG

CHIPS & PUTTS

Hold This Thought

CHIPS & PUTTS

Hold This Thought

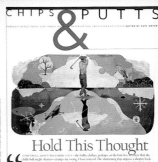

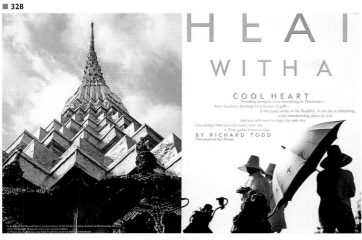

HEAT
WITH A

COOL HEART

Presiding benignly over everything in Thailand—
from business dealings to a round of golf—
is the quiet smile of the Buddha. It can be a refreshing,
even transforming place to visit,
but you will have to cope too with the
knowledge that you will never, ever see
a Thai golfer throw a club.
BY RICHARD TODD
Photographs by Paul Elledge

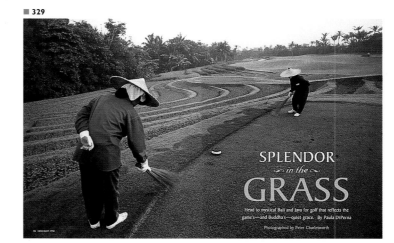

SPLENDOR
in the
GRASS

Head to mystical Bali and Java for golf that reflects the
game's—and Buddha's—quiet grace. By Paula DiPerna
Photographed by Peter Charlesworth

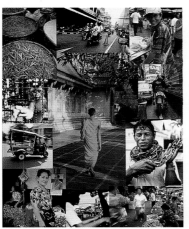

Putt to the Chase
In the market for a putter?
Here's how to get the ball rolling
BY ANDY BRUMER
PHOTOGRAPHY BY CHARLES MASTERS

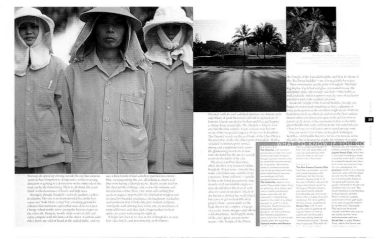

TURN YOUR
SWING AROUND

BY DAVE COLLINS
PHOTOGRAPHY BY GLOBUS BROTHERS STUDIOS

A GREAT **SWING**
IS A RESULT OF
A GREAT **PIVOT**

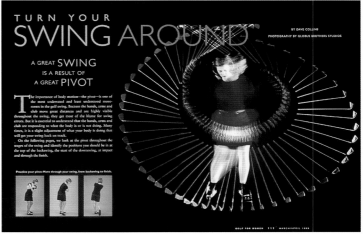

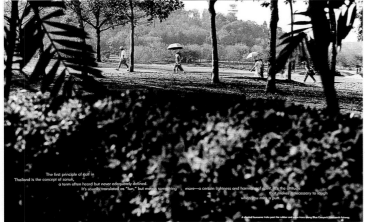

The first principle of golf in
Thailand is the concept of *sanuk*,
a term often heard but never adequately defined.
It's usually translated as "fun," but it means something
more—a certain lightness and harmony of spirit. It's the attitude
that makes it necessary to laugh
when you miss a putt.

■ 328
Publication Travel & Leisure Golf
Design Director Tom Brown
Designer Tom Brown
Photo Editor Sheryl Olson
Photographer Paul Elledge
Publisher
American Express Publishing Co.
Issue May/June 1998
Category Feature Story

■ 329
Publication Turnstile's Golf & Travel
Art Director Nazan Akyavas
Designer Nazan Akyavas
Photo Editor María Millán
Photographer Peter Charlesworth
Publisher Turnstile
Issue June/July 1998
Category Feature Spread

■ 330
Publication Golf for Women
Design Director Ina Saltz
Designer Jill Tashlik
Photographer Charles Masters
Stylist Vicky McGarry
Publisher Meredith Corp.
Issue January/February 1998
Category Feature Spread

■ 331
Publication Golf for Women
Design Director Ina Saltz
Designer Ina Saltz
Photographer Globus Brothers
Publisher Meredith Corp.
Issue April 1998
Category Feature Spread

■ 332

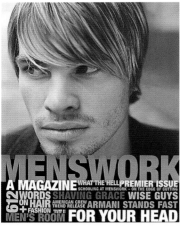

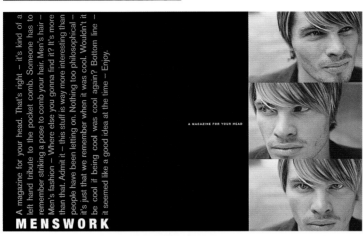

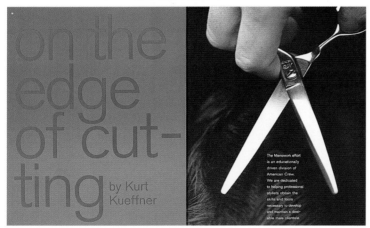

■ 333

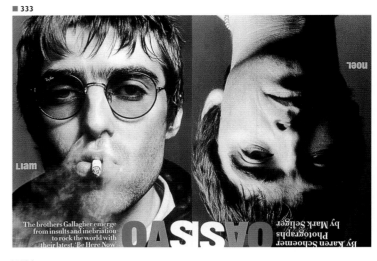

■ 334

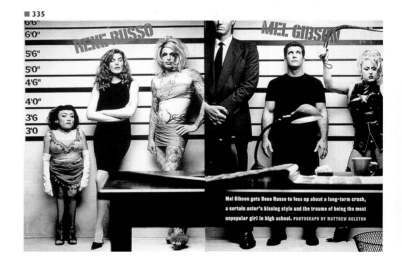

■ 335

■ 332
Publication Menswork Magazine
Creative Director David Raccuglia
Design Director Marcos Chavez
Designer Aimee Sealfon
Photographer David Raccuglia
Studio Liska + Associates, Inc.
Client American Crew
Issue June 1998
Category Entire Issue

■ 333
Publication US
Art Director Richard Baker
Photo Editors Jennifer Crandall,
Rachel Knepfer
Photographer Mark Seliger
Publisher US Magazine Co., L. P.
Issue January 1998
Category Feature Spread

■ 334
Publication US
Art Director Richard Baker
Designer Rina Migliaccio
Photo Editor Jennifer Crandall
Photographer Mark Seliger
Publisher US Magazine Co., L. P.
Issue February 1998
Category Feature Spread

■ 335
Publication US
Art Director Richard Baker
Photo Editor Jennifer Crandall
Photographer Matthew Rolston
Publisher US Magazine Co., L. P.
Issue July 1998
Category Feature Spread

■ 336

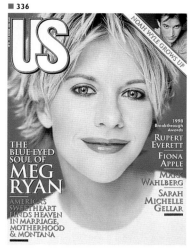

■ 337

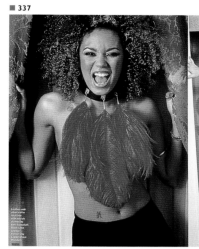 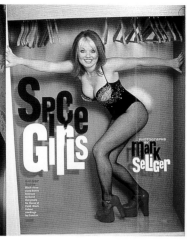

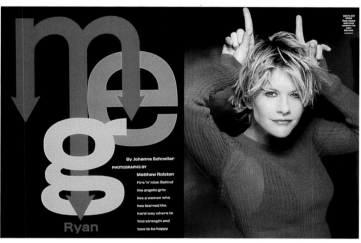

■ 338

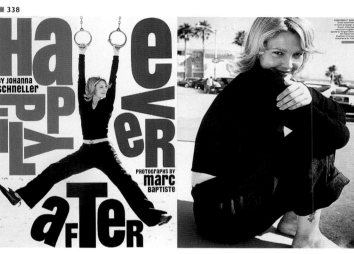

■ 339

SPADE

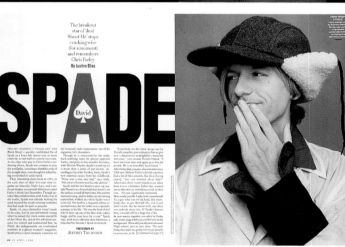

■ 336
Publication US
Art Director Richard Baker
Designer Rina Migliaccio
Photo Editor Jennifer Crandall
Photographer Matthew Rolston,
Jeffrey Thumher, Mark Seliger
Publisher US Magazine Co., L. P.
Issue April 1998
Category Entire Issue

■ 337
Publication US
Art Director Richard Baker
Photo Editor Jennifer Crandall
Photographer Mark Seliger
Publisher US Magazine Co., L. P.
Issue March 1998
Category Feature Spread

■ 338
Publication US
Art Director Richard Baker
Photo Editor Jennifer Crandall
Photographer Marc Baptiste
Publisher US Magazine Co., L. P.
Issue November 1998
Category Feature Spread

■ 339
Publication Vibe
Art Director Dwayne N. Shaw
Photo Editor George Pitts
Photographer Butch Belair
Publisher Vibe/Spin Ventures
Issue June 1998
Category Feature Spread

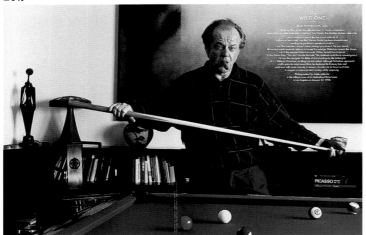

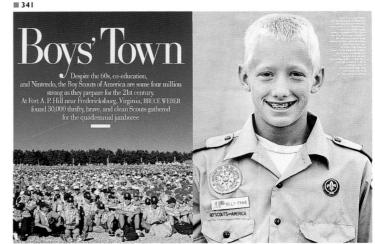

Boys' Town

Despite the 60s, co-education, and Nintendo, the Boy Scouts of America are some four million strong as they prepare for the 21st century. At Fort A. P. Hill near Fredericksburg, Virginia, BRUCE WEBER found 30,000 thrifty, brave, and clean Scouts gathered for the quadrennial jamboree

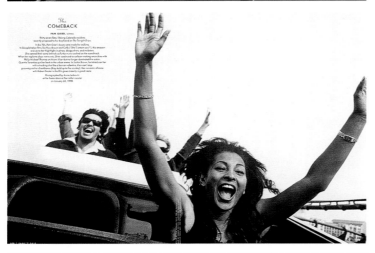

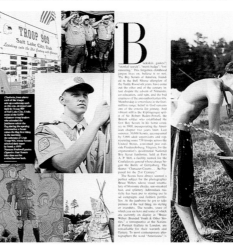

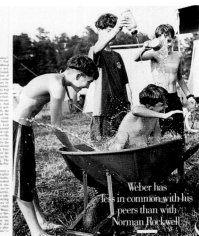

Weber has less in common with his peers than with Norman Rockwell

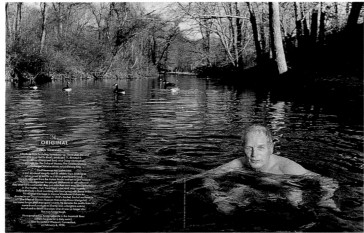

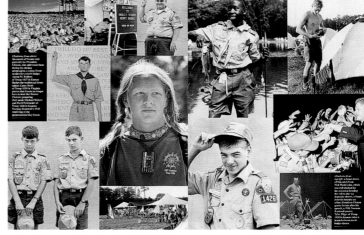

Belief in God remains one of the criteria for joining the Scouts

■ 340

Publication Vanity Fair
Design Director David Harris
Art Director Gregory Mastrianni
Designers David Harris,
Gregory Mastrianni
Photo Editors Susan White,
Lisa Berman
Photographer Annie Leibovitz
Publisher Condé Nast Publications Inc.
Issue April 1998
Category Feature Story

■ 341

Publication Vanity Fair
Design Director David Harris
Art Director Gregory Mastrianni
Designer David Harris
Photo Editors Susan White,
Lisa Berman
Photographer Bruce Weber
Publisher Condé Nast Publications Inc.
Issue February 1998
Category Feature Story

HALL OF FAME
1998
LOOK BACK IN ANGER, IN AWE, IN CELEBRATION: VANITY FAIR INDUCTS
19 MEN AND WOMEN
WHO GAVE THE YEAR ITS EDGE
PHOTOGRAPHS BY ANNIE LEIBOVITZ AND OTHERS • TEXT BY JAMES WOLCOTT

Balanchine's Dream

Starting in 1948, in an odd-couple partnership with wealthy Harvard graduate Lincoln Kirstein, a homeless Russian exile named George Balanchine turned New York, already the capital of the world, into the capital of dance. As the New York City Ballet, the company they founded, turns 50, ROBERT GOTTLIEB, taking a look at it from six different vantage points, traces the tumultuous saga of the 20th century's greatest choreographer and the string of ballerinas, including Maria Tallchief, Allegra Kent, and Suzanne Farrell, through whom Balanchine remade classical ballet, and looks toward the future of his legacy

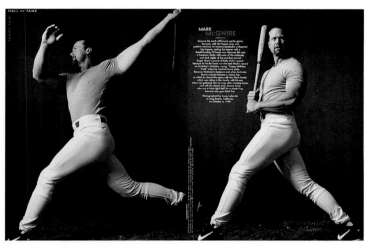

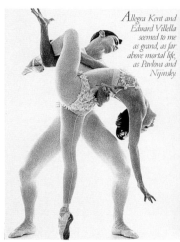

Allegra Kent and Edward Villella seemed to me as grand, as far above mortal life, as Pavlova and Nijinsky

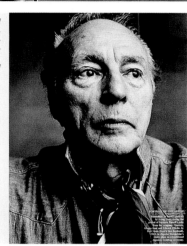

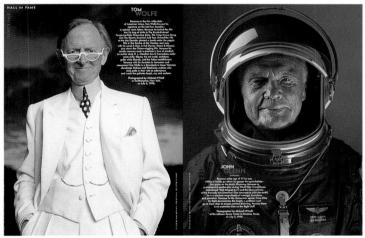

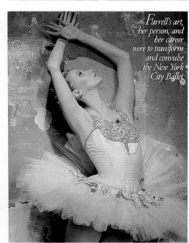

Farrell's art, her person, and her career were to transform and convulse the New York City Ballet

The company is facing a critical moment: the last of Balanchine's dancers are fading away

■ 342
Publication Vanity Fair
Design Director David Harris
Art Director Gregory Mastrianni
Designers Gregory Mastrianni, David Harris
Photo Editors Susan White, Lisa Berman
Photographer Annie Leibovitz, Herb Ritts, Michael O'Neill
Publisher Condé Nast Publications Inc.
Issue December 1998
Category Feature Story

■ 343
Publication Vanity Fair
Design Director David Harris
Art Director Gregory Mastrianni
Designers Gregory Mastrianni, David Harris
Photo Editors Susan White, Lisa Berman
Photographer Bruce Weber
Publisher Condé Nast Publications Inc.
Issue December 1998
Category Feature Story

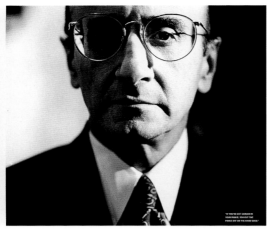

TRADITION BE DAMNED

THE NEW YORK
STOCK EXCHANGE'S
RICHARD GRASSO
IS SO AGGRESSIVE HE HAS
SCARED HIS RIVALS
INTO A PROPOSED MERGER,
AND HE'S JUST GETTING STARTED.
BY STEVE SALERNO
PHOTOGRAPHS BY BRIAN VELENCHENKO

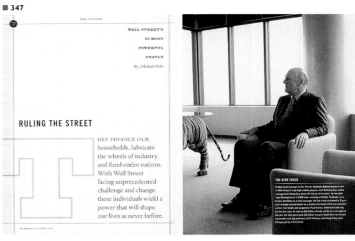

WALL STREET'S
20 MOST
POWERFUL
PEOPLE
By Michael Peltz

RULING THE STREET

THEY FINANCE OUR
households, lubricate
the wheels of industry,
and fund entire nations.
With Wall Street
facing unprecedented
challenge and change,
these individuals wield a
power that will shape
our lives as never before.

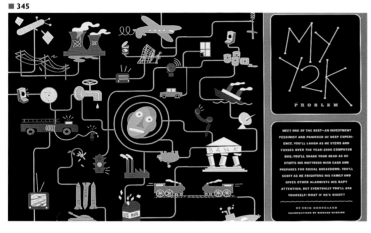

MY Y2K PROBLEM

MEET ONE OF THE BEST—AN INVESTMENT
PESSIMIST AND PANICKER OF DEEP EXPERI-
ENCE. YOU'LL LAUGH AS HE STEWS AND
FUSSES OVER THE YEAR-2000 COMPUTER
BUG. YOU'LL SHAKE YOUR HEAD AS HE
STUFFS HIS MATTRESS WITH CASH AND
PREPARES FOR SOCIAL BREAKDOWN. YOU'LL
SCOFF AS HE FRIGHTENS HIS FAMILY AND
GIVES OTHER ALARMISTS HIS RAPT
ATTENTION. BUT EVENTUALLY YOU'LL ASK
YOURSELF: WHAT IF HE'S RIGHT?

BY ERIK HEDEGAARD
ILLUSTRATION BY RICHARD McGUIRE

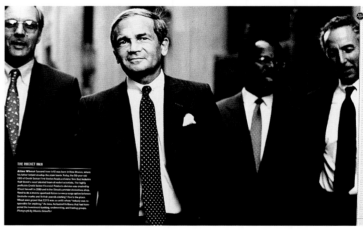

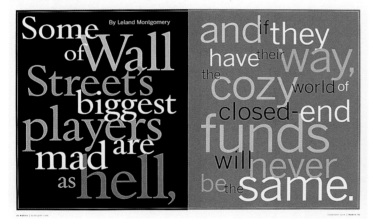

Some of Wall Street's biggest players are mad as hell,

By Leland Montgomery

and if they have their way, the cozy world of closed-end funds will never be the same.

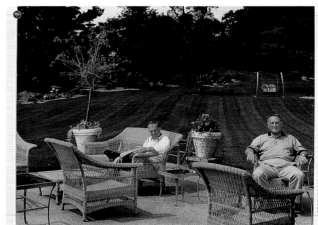

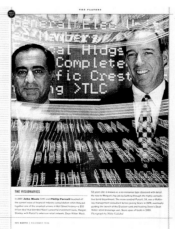

■ 344
Publication Worth
Art Director Philip Bratter
Designer Deanna Lowe
Photo Editor Sabine Meyer
Photographer Brian Velenchenko
Publisher Capital Publishing L. P.
Issue May 1998
Category Feature Spread

■ 345
Publication Worth
Art Director Philip Bratter
Designer Chalkley Calderwood Pratt
Illustrator Richard McGuire
Publisher Capital Publishing L. P.
Issue December 1998
Category Feature Spread

■ 346
Publication Worth
Art Director Philip Bratter
Designer Deanna Lowe
Publisher Capital Publishing L. P.
Issue February 1998
Category Feature Spread

■ 347
Publication Worth
Art Director Philip Bratter
Designer Deanna Lowe
Photo Editor Melanie Osterhout
Photographers Chris Buck,
James Smolka, Larry Fink,
Dana Lixenberg, Robert Maxwell,
John Barrett, Barron Claiborne,
Martin Schoeller, Harry Benson,
Antonin Kratochvil,
Michael O'Neill, Brian Velenchenko,
Nitin Vadukul, David Barry
Publisher Capital Publishing L. P.
Issue November 1998
Category Feature Story

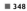

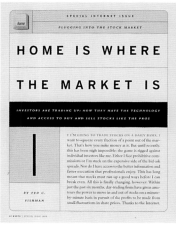

HOME IS WHERE
THE MARKET IS

INVESTORS ARE TRADING UP; NOW THEY HAVE THE TECHNOLOGY
AND ACCESS TO BUY AND SELL STOCKS LIKE THE PROS

BY TED C. FISHMAN

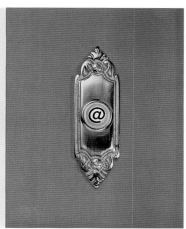

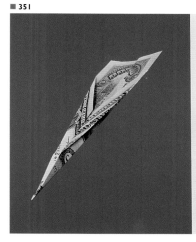

THE FUTURE
OF .INVESTING

A ROUNDTABLE DISCUSSION, CONDUCTED ON THE INTERNET,
WITH SIX PIONEERS OF ONLINE INVESTING

BY JOHN KOTEN

TRADING
PLACES

HERE'S HOW TO FIND AN ELECTRONIC BROKERAGE THAT
WON'T COST YOU MORE THAN YOU BARGAINED FOR

BY ERIC TYSON

A BUYER'S
MARKET

YOU'RE IN COMMAND AT THE NET BAZAAR, WHERE SELLERS
OF PLANE TICKETS AND COMPUTERS BID FOR YOUR BUSINESS

BY BESHMA MEMON YAQUB

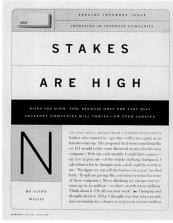

STAKES
ARE HIGH

RISKS ARE HIGH, TOO, BECAUSE ONLY THE VERY BEST
INTERNET COMPANIES WILL THRIVE—OR EVEN SURVIVE

BY CLINT WILLIS

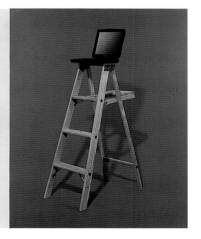

DIVE
RIGHT IN

WE BURNED OUR MIDNIGHT COMPUTER SCREENS EXAMINING
THE BEST WEB SITES FOR INVESTORS. NINE MADE OUR CUT.

BY LELAND MONTGOMERY

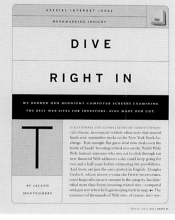

348
Publication Worth
Art Director Philip Bratter
Designers Deanna Lowe, Sarah Garcea
Photo Editor Sabine Meyer
Photographer Steve Wisbauer
Publisher Capital Publishing L. P.
Issue August 1998
Category Feature Spread

349
Publication Worth
Art Director Philip Bratter
Designers Deanna Lowe, Sarah Garcea
Photo Editor Sabine Meyer
Photographer Steve Wisbauer
Publisher Capital Publishing L. P.
Issue August 1998
Category Feature Spread

350
Publication Worth
Art Director Philip Bratter
Designers Deanna Lowe, Sarah Garcea
Photo Editor Sabine Meyer
Photographer Steve Wisbauer
Publisher Capital Publishing L. P.
Issue August 1998
Category Feature Spread

351
Publication Worth
Art Director Philip Bratter
Designers Deanna Lowe, Sarah Garcea
Photo Editor Sabine Meyer
Photographer Steve Wisbauer
Publisher Capital Publishing L. P.
Issue August 1998
Category Feature Spread

352
Publication Worth
Art Director Philip Bratter
Designers Deanna Lowe, Sarah Garcea
Photo Editor Sabine Meyer
Photographer Steve Wisbauer
Publisher Capital Publishing L. P.
Issue August 1998
Category Feature Spread

353
Publication Worth
Art Director Philip Bratter
Designers Deanna Lowe, Sarah Garcea
Photo Editor Sabine Meyer
Photographer Steve Wisbauer
Publisher Capital Publishing L. P.
Issue August 1998
Category Feature Spread

DESIGN MERIT

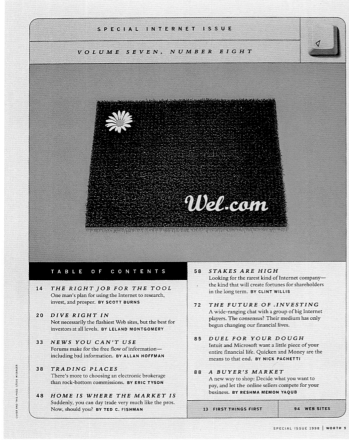

Table of contents shown in image includes:

CENTERING ON HUMILITY

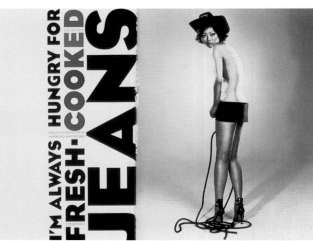

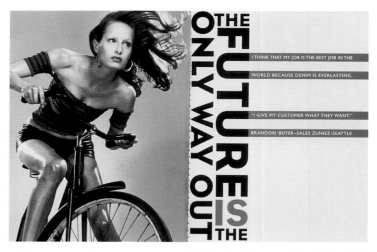

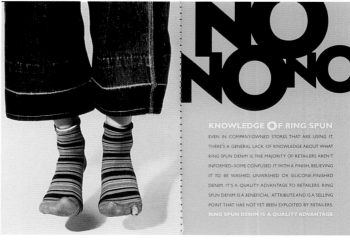

THE FUTURE IS THE ONLY WAY OUT

I THINK THAT MY JOB IS THE BEST JOB IN THE WORLD BECAUSE DENIM IS EVERLASTING.

"I GIVE MY CUSTOMER WHAT THEY WANT."

BRANDON • BUYER–SALES ZUNIEZ • SEATTLE

KNOWLEDGE OF RING SPUN

EVEN IN COMPANY-OWNED STORES THAT ARE USING IT, THERE'S A GENERAL LACK OF KNOWLEDGE ABOUT WHAT RING SPUN DENIM IS. THE MAJORITY OF RETAILERS AREN'T INFORMED—SOME CONFUSED IT WITH A FINISH, BELIEVING IT TO BE WASHED, UNWASHED, OR SILICONE-FINISHED DENIM. IT'S A QUALITY ADVANTAGE TO RETAILERS. RING SPUN DENIM IS A BENEFICIAL ATTRIBUTE AND IS A SELLING POINT THAT HAS NOT YET BEEN EXPLOITED BY RETAILERS. RING SPUN DENIM IS A QUALITY ADVANTAGE

■ 354
Publication Worth
Art Director Philip Bratter
Designers Deanna Lowe, Sarah Garcea
Photo Editor Sabine Meyer
Photographer Steve Wisbauer
Publisher Capital Publishing L. P.
Issue August 1998
Category Contents

■ 355
Publication Clark Memorandum
Art Director David Eliason
Designer David Eliason
Photographer John Snyder
Studio Publications & Graphics
Publisher Brigham Young University
Client J. Reuben Clark Law School
Issue Winter 1998
Category Feature Spread

■ 356
Publication
Cone Denim Trend Book
Creative Director Bridget de Socio
Designers Albert Lin, Jason Endres, Lara Harris
Photo Editors Bridget de Socio, Joshua Jordan
Photographer Joshua Jordan
Studio Socio X
Publisher PBM Graphics
Issue May 25, 1998
Category Entire Issue

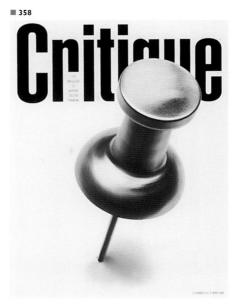

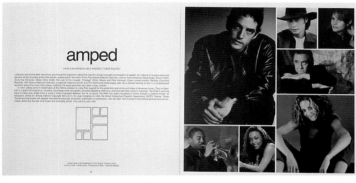

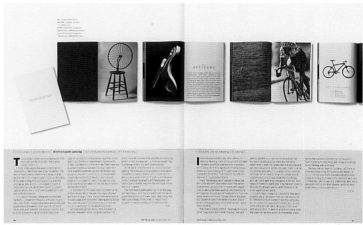

THE NUMBERS

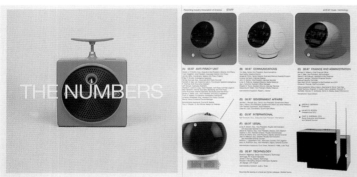

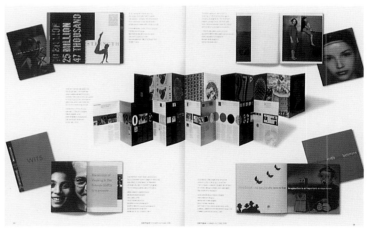

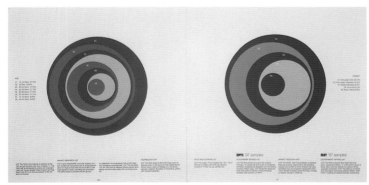

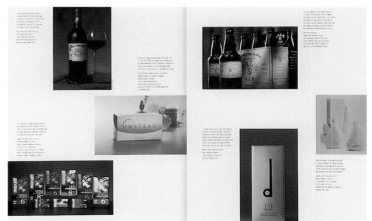

■ 357
Publication AR.97 Techno/Music
Creative Director Neal Ashby
Designer Neal Ashby
Illustrator John Moore
Photographer Mike Northrup
Studio RIAA
Issue May 1998
Category Entire Issue

■ 358
Publication Critique
Creative Director Christopher Chu
Design Director Marty Neumeier
Art Director Heather McDonald
Designers Vinh Chung,
Donna Wan, Chris Willis
Photographer Jeanne Carley
Issue Summer /Autumn1998
Category Entire Issue

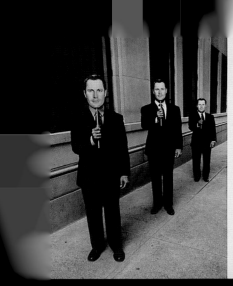

The McDonaldization of Business

ETHiCS

The world struggles toward a global definition of right and wrong.
By Laurie Joan Aron

PHOTOGRAPH BY FREDRIK BRODÊN

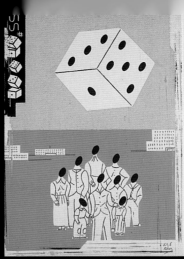

pension reform worth the gamble

is ?

privatization could be a smart bet — or a one-way ticket to palookaville.
BY VANESSA KRUCKER
ILLUSTRATIONS BY BRIAN CRONIN

For as long as companies have

An East-Meets-West
PERSPEC TIVE

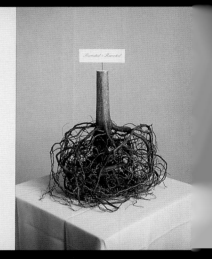

Are We Working for the Same Company

?

Photographs by Fredrik Brodén

Rooted & Riveted

Within multinational corporations, an appearance of global sameness often belies a prejudice of cultural differences.
BY BRUCE PELTON

An interview with
GEOFF MULGAN

ETHICS

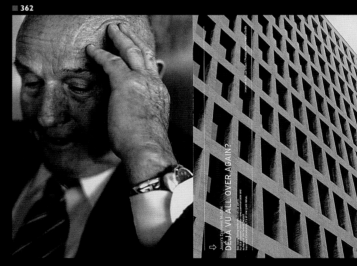

DÉJÀ VU ALL OVER AGAIN?

■ 359
Publication Global
Creative Director Sarah Vinas
Art Director Tom Brown
Designers Sarah Vinas, Tom Brown
Photographer Fredrik Brodén
Publisher Deloitte & Touche
Issue November/December 1998
Categories Feature Story

■ 360
Publication Global
Creative Director Sarah Vinas
Art Director Tom Brown
Designers Tom Brown, Rob Hewitt
Illustrator Brian Cronin
Publisher Deloitte & Touche
Issue November/December 1998
Category Feature Spread

■ 361
Publication Global
Creative Director Sarah Vinas
Art Director Tom Brown
Designer Tom Brown
Photographer Fredrik Brodén
Publisher Deloitte & Touche
Issue July/August 1998
Category Feature Spread

■ 362
Publication Global
Creative Director Sarah Vinas
Art Director Tom Brown
Designer Tom Brown
Photographer Marina Dodis
Publisher Deloitte & Touche
Issue November/December 1998
Category Feature Spread

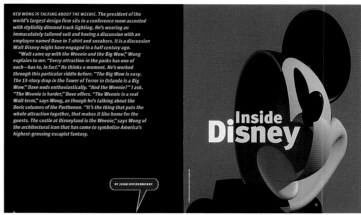

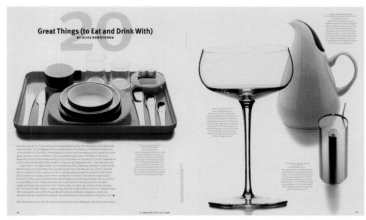

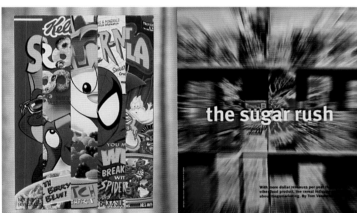

■ 365

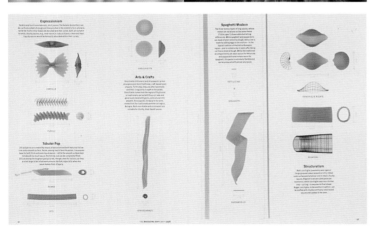

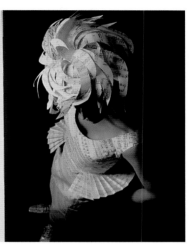

■ 363
Publication I. D.
Design Director Luke Hayman
Designers Miranda Dempster, Darren Ching
Illustrator J. J. Gifford
Photographers Graham MacIndoe, James Wojcik, Mikako Koyama, Davies + Starr, Jay Zuckerkorn, Steve Richter, John Holderer
Publisher F&W Publications
Issue September/October 1998
Category Entire Issue

■ 364
Publication I. D.
Design Director Luke Hayman
Designer Miranda Dempster
Illustrators Antoine Bordier, Lex Curtiss
Publisher F&W Publications
Issue March/April 1998
Category Feature Spread

■ 365
Publication Rough
Designers Liz C. Bulloch, Jeff B. Breazeale
Illustrator Josh Bishop
Photographers Phil Hollenbeck, Danny Hollenbeck, Doug Davis, François Robert
Studio Matchbox Studio
Client Dallas Society of Visual Communications
Issue March 1998
Category Entire Issue

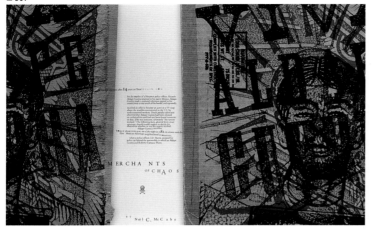

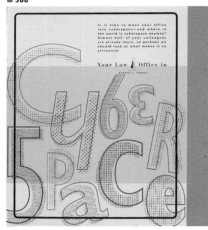

LAW·STANDS
MUTE
IN·THE·MIDST
OF·ARMS
MARCUS CICERO
THE·CENTER·FOR·LEGAL
RESPONSIBILITY
PROVIDES ALTERNATIVE DISPUTE
RESOLUTION
WRITTEN BY MOLLY GLENTZER
ART BY PHILIPPE WEISBECKER

OPTIONS
AUG. 25 - SEPT. 1

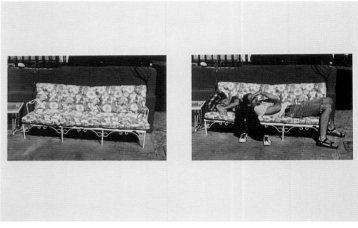

■ 367
Publication Quarterly
Design Director Mark Geer
Designer Mark Geer
Illustrator Larry McEntire
Studio Geer Design, Inc.
Client South Texas College of Law
Issue Fall 1998
Category Feature Spread

■ 368
Publication Quarterly
Design Director Mark Geer
Designer Mark Geer
Illustrator David Plunkert
Studio Geer Design, Inc.
Client South Texas College of Law
Issue Winter 1998
Category Feature Spread

■ 369
Publication Quarterly
Design Director Mark Geer
Art Director Stephanie Birdsong
Designer Jeffrey W. Savage
Illustrator Philippe Weisbecker
Photographer Jack Thompson
Studio Geer Design, Inc.
Client South Texas College of Law
Issue Winter 1998
Category Feature Spread

■ 370
Publication
Mohawk Options Paper Promotion
Creative Director Bill Cahan
Designers Bob Dinetz, Kevin Roberson
Illustrators Bob Dinetz, Kevin Roberson
Photographers Bob Dinetz,
Kevin Roberson
Studio Cahan & Associates
Client Mohawk Paper Mills, Inc.
Issue October 1998
Category Entire Issue

348

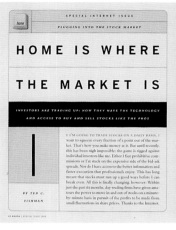

HOME IS WHERE THE MARKET IS

351

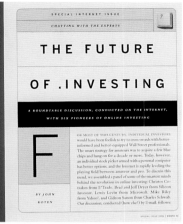

THE FUTURE OF .INVESTING

349

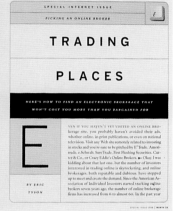

TRADING PLACES

352
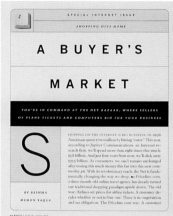

A BUYER'S MARKET

350
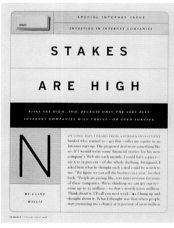

STAKES ARE HIGH

353

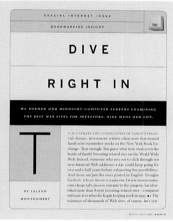

DIVE RIGHT IN

■ 348
Publication Worth
Art Director Philip Bratter
Designers Deanna Lowe, Sarah Garcea
Photo Editor Sabine Meyer
Photographer Steve Wisbauer
Publisher Capital Publishing L. P.
Issue August 1998
Category Feature Spread

■ 349
Publication Worth
Art Director Philip Bratter
Designers Deanna Lowe, Sarah Garcea
Photo Editor Sabine Meyer
Photographer Steve Wisbauer
Publisher Capital Publishing L. P.
Issue August 1998
Category Feature Spread

■ 350
Publication Worth
Art Director Philip Bratter
Designers Deanna Lowe, Sarah Garcea
Photo Editor Sabine Meyer
Photographer Steve Wisbauer
Publisher Capital Publishing L. P.
Issue August 1998
Category Feature Spread

■ 351
Publication Worth
Art Director Philip Bratter
Designers Deanna Lowe, Sarah Garcea
Photo Editor Sabine Meyer
Photographer Steve Wisbauer
Publisher Capital Publishing L. P.
Issue August 1998
Category Feature Spread

■ 352
Publication Worth
Art Director Philip Bratter
Designers Deanna Lowe, Sarah Garcea
Photo Editor Sabine Meyer
Photographer Steve Wisbauer
Publisher Capital Publishing L. P.
Issue August 1998
Category Feature Spread

■ 353
Publication Worth
Art Director Philip Bratter
Designers Deanna Lowe, Sarah Garcea
Photo Editor Sabine Meyer
Photographer Steve Wisbauer
Publisher Capital Publishing L. P.
Issue August 1998
Category Feature Spread

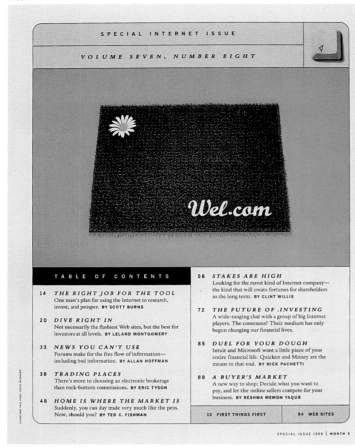

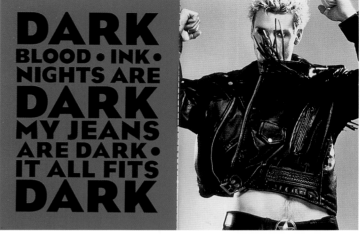

SPECIAL INTERNET ISSUE

VOLUME SEVEN, NUMBER EIGHT

Wel.com

TABLE OF CONTENTS

SPECIAL ISSUE 1998 | WORTH 5

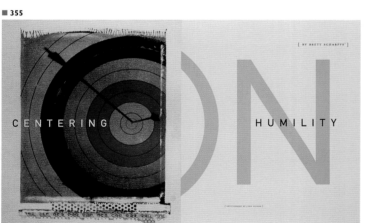

[BY BRETT SCHARFFS]

CENTERING ON HUMILITY

■ 354
Publication Worth
Art Director Philip Bratter
Designers Deanna Lowe,
Sarah Garcea
Photo Editor Sabine Meyer
Photographer Steve Wisbauer
Publisher Capital Publishing L. P.
Issue August 1998
Category Contents

■ 355
Publication Clark Memorandum
Art Director David Eliason
Designer David Eliason
Photographer John Snyder
Studio Publications & Graphics
Publisher Brigham Young University
Client J. Reuben Clark Law School
Issue Winter 1998
Category Feature Spread

■ 356
Publication
Cone Denim Trend Book
Creative Director Bridget de Socio
Designers Albert Lin,
Jason Endres, Lara Harris
Photo Editors Bridget de Socio,
Joshua Jordan
Photographer Joshua Jordan
Studio Socio X
Publisher PBM Graphics
Issue May 25, 1998
Category Entire Issue

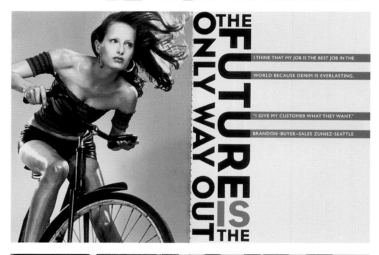

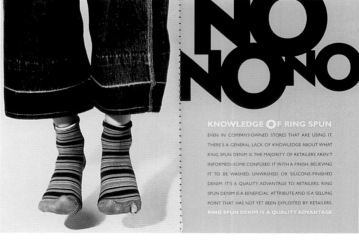

■ 371

■ 372

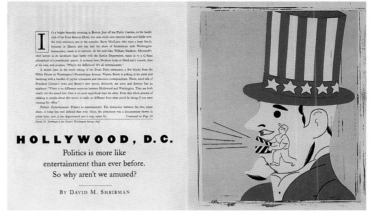

HOLLYWOOD, D.C.

Politics is more like
entertainment than ever before.
So why aren't we amused?

BY DAVID M. SHRIBMAN

■ 373

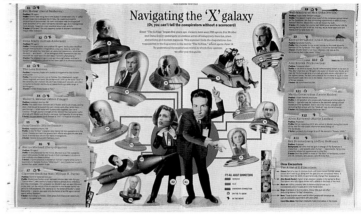

■ 374

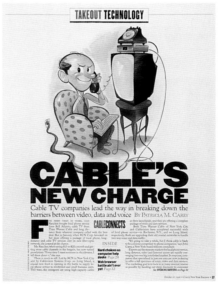

TAKEOUT TECHNOLOGY

CABLE'S NEW CHARGE

Cable TV companies lead the way in breaking down the
barriers between video, data and voice BY PATRICIA M. CAREY

INTERNATIONAL CLIENTELE

CROSS CULTURAL SENSIBILITY

■ 371
Publication
San Francisco Design Solutions
Creative Director Bill Cahan
Designer Kevin Roberson
Illustrator Kevin Roberson
Studio Cahan & Associates
Client Bay Area World Trade Center
Issue July 1998
Category Entire Issue

■ 372
Publication The Boston Globe
Art Director Catherine Aldrich
Designer Catherine Aldrich
Illustrator Brian Cronin
Publisher The Boston Globe
Issue August 9, 1998
Category Feature Spread

■ 373
Publication Chicago Tribune
Design Director Therese Shechter
Art Director Joe Darrow
Illustrator Mike Smith
Publisher Chicago Tribune
Issue June 7, 1998
Category Feature Spread

■ 374
Publication
Crain's New York Business
Art Directors Steven Krupinski,
Edward Levine
Designer Edward Levine
Illustrator Eric Palma
Publisher Crain Communications
Issue October 26, 1998
Category Feature Single Page

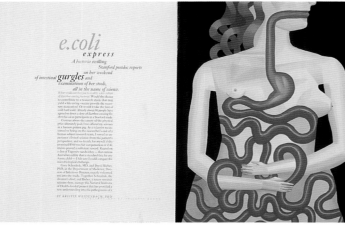
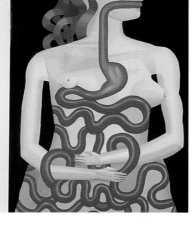

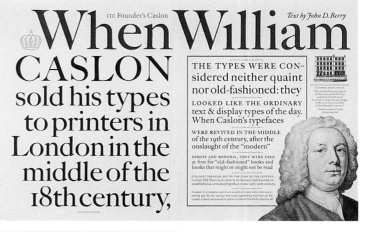

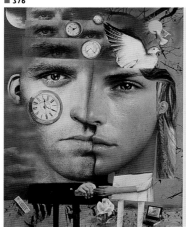

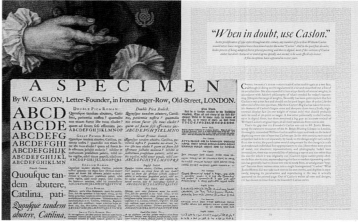

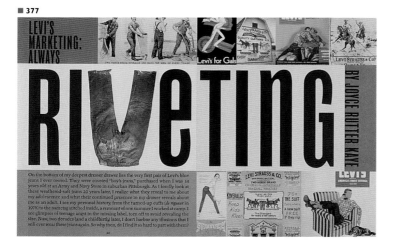

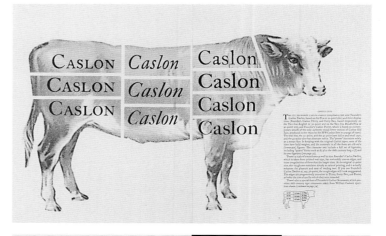

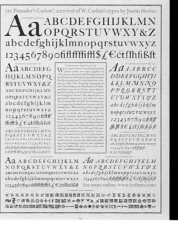

■ 375
Publication Stanford Medicine
Art Director David Armario
Designer David Armario
Illustrator Juliette Borda
Studio David Armario Design
Publisher Stanford Medicine
Issue Spring 1998
Category Feature Spread

■ 376
Publication Stanford Magazine
Art Director Bambi Nicklen
Illustrator Janet Woolley
Publisher
Stanford Alumni Association
Issue January 1998
Category Feature Spread

■ 377
Publication U&lc
Creative Director John D. Berry
Design Director Clive Chiu
Art Director Mark van Bronkhorst
Designer Mark van Bronkhorst
Publisher
International Typeface Corp.
Issue February 23, 1998
Category Feature Spread

■ 378
Publication U&lc
Creative Director John D. Berry
Design Director Clive Chiu
Art Director Mark van Bronkhorst
Designer Mark van Bronkhorst
Publisher
International Typeface Corp.
Issue Winter 1998
Category Feature Story

■ 379
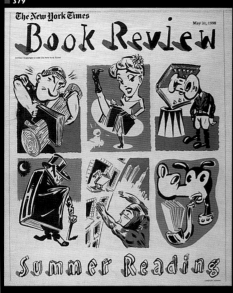
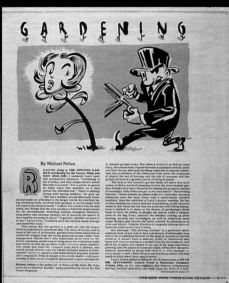
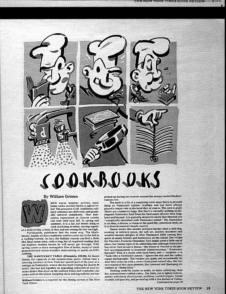

■ 380
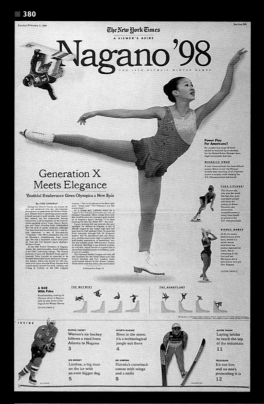
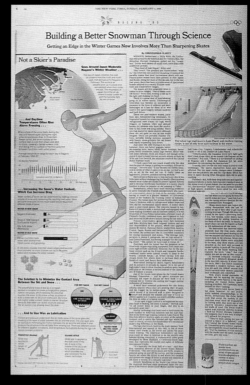
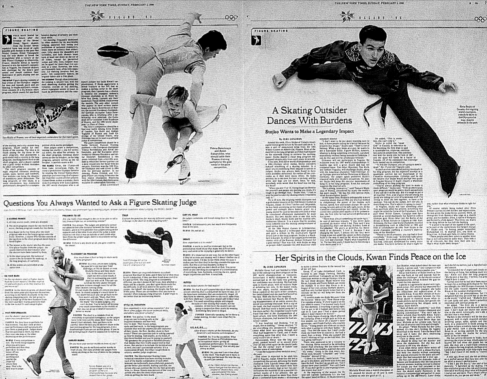

■ 379
Publication The New York Times Book Review
Art Director Steven Heller
Illustrator Christoph Niemann
Publisher The New York Times
Issue May 31, 1998
Category Entire Issue

■ 380
Publication The New York Times
Art Director Wayne Kamidoi
Designer Wayne Kamidoi
Illustrator Frank O'Connell
Graphics Editors Joe Ward, Bedel Saget, Mika Grondahl, Juan Velasco
Publisher The New York Times
Issue February 1, 1998
Category Entire Issue

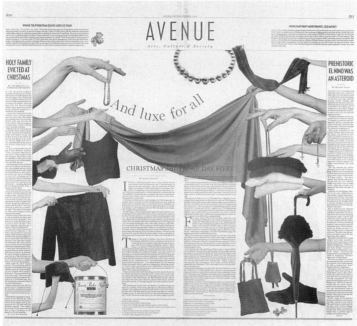

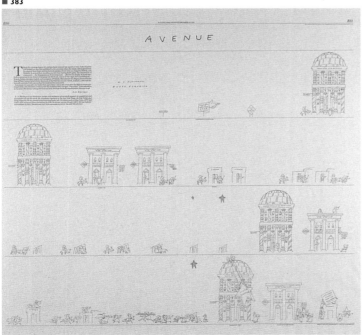

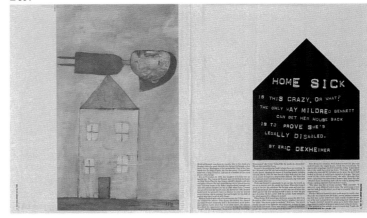

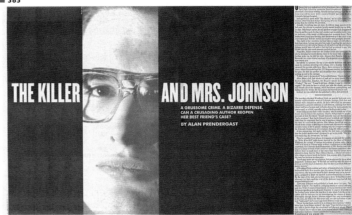

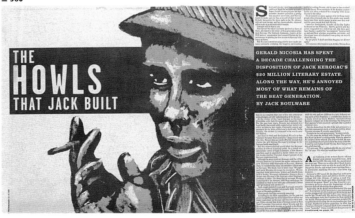

■ 381
Publication The New York Times
Art Director Kevine McFarlin
Illustrator Mika Grondahl
Graphics Editor David Circoran
Publisher The New York Times
Issue January 25, 1998
Category Feature Spread

■ 382
Publication National Post
Creative Director Leanne M. Shapton
Design Directors Lucie Lacava,
Roland-Yves Carignan, Gayle Grin
Designer Leanne M. Shapton
Photographer Hans Deryk
Issue December 11, 1998
Category Feature Spread

■ 383
Publication National Post
Creative Director Leanne M. Shapton
Design Directors Lucie Lacava, Roland-
Yves Carignan, Gayle Grin
Designer Leanne M. Shapton
Illustrator R. O. Blechman
Issue December 24, 1998
Category Feature Spread

■ 384
Publication Westword
Art Director Dana Collins
Designer Dana Collins
Illustrator Jordin Isip
Publisher New Times Inc.
Issue January 22, 1998
Category Feature Spread

■ 385
Publication Westword
Art Director Dana Collins
Designer Dana Collins
Photographer Brett Amole
Publisher New Times Inc.
Issue March 19, 1998
Category Feature Spread

■ 386
Publication Westword
Art Director Dana Collins
Designer Dana Collins
Illustrator Dana Collins
Publisher New Times Inc.
Issue August 13, 1998
Category Feature Spread

online

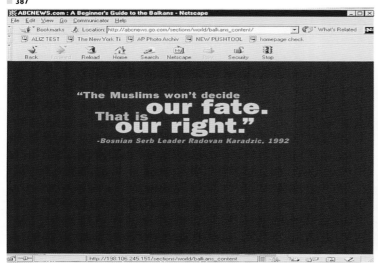

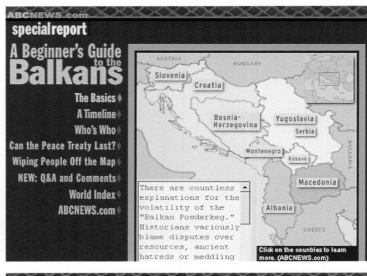

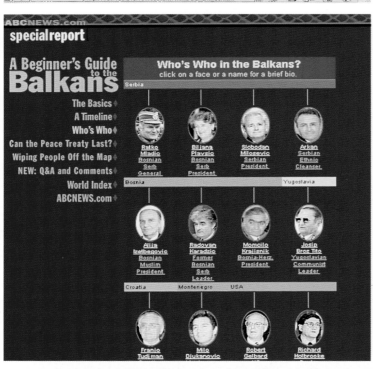

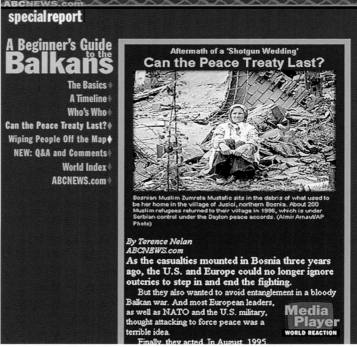

■ 387
Publication ABCNews.com
Creative Director Kate L. Thompson
Art Director Betsy Vardell
Designer Betsy Vardell
Illustrator Mark Bloch
Photo Editor Alizabeth Fritz
Photographer AP
Publisher ABCNews
Online Address http://abcnews.go.com/sections/world/balkans/index.html
Issue August 1998
Category Feature Story

GOLD ONLINE

TIME.com

TIME.com Home
TIME Daily
From TIME Magazine
Web Features
TIME Digital
Breaking News
Boards & Chat
Magazine Archives

Search TIME magazine and TIME.com.
[Go]

Subscribe to TIME
Subscriber Services
Bookmark TIME.com

PATHFINDER
20 TOP NEWS SITES

SEARCH:
[Go]

FORTUNE.com
> How Can You Turn a Department Around?

MONEY.com
> Bulls Fall Short Of Goal Line

PEOPLE.com
> Tom Cruise Protects Kubrick

ASK DR. WEIL.com
> Overeating in Your Sleep?

ENTERTAINMENT WEEKLY.com
> Sandra Bullock Talks About Love

MORE:
[CNN]

• marketplace •

Giftfinder:
Click here to shop

timedaily
What the News Means Today

Web-only news
Monday, Mar. 15, 1999

top features

Talks Progress, But No Peace for Unyielding Kosovo

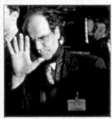

Western-sponsored negotiations resume without optimism. What will NATO do if they fail? FULL STORY >>

Kosovar Albanian delegation leader Ibrahim Rugova.

Kurds Threaten Turkish Tourism
A new wave of terror attacks confirms that Abdullah Ocalan's capture hasn't resolved the conflict | special

Is the New Abortion Clinic Bomb a Rudolph Message?
A North Carolina abortion clinic attack suggests the Olympic bomb fugitive may be feeling lucky | special

Hillary's Encounter With a Runaway Snow Bunny
Turns out the First Lady really did hurt her back

Another Cuomo Playing Hard to Get
Will Andrew rethink a run at the New York Senate?

The Prisoner and the Academy
With his movie about Louisiana's Angola prison, convict-journalist Wilbert Rideau has a life sentence and an Oscar nod

Winner & Loser of the Day
Boxing takes a hit, and "don't ask, don't tell" claims more casualties

Discuss the Hunt for Eric Robert Rudolph

time digital
TIME Digital's Y2K Central offers a comprehensive overview of the millennium bug and how it relates to you. MORE >>

time asia
One Man's Tiananmen: Blending animation and art, Wang Shuibo tells his life story in an Oscar-nominated short film. MORE >>

editions
TIME ASIA
TIME FOR KIDS
TIME INTERNATIONAL

AFTERNOON UPDATE
Subscribe to Afternoon Update from TIME.com. It's a free, two-page digest of the day's news that prints directly to your printer.

Cover Story

Gates Rules
Excerpt from his new book, and our update on the trial

Dole 2000
Is she a liberal?

The Bombers' Club
McVeigh and Kaczynski, hanging with Yousef

Cybercrime
Think your e-mail is secure? Ha!

Joel Stein on Hugh Hefner
Getting along with Viagra and his new girlfriend (twin sisters)

TIME.com — magazine

March 22, 1999 Vol. 153 No. 11

TIME.com Home
TIME Daily
From TIME Magazine
Web Features
TIME Digital
Breaking News
Boards & Chat
Magazine Archives

Search TIME magazine and TIME.com.
[Go]

Subscribe to TIME
Subscriber Services
Bookmark TIME.com

PATHFINDER
20 TOP NEWS SITES

SEARCH:
[Go]

FORTUNE.com
> How Can You Turn a Department Around?

MONEY.com
> Bulls Fall Short Of Goal Line

PEOPLE.com
> Tom Cruise Protects Kubrick

ASK DR. WEIL.com
> Overeating in Your Sleep?

C O V E R

Bill Gates Rules: In an excerpt from a new book, he spells out how the digital revolution will continue to transform our work and our life

The Trial: Two faces of Bill Gates

Lobbying: Microsoft gets cozy with the Republicans

N A T I O N
SUBURBS: The Un-Sprawling of America -- The endless elasticity of suburbia is now a hot political issue

ESPIONAGE: The Big Nuclear Giveaway -- Why weren't more alarms sounded over a China spy scandal?

The Suspect: A gardener and a good neighbor

CAMPAIGN 2000: Liddy Dole, Closet Liberal? -- The candidate may not identify with issues, but her staff does

Forbes: Hey, big spender!

PRISONS: The Talk of Murderers' Row -- Chatting up America's most dangerous criminals

TIME SELECT
BUSINESS: Superconnected -- How to turn your home into an electronic nerve center

NOTEBOOK, ETC.
JOEL STEIN visits Hugh Hefner's pad

B U S I N E S S
CORPORATIONS: It's a Dirty Job -- The FBI is cracking down, but corporate spies are still busy

Cybercrime: Suits learn to beat hackers at their own game

OIL: Once more, with Feeling -- OPEC again tries to cut production in order to boost prices

S O C I E T Y & S C I E N C E
TECHNOLOGY: Sorry, No Web for You! -- The peril facing towns that lack high-speed Internet access

P E R S O N A L T I M E
YOUR HEALTH: Christine Gorman on cellulite

Good News, Bad News

YOUR MONEY: James J. Cramer on risk

YOUR TECHNOLOGY: Anita Hamilton on electronic greetings

Bytes

For the full content of this week's issue, check out the magazine archive next weekend.

TIME.com — timedaily
What the News Means Today

Web-only news
Monday, Mar. 15, 1999

TIME.com Home
TIME Daily
From TIME Magazine
Web Features
TIME Digital
Breaking News
Boards & Chat
Magazine Archives

Search TIME magazine and TIME.com.
[Go]

Subscribe to TIME
Subscriber Services
Bookmark TIME.com

PATHFINDER
20 TOP NEWS SITES

SEARCH:
[Go]

FORTUNE.com
> How Can You Turn a Department Around?

MONEY.com
> Bulls Fall Short Of Goal Line

PEOPLE.com
> Tom Cruise Protects Kubrick

ASK DR. WEIL.com
> Overeating in Your Sleep?

ENTERTAINMENT WEEKLY.com
> Sandra Bullock Talks About Love

MORE:
[CNN]

• marketplace •

Giftfinder:
Click here to shop

Is the New Abortion Clinic Bomb a Rudolph Message?

A North Carolina abortion clinic attack suggests the Olympic bomb fugitive may be feeling lucky

Police in Asheville, N.C. block off a road leading to the bombed abortion clinic.

Is Eric Robert Rudolph taunting the feds? That question was simply irresistible after an explosion Sunday at a North Carolina abortion clinic in Asheville, N.C., near Rudolph's presumed hideout in the Nantahala National Forest. "It's certainly possible because it's in his neighborhood, it's an abortion clinic and it's his modus operandi -- although at this stage it's all speculation," says TIME Atlanta bureau chief Sylvester Monroe. "Not for long, though -- the feds recovered enough forensic evidence to determine quickly whether this was Rudolph's handiwork."

RUDOLPH ON THE RUN SPECIAL REPORT CLICK HERE

Rudolph, who is wanted for bomb attacks on an Alabama abortion clinic and on the Atlanta Olympic games has been on the run for 14 months. "If indeed he's still in the area, he's unlikely to be hiding alone in the woods," says Monroe. "It's more likely that he's being hidden, warm and safe and watching cable TV somewhere." Rudolph may be wanted for killer bomb attacks, but he remains something of a local hero in a community that has little enthusiasm for federal agents. And if the Asheville bomb bears his forensic "fingerprints," they'll hint that a year on the lam has left him feeling pretty lucky. Discuss the issues >>

— TONY KARON

NEXT STORY >>

RELATED STORIES:
Damage, No Injuries in N.C. Clinic Blast
-Reuters Newswire

Fugitive Faces Olympic Bomb Charges
-TIME Daily

SPECIAL:
Rudolph On the Run

WRITE TO US

editions
TIME ASIA | TIME FOR KIDS | TIME INTERNATIONAL

more STORIES

Talks Progress, but No Peace for Unyielding Kosovo
Western-sponsored negotiations resume without optimism. What will NATO do if they fail

Gephardt Says He's Backing Gore for President
With each man eyeing a prize of his political career, the House minority leader and the vice president make up

Kurds Threaten Turkish Tourism
A new wave of terror attacks confirms that Abdullah Ocalan's capture hasn't resolved the conflict

Star Wars Revisited
Senators push for national missile defense system

Is the New Abortion Clinic Bomb a Rudolph Message?
A North Carolina abortion clinic attack suggests it's Olympic bomb fugitive may be feeling lucky

Hillary's Encounter With a Runaway Snow Bunny
Turns out the First Lady really did hurt her back

Another Cuomo Playing Hard to Get
Will Andrew rethink a run at the New York Senate?

The Prisoner and the Academy
With his movie about Louisiana's Angola prison, convict-journalist Wilbert Rideau has a life sentence and an Oscar nod

TIME.com — web features
only online

TIME.com Home
TIME Daily
From TIME Magazine
Web Features
TIME Digital
Breaking News
Boards & Chat
Magazine Archives

Search TIME magazine and TIME.com.
[Go]

Subscribe to TIME
Subscriber Services
Bookmark TIME.com

PATHFINDER
20 TOP NEWS SITES

SEARCH:
[Go]

FORTUNE.com
> How Can You Turn a Department Around?

MONEY.com
> Bulls Fall Short Of Goal Line

PEOPLE.com
> Tom Cruise Protects Kubrick

ASK DR. WEIL.com
> Overeating in Your Sleep?

ENTERTAINMENT WEEKLY.com
> Sandra Bullock

TIME 100
Profiling the most important 100 people of the 20th century. Check out Builders & Titans, Artists & Entertainers, and Leaders & Revolutionaries. Still to come: Scientists & Thinkers and Heroes & Inspirations. The TIME 100 culminates with the selection of Person of the Century

Visions of Europe
With the January 1999 launch of the European Monetary Union, profound changes are coming

Millennium
The countdown is on! Catch up with the Y2K bug and review the 100 most important events of the last 1,000 years

Target: Microsoft
Federal Antitrust action against Microsoft is exposing both raw nerves and profound issues

RECENT WEB FEATURES
Men of the Year
Bill Clinton and Kenneth Starr are TIME's 1998 Men of the Year. Plus, check out our Man of the Year archives

Heroes for the Planet
Our two-year series profiles people doing extraordinary things for the environment

1998 Technology Buyer's Guide
A Web supplement to TIME magazine's

The President on Trial
News, analysis, documents, polls and more

Space
Our celestial vault of information about the exploration of space. Check out our virtual vault of the Johnson Space Center in QTVR

World Cup '98

388

Publication TIME.com
Design Director Ronnie Peters
Art Director Melanie McLaughlin
Photo Editors Christina Holovach, Melissa Ciano
Publisher Time Inc. New Media
Online Address http://www.pathfinder.com/time/
Issue August 1999

 miked

3/18/99

Hey you miked,
Let's face it, Bolt is really the thinking people's page: Bolt reporter, all the intellectual pages, the poetry slam and religion boards. If you are a teenager who wants to talk to other intelligent teenagers, then this is the place to be! (Of course, there's also chat, coolhunting and misc.boards...)

Cya!,
lintilla

- idcard
- signout
- boards
- notes 14 total
- zap
- members amigos
- chat
- pages edit
- email
- polls
- cards

horoscopes

ava16 my secret

COLLEGE
College Diaries, applesauce

REPORTER
This Week's Hero: Terry Fox

Quote of the Day
Ska Addict . . . Hey, what can I say? Even my dad likes it.....sorta.—Angelgirl182 go

Search!
Optometrists Search

Welcome to Freevibe! Come in, take a look around, learn a little something, have some fun and let us know what you think.

Freevibe

welcome

- home
- heads up
- shout out
- hangtime
- contact us

did you know?

25% of 8th graders say they have been drunk at least once. 75% say they haven't. What do you say?
more...

heads up
Get the skinny on drugs. What are the facts? What's just hype? Why do people take 'em? How can I say no? What's the latest word?

SEARCH OUR DATABASE

Name a drug, ask a question, get the facts. Medical, emotional and social information here.

shout out
Limber up your typing fingers... it's your turn to talk about drugs. Hear some stories, tell your own, post on our boards, make some friends and answer our polls.

THIS WEEK'S QUOTE

You have to say no right up front...if you say "maybe" or "just this once" then you'll feel weak and start saying "Yes" all the time.
more

hangtime
Enough about drugs. Find out what's up in Hollywood, what's new at the movies, what's hot at the music store. Oh, and play some games.

WHAT'S NEW

Come exercise your brain, and your fingers, with our kickbutt games!

389
Publication Bolt
Art Director Hafeez Raji
Designers Hafeez Raji, Michael Merril, Liz Welchman
Publisher Bolt Media Inc.
Online Address http://www.bolt.com

390
Publication Freevibe
Design Director Liza Pagano
Designer Will Hadley
Studio Concrete Media Inc.
Client ABC

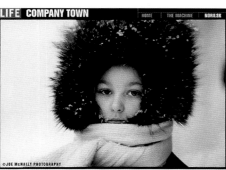

COMPANY TOWN
NORILSK, RUSSIA

PHOTOGRAPHY BY JOE McNALLY

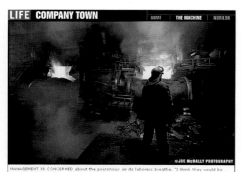

©JOE McNALLY PHOTOGRAPHY

THIS NORILSK SCHOOL GIRL LIVES under a harsh form of Russian "capitalism." In 1995 the residents of Norilsk became an investment for Vladimir Potanin. Potanin, 37, head of the United Export-Import Bank (UNEXIM Bank), and singled out by Business Week as "the most powerful businessman in modern Russia," acquired a controlling share in Norilsk Nickel for his bank, then put forth a management plan to place the company on more solid financial ground. So far, like the permafrost supporting Norilsk, a 6.6 trillion-ruble bill for back taxes and debts presents a formidable obstacle to change.

LIFE COMPANY TOWN HOME | THE MACHINE | NORILSK

©JOE McNALLY PHOTOGRAPHY

MANAGEMENT IS CONCERNED about the poisonous air its laborers breathe. "I think they would be very pleased to catch up with western standards," says mining industry specialist Doug Upton. "After all, they live there." But before Norilsk Nickel can invest in modernization, it must pick up the tab for 3,000 federally-owned social, cultural and municipal facilities with a combined cost of 15 billion, reports the Interfax news agency. The company actually supports three other and several communities with a total population of over 300,000. For the social services alone, Norilsk Nickel recently bestowed a deal with the municipal government to pay $150 million. "As you maybe know, now there is new government," wrote Norilsk Nickel's press secretary, Anatoly Korivakov, in an e-mail to LIFE Online. "At this moment Norilsk Nickel is still paying for the workers' social services and government is not in position to help pay."

THE BEATLES!

ESSAY / PHOTO GALLERY / QUIZ / RECORD GUIDE

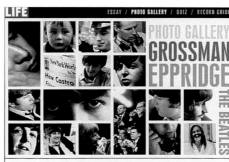

PLACES WE REMEMBER

PHOTO GALLERY
Photographers Henry Grossman (pictured above, right, Ringo Starr was behind the camera) and Bill Eppridge bring the Beatles to LIFE online.

QUIZ
How well do you know the Beatles?

RECORD GUIDE
A complete list of recordings from "I Want to Hold Your Hand" to "The Long and Winding Road"

YOU SAY YOU'VE GOT A REAL CONCLUSION
Beatles producer George Martin helps answer the question: Just how good were the Beatles?
By Charles Hirshberg

FROM THE ARCHIVES
LIFE: August 8, 1964
A Disaster? Well, not exactly

TIME: September 22, 1967
The Messengers

LIFE: April 16, 1971
Paul McCartney talks about the Beatle breakup

LETTERS
Readers' mail and memories

NAME THAT TUNE 123456789
Click above to listen, then check you're answers 1/2/3/4/5/6/7/8/9

LIFE ESSAY / PHOTO GALLERY / QUIZ / RECORD GUIDE

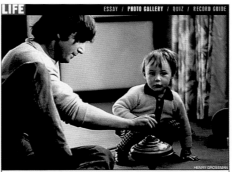

PHOTO GALLERY
GROSSMAN
EPPRIDGE
THE BEATLES

TWO WORLD-FAMOUS LENSMEN describe the incomparable experience of photographing the Fab Four. Bill Eppridge shadowed them on their first tour of America and Henry Grossman was there at the catastrophic moment when they learned of the death of their beloved manager, Brian Epstein. The result is two very different views of the ever-changing geniuses of rock.

the beatles

LIFE ESSAY / PHOTO GALLERY / QUIZ / RECORD GUIDE

GROSSMAN WAS ONE OF A VERY FEW PHOTOGRAPHERS allowed to photograph the Beatles at home. When Brian Epstein heard he'd taken a slew of intimate shots, he called Grossman in a panic and begged him not to use them. "I think he didn't want pictures of George and Paul with their girlfriends," says Grossman today. "He wanted them to appear 'available' to their fans." But when Epstein actually saw the pictures -- which included this snapshot of John and Julian -- he immediately sent Grossman a cable. "Please disregard the telephone call," it read. "I've just seen the pictures. May I have a set?"

HENRY GROSSMAN

LIFE ESSAY / PHOTO GALLERY / QUIZ / RECORD GUIDE

PLACES WE REMEMBER: A BEATLES ALBUM

YOU SAY YOU'VE GOT A REAL CONCLUSION

AS BEATLE PRODUCER GEORGE MARTIN SAYS FAREWELL, HE ANSWERS THE UNANSWERABLE QUESTION: JUST HOW GOOD WERE THE BEATLES ANYWAY? BY CHARLES HIRSHBERG

"I DID IT!" SCREECHES JIM CARREY as he finishes singing "I Am the Walrus." "I defiled a timeless piece of art! For my next trick, I will paint a clown face on the Mona Lisa while using the Shroud of Turin as a drop cloth."

Actually, Carrey does a pretty nice job of singing the song on George Martin's new CD, "In My Life." Martin, of course, is the maestro who produced all of the Beatles albums, except for the execrable "Let It Be," which John Lennon later called "the shittiest load of badly recorded shit." "In My Life" is Martin's final bow: He's retiring after nearly 50 years in the music business and thought it would be fun to say good-bye with a collection of his favorite Beatles songs, sung and played by his "friends and heroes," including Phil Collins, Robin Williams, Bobby McFerrin, Jeff Beck, Celine Dion, Goldie Hawn and Carrey. (A documentary on the making of the album will air on the Bravo network November 12, 9 p.m./ET, 10 p.m./PT.) It's not the greatest album ever made, but it -- and the venerable Martin's retirement -- do raise an interesting question: Just how good is Beatles music?

NEXT >>

LIFE Letters:
Send us your memories of the Beatles! Whether you first heard them on a transistor radio or you're Paul's age or Hanson's, whether you went to a Beatles concert or only wish you'd been around to try: If you love the Beatles, we want to hear your stories about what their music means to you. Do you have a favorite Beatle? Have you ever seen any of them perform? How has their music affected you?
Our editors will pick the best of your letters and excerpt them in a page on this site written by you and other Beatles fans.
Letters submitted to LIFE Online become the property of Time Inc. and may be used for publication online or in print.

PHOTOGRAPHER BILL EPPRIDGE captured the audience at a Beatles concert in Washington D.C. in February, 1964. The concert was played under trying circumstances: The stage was placed in the middle of the Coliseum, with the audience surrounding it on all four sides. Every 15 minutes, the band had to be rotated 45 degrees, so that everyone would have a chance to see their faces. And yet, no one complained. "I wasn't that mystical in those days," recalls Eppridge, "but even I was reacting to the music -- it was so fresh and different, but mostly, I was looking back at the crowd of kids, so alive, so ecstatic -- some almost to the point of orgasm. There were older folks in the audience, as well. 'Oh, do you like them too, sir?' a teenage girl asked a middle-aged man who was up on his feet, screaming, 'Yes,' replied George Martin. 'I do rather.'

More images and stories from the road in the Photo Gallery.

the beatles

"A GIANT LEAP FOR MANKIND"

RUSSIA WAS FIRST
ROCKET SCIENCE
MEN OF MERCURY
SPACE WALK
TRAGEDY
TO THE MOON AND BACK
LIFE PLANETARIUM

LIFE

Sputnik sent back the first signals from the cosmos and the space race was on. From the archives of LIFE comes one of the most momentous chapters in the Cold War and "a giant leap for mankind."

Editor: Seth Goddard
Art Direction & Design: Carlos Pisco
Producer: Elizabeth Owen
Photo Research: Neal Jackson
Photo Production: Mary Ann Koopman

"A GIANT LEAP FOR MANKIND" A HERO'S JOURNEY | IMPACT ON WASHINGTON | U.S. SPACE FUTURE | EDITORIAL

RUSSIA WAS FIRST
ROCKET SCIENCE
MEN OF MERCURY
SPACE WALK
TRAGEDY
TO THE MOON AND BACK
LIFE PLANETARIUM
LIFE HOMEPAGE

СССР-75М

SOVIET TRAVELER RETURNS FROM OUT OF THIS WORLD

The medieval mind held man to be a fallen angel. Remembering heaven, he sometimes struggled back toward radiant heights of wisdom and beauty. But, frustrated at being earthbound, he continually fouls the world with anger, and devilish war. This week there two contradictory faces of man loomed dramatically behind the solitary progress of the world's newest hero, Major Yuri Gagarin, as he paced alone a red carpet leading to the triumphal reception which Moscow had prepared him.

From Russia, where for centuries freedom has been a mockery, this man had been hurled, briefly free of earth, into the high airlessness of space. In about as long as it might take an average American family to down a Thanksgiving dinner, he had circled the globe in a giant capsule and come safely back.

"A GIANT LEAP FOR MANKIND" INTRODUCTION | IN THEIR OWN WORDS | GLENN'S FIRST FLIGHT COOPER SCHIRRA GLENN GRISSOM SHEPARD CARPENTER SLAYTON

RUSSIA WAS FIRST
ROCKET SCIENCE
MEN OF MERCURY
SPACE WALK
TRAGEDY
TO THE MOON AND BACK
LIFE PLANETARIUM
LIFE HOMEPAGE

"THIS IS GOING TO BE ONE HELL OF A THRILL"

BY DONALD SLAYTON

I figure that until Project Mercury came along, I had the best job a military pilot could have. I'd been in on the testing of high performance jet aircraft for three years, and it was exciting and rewarding work. You're always evaluating your vehicle, you're always running into things that nobody's written the book on yet. This situation can come unstuck right now, and you have to learn to think and act in one motion. If you think you're in trouble and you're not, you can get yourself in a serious mess very quickly. And sometimes in a real jam you have to ride it a way and work it out by plain old trial-and-error.

HOW HE WILL RIDE CAPSULE is demonstrated in double-exposure photograph of Donald Slayton using training device called an Air Bearing Orbital Attitude Simulator. Lying on his back, Slayton rides perfectly flat (side view), then tilts chair upward as he faces camera. He would use the same principle in orbital flight to revolve or tilt the capsule to keep it in the proper "attitude" or position as it moves through space. Using the same hand motions to control the yaw, pitch and roll of the capsule demonstrated earlier by Gordon Cooper, Slayton activates tiny jet at nozzles in control box near his right hand to make the simulator rotate or tilt. His fiber glass contour couch is mounted on top of the simulator which rest on cushion of air rather than metal bearings to diminish friction. Large lens like one under Slayton's feet (far left) will be connected with periscope in the capsule to show him the capsule's attitude in relation to the earth. During the training period the lens reflects horizon maps of the earth so he can practice maintaining correct attitude. Each Astronaut must spend a total of about 50 hours in this simulator to get used to the feel of guiding himself through space flat on his back and driving with one hand.

■ 391
Publication LIFE Online
Art Director Seth Goddard
Designer Uzi Halimum
Photo Editor Seth Goddard
Photographer Joe McNally
Publisher Time Inc. New Media
Online Address http://www.lifemag.com/essay/norilsk
Issue September 24, 1998
Category Feature Story

■ 392
Publication LIFE Online
Art Director Melanie McLaughlin
Designer Seth Goddard
Photo Editors Melissa Ciano, Seth Goddard
Photographers Bill Eppridge, Henry Grossman
Publisher Time Inc. New Media
Online Address http://www.pathfinder.com/life/thebeatles/
Issue November 1, 1998
Category Feature Story

■ 393
Publication LIFE Online
Art Director Carlos Pisco
Designer Carlos Pisco
Photo Editor Seth Goddard
Photographers Ralph Morse, Don Uhrbrock, James Whitmore, NASA
Publisher Time Inc. New Media
Online Address
http://www.pathfinder.com/Life/space/giantleap
Issue April 1, 1998
Category Feature Story

V iagra calls: My date with the wonder drug

SALON
------- SEXPERT
OPINION

TheCentury

March 22, 1999

HOME
TIME CAPSULE
STORIES
VIDEO MOMENTS
TIMELINES
TV SERIES
CLASSROOM

SEARCH
ABOUT US
CONTACT US
CENTURY STORE
ABCNEWS.COM
ABC.COM

REGISTER
MAKE US YOUR
HOMEPAGE

HOW TO POST
A MEMORY❍

PRIDE&PREJUDICE ARTS&CULTURE
WORK&PLAY
MOVERS&SHAKERS
SCIENCE&TECHNOLOGY
MILLENNIUM&BEYOND

FLASHBACK

A Century of Movies
With the usual parties and gala celebrations, the 1999 Academy Awards Ceremony came to a close late last night. As the winners polish their statuettes and the losers console themselves in their chosen way, we recall a magical century of film. Come experience the memories or share your own. ❍

Click to Buy

MEMORY OF THE DAY
Marilyn Monroe Memory
"...She was sexy without being vulgar, she brought something fresh to being beautiful and desirable..."
- Roxy176

Click here! to post your own memories of Marilyn Monroe in our 20th Century Time Capsule. ❍

Frank Epperson patented the popsicle in 1923 after he left his spoon in a glass of lemonade on the windowsill overnight

[u R Ge ...]

SALON

the blessings
of the butt

BY ROSARIO FERRÉ

excerpt—[DATE OF PLEASURE]

i've always had a positive feeling about my butt. It's a part of my body I like, and I am very conscious of it when I walk down the streets of Old San Juan. The rear end is an instant seduction, a magnet for male eyes in Puerto Rico. If I'm depressed because I've had an argument with my husband, I slip on my tightest nubs' shirt, climb on my spiked heels and swing down Calle Fortaleza to La Bombonera. There I sit at the counter, my behind sticking out on the red leather stool like a bull's-eye, and order a sweet, squashed, buttered malloreca and a café con leche loudly, enjoying the amorous looks of neighboring males. As soon as the street scent of warm bread and coffee tickles my nostrils, my spirits rise. I don't know why, but I can't feel happy unless I know someone wants to squash my butt like a sweet, buttered malloreca. Otherwise, I just seem to mope around and survive.

I suspect it's because of my obsession with the behind that, when I visit the zoo, I head straight for the cage of the apes. I love to watch them. They walk around on their hind legs, using their hands as points of support, so that they grow those large calluses on their knuckles. I feel sorry for them because they get caught in between, they came down from the tree but never stand up completely, coming free of the ground. I look at their skinny rumps, two pink lollipops swinging behind them, half hidden by their thick mats of hair, and I thank God for my gorgeous, human derrière.

NEXT PAGE

The behinds of our ancestors

SALON ARCHIVES SEARCH CONTACT US SERVICES EMPORIUM TABLE TALK

■ 395

VOICE

America's largest weekly newspaper.

SEARCH ➡ keyword [_____] category [all articles ▾]

home
features
columns
arts
listings
classifieds
personals
eats
letters

VLS
back issues
about us
site map

march 10 - 16

CITIZEN GATIEN
Facing jail time and a liquor-license challenge, nightclub mogul Peter Gatien tries to clean up his act.

cover illustration by Cliff Nielsen

also featured
MICROSOFT INVESTS IN THE GOP
CLINTON'S SUDAN: WAG IT, THEN SPIN IT
DIALLO: SHARPTON REACHING OUT TO HILLARY

CLASSIFIEDS

ON THE MOVE?
Use our enhanced search engine to find the apartment of your dreams. New rentals added daily!

PERSONALS

SCRABBLE ANYONE?
Fat Bi F on uppr w side sks scrabble partner. I play long games w/free use of dictionary thruout. Bring a book. Must love words. (Activity Pals)

COLUMNS

LA DOLCE MUSTO
What porn star is a part-time rent boy who's been hired by that movie mogul and that faded sitcom actor, just to name two illustrious checkbook carriers? (Musto)

ARTS

NY UNDERGROUND FILM FEST
Over a hundred features, docs, and short films push all the expected right/wrong buttons while also offering much to chew on beyond the rotely outre. (Dauphin)

LISTINGS

SALT-N-PEPA
Let us now honor the best-selling female rap act of all time until recently. Pepa is hot, Salt of the earth, and they've been around long enough to know they're in show business. Tues at 1am, Life. (Christgau)

LETTERS

TIME FOR A CHANGE
As far as Giuliani is concerned, don't bet on him drawing big numbers in a statewide run. His doctored figures on the crime rate just don't wash anymore. Hillary would clean his clock.

Features | Columns | Arts | Letters | Classifieds | Personals | Listings | Eats
About Us | Site Map | Contact Us | Copyright/Fine Print

LA Weekly | Seattle Weekly | City Pages | Cleveland Free Times | Long Island Voice | OC Weekly

Site design by Concrete Media, Inc.

TheCentury
TIME CAPSULE

HOME
TIME CAPSULE
STORIES
VIDEO MOMENTS
TIMELINES
TV SERIES
CLASSROOM

SEARCH
ABOUT US
CONTACT US
CENTURY STORE
ABCNEWS.COM
ABC.COM

HOW TO POST
A MEMORY

MESSAGE BOARDS❭ [Select a Topic ▾] BOARDS INDEX ❍

SCIENCE&TECHNOLOGY

PRIDE&PREJUDICE
ARTS&CULTURE
WAR&PEACE
MOVERS&SHAKERS
SCIENCE&TECHNOLOGY
MILLENNIUM&BEYOND

THE
20TH
CENTURY
COLLECTIVE
MEMORY

MEMORY OF THE WEEK
Soviets Launch Sputnik
"I said 'What's a Sputnik?' And they said, 'They shot something up in the air, and it went around the earth.' Wow. Then they sent a dog up. And I felt so bad because America, we won the War, we got things moving, we're selling automobiles, we're buying, we're selling, we're going, everybody's happy. And to have this happen. "
— SID CAESAR

BACKGROUND
"Blackie" the Dog
The Soviet Union followed on the success of Sputnik by launching dogs into space. On March 9, 1961, Sputnik 9 carried Chernushka, "Blackie", into orbit. Blackie was joined by a dummy cosmonaut, mice, and a guinea pig.

Come post your stories about Sputnik.

Click to Buy

TheCentury
VIDEO MOMENTS

Have you done
your taxes?

HOME
TIME CAPSULE
VIDEO MOMENTS
TIMELINES
TV SERIES
CLASSROOM

SEARCH
ABOUT US
CONTACT US
CENTURY STORE
ABCNEWS.COM
ABC.COM

HOW TO POST
A MEMORY

PRIDE&PREJUDICE
1968 Democratic convention ... Little Rock Nine ... Tiananmen Square ... Nazi camps ... Oklahoma City bombing ... Rwanda massacres ... Prague Spring

ARTS&CULTURE
1950s commercials ... Beatles in America ... anti-Japanese propaganda ... silent "strip tease" ... WWI propaganda ... WWII propaganda ... jingle ❍

WORK&PLAY
Black power at '68 Olympics ... Model T ... Jackie Robinson ... Babe Ruth ... 1950s Marriage boom ❍

WAR&PEACE
WWII end ... Hiroshima ... D-Day ... Poison gas in WWI ... Pearl Harbor ... Battle of Somme ... Fall of Saigon ❍

MOVERS&SHAKERS
Martin Luther King assassination ... Bobby Kennedy ... Princess Diana ... Huey Long ... Ronald Reagan ❍

THIS WEEK'S
VIDEO MOMENT

The World Mourns Diana
From our Arts & Culture section, we watch Princess Diana's funeral. She was respected as royalty and as a humanitarian during her life, and mourned after her tragic death in 1997. ❍

real
Download Real Player to see video

[u R Ge ...]

SALON

the bridegroom stripped Bare

A GAY MAN DISCOVERS THAT THE GODDESS-ON AT A STRAIGHT MALE STAG PARTY ARE KINKIER THAN HE COULD HAVE IMAGINED.

EDITOR'S NOTE: Urge is devoted to the pleasures and problems that flesh is heir to. Urge will feature provocative, frank and incisive reports on sex, romance, obsession and other preoccupations of the body and its related appendage, the mind. From celebrations of morbid indiscretions to reports on below-the-belt trends, Urge will cover the world of carnal delights and abstinence like nothing else does. Get the Urge every other Thursday.

BY DANIEL REITZ

To a gay man, the allure of a stag party is obvious: the sweet thrill of watching straight men brandishing their own, the stink of sexual frustration disguised in the smell of a great heterosexual American male ritual, the forced bacchanalian posing. I have never understood the coverage that so many straight men express at the idea of two men together; after all, the geography of one man's body is hardly alien to another man. To hate and fear gay sex seems the most primal kind of self-loathing.

Having attended my first stag party for my partner's brother, I can now say that I have witnessed the manifestation of sexual tension straight men possess for each other in all its screwed-up glory, and the danger, dear reader, was more than a little titillating. It wasn't that I was particularly looking forward to what I imagined would be the ad-man equivalent of a frat party, but Phil was family. Every riddled

NEXT PAGE

At the party for the classmate Phil

■ ARCHIVES SEARCH CONTACT US SERVICES EMPORIUM TABLE TALK

■ 396

girls NETWORK
SITES: home us you

JOIN
SIGN IN! CHECK YOUR
Go NOTES HELP?

Herbal
Essences
CyberHunt
SweepStakes

THE DEEP END OF THE OCEAN
3/12

FROM THE BEST-SELLING BOOK
MICHELLE PFEIFFER
and
TREAT WILLIAMS

CLICK
HERE TO... gofilm

CLICK
HERE TO... gotv

CLICK
HERE TO... gobooks

feature
women

CLARE reviews
THE CORRUPTOR
"Despite my problems with the class-sexual humor, [the] script is taut enough, and does hold a few surprises."

AGREE? DISAGREE?

Movie Reviews! [▾]

NEW IN THEATERS
• ANALYZE THIS
• THE RAGE: CARRIE 2

MORE FEATURES
• Oscar Predictions!
• Classic Girl: Herstory

NEW ON VIDEO
• EVER AFTER
• RONIN

Monica's Closet
"Discover which special item is Monica's absolute favorite this week and be a part of a curator... and see. Vote for your favorite."

What Happened [▾]

MORE FEATURES
• James Van Der Beek
• Loman O'Brien

MORE FEATURES
• James Van Der Beek
• Loman O'Brien

MORE REVIEWS OF...
• "Xena"
• "The Sopranos"

Feature
Women's History
Month
Live celebrates Women's History with three of her favorite books.

READ ON!

More Reviews! [▾]

MORE FEATURES
• Finance Books
• Early Award Winners

MORE FEATURES
• Finance Books
• Early Award Winners

NEW GENRE BOARDS
• Mysteries
• Very Very Bad Books

TheCentury
STORIES OF THE CENTURY

The MR SHOWBIZ latest Hollywood headlines daily.

JUNE 7, 1998
Black Man Killed
By Michelle Brown
James Byrd, a black man, was just trying to hitch a ride in Jasper County, Texas. When three white men in a pickup truck stopped to give him a lift, they had something drastically different in mind. Lawrence Brewer, Shawn Berry and John King allegedly drove Byrd 10 miles outside town, beat him mercilessly, chained him to the truck by his ankles and dragged him 2.5 miles to his death. The gruesome slaying was just the latest incident in a century of racial brutality.

Slide 1 of 8. Experts credit white supremacy groups for fostering hatred and inciting violence. (AP Photo)

DID YOU KNOW?
Of the nearly 9,000 hate crimes reported to the FBI in 1996, more than half of them were motivated by race.

NEXT SLIDE: DEATH BY LYNCHING ❍

■ 395
Publication The Village Voice
Design Director Liza Pagano
Designer Anh Tuan Pham
Studio Concrete Media Inc.
Publisher VV Publishing Corp.
Online Address www.villagevoice.com
Category Home Page

■ 394
Publication Salon Magazine
Design Director Mignon Khargie
Art Director Elizabeth Kairys
Designers Mignon Khargie, Elizabeth Kairys
Illustrator Mignon Khargie
Online Address www.salonmagazine.com/urge/

■ 396
Publication Girls On
Design Director Shannon McGarity
Designer Diane Goodman
Studio Concrete Media
Publisher Concrete Media Inc.
Online Address http://www.girlson.com

■ 397
Publication ABCNews.com
Creative Director Kate L. Thompson
Designer Randy Ramsey
Photo Editor Peter Mumford
Publisher ABCNews
Online Address http://abcnews.go.com/century/

CHRISTIE'S

visit a [Specialist Department ▼]

HOW TO BUY · HOW TO SELL · APPRAISALS · CALENDAR · LOCATIONS · SALES RESULTS · PUBLICATIONS

auctions MARCH 99

NEW YORK
Asian Art

A visual journey of discovery through the spiritual lands of Asia. Highlights from the three sales comprising this event include a very rare and unusually large double-gourd Yuan Dynasty vase; an important bronze and gilt figure from 14th/15th-century Tibet; a 17th-century Japanese six-panel screen; and a 19th-century Korean screen depicting scholars' accoutrements.

Exhibition: 18 - 22 March 1999
Auction: 22 - 23 March 1999

get **DETAILS** order **CATALOGUES**

The Lassiter Collection
A diverse selection of pre-war American and European motor cars.

READ MORE >

Magnificent Silver
Including pieces by Fabergé, Storr, and Odiot.
READ MORE >

Click here for Christie's Internet Initiative Statement.

18 March 1999:

German Noble Houses
A tribute to two

IN THE NEWS · HISTORY · EDUCATION · LOTFINDER™ · CHRISTIE'S IMAGES · CHRISTIE'S GREAT ESTATES

CHRISTIE'S *How To Sell*

[Specialist Department ▼]

HOW TO BUY · HOW TO SELL · APPRAISALS · CALENDAR · LOCATIONS · SALES RESULTS · PUBLICATIONS

HOW TO SELL

THE MAGIC OF AUCTION
AUCTION ESTIMATES
ESTIMATES FOR PICTURES
ESTIMATES FOR OBJECTS
AUCTION GLOSSARY

Create a Personal Profile
How can we better serve you?
READ MORE >

Since 1766, people around the world have entrusted Christie's to sell their treasures. A strong emphasis on customer service, unparalleled expertise in the global art market, and an international network of salerooms and representative offices, are just a few of the reasons why sellers have made Christie's the world's largest auction house. If you are interested in having your valuables appraised or sold by Christie's, read on.

WHAT IS IT WORTH?

At Christie's, we are happy to give you a free verbal auction estimate of an object's value. With a team of experienced specialists in over 80 collecting fields, we are able to provide authoritative evaluations of fine and decorative art, furniture, jewellery, stamps, coins, wine, vintage automobiles, sports and celebrity memorabilia, and other valuables. Our specialists, many of whom are acknowledged experts in their field, determine estimates by evaluating recent prices realized for similar objects, the current state of the art market, as well as the condition, rarity, and history of your object. *Please note: Christie's can only provide auction estimates or any other information on the type of property that we sell.* To get a free estimate of your valuable, we invite you to make an appointment to come into Christie's, or simply send in a photograph with an Auction Estimate Questionnaire.

ESTATE SERVICES

Christie's offers executors, attorneys and financial planners an exceptional range of services including authoritative appraisals of personal property for estate and gift tax, estate planning, insurance, loan collateral and charitable donations. Christie's Appraisals is comprised of a network of representatives around the world who are prepared to assist you in a wide variety of circumstances. We are pleased to consult on single items, moderately priced property, as well as entire collections. For more information please contact your nearest Christie's office.

HOME · IN THE NEWS · HISTORY · EDUCATION · LOTFINDER™ · CHRISTIE'S IMAGES · CHRISTIE'S GREAT ESTATES

CHRISTIE'S *How To Sell*

[Specialist Department ▼]

HOW TO BUY · HOW TO SELL · APPRAISALS · CALENDAR · LOCATIONS · SALES RESULTS · PUBLICATIONS

auction CALENDAR 99

Select a month: March | April | May
Sort by: Location

Visit a Specialist Department to view a calendar by sales category.

March

		Time	Location
1	Vintage Port and Fine Wines	12:30 pm	Offsite
1	Foreign Coins and Commemorative Medals	2:00 pm	London, King Street
2	English Coins and Commemorative Medals	10:00 am	London, King Street
2	Fine and Rare Wines	10:30 am / 2:00 pm	Amsterdam
2	Jewellery	2:00 pm	London, South Kensington
2	The Herman Selig Collection, Part II--Coins of George III	2:00 pm	London, King Street
3	Carpets, Decorative Objects and Furniture	10:30 am	London, South Kensington
3	20th Century British Decorative Arts	10:30 am	London, South Kensington
3	British and Continental Watercolours and Drawings	2:00 pm	London, South Kensington

HOME · IN THE NEWS · HISTORY · EDUCATION · LOTFINDER™ · CHRISTIE'S IMAGES · CHRISTIE'S GREAT ESTATES

GUARDIAN

retirement happens. will you be ready?

practical solutions... complete online access... your retirement plan.

The Guardian | Retirement Planning

GUARDIAN

retirement**plan**ning

go figure
You've got questions. How much will I need to retire? How much do I need to save? Let's figure it out...

shape your future
Find the information you need. Plus our Retirement Investment Insider section.

take advantage
Retirement planning products and services from The Guardian.

contact us

your plan
If you participate in a retirement plan that uses The Guardian Advantage(SM), enter here.

For more information on The Guardian and its services click here.
©1998, The Guardian Life Insurance Company of America
201 Park Avenue South, New York, N.Y. 10003, U.S.A.

retirement**plan**ning

your plan | go figure | shape your future | take advantage | contact us

shape your future

what do you need to know about investing?
The sooner you start saving for your retirement, the closer you'll be to reaching your goals. Take a moment to look over these retirement investing basics.

Investing Takes Careful Consideration
Investments carry some degree of risk. There is always the chance that your money won't grow as much as you expect or that you may even lose some money. That's why understanding risk and reward can help you decide what investments are right for you.

Managing Risk
One of the most important aspects of retirement planning is creating an investment portfolio that fits your own personal circumstances. You must be comfortable with the amount of risk your investments involve and how they relate to your financial goals.

Diversify
A critical component of long-term investing is diversification. When you diversify your portfolio, you balance the risks of individual investment categories by spreading your money among a variety of asset classes such as bonds, stocks, cash equivalents, and stable value investments. No single type of investment performs best under all conditions. That's why it may make sense to diversify, so your investments can weather a variety of

GUARDIAN

who
will you turn to?

why
a 401(k) plan?

what
do you need
to know
about investing?

where do you get
more information?

398
Publication Christie's Auction House
Creative Director Thomas Mueller
Designer Thomas Mueller
Studio Razorfish
Client Christie's
Online Address http://www.christies.com
Category Web Site

399
Publication Guardian Retirement
Creative Director Peter Seidler
Design Director David Warner
Designer Erik Post
Photographers Kevin Irby, Jeremy Green, Giles Hancock, Joe Standart
Studio Razorfish
Online Address http://www.guardianretirement.com
Category Web Site

ONLINE MERIT ■

■ 400
Publication BabyCenter
Design Director Jonathan Tuttle
Art Director Allyson Appen
Designer Kathy Azada
Photographer Photodisc
Publisher BabyCenter
Online Address http://www.babycenter.com
Category Web Site

■ 401
Publication Travel & Leisure
Creative Director Sumin Chou
Designer Valerie Haller
Publisher American Express Publishing Co.
Online Address http://www.travelandleisure.com
Category Web Site

■ 402
Publication The New York Times on the Web
Design Director Ron Louie
Designer Christine Thompson
Photo Editors Liz Claus, John Decker
Photographer Steve Lehman
Publisher The New York Times Electronic Media Co.
Online Address http://www.nytimes.com/library/
world/asia/index-tibet.html
Category Feature Story

■ 403
Publication Learning Network
Design Director Ron Louie
Illustrator Jean Tuttle
Publisher The New York Times Electronic Media Co.
Online Address http://www.nytimes.com/learning/
Category Web Site

photography

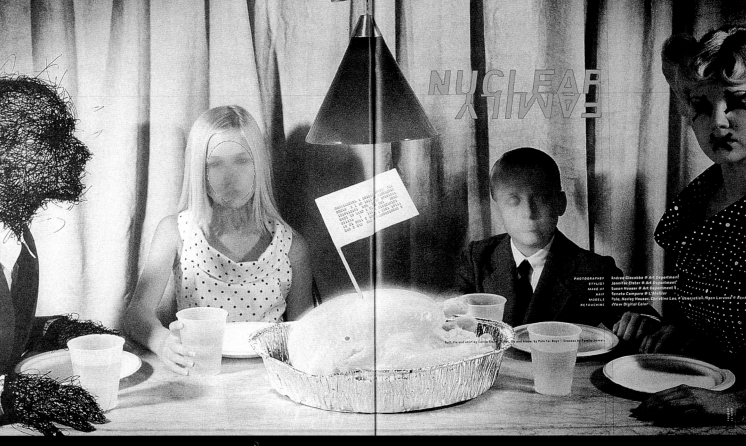

NUCLEAR FAMILY

PHOTOGRAPHER Andrea Giacobbe @ Art Department
STYLIST Jennifer Elster @ Art Department
MAKE-UP Susan Houser @ Art Department
HAIR Renato Camparo @ L'Atelier
MODELS Polo, Harley Houser, Christine Lee, o'Generation, Ryan Larosso @ Aqua
RETOUCHING New Digital Color

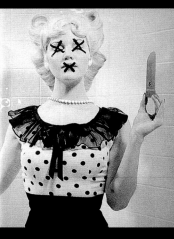

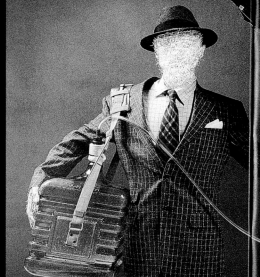

■ 404
Publication Ray Gun
Art Directors Barry Deck, Robyn Forest
Designer Barry Deck
Photo Editor Robyn Forest
Photographer Andrea Giacobbe
Publisher Ray Gun Publishing
Issue November 1998
Category Fashion, Beauty, Still Life, Interiors/Story

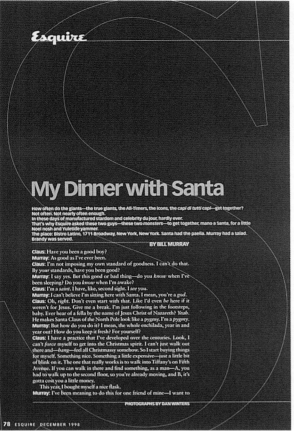

Esquire

My Dinner with Santa

How often do the giants—the true giants, the All-Timers, the Icons, the *capi di tutti capi*—get together?
Not often. Not nearly often enough.
In these days of manufactured stardom and celebrity du jour, hardly ever.
That's why Esquire asked these two guys—these two monsters—to get together, mano a Santa, for a little
Noel nosh and Yuletide yammer.
The place: Bistro Latino, 1711 Broadway, New York, New York. Santa had the paella. Murray had a salad.
Brandy was served.

BY BILL MURRAY

Claus: Have you been a good boy?
Murray: As good as I've ever been.
Claus: I'm not imposing my own standard of goodness. I can't do that.
By *your* standards, have you been good?
Murray: I say yes. But this good or bad thing—do you *know* when I've
been sleeping? Do you *know* when I'm awake?
Claus: I'm a *saint*. I have, like, second sight. I *see* you.
Murray: I can't believe I'm sitting here with Santa. I mean, you're a *god*.
Claus: Oh, *right*. Don't even start with that. Like I'd owe him here if it
weren't for Jesus. Give me a break. I'm just following in the footsteps,
baby. Ever hear of a fella by the name of Jesus Christ of Nazareth? *Yeah*.
He makes Santa Claus of the North Pole look like a pygmy. I'm a *pygmy*.
Murray: But how do you do it? I mean, the whole enchilada, year in and
year out? How do you keep it fresh? For yourself?
Claus: I have a practice that I've developed over the centuries. Look, I
can't *force* myself to get into the Christmas spirit. I can't just walk out
there and—*bang*—feel all Christmassy somehow. So I start buying things
for myself. Something nice. Something a little expensive—just a little bit
of blink on it. The one that really works is to walk into Tiffany's on Fifth
Avenue. If you can walk in there and find something, as a man—A, you
had to walk up to the second floor, so you're already moving, and B, it's
gotta cost you a little money.
This year, I bought myself a nice flask.
Murray: I've been meaning to do this for one friend of mine—I want to

PHOTOGRAPHS BY DAN WINTERS

78 ESQUIRE DECEMBER 1998

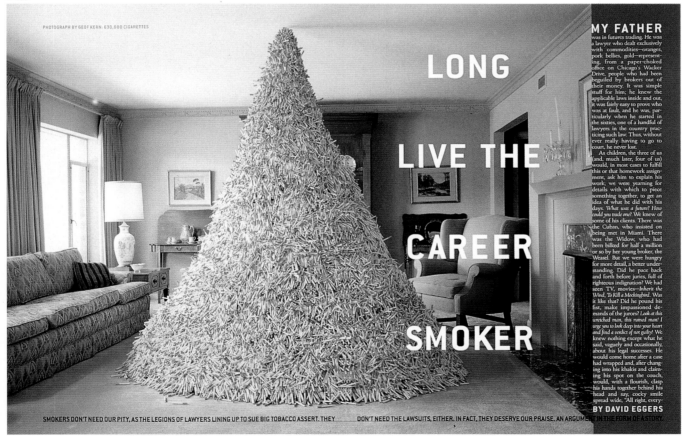

PHOTOGRAPH BY GEOF KERN: 630,000 CIGARETTES

LONG LIVE THE CAREER SMOKER

MY FATHER was in futures trading. He was a lawyer who dealt exclusively with commodities—oranges, pork bellies, gold—representing, from a paper-choked office on Chicago's Wacker Drive, people who had been beguiled by brokers out of their money. It was simple stuff for him; he knew the applicable laws inside and out, it was fairly easy to prove who was at fault, and he was, particularly when he started in the sixties, one of a handful of lawyers in the country practicing such law. Thus, without ever really having to go to court, he never lost.

As children, the three of us (and, much later, four of us) would, in most cases to fulfill this or that homework assignment, ask him to explain his work; we were yearning for details with which to piece something together, to get an idea of what he did with his days. *What was a future? How could you trade one?* We knew of some of his clients. There was the Cuban, who insisted on being met in Miami. There was the Widow, who had been bilked for half a million or so by her young broker, the Weasel. But we were hungry for more detail, a better understanding. Did he pace back and forth before juries, full of righteous indignation? We had seen TV, movies—*Inherit the Wind, To Kill a Mockingbird*. Was it like that? Did he pound his fist, make impassioned demands of the jurors? *Look at this wretched man, this ruined man! I urge you to look deep into your heart and find a verdict of not guilty!* We knew nothing except what he said, vaguely and occasionally, about his legal successes. He would come home after a case had wrapped and, after changing into his khakis and claiming his spot on the couch, would, with a flourish, clasp his hands together behind his head and say, cocky smile spread wide: "All right, every

BY DAVID EGGERS

SMOKERS DON'T NEED OUR PITY. AS THE LEGIONS OF LAWYERS LINING UP TO SUE BIG TOBACCO ASSERT. THEY DON'T NEED THE LAWSUITS. EITHER. IN FACT, THEY DESERVE OUR PRAISE. AN ARGUMENT IN THE FORM OF A STORY.

405
Publication Esquire
Design Director Robert Priest
Art Director Rockwell Harwood
Designer Joshua Liberson
Photo Editor Patti Wilson
Photographer Dan Winters
Publisher The Hearst Corporation-Magazines Division
Issue December 1998
Category Reportage, Travel, Portraits/Spread

406
Publication Esquire
Design Director Robert Priest
Art Director Rockwell Harwood
Designer Joshua Liberson
Photo Editor Patti Wilson
Photographer Geof Kern
Publisher The Hearst Corporation-Magazines Division
Issue April 1998
Category Reportage, Travel, Portraits/Spread

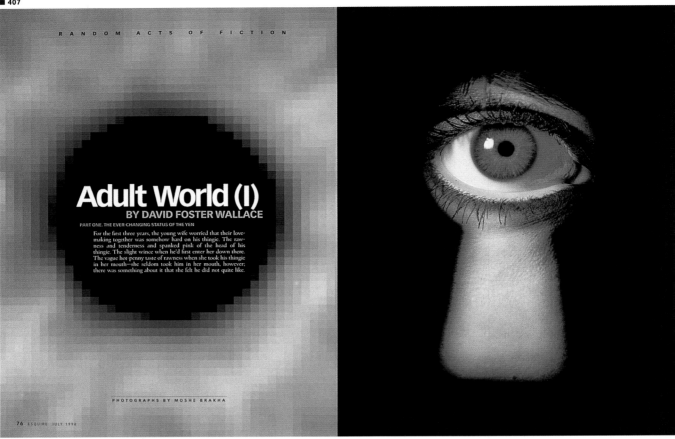

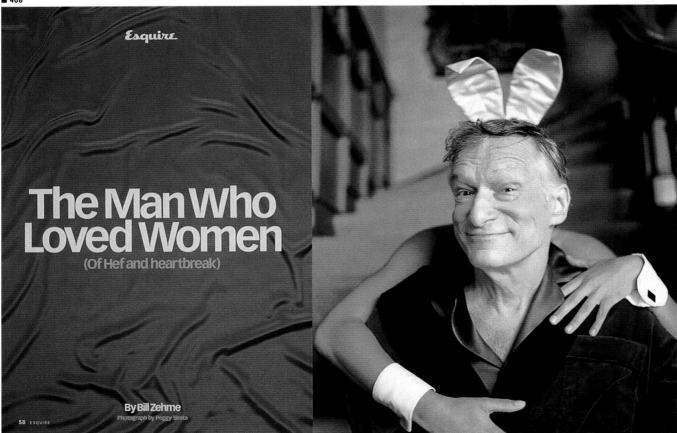

■ 407
Publication Esquire
Design Director Robert Priest
Art Director Rockwell Harwood
Designer Joshua Liberson
Photo Editor Patti Wilson
Photographer Moshe Brakha
Publisher The Hearst Corporation-Magazines Division
Issue March 1998
Category Reportage, Travel, Portraits/ Spread

■ 408
Publication Esquire
Design Director Robert Priest
Art Director Rockwell Harwood
Designer Joshua Liberson
Photo Editor Patti Wilson
Photographer Peggy Sirota
Publisher The Hearst Corporation-Magazines Division
Issue August 1998
Category Reportage, Travel, Portraits/Spread

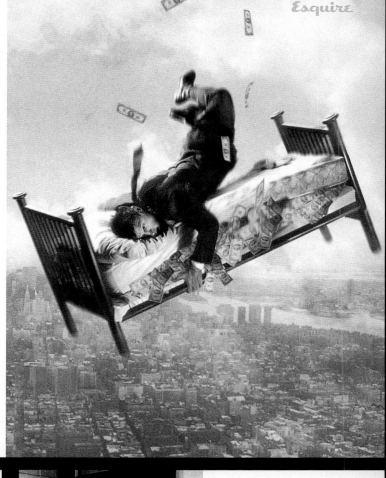

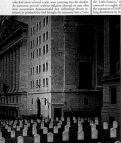

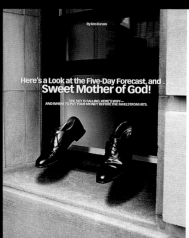

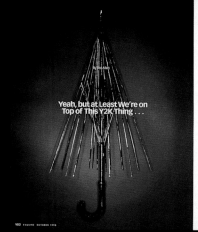

Rule 1
Don't Panic

They said the Asian markets wouldn't crash. They crashed. They said the crisis wouldn't spread. It spread. They said the catastrophe wouldn't affect us. Get ready.

Rule 2
Panic First

By Walter Russell Mead

Not long ago, at a very private briefing about the state of the United States economy attended by senior government officials from as far back as the Kennedy years and business and community leaders from all walks of life, a powerful figure in the room stood up. "Sometimes," he said, "it feels like 1928."

Nineteen twenty-eight was, of course, the last good year before the crash of 1929. The entire room was stunned. And perhaps most frightening was that not a single one of the assembled wise men and women

92 ESQUIRE

PHOTOGRAPHS BY MATT MAHURIN

Esquire

PHOTOGRAPHY SILVER

By Kim Kurson

Here's a Look at the Five-Day Forecast, and
Sweet Mother of God!

THE SKY IS FALLING, HERE'S WHY—
AND WHERE TO PUT YOUR MONEY BEFORE THE MAELSTROM HITS.

Yeah, but at Least We're on
Top of This Y2K Thing . . .

409
Publication Esquire
Design Director Robert Priest
Art Director Rockwell Harwood
Designer Joshua Liberson
Photo Editor Patti Wilson
Photographers Matt Mahurin, Nitin Vadukul, Aaron Goodman
Publisher The Hearst Corporation-Magazines Division
Issue October 1998

Working Stiffs

PHOTOGRAPHS BY MAX AGUILERA-HELLWEG

BY DAVID SEDARIS

Death is sometimes ugly, it's often cruel, and it almost always smells like hell. But for the men and women who work inside the Maricopa County Medical Examiner's Office, death is something more: It's a living.

Charles Harvey, a foren-pathologist, weighs and samples the glistening liver of a stroke victim.

LITERALLY UP TO THEIR ELBOWS IN HORROR, THESE COUNTY WORKERS PERFORM THEIR GRIM PROCEDURES WITH STARTLING GRACE AND COMPASSION.

IT IS A SAD FACT THAT OUR PETS ARE NOT AS FAITHFUL AS WE BELIEVE THEM TO BE. LEFT ALONE WITH YOUR DEAD BODY, THE DOG OR CAT USUALLY BEGINS WITH THE SOFT AREAS OF YOUR FACE.

"SOMETIMES YOU'LL BE FINGERPRINTING A DECOMPOSED BODY AND THE ARM WILL JUST COME OFF," VINNY SAYS. "IT'S NOT THE NICEST WAY TO START YOUR EVENING, BUT HEY, THESE THINGS HAPPEN."

410
Publication Esquire
Design Director Robert Priest
Art Director Rockwell Harwood
Designer Joshua Liberson
Photo Editor Patti Wilson
Photographer Max Aguilera-Hellweg
Publisher The Hearst Corporation-Magazines Division
Issue April 1998
Category Reportage, Travel, Portraits/Story

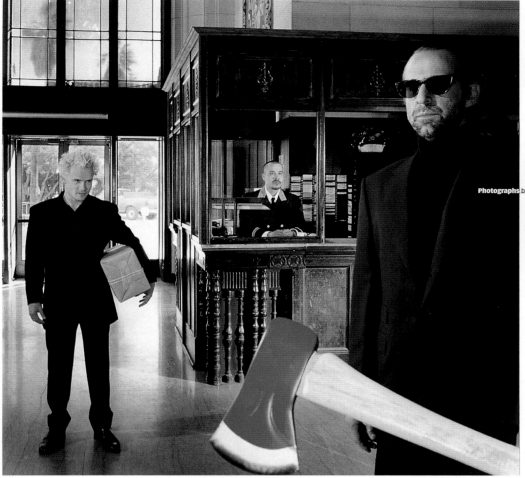

Captions by Joel and Ethan Coen

Photographs by Dan Winters

a fashion caper in ten pages

We had this idea: We said, Let's shoot Jeff Bridges, John Goodman, and the rest of the cast of the new Coen-brothers movie, *The Big Lebowski,* in some of spring's sharpest suits. Then the photographer had an idea: He said, Let's do something completely unlike what a fashion magazine would do when it does its fashion deal. Then Joel and Ethan Coen piped up with an idea of their own: They said, Let us write the copy for the story. So we did, and this, in the nine captions that follow, is what they had to say. As for what it all means, well, we have no idea.

Flea, in Gene Meyer's latest, gazes upon Ralph Lauren–clad Peter Stormare. The ax is maple, accented by red steel tipped in silver (Home Depot). The wax bell-man is from Hammacher Schlemmer.

MARCH 1998 ESQUIRE **89**

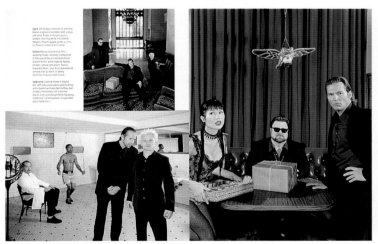

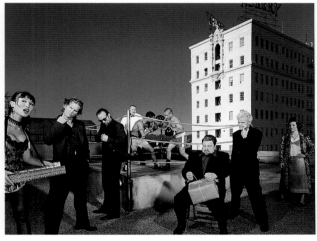

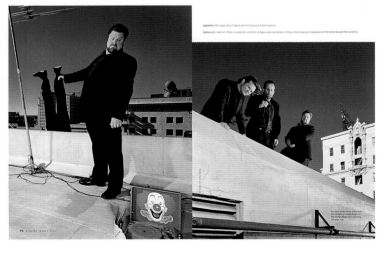

■ 411
Publication Esquire
Design Director Robert Priest
Art Director Rockwell Harwood
Designer Joshua Liberson
Photo Editor Patti Wilson
Photographer Dan Winters
Publisher The Hearst Corporation-Magazines Division
Issue March 1998
Category Fashion, Beauty, Still Life, Interiors/Story

x-ray *vision*

"ALL SERIOUS DARING STARTS FROM WITHIN," Eudora Welty said. Donghia's Lakehill club chair is a case in point: beautiful on the outside but equally so inside, where hand-tied springs are arranged as intricately as the cables in a suspension bridge.

Donghia's design director, John Hutton, spent years researching ergonomics; he even X-rayed himself seated in various postures to find the best support for the back and neck. This X ray shows the results, an engineering feat hidden beneath down and feathers.

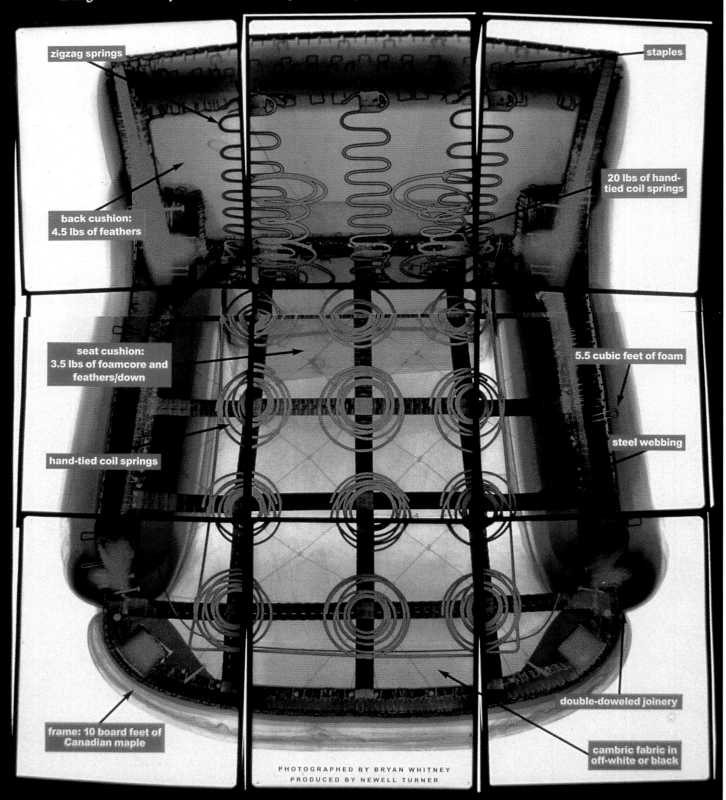

zigzag springs

staples

back cushion:
4.5 lbs of feathers

20 lbs of hand-tied coil springs

seat cushion:
3.5 lbs of foamcore and feathers/down

5.5 cubic feet of foam

hand-tied coil springs

steel webbing

frame: 10 board feet of Canadian maple

double-doweled joinery

cambric fabric in off-white or black

PHOTOGRAPHED BY BRYAN WHITNEY
PRODUCED BY NEWELL TURNER

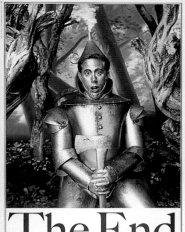

The End

The 180th and final episode of "Seinfeld," to be broadcast on May 14th, was scheduled to be filmed over nine days, from March 31st to April 8th. ROLLING STONE was there the whole time – for more than 100 hours on set – watching. Hiding in corners. Being nosy. All Jerry Seinfeld asked in return was that the ensuing story not reveal anything. This is that story. BY CHRIS HEATH

412
Publication House & Garden
Art Director Diana LaGuardia
Photo Editor Dana Nelson
Photographer Bryan Whitney
Publisher Condé Nast Publications, Inc.
Issue April 1998
Category Fashion, Beauty, Still Life, Interiors/Spread

413
Publication Rolling Stone
Art Director Fred Woodward
Designers Fred Woodward, Gail Anderson
Photo Editor Rachel Knepfer
Photographer Mark Seliger
Publisher Straight Arrow Publishers
Issue May 28, 1998
Category Reportage, Travel, Portraits/Story

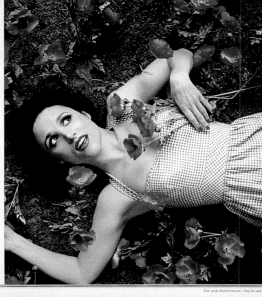

TUESDAY, MARCH 31ST

66 This show is a lot to live up to. I don't want to sully the experience. 99

JULIA LOUIS-DREYFUS

MICHAEL RICHARDS

66 I would like to burn this character. And I will rise out of the ashes. 99

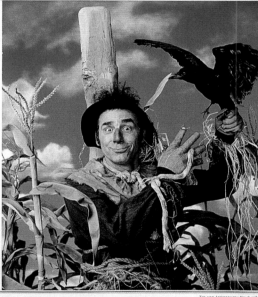

WEDNESDAY, APRIL 1ST

THURSDAY, APRIL 2ND

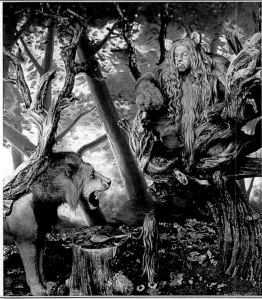

FRIDAY, APRIL 3RD

SATURDAY, APRIL 4TH

66 I would put Jerry's emotional age at nineteen: innocence with an attitude. 99

JASON ALEXANDER

66 · THE 30TH ANNIVERSARY · May 28, 1998
The 30th Anniversary · May 28, 1998 · 67
68 · THE 30TH ANNIVERSARY · May 28, 1998
THE 30TH ANNIVERSARY · May 28, 1998 · 69
70 · THE 30TH ANNIVERSARY · May 28, 1998
THE 30TH ANNIVERSARY · May 28, 1998 · 71

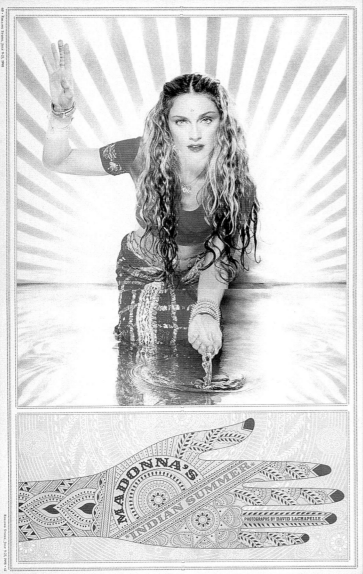

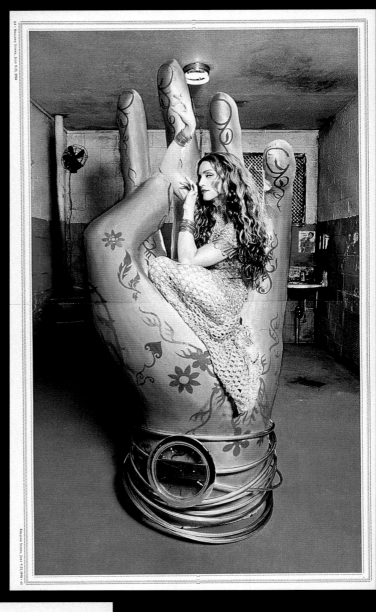

MADONNA'S INDIAN SUMMER
PHOTOGRAPHS BY DAVID LACHAPELLE

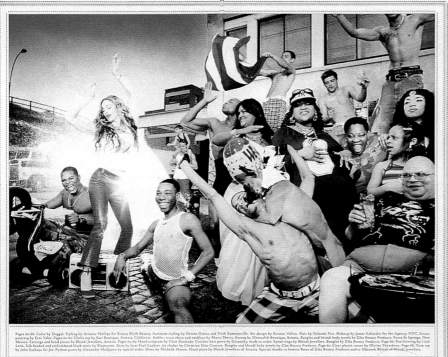

414
Publication Rolling Stone
Art Director Fred Woodward
Designers Fred Woodward, Siung Tjia
Photo Editor Rachel Knepfer
Photographer David LaChapelle
Publisher Straight Arrow Publishers
Issue July 9,1998
Category Reportage, Travel, Portraits/Story

415
Publication Rolling Stone
Art Director Fred Woodward
Designers Fred Woodward, Hannah McCaughey
Photo Editor Rachel Knepfer
Photographer Mark Seliger
Publisher Straight Arrow Publishers
Issue November 12, 1998
Category Reportage, Travel, Portraits/Story

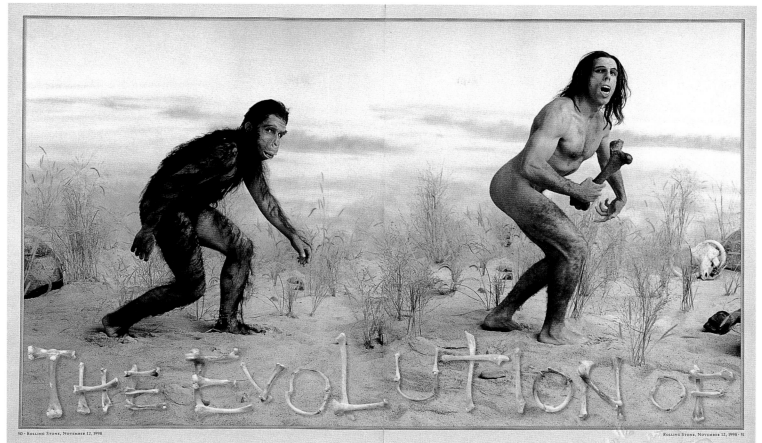

THE EVOLUTION OF

50 · ROLLING STONE, NOVEMBER 12, 1998 ROLLING STONE, NOVEMBER 12, 1998 · 51

PHOTOGRAPHY SILVER ■

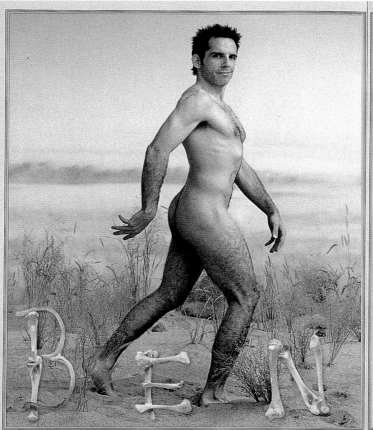

BEN

PHOTOGRAPHS BY MARK SELIGER

HIS JOURNEY
FROM NERDY NEW YORK KID
TO HIP HOLLYWOOD ROYALTY PROVES
THERE'S SOMETHING ABOUT BEN STILLER

by Chris Mundy

BEN STILLER'S LOS ANGELES apartment is striking for a number of reasons (the penthouse deck with a view of the Wilshire Country Club springs to mind), but what stands out most is why he feels at home there. "What I really like," says Stiller as he shows you around, "is that it feels like a New York apartment."

He's right. Much like Stiller himself, the home seems slightly out of place in the high glare of Hollywood, more subdued, the kind of space as likely to have the curtains drawn as it is to have the sun pouring in. Stiller points out the the hardwood floors, the Twenties-style kitchen, the original moldings. In the large main room of the duplex's bottom floor, there is a collection of black-and-white photographs, nothing else – like a SoHo gallery space.

As he gives the tour, Stiller is warm; yet, for someone who has made his mark in comedy, he does not strike you as the casual sort. He is unfailingly polite; he is friendly; but there is also a quiet intensity and a nervousness that seeps into the air around him. You like him. You just wouldn't call him to entertain at a child's birthday party.

"I've never really felt like a funny, funny guy," says Stiller as we make our way to the deck. "I've never really felt like Mr. Life of the Party. People who know me know that I'm not the most gregarious person. I'm trying to open myself up more. I've realized in the last few years that my state of mind affects how I live my life."

Stiller's mind these days must be in a dizzy state – a career high induced by the sheer goofiness and phenomenal success of *There's Something About Mary.* Stiller has always been one of the most versatile talents of his generation: an Emmy-winning writer (for *The Ben Stiller Show*); a director of major stars in major motion pictures (Winona Ryder in *Reality Bites,* Jim Carrey in *The Cable Guy*); and a steadily employed actor drawn to small, intriguing comedies such as *Flirting With Disaster, Zero Effect* and the controversial *Your Friends and Neighbors.* But rarely have the heavens been better aligned for a performer than they are now for Stiller. First comes *There's Something About Mary,* the summer comedy that won't quit even deep into the fall and the kind of colossal hit that every star needs. At the same time, Stiller nails a performance as a junkie TV writer in *Permanent Midnight* that, most serious actors wait a lifetime to deliver. After a career spent working diligently, Stiller has finally hit the big time by shooting dope, donning braces and getting his penis caught in his zipper.

But then, the map of Stiller's world has always been drawn with blurry borders between reality and popular fantasy. As a child, he was taught to swim, in Las Vegas, by the Pips; he watched home movies of Rodney Dangerfield holding him when he was an infant; Stiller even had the Swami Satchidanada borrow his skateboard outside the Stillers' apartment building, on Riverside Drive in New York. When one of the Beatles' robed gurus of choice borrows your skateboard, it's tough to talk about a normal childhood with a straight face.

Stiller's parents, Jerry Stiller and Anne Meara, are a veteran comedy duo and were thirty-two-time guests on *The Ed Sullivan Show.* (Today, Dad is best known as Frank Costanza on *Seinfeld,* and Mom from movies like *The Daytrippers.*) The pair often traveled for work, leaving Ben and his older sister, Amy, alone. Upset that show business had taken their parents out of town, the two would fill the void with show business. Not surprisingly, both are now actors. From the moment Ben began to look at the world around him, he has been building his body of work.

"Ben and Amy did a lot of films together," says Anne Meara. "They would do show tunes and do our act. We weren't there a lot, and I think that was painful for them."

"But we didn't want to go to L.A.," says Jerry. "We thought a bigger danger was growing up in a community where the neighbors were all stars and the kids were in competition with their parents' roles."

The irony is that while his parents agonized over whether to live in New York or Los Angeles, Stiller was learning to exist in the entertainment industry. Today, at thirty-two, Stiller lives comfortably in all three.

SCENE 2 – AS STILLER lounges on his deck in L.A., he tips back in his chair and tries to make some sense of it all. He has spent a great deal of time in therapy – "I haven't been going for about a year, but I actually really like it," he says – and his approach to answers often seems rooted in those sessions.

"I'm working on that whole happiness-balance issue in life," says Stiller. "I think you're always working on that. I tend to lean more toward the work side of life. It's important to find happiness outside of your work."

Yet, if you listen to the people who know him best, you wonder how precarious that balance really is.

His friend (and *Permanent Midnight* memoirist) Jerry Stahl: "I've never seen anybody put in the sheer man-hours Ben does. Being a forty-five-year-old guy with a live that lives in an adjoining county, I sure as hell can't keep up. It's amazing."

His father: "He works much too hard, for my money. I just wish he would take a rest."

His friend and frequent collaborator Janeane Garofalo: "He works harder than anyone I know. He never, ever, ever is not working. It's actually bizarre."

Not that Stiller seems unhappy. On the contrary, as he sits on his deck, feet propped up, Stiller is content, almost unable to imagine another way of life. It's as if because film was his source of pleasure as a child, his work and life have morphed into one. Still, it's difficult to understand what drives him.

"As a kid, I was just fascinated by the mechanics of filmmaking," says Stiller. "I thought I was going to be a cinematographer for a while. The idea of making movies was so much fun. Then, as I got older, acting and writing and the content became more important."

The question is rephrased. His fascination with film is a well-known fact, but what drives Stiller personally?

"In terms of what I've kept on doing," he says, "I've rarely stopped and stepped back."

SCENE 3 – STILLER'S FIRST films were highly derivative. Based mostly on his favorite television shows and on movies like *Airport 1975,* they articulated his obsession with popular culture yet displayed little vision of his own. Of course, he was barely a teenager. But still, His seminal work had actually blossomed earlier – when he was able to locate his demons. He found them on Eighty-fourth Street in Manhattan.

Stiller's apartment was on Riverside Drive; his best friend lived on Central Park West; in between was Brandeis High School. "Those four or five blocks were like a gantlet," remembers Stiller. "I used to live in fear of those Brandeis kids."

"One day he was mugged twice, once on the East Side and once on the West Side," says Jerry Stiller. He laughs. "And once they came back and said, 'We don't like this watch.'"

All this helped young Ben evolve a personal style of film. "One guy would get mugged and then we'd run after them through Riverside Park," recalls Stiller of his earliest works. "They all had names like *They Called It Murder* and *Murder in the Park.*"

As Stiller's adult career blossomed, it followed a similar path – *The Ben Stiller Show* showcased his ability to ape his favorite movies before homing in on his darker depths. Yet Stiller's range almost never came to light. Perhaps having missed his dramatic turn in *They Called It Murder,* the producers of *Permanent Midnight* first offered Stiller's role to David Duchovny and (no, this is not a type) Jon Bon Jovi. Even Stiller had his doubts.

"The biggest challenge was convincing myself that I was allowed to play that part," Stiller says. "I was fascinated by it. There were a lot of similarities as far as Jerry Stahl as a person – this Jewish comedy writer in L.A."

Based on Stahl's autobiography of his descent into the hells of heroin and Hollywood, the film is as relentless as any in recent memory, and Stiller – who barely ate during the course of filming – is riveting.

"Meeting Jerry and talking about this role really changed me as a person," says Stiller. "The key for me was that he showed me I didn't have to be a drug addict to understand why addicts take drugs – it's about not wanting to feel pain. I figured out what I did in my

"I've never really felt like a funny, funny guy, like Mr. Life of the Party," says Stiller. HE IS UNFAILINGLY POLITE; HE IS FRIENDLY; BUT THERE IS ALSO A QUIET INTENSITY AND A NERVOUSNESS that seeps into the air around him.

ROLLING STONE, NOVEMBER 12, 1998 · 53

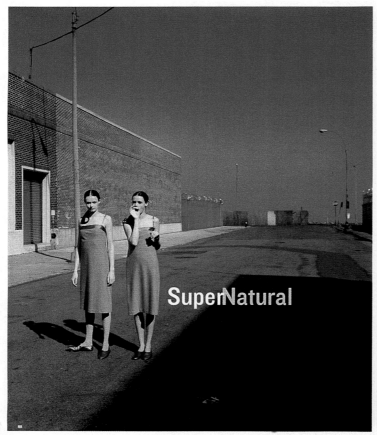

SuperNatural

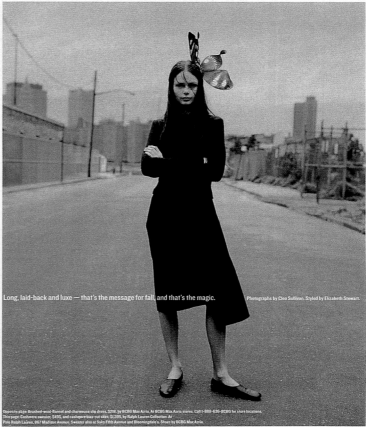

Long, laid-back and luxe — that's the message for fall, and that's the magic. Photographs by Cleo Sullivan. Styled by Elizabeth Stewart.

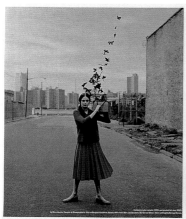

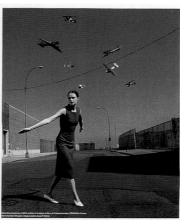

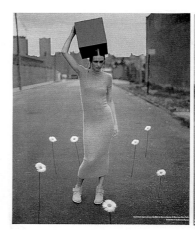

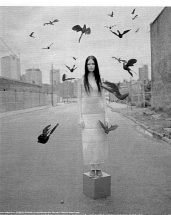

■ 416
Publication The New York Times Magazine
Art Director Janet Froelich
Designer Claudia Brandenburg
Photographer Cleo Sullivan
Publisher The New York Times
Issue September 13, 1998
Category Fashion, Beauty, Still Life, Interiors/Story

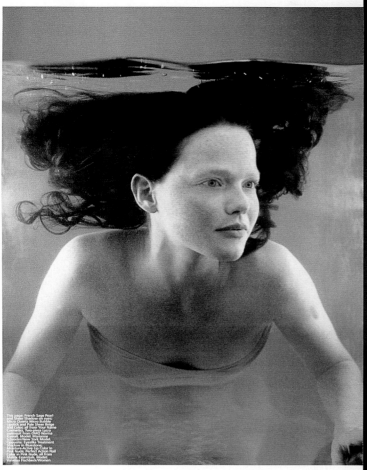

watersigns

FROM ICY BLUES AND MARINE GREENS
TO TROPICAL TURQUOISE HUES, THE
NEWEST MAKEUP IS SATURATED WITH
AQUATIC COLOR—AND EDITORIAL
MAKEUP ARTIST YASUO KNOWS
EXACTLY WHICH STROKES TO USE.

PHOTOGRAPHED BY CLEO SULLIVAN

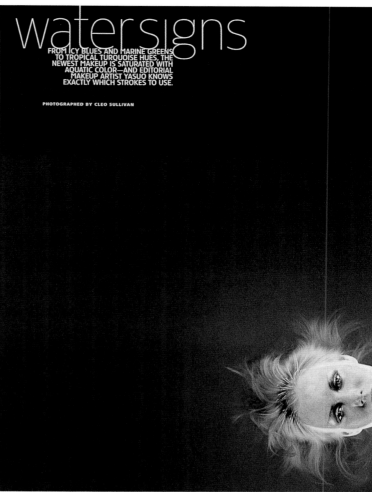

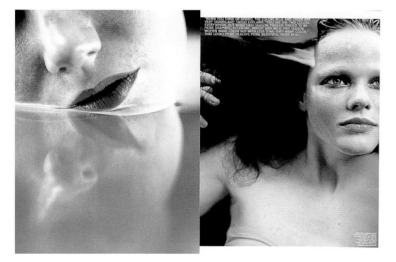

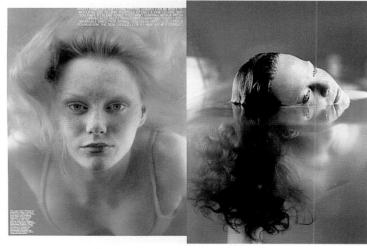

■ 417
Publication Salon News
Creative Director Victoria Maddocks
Design Director Jean Griffin
Designer Victoria Maddocks
Photo Editor Victoria Maddocks
Photographer Cleo Sullivan
Publisher Fairchild Publications
Issue April 1998
Category Fashion, Beauty, Still Life, Interiors/Story

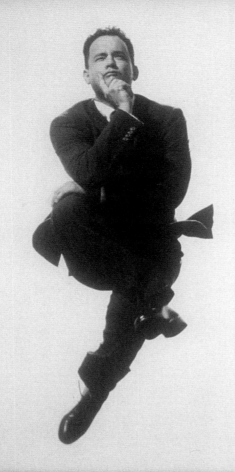

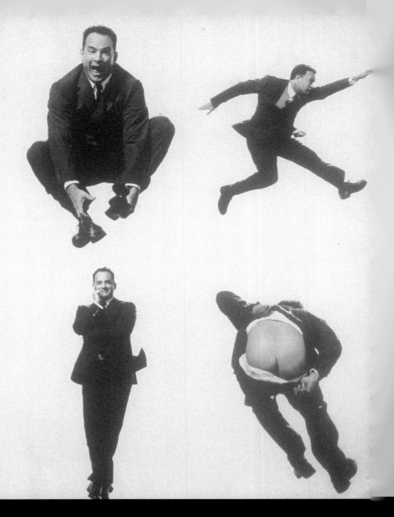

BY CURTIS RIST PHOTOGRAPHS BY BILL WHITE

FIRE SPRINKLERS FOR YOUR HOME

**THEY SAVE LIVES AND PROPERTY BUT COST A FORTUNE.
HERE'S HOW TO GET MOST OF THE BENEFITS—FOR A FRACTION OF THE PRICE.**

Rebecca and Greg Mizioch found themselves chuckling at some of the hurdles they faced when they built their house on the outskirts of Scottsdale, Arizona, in 1995. One local law required them to maintain a wildlife preserve—known derisively as a "bunny bumper"—alongside their home. Another forced them to outfit all 10 rooms with fire sprinklers, at a cost of $3,400. "We thought they were pointless," says Rebecca Mizioch, who runs a road construction company with her husband. "The odds of us ever needing them were slim to none."

Then, shortly after 6 a.m. on July 3, 1996, Greg and Rebecca's teenage daughter, Rachel, lit a few candles in her room while she was getting ready for dance camp. She placed one on a rattan bookcase, which suddenly caught fire, fueled by an explosively flammable varnish. "It went up incredibly fast," says the mother. A ball of flame rolled across the ceiling, triggering the room's lone sprinkler head even before the smoke detector sounded. Rebecca Mizioch rushed everyone out of the house and called the fire department. "By the time they got here," she says, "the fire was out."

Most of us count on smoke detectors as our first line of defense against dying in a fire, and for good reason. The number of fire deaths fell from about 6,000 a year when the alarms were just becoming popular in the mid 1970s to 4,035 in 1996. Yet as effective as detectors are,

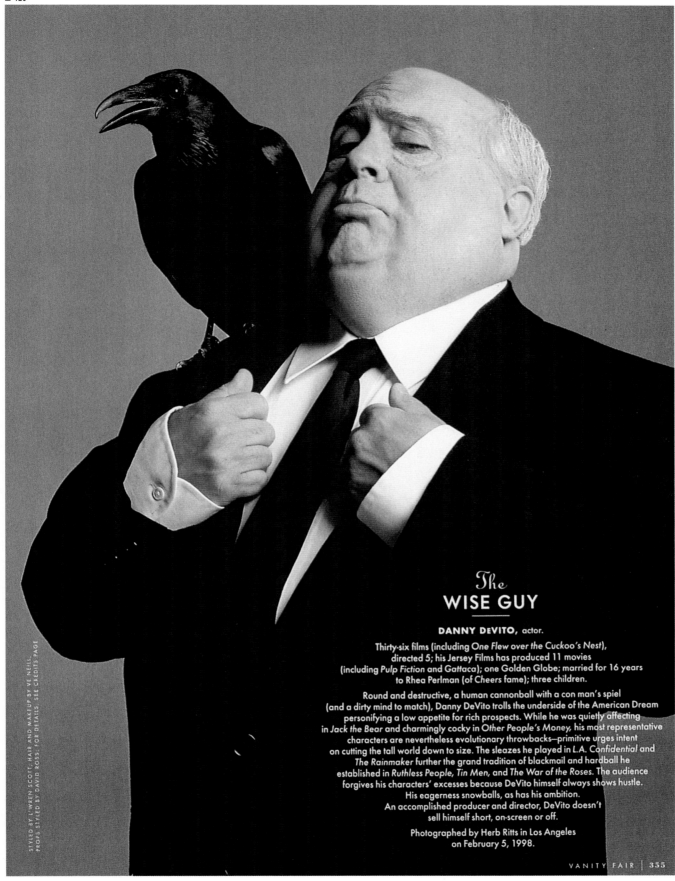

STYLED BY L-WREN SCOTT; HAIR AND MAKEUP BY VE NEILL; PROPS STYLED BY DAVID ROSS. FOR DETAILS, SEE CREDITS PAGE

The
WISE GUY

DANNY DeVITO, actor.

Thirty-six films (including *One Flew over the Cuckoo's Nest*),
directed 5; his Jersey Films has produced 11 movies
(including *Pulp Fiction* and *Gattaca*); one Golden Globe; married for 16 years
to Rhea Perlman (of *Cheers* fame); three children.

Round and destructive, a human cannonball with a con man's spiel
(and a dirty mind to match), Danny DeVito trolls the underside of the American Dream
personifying a low appetite for rich prospects. While he was quietly affecting
in *Jack the Bear* and charmingly cocky in *Other People's Money,* his most representative
characters are nevertheless evolutionary throwbacks—primitive urges intent
on cutting the tall world down to size. The sleazes he played in *L.A. Confidential* and
The Rainmaker further the grand tradition of blackmail and hardball he
established in *Ruthless People, Tin Men,* and *The War of the Roses.* The audience
forgives his characters' excesses because DeVito himself always shows hustle.
His eagerness snowballs, as has his ambition.
An accomplished producer and director, DeVito doesn't
sell himself short, on-screen or off.

Photographed by Herb Ritts in Los Angeles
on February 5, 1998.

VANITY FAIR | 355

PHOTOGRAPHY SILVER ■

■ 418
Publication Vogue
Design Director Charles R. Churchward
Photographer Herb Ritts
Publisher Condé Nast Publications Inc.
Issue December 1998
Category Reportage, Travel, Portraits/Spread

■ 419
Publication This Old House
Design Director Matthew Drace
Art Director Tim Jones
Photographer Bill White
Publisher Time Inc.
Issue January/February 1998
Category Fashion, Beauty, Still Life, Interiors/Spread

■ 420
Publication Vanity Fair
Design Director David Harris
Art Director Gregory Mastrianni
Photo Editors Susan White, Lisa Berman
Photographer Herb Ritts
Publisher Condé Nast Publications Inc.
Issue April 1998
Category Reportage, Travel, Portraits/Single Page

Style is hearing the call of the wild—so we followed along with these four **tabletop tableaux** in materials straight from nature. With simple shapes and earth-toned **woods and leathers**, this dinnerware brings new meaning to eating organically. For details, see our shopping guide, page 126.

natural selections

{faces of the city}

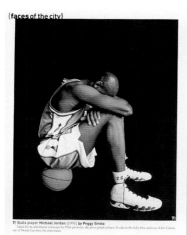

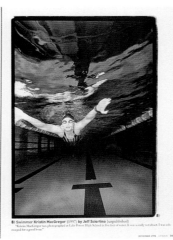

{faces of the city}

the defining details

Moldings come in an array of styles. Here's help deciphering them

{faces of the city}

■ 421

Publication Chicago
Art Director Kerry Robertson
Designer Kerry Robertson
Photographers Susan Anderson, Peggy Sirota, Jeff Sciortino, Jim Purdum, Dr. David Teplica, Marc Hauser, Victor Skrebmeski
Publisher Primedia Magazines Inc.
Issue December 1998
Category Photo Illustration/Story

■ 422

Publication American Home Style
Art Director Nora Negron
Designer Wendy Scofield
Photo Editor Fredrika Stjäme
Photographer Antonis Achilleos
Publisher G & J USA
Issue October 1998
Category Fashion, Beauty, Still Life, Interiors/Single Page

■ 423

Publication American Home Style
Art Director Nora Negron
Designer Jason Lancaster
Photo Editor Fredrika Stjäme
Photographer Anita Calero
Publisher G & J USA
Issue November 1998
Category Fashion, Beauty, Still Life, Interiors/Spread

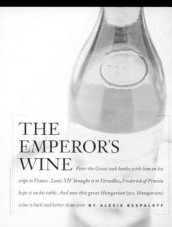

THE EMPEROR'S WINE

Peter the Great took bottles with him on his trips to France. Louis XIV brought it to Versailles. Frederick of Prussia kept it on his table. And now this great Hungarian (yes, Hungarian) wine is back and better than ever. BY ALEXIS BESPALOFF

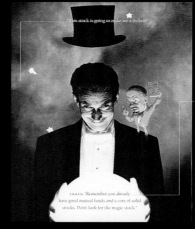

Support From the Sidelines

Financial coaches — a New Age mix of therapist, educator, and bean counter — help the confused gain confidence

BY RICHARD BIERCK

Photographs by Patrick Harbron • Illustrations by Daniel Adel

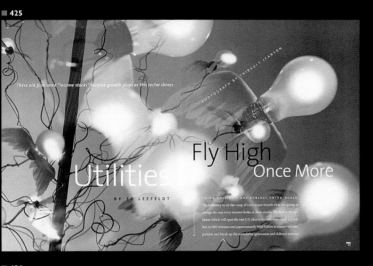

These old-fashioned "income stocks" become growth plays as this sector shines

Utilities Fly High Once More

BY ED LEEFELDT

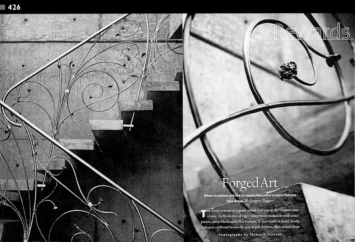

Rewards

Forged Art

When sculptors put fire to metal, beautiful custom fixtures take shape. By Gregory Taggert

Photographs by Thibault Jeanson

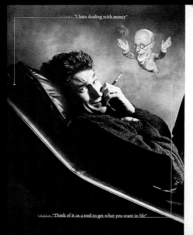

PHOTOGRAPHY MERIT

424
Publication Attaché
Art Director Paul Carstensen
Designer Paul Carstensen
Photographer Leigh Beisch
Publisher Pace Communications
Client US Airways
Issue May 1998
Category Fashion, Beauty, Still Life, Interiors/Spread

425
Publication Bloomberg Personal Finance
Art Director Carol Layton
Designer Carol Layton
Illustrator Ian Whadcock
Photo Editor Mary Shea
Photographer Thibault Jeanson
Publisher Bloomberg L. P.
Issue April 1998
Category Fashion, Beauty, Still Life, Interiors/Spread

426
Publication Bloomberg Personal Finance
Art Director Carol Layton
Designers Carol Layton, Evelyn Good
Photo Editor Mary Shea
Photographer Thibault Jeanson
Publisher Bloomberg L. P.
Issue June 1998
Category Fashion, Beauty, Still Life, Interiors/Spread

427
Publication Bloomberg Personal Finance
Art Director Carol Layton
Designers Carol Layton, Owen Edwards
Illustrator Daniel Adel
Photo Editor Mary Shea
Photographer Patrick Harbron
Publisher Bloomberg L. P.
Issue March 1998
Category Photo Illustration/Story

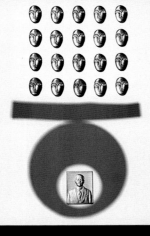

21

FUNDS FOR THE 21ST CENTURY

BY MARY ROWLAND Photographs by *Pierre-Yves Goavec*

Looking for consistency,
experience, low costs,
and stellar long-term
performance? This
EXCLUSIVE
list has it all.

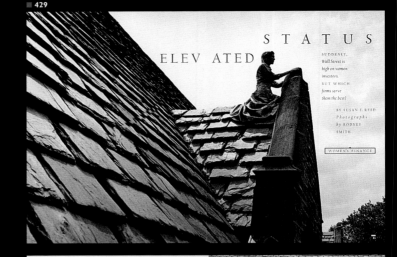

S T A T U S

ELEV ATED

SUDDENLY,
Wall Street is
high on women
investors.
BUT WHICH
*firms serve
them the best?*

BY SUSAN E. REED
*Photographs
by RODNEY
SMITH*

WOMEN'S FINANCE

We valued **CONSISTENCY** *wherever we could find it, in small shops and large*

All of our winners offer below-average expenses; some are **DOWNRIGHT CHEAP**

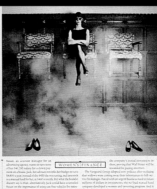

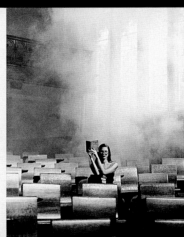

Our investors have **CONVICTION** *and position themselves accordingly*

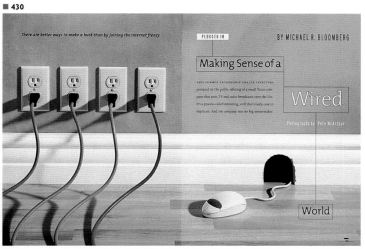

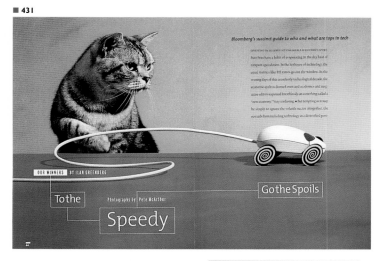

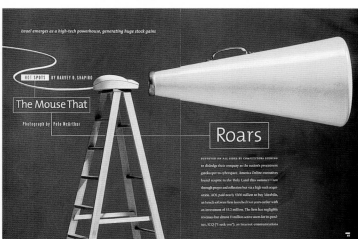

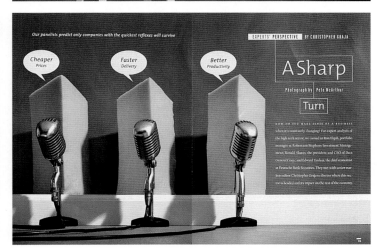

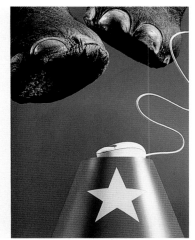

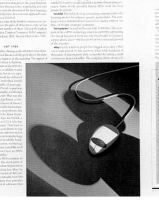

■ 428
Publication Bloomberg Personal Finance
Art Director Carol Layton
Designers Carol Layton,
Frank Tagariello
Photo Editor Mary Shea
Photographer Pierre-Yves Goavec
Publisher Bloomberg L. P.
Issue December 1998
Category Photo Illustration/Story

■ 429
Publication Bloomberg Personal Finance
Art Director Carol Layton
Designer Carol Layton
Photo Editor Mary Shea
Photographer Rodney Smith
Publisher Bloomberg L. P.
Issue November 1998
Category Photo Illustration/Story

■ 430
Publication Bloomberg Personal Finance
Art Director Carol Layton
Designer Carol Layton
Photo Editor Mary Shea
Photographer Pete McArthur
Publisher Bloomberg L. P.
Issue October 1998
Category Photo Illustration/Story

■ 431
Publication Bloomberg Personal Finance
Art Director Carol Layton
Designer Carol Layton
Photo Editor Mary Shea
Photographer Pete McArthur
Publisher Bloomberg L. P.
Issue October 1998
Category Photo Illustration/Story

PHOTOGRAPHY MERIT ■

In Guns We Trust

When Kip Kinkel walked into the cafeteria, pulled out a semiautomatic rifle, and opened fire on his classmates, he was speaking in an increasingly popular American vernacular. Rick Moody interprets the language of the schoolyard massacre. Photographs by Dan Winters. It must have been the alliteration that did it, that caused the chaos, that lit the light, that flipped the switch, that made Kip Kinkel kill—that ugly sequence of *k*'s, like the stutter of hard *c*'s in *crack cocaine* or in the *Second Coming of Christ*, the *k* of Khmer Rouge, krazy as in Krazy Kat, creepy as in *Kaposi's* or *carcinoma*, Kip, short for Kipland, kamikaze, kabuki, with Glock or Ruger or maybe Colt or AK-47; Kip and his keynote address, craven, careless, callous, cold-blooded (his temperature in Kelvin), calculating, cagey; Kip Kinkel, *a kid who kills*, under the kliegs now, for good. As the courtroom is called to order.

Alliteration, at least, is as good as any other

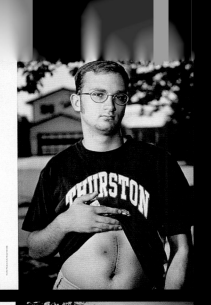

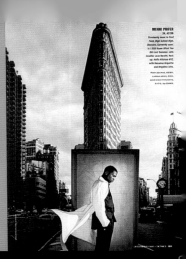

MN ON THE STREET

Seven men-about-town hit the streets in this month's best casual city styles

In Guns We Trust

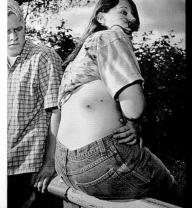

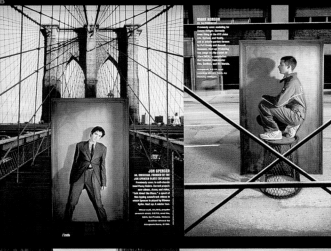

In Guns We Trust

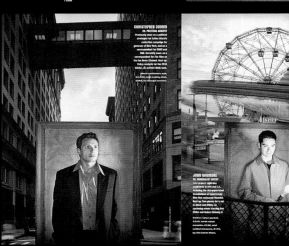

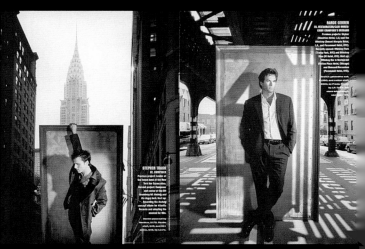

432
Publication Details
Design Director Robert Newman
Photo Editors Greg Pond, Halla Timon
Photographer Dan Winters
Publisher Condé Nast Publications Inc.
Issue October 1998
Category Reportage, Travel, Portraits/Story

433
Publication Details
Design Director Robert Newman
Designer John Giordani
Photo Editors Greg Pond, Halla Timon
Photographer Dan Winters
Stylist William Gilchrist
Publisher Condé Nast Publications Inc.
Issue December 1998
Categories Fashion, Beauty, Still Life, Interiors/Story
A Fashion, Beauty, Still Life, Interiors/Spread

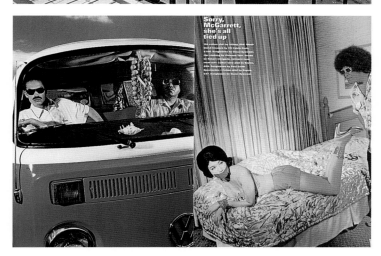

Nine to Five-O

Princess Mai Tai is missing!

Make a collar like McGarrett with this summer's cool business suits. How do you like them pineapples?

Sorry, McGarrett, she's all tied up

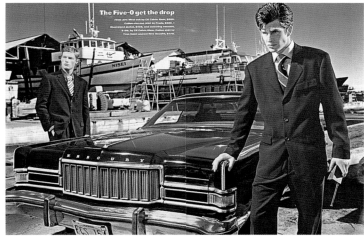

The Five-O get the drop

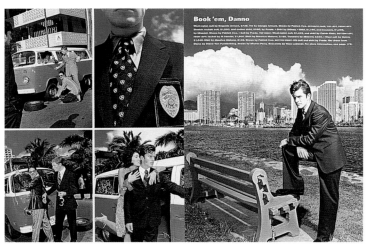

Book 'em, Danno

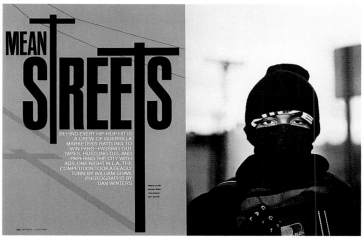

MEAN STREETS

BEHIND EVERY HIP-HOP HIT IS A CREW OF GUERRILLA MARKETERS BATTLING TO WIN FANS—PASSING OUT TAPES, HUSTLING DJS, AND PAPERING THE CITY WITH ADS. ONE NIGHT IN L.A., THE COMPETITION TOOK A DEADLY TURN. BY WILLIAM SHAW. PHOTOGRAPHS BY DAN WINTERS

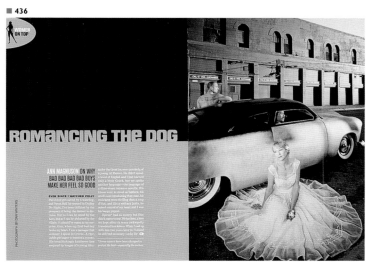

WOMEN ON TOP

ROMANCING THE DOG

ANN MAGNUSON ON WHY BAD BAD BAD BOYS MAKE HER FEEL SO GOOD

EVER SINCE I WATCHED Polly

PHOTOGRAPH BY DAN WINTERS

■ 434
Publication Details
Design Director Robert Newman
Designer Alden Wallace
Photo Editors Greg Pond, Halla Timon
Photographer Moshe Brakha
Fashion Director Derick Procope
Publisher Condé Nast Publications Inc.
Issue June 1998
Category Fashion, Beauty, Still Life, Interiors/Story

■ 435
Publication Details
Design Director Robert Newman
Designer John Giordani
Photo Editors Greg Pond, Halla Timon
Photographer Dan Winters
Publisher
Condé Nast Publications Inc.
Issue July 1998
Category Reportage, Travel, Portraits/Spread

■ 436
Publication Details
Design Director Robert Newman
Designer John Giordani
Photo Editors Greg Pond, Halla Timon
Photographer Dan Winters
Publisher Condé Nast Publications Inc.
Issue February 1998
Category Reportage, Travel, Portraits/Spread

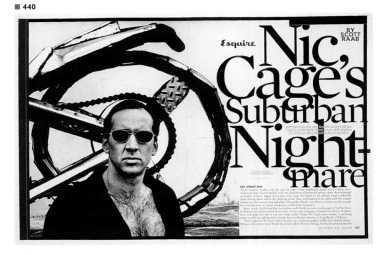

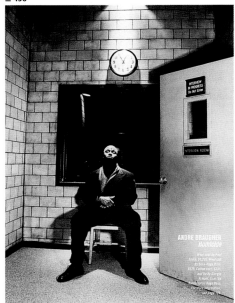

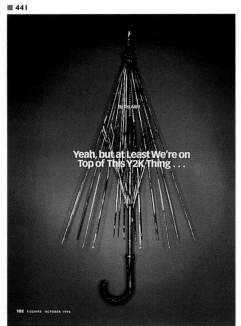

■ 437
Publication Details
Design Director Robert Newman
Designer John Giordani
Photo Editors Greg Pond, Halla Timon
Photographer Nigel Dickson
Publisher Condé Nast Publications Inc.
Issue May 1998
Category Reportage, Travel, Portraits/Spread

■ 438
Publication Details
Design Director Robert Newman
Designer John Giordani, Marlene Sezni
Photo Editors Greg Pond, Halla Timon
Photographer Alastair Thain
Publisher Condé Nast Publications Inc.
Issue January 1998
Category Reportage, Travel, Portraits/Single Page

■ 439
Publication Details
Design Director Robert Newman
Photo Editors Greg Pond, Halla Timon
Photographer Richard Burbridge
Publisher Condé Nast Publications Inc.
Issue March 1998
Category Reportage, Travel, Portraits/Spread

■ 440
Publication Esquire
Design Director Robert Priest
Art Director Rockwell Harwood
Designer Joshua Liberson
Photo Editor Patti Wilson
Photographer Anton Corbijn
Publisher The Hearst Corporation-Magazines Division
Issue September 1998
Category Reportage, Travel, Portraits/Spread

■ 441
Publication Esquire
Design Director Robert Priest
Art Director Rockwell Harwood
Designer Joshua Liberson
Photo Editor Patti Wilson
Photographer Nitin Vadukul
Publisher The Hearst Corporation-Magazines Division
Issue October 1998
Category Reportage, Travel, Portraits/Single Page

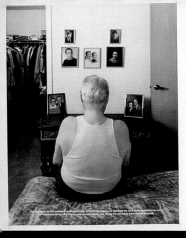

PHOTOGRAPHS BY DAN WINTERS

Old

Hey, oh boy, whitey, Grampa, 'ma-ho'kt. And you've been old longer than you've been anything else.

BY MIKE SAGER

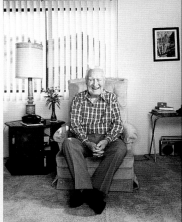

The Man Who Mistook a Woman for a Sheep

The clone, the chimera, the infinite bull, and other tales from the frontier of the life business

BY TOM JUNOD

PHOTOGRAPH BY DAN WINTERS

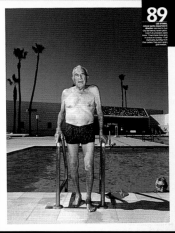

89

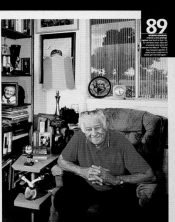

89

442

Publication Esquire
Design Director Robert Priest
Art Director Rockwell Harwood
Designer Joshua Liberson
Photo Editor Patti Wilson
Photographer Dan Winters
Publisher The Hearst Corporation-
Magazines Division
Issue September 1998
Category
Reportage Travel Portraits/Story

443

Publication Esquire
Design Director Robert Priest
Art Director Rockwell Harwood
Designer Joshua Liberson
Photo Editor Patti Wilson
Photographer Dan Winters
Publisher The Hearst Corporation-
Magazines Division
Issue May 1998
Category
Reportage Travel Portraits/Story

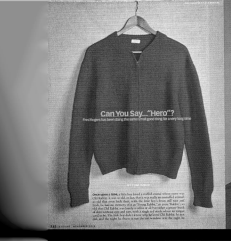

Can You Say..."Hero"?
Fred Rogers has been doing the same small good thing for a very long time

BY TOM JUNOD

Once upon a time, a little boy loved a stuffed animal whose name was Old Rabbit. It was so old, in fact, that it was really an unstuffed animal; so old that even back then, with the little boy's brush still wet with the paint of babyhood, it was old. It had lost its shape, so that the only way the little boy could still tell that it was a rabbit was...

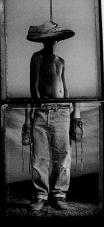

Miracle Boy

First he lost his feet. Then he lost his shoes.

By Pinckney Benedict

Lizard and Geronimo and Eskimo Pie wanted to see the scars. Show us the scars, Miracle Boy, they said.

They cornered Miracle Boy after school one day behind the shop-class shed, out beyond the baseball diamond, where the junior high's property bordered McClung's place. Miracle Boy always went home that way, over the fence stile and across the fields with his weird shuffling gait and the black-locust walking stick that his old man had made for him. His old

PHOTOGRAPHS BY DAN WINTERS

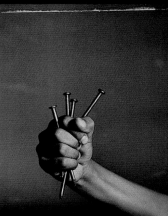

I TOLD MISTER ROGERS that I'd stopped to help a turtle cross a road. Two other cars stopped, and five people wound up making sure a malevolent old snapping turtle didn't get crushed. He asked if I was going to write about it, "because whenever people join together to help another creature, people should know about it," he said. "We all long to know there is a graciousness at the heart of creation."

RANDOM ACTS OF FICTION

Morning in America
Heaven and earth contained in an atom of thought

BY TONY EARLEY

PHOTOGRAPH BY NITIN VADUKUL

444
Publication Esquire
Design Director Robert Priest
Art Director Rockwell Harwood
Designer Joshua Liberson
Photo Editor Patti Wilson
Photographer Dan Winters
Publisher The Hearst Corporation-Magazines Division

445
Publication Esquire
Design Director Robert Priest
Art Director Rockwell Harwood
Designer Joshua Liberson
Photo Editor Patti Wilson
Photographer Dan Winters
Publisher The Hearst Corporation-Magazines Division

446
Publication Esquire
Design Director Robert Priest
Art Director Rockwell Harwood
Designer Joshua Liberson
Photo Editor Patti Wilson
Photographer Nitin Vadukul
Publisher The Hearst Corporation-Magazines Division

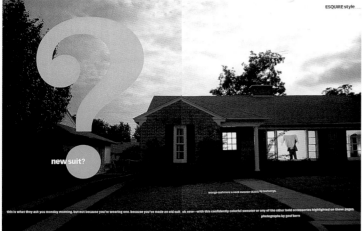

ESQUIRE style

new suit?

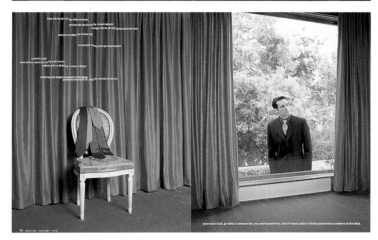

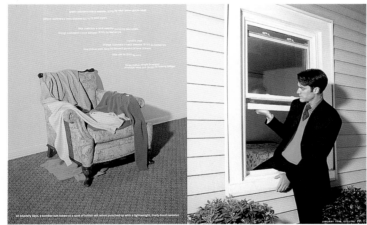

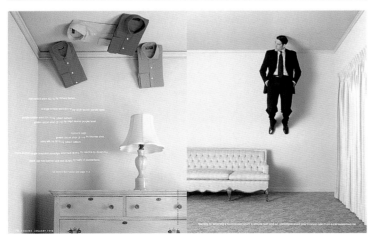

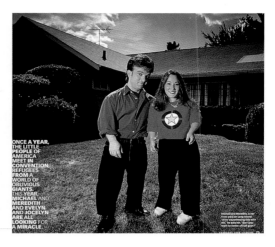

DWARFS
BY JOHN H. RICHARDSON
A Love Story
PHOTOGRAPH BY BRIAN SMALE

ONCE A YEAR, THE LITTLE PEOPLE OF AMERICA MEET IN CONVENTION REFUGEES FROM A WORLD OF OBLIVIOUS GIANTS. THIS YEAR, MICHAEL AND MEREDITH AND EVELYN AND JOCELYN ARE ALL LOOKING FOR A MIRACLE.

Marry the One Who Gets There First

Outtakes from the Sheidegger-Krupnik wedding album

By Heidi Julavits

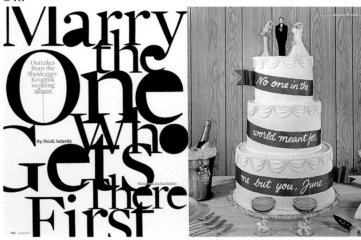

No one in the world meant for me but you, June

■ 447
Publication Esquire
Design Director Robert Priest
Art Director Rockwell Harwood
Designer Laura Harrigan
Photo Editor Patti Wilson
Photographer Geof Kern
Publisher The Hearst Corporation-Magazines Division
Issue January 1998
Category Fashion, Beauty, Still Life, Interiors/Story

■ 448
Publication Esquire
Design Director Robert Priest
Art Director Rockwell Harwood
Designer Joshua Liberson
Photo Editor Patti Wilson
Photographer Brian Smale
Publisher The Hearst Corporation-Magazines Division
Issue February 1998
Category Reportage, Travel, Portraits/Spread

■ 449
Publication Esquire
Design Director Robert Priest
Art Director Rockwell Harwood
Designer Joshua Liberson
Photo Editor Patti Wilson
Photographer Dan Winters
Publisher The Hearst Corporation-Magazines Division
Issue April 1998
Category Reportage, Travel, Portraits/Spread

PHOTOGRAPHY MERIT ■

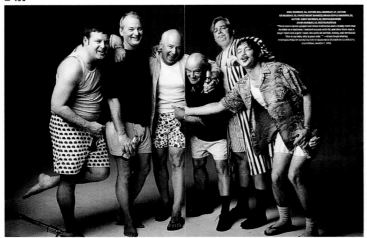

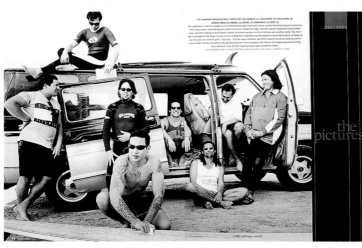

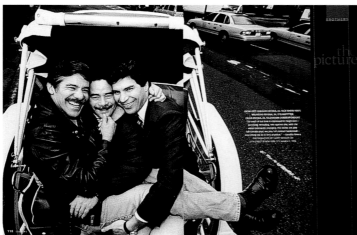

The Vegas
FANTASY

A polished, pumped-up Las Vegas—Playland USA—is erupting feverishly in the old sin city. LUC SANTE, swizzle

At any given point along the Strip, you are in the middle of SOMEONE'S ACID TRIP: fireworks and volcanoes, roller coasters and TIMES SQUARE-SIZE video screens, sonic et lumière displays, and the 315,000-watt xenon beam

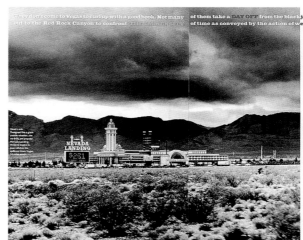

■ 450
Publication Esquire
Design Director Robert Priest
Art Director Rockwell Harwood
Designer Joshua Liberson
Photo Editor Patti Wilson
Photographers Stephane Sednaoui, Davis Factor, Danny Clinch, John Huet, Jeff Dunas, Gregory Heisler, Harry Benson, Dorian Caster, Nitin Vadukul, Brian Velenchenko, Marc Hom, Andrew French, Hannes Schmid, Dan Winters
Publisher The Hearst Corporation-Magazines Division
Issue June 1998
Category Reportage, Travel, Portraits/Story

■ 451
Publication Condé Nast Traveler
Design Director Robert Best
Photo Editor Kathleen Klech
Photographer Helmut Newton
Publisher Condé Nast Publications Inc.
Issue September 1998
Category Reportage, Travel, Portraits/Story

The Talking

CHIHUAHUA

The It Bitch

photograph by
WILLIAM WEGMAN

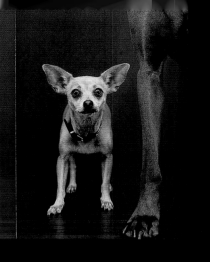

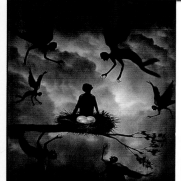

PHOTO-ILLUSTRATIONS BY MATT MAHURIN

453

PLEASANTVILLE, set in a bizarre world where 1950s TV and real life blur, may be bringing DON KNOTTS back into focus, but a whole generation of comics already believes life is beautiful. ~ BY CHRIS NASHAWATY

the
DON
LAST

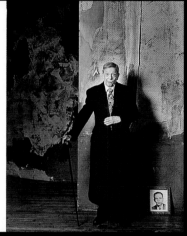

WHAT ADVICE did one employer give? 'It was basically an e-mail that said, "Here's the deal. Call so-and-so if you want some help."'

454

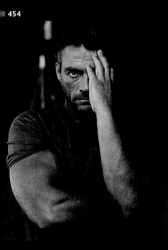

DAMME
Straight

FOR THE FIRST TIME, JEAN-CLAUDE
VAN DAMME TALKS ABOUT THE
COCAINE ADDICTION THAT SHAT-
TERED HIS LIFE AND WRECKED
HIS CAREER. NOW THAT HE HAS
OUR ATTENTION, CAN HE MAKE A
GOOD MOVIE?

by Rebecca Ascher-Walsh

WHY ARE many
employers afraid to be
helpful? 'You put
yourself at risk [of
a lawsuit] if the advice
doesn't work out.'

452
Publication Entertainment Weekly
Design Director John Korpics
Photographer William Wegman
Publisher Time Inc.
Issue June 26, 1998
Category
Reportage, Travel, Portraits/Spread

453
Publication Entertainment Weekly
Design Director John Korpics
Art Director Geraldine Hessler
Photo Editor Sarah Rozen
Photographer Ethan Hill
Publisher Time Inc.
Issue August 23, 1998

454
Publication Entertainment Weekly
Design Director John Korpics
Photo Editor Mary Dunn
Photographer Jeffrey Thurnher
Publisher Time Inc.
Issue September 4, 1998
Category

455
Publication SmartMoney
Art Director Amy Rosenfeld
Designer Anna Kula
Photo Editor Jane Clark
Photographer Matt Mahurin
Publisher Dow Jones & Hearst Corp
Issue December 1998

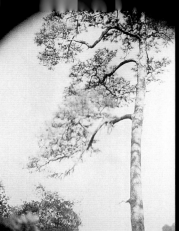

A quarter of a century ago, photographer Sally Mann came across a cache of 10,000 19th-century glass negatives.

The photographs, taken by a Civil War amateur named Michael Miley, showed scenes—many of them familiar and unchanged—

of the landscape around her hometown of Lexington, Virginia. ● In the two years she spent cleaning and printing the negatives,

Mann discovered a new way of looking at the world. A dozen years later, when she began her famous series of photographs of

her children, she borrowed the rich shadows and glowing light of those early photos by using a 100-year-old box camera to

SALLY

to induce their distinctive depth and stillness. ● Now, with her children nearly grown,

Mann has returned to landscapes. The photographs here, part of a series she calls

MANN

"Mother Land," are of Mann's native South, taken near her home in Virginia and in rural Georgia. Many of the prints appear

damaged, and they are: Light leaks, spots, cracks, and double exposures that occurred during the chance process of photographing

with old equipment become part of their otherworldly vision. ● The level gaze of Sally Mann's ancient view camera returns

us to a way of seeing that has been nearly lost in the whirr and click of modern picture-taking. Like the Southern landscapes it

records, her camera's eye lingers in that long, haunting moment when experience turns into memory. / By Margaret Mann

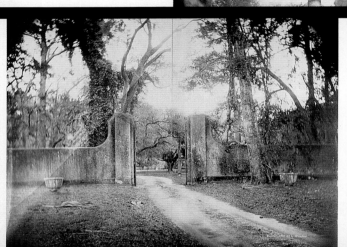

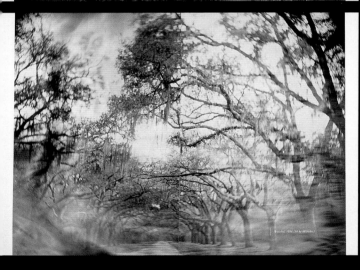

Untitled, 1998 (38 by 48 inches)

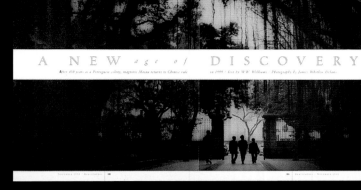

A NEW age of DISCOVERY

After 450 years as a Portuguese colony, magnetic Macau returns to Chinese rule in 1999. / Text by W.W. Williams / Photography by James Whitlow Delano

WHEN I FOUND IT IT WAS DEEMED THAT I should strive some useful purpose around the ranch, but I was too small to dig since (put help) or swing barbed wire. I couldn't even saddle my own horse. I rode Midnight—the sweater black Shetland next of the Mississippi—bareback until at my father said, I was loan enough to saddle him. So I ended up helping Cookie cast T her 2 inch cook wire, though shot as a hairless shore, could hack through a of of feet with a magic blow of his cleaver. Being Cookie's helper meant I sit and cleaned the table and washed the dirty dishes: a chore I still cannot stand.

But working with him proved beneficial. Within weeks I was hobbling next as Chinese Cookie's native Cantonese to be specific. The trouble was most of his words were not what could be called "fit for nice folks' ears." Many years must be though before I learned the full meaning of my new vocabulary. Just clear my 40th birthday, my father sent me on a heart's "take a look at," as he put it. I threw off a ship in San Francisco bound for Yokohama. I had long had the itch to travel, and what I've traced to see must arise the mysteries of the Middle

'East is East, and West is West, and never the twain shall meet," wrote Rudyard Kipling. But he was wrong. Evidently he forgot about Macau.

Kingdom. But by the time I got there in the 1980s, China was closed to so-called "glass people." Foreigner's outsiders. In 1982, Sun Yat-sen a doctor who had practiced in Macau and turned political agitator, overthrew the Qing (Ching) Manchu Dynasty, which had ruled from 1644 to 1911, and inaugurated the Republic of China. Then in 1949 Mao Zedong defeated Chiang Kai-shek and formed the People's Republic of China. In 1972, Portugal became the first Western nation to seek its agreement with the newly emerged China when it signed the Macau Cooperation Agreement.

So Macau was the closest I could get to China. I took the tepid double-decked ferry from Hong Kong—the same one that William Holden and Jennifer Jones met on in Love Is a Many-Splendored Thing. Hydrofoils, helicopters, and catamarans are not yet part of the scene, and James Bond (Agent 007 had yet to crack the Man with the Golden Gun in mysterious Macau. In those days one made the long ferry trip and around a week. Now-a-days you can pull off ove for dinner and gambling and be back in Hong Kong before midnight.

Upon arriving I stumped over to the Portas do Cerco (Barrier Gate), where I could reach between the narrow green

plastic and actually touch China. Today, thousands pass through the gate on their way to Guangzhou (Canton) and southern China's exotic sights.

Exotic sights though, had a different meaning for that wide-eyed teenager. The Portuguese doesn't fee red their following was performing a folk dance to portuguese Largo do Senado (Senate Square). She sweetly claimed me and I set, with no heart still pounding from my encounter with that Bristow

I was enthralled with Macau and everything in it. But it was more than human beauty that would draw me back to Macau time and again over the years. Since opening my new history book, I was always fascinated by the Age of Discovery and particularly by Vasco da Gama who in 1493 accomplished what Christopher Columbus had failed to do in 1492, open a sea route to the riches of the Orient. His monument stands at the two-mided garden at the center of Macau's Rua Bocare de Amaral and Calcada do Gois.

By 1557, six decades before the Pilgrims set foot on North America, Portuguese traders were anchored in Macau's Porto Exterior (Outer Harbor). The Mandarin of Canton ceded

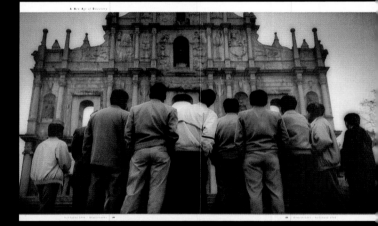

this tiny peninsula to the Portuguese as a reward for chasing out the pirates terrorizing the Pearl River Delta. No record of the transfer however, has ever been found. It was not until 1887, 40 years after England took over Hong Kong, that Macau and the islands of Taipa and Coloane were ceded by document to Portugal.

When the Portuguese landed in 1557 all they found was a small fishing village known to Hoy Kong and a temple to A-Ma the Chinese goddess of seamen and industrials. When the Portuguese asked the villagers the name of the place, they were told it was "A-Ma-Gau" (Bay of A-Ma), which they promptly corrupted to "Macau."

I have passed many hours in the Temple of A-Ma pondering Ama's early impenetrable tales. It stands on the top of the ravine peninsula, at the entrance to the Porto Interior (Inner Harbor). The prayer halls and pavilions built into boulder-strewn Barra Hill, run in winding paths through moss gates and mountain gardens. The results-domed stone has ruled at the entrance is a rendering of the junk that first carried the mythical Portuguese goddess A-Ma into the harbor. The upper

shrine, with its pleasure vista, of the Porto Interior Solitaire Kun Iam Tong, the Buddhist podest is a treaty. For me the best taste to visit is on the 25th day of the lunar new month lus Ap-che-Ma f, when the festival of A-Ma is celebrated.

But strangers to only part of Macau's story. There is also a shabby fort, Barford Kipling, and star "East is East, and West is West, and never the twains shall meet," but he was wrong because the times slid down over in Macau. It has this-worldly attraction seeing the Porto Interior. Yet, a few blocks around town had a fleet real-liner of ancient Chinese with the shallow Porto Interior beyond serving as home to a raft of junks, where thousands of Chinese live out their lives afloat.

The land among the best in Asia is favored by European, Chinese, and other volunteers. Macau's current thrives the paint of Barra with the ring of Africa, the spice of India, and the exterior milk of the Malay. Torqueis for one exhal night out of Macau to take Japanese cuisine by storm.

I was remaining on Macau's the pensioners one day along the lofty Coloa de Penha (Penha Hill). It was in that the 1960s, and I was living in Bangkok, Thailand though I

I pondered the lessons that Macau has taught me over the years. This unique cultural confluence has helped open my eyes to the world.

■ 456
Publication Hemispheres
Design Director Jaimey Easler
Art Directors Jaimey Easler, Jody Mustain, Kevin de Miranda
Photographer Sally Mann
Publisher Pace Communications
Client United Airlines
Issue April 1998
Category Reportage, Travel, Portraits/Story

■ 457
Publication Hemispheres
Design Director Jaimey Easler
Art Directors Jaimey Easler, Jody Mustain, Kevin de Miranda
Photographer James Whitlow Delano
Publisher Pace Communications

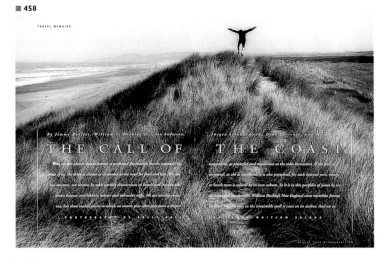

TRAVEL MEMOIRS

By Jimmy Buffett, William F. Buckley Jr., Ian Anderson, Jorgen ...

THE CALL OF THE COAST

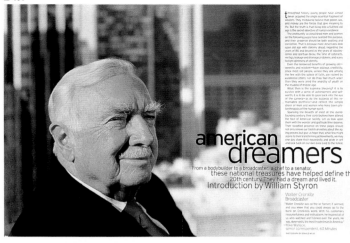

american dreamers

From a bodybuilder to a broadcaster, a chef to a senator,
these national treasures have helped define the
20th century. They had a dream and lived it.
Introduction by William Styron

Walter Cronkite
Broadcaster

Dale Earnhardt Jr.

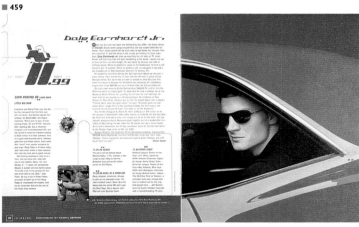

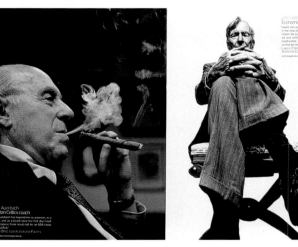

John Kenneth Galbraith
Economist

Red Auerbach
Boston Celtics coach

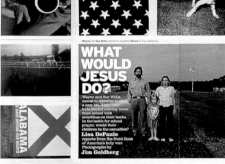

WHAT WOULD JESUS DO?

Wayne and Sue Willis ...
Photographed by Jim Goldberg

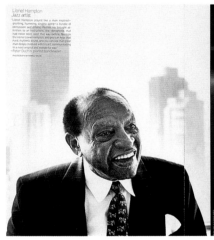

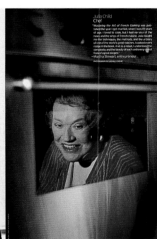

Lionel Hampton
Jazz artist

Julia Child
Chef

■ 458
Publication Hemispheres
Design Director Jaimey Easler
Art Directors Jaimey Easler,
Jody Mustain, Kevin de Miranda
Photographer Sally Gall
Publisher Pace Communications
Client United Airlines
Issue August 1998
Category
Reportage, Travel, Portraits/Spread

■ 459
Publication ESPN
Design Director F. Darrin Perry
Art Director Gabe Kuo
Photo Editor Axel Kessler
Photographer Darryl Estrine
Publisher Disney
Issue December 28, 1998
Category
Reportage, Travel, Portraits/Spread

■ 460
Publication George
Creative Director Matt Berman
Design Director Michele Tessler
Designer Paul Morris
Photo Editor Jennifer Miller
Photographer Jim Goldberg
Publisher
Hachette Filipacchi Magazines, Inc.
Issue November 1998
Category
Reportage, Travel, Portraits/Spread

■ 461
Publication George
Creative Director Matt Berman
Design Director Michele Tessler
Designer Kristi Norgaard
Photo Editor Jennifer Miller
Photographers Mario Sorrenti,
Platon, Donald Milne
Publisher
Hachette Filipacchi Magazines, Inc.
Issue July 1998
Category
Reportage, Travel, Portraits/Story

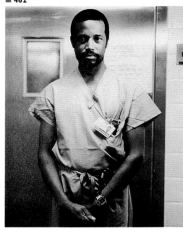

THIS IS
BRAIN SURGERY

BY CHUCK SALTER

Photographs by Andrew French

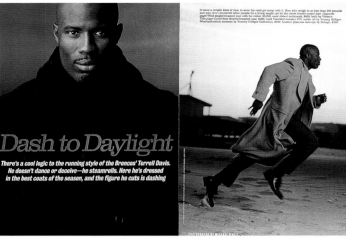

Dash to Daylight

There's a cool logic to the running style of the Broncos' Terrell Davis.
He doesn't dance or deceive—he steamrolls. Here he's dressed
in the best coats of the season, and the figure he cuts is dashing

Richard Barrett preaches the
gospel of spirituality in the
workplace—with a difference.
His approach is pragmatic,
quantifiable, and all business.

The New Spirit of Work

BY DAVID DORSEY

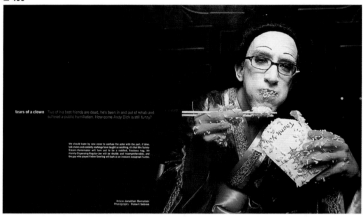

tears of a clown Two of his best friends are dead, he's been in and out of rehab and suffered a public humiliation. How come Andy Dick is still funny?

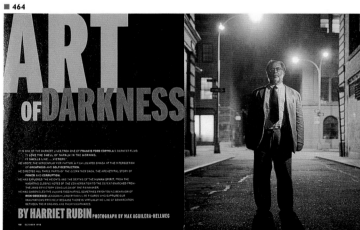

ART
OF DARKNESS

BY HARRIET RUBIN PHOTOGRAPH BY MAX AGUILERA-HELLWEG

■ 462
Publication Fast Company
Art Director Patrick Mitchell
Designer Patrick Mitchell
Photographer Andrew French
Publisher Fast Company
Issue February/March 1998
Category
Reportage, Travel, Portraits/Spread

■ 463
Publication Fast Company
Art Director Patrick Mitchell
Designer Patrick Mitchell
Photographer Karen Kuehn
Publisher Fast Company
Issue August 1998
Category
Reportage, Travel, Portraits/Spread

■ 464
Publication Fast Company
Art Director Patrick Mitchell
Designer Patrick Mitchell
Photographer
Max Aguilera-Hellweg
Publisher Fast Company
Issue October 1998
Category
Reportage, Travel, Portraits/Spread

■ 465
Publication GQ
Creative Director Jim Moore
Art Directors Kay Gibson,
George Moscahlades
Designer George Moscahlades
Photo Editor Karen Frank
Photographer Michael O'Neill
Publisher Condé Nast Publications Inc.
Issue September 1998
Category
Fashion, Beauty, Still Life, Interiors/Spread

■ 466
Publication Gear
Art Director Matt Guemple
Photographer Robert Sebree
Publisher Guccione Media
Issue November/December 1998
Category
Reportage, Travel, Portraits/Story

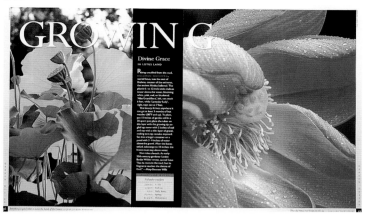

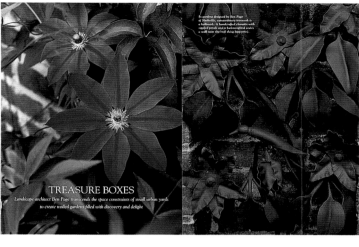

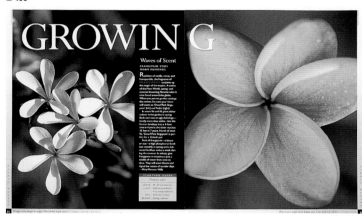

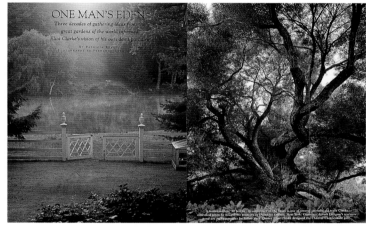

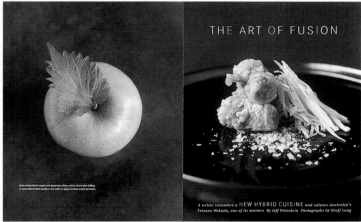

PHOTOGRAPHY MERIT ■

■ 467
Publication Garden Design
Creative Director Michael Grossman
Art Director Christin Gangi
Designer Christin Gangi
Photo Editor Lauren Hicks
Photographers Linny Morris
Cunningham, André Baranowski
Publisher Meigher Communications
Issue June/July 1998
Category
Reportage, Travel, Portraits/Spread

■ 468
Publication Garden Design
Creative Director Michael Grossman
Art Director Christin Gangi
Designer Christin Gangi
Photo Editor Lauren Hicks
Photographer Glenn Stokes
Publisher Meigher Communications
Issue December 1998/January 1999
Category
Reportage, Travel, Portraits/Spread

■ 469
Publication Food & Wine
Creative Director Stephen Scoble
Art Director Lou DiLorenzo
Designer Patricia Kelleher
Photo Editor Kim Gougenheim
Photographer Geoff Lung
Publisher
American Express Publishing Co.
Issue September 1998
Category Fashion, Beauty, Still Life,
Interiors/Spread

■ 470
Publication House Beautiful
Art Director Andrzej Janerka
Photographer John Hall
Publisher The Hearst Corporation-
Magazines Division
Issue May 1998
Category Fashion, Beauty, Still Life,
Interiors/Spread

■ 471
Publication House Beautiful
Art Director Andrzej Janerka
Photographer
Fernando Bengoechea
Publisher The Hearst Corporation-
Magazines Division
Issue November 1998
Category Fashion, Beauty, Still Life,
Interiors/Spread

■ 472
Publication Cigar Aficionado
Creative Director Martin Leeds
Art Director Lori A. Ende
Designer Nancy Smith
Photo Editor Bess Hecock Hauser
Photographer Zubin Shroff
Publisher
M. Shanken Communications Inc.
Issue December 1998
Category Fashion, Beauty, Still Life,
Interiors/Spread

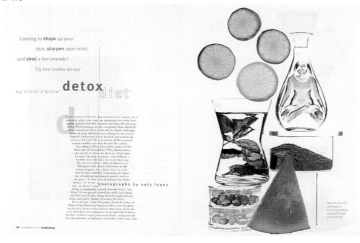

Looking to **shape** up your
skin, **sharpen** your mind,
and **shed** a few pounds?
Try two weeks on our

detox diet

by Trisha O'Brien

photographs by nola lopez

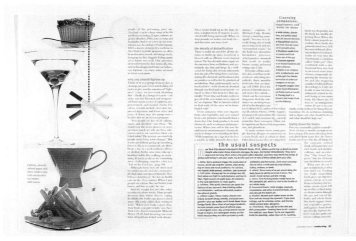

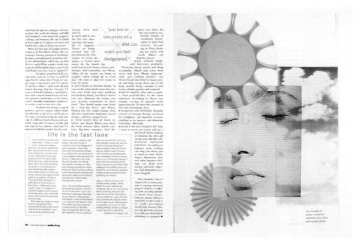

life in the fast lane

just one to
two weeks on a
detox diet can
make you feel
invigorated.

heavy petting
Your dogs will lap this up . . .

and so will you. Sit. Stay.

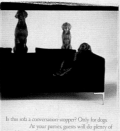

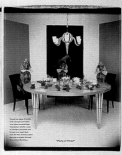

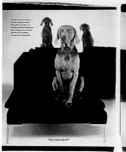

Is this sofa a conversation-stopper? Only for dogs.
At your parties, guests will do plenty of
chin-wagging over its clean, elegant lines

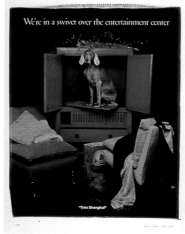

We're in a swivel over the entertainment center

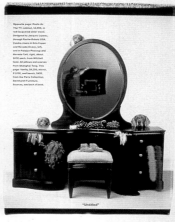

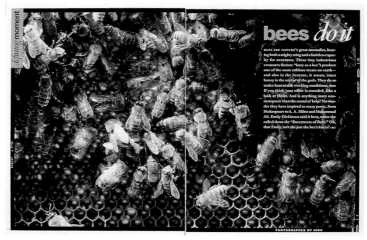

bees do it

PHOTOGRAPHED BY HIRO

■473
Publication Healthy Living
Art Director Gigi Fava
Designer Gigi Fava
Photographer Nola Lopez
Publisher The Hearst Corporation-
Magazines Division
Issue October 1998
Category Photo Illustration/Story

■474
Publication House & Garden
Art Director Diana LaGuardia
Designer Nancy Brooke Smith
Photo Editor Dana Nelson
Photographer William Wegman
Publisher Condé Nast Publications Inc.
Issue April 1998
Category Fashion, Beauty, Still Life, Interiors/Story

■475
Publication House & Garden
Art Director Diana LaGuardia
Photo Editor Dana Nelson
Photographer HIRO
Publisher Condé Nast Publications Inc.
Issue March 1998
Category Fashion, Beauty, Still Life, Interiors/Spread

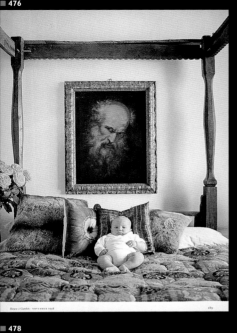

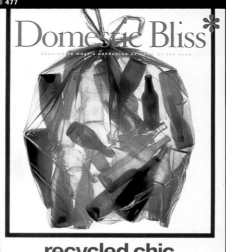

recycled chic

Whether it's **reviving vintage furniture** or retrofitting broken toasters, we're clearly obsessed with giving **everything in our homes** a second chance. The **recycling aesthetic** is having an impact on the design of kitchens, lamps, birdhouses, and vases. Also this month, getting high with **The 20-Minute Gardener**.

■476
Publication House & Garden
Art Director Diana LaGuardia
Designer Nancy Brooke Smith
Photo Editor Dana Nelson
Photographer Pieter Estersohn
Publisher Condé Nast Publications Inc.
Issue November 1998
Category Fashion, Beauty, Still Life, Interiors/Single Page

■477
Publication House & Garden
Art Director Diana LaGuardia
Designer Stephanie Sterling
Photo Editor Deborah Weisbach
Photographer Jay Zuckerkom
Publisher Condé Nast Publications Inc.
Issue June 1998
Category Fashion, Beauty, Still Life, Interiors/Single Page

PHOTOGRAPHY MERIT ■

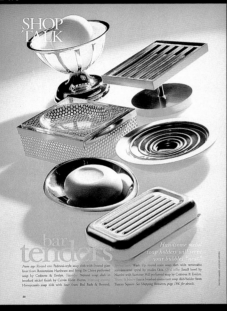

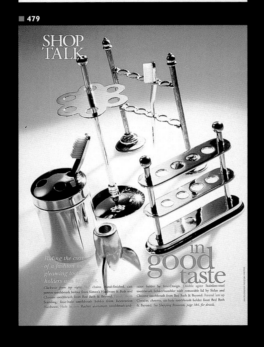

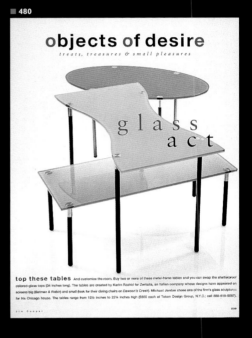

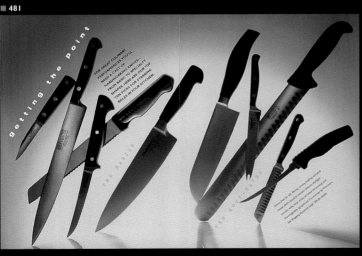

■481
Publication Home
Art Director Ragnar Johnsen
Designer Ragnar Johnsen
Photographer Nedjeljko Matura
Publisher Hachette Filipacchi Magazines, Inc.
Issue April 1998
Category Fashion, Beauty, Still Life, Interiors/Spread

■478
Publication Home
Art Directors Ragnar Johnsen, Ian Doherty
Designer Ian Doherty
Photographer Nedjeljko Matura
Publisher Hachette Filipacchi Magazines, Inc.
Issue April 1998
Category Fashion, Beauty, Still Life, Interiors/Single Page

■479
Publication Home
Art Directors Ragnar Johnsen, Ian Doherty
Designer Ian Doherty
Photographer Nedjeljko Matura
Publisher Hachette Filipacchi Magazines, Inc.
Issue April 1998
Category Fashion, Beauty, Still Life, Interiors/Single Page

■480
Publication InStyle
Art Director Paul Roelofs
Designer Garrett Yankou
Photo Editor Allyson M. Torrisi
Photographer Jim Cooper
Publisher Time Inc.
Issue November 1998
Category Fashion, Beauty, Still Life, Interiors/Single Page

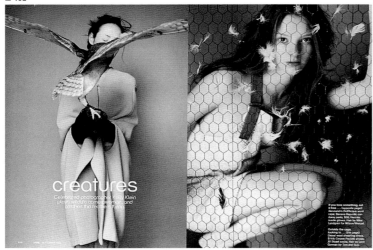

creatures

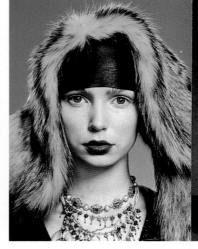

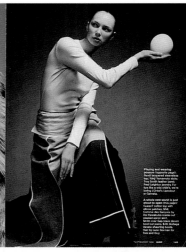

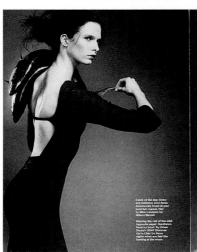

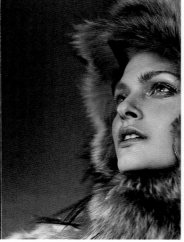

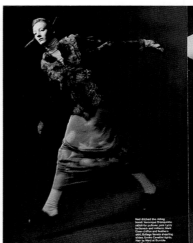

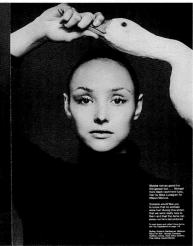

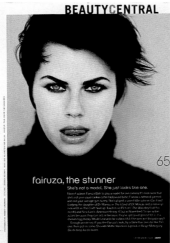

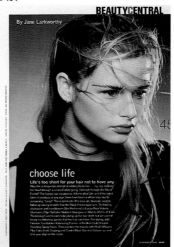

BEAUTYCENTRAL

fairuza, the stunner

BEAUTYCENTRAL
By Jane Larkworthy

choose life

I'LL BET
Acid brights will be in your closet next spring.

■ 482
Publication Jane
Art Director Johan Svensson
Designer Amy Demas
Photo Editor Cary Estes Leitzes
Photographer Kelly Klein
Publisher Fairchild Publications
Issue September 1998
Category Fashion, Beauty, Still Life, Interiors/Story

■ 483
Publication Jane
Art Director Johan Svensson
Designer Amy Demas
Photo Editor Cary Estes Leitzes
Photographer Robert Erdmann
Publisher Fairchild Publications
Issue September 1998
Category Fashion, Beauty, Still Life, Interiors/Single Page

■ 484
Publication Jane
Art Director Johan Svensson
Designer Amy Demas
Photo Editor Cary Estes Leitzes
Photographer Kelly Klein
Publisher Fairchild Publications
Issue November 1998
Category Fashion, Beauty, Still Life, Interiors/Single Page

■ 485
Publication Jane
Art Director Johan Svensson
Designer Amy Demas
Photo Editor Cary Estes Leitzes
Photographer Gerrit Scheurs
Publisher Fairchild Publications
Issue October 1998
Category Fashion, Beauty, Still Life, Interiors/Single Page

It's among the most scenic roads in the world—and one of the most sinister. ANGELES CREST HIGHWAY, and the surrounding national forest, is a devil's playpen of murderers, satanists, psychopaths and the suicidal. It's also a beautiful spot for a picnic. Just make sure to get home before sundown

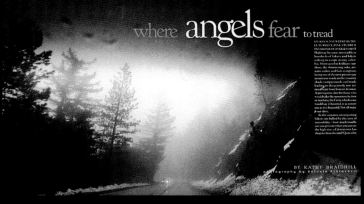

where angels fear to tread

BY KATHY BRAIDHILL
Photography by Antonin Kratochvil

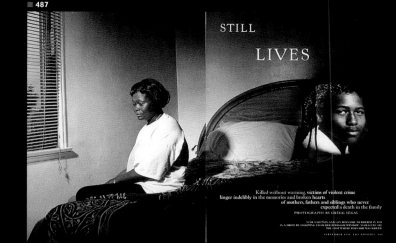

STILL

LIVES

Killed without warning, victims of violent crime linger indelibly in the memories and broken hearts of mothers, fathers and siblings who never expected a death in the family

PHOTOGRAPHS BY GREGG SEGAL

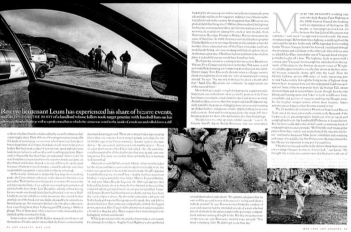

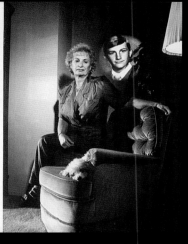

THIS CITY EXISTS TO DENY DEATH.

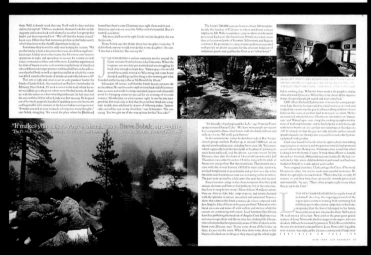

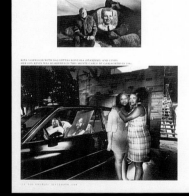

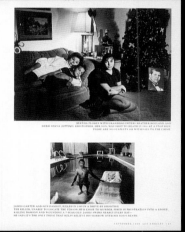

486
Publication Los Angeles
Creative Director David Armario
Designers Myla Sorensen, David Armario
Photo Editor Lisa Thackaberry
Photographer Antonin Kratochvil
Publisher Fairchild Publications
Issue May 1998
Categories Reportage, Travel, Portraits/Story
 A Reportage, Travel, Portraits/Spread

487
Publication Los Angeles
Creative Director David Armario
Designers David Armario, Myla Sorensen
Photo Editor Lisa Thackaberry
Photographer Gregg Segal
Publisher Fairchild Publications
Issue September 1998
Category Reportage, Travel, Portraits Story

488
Publication Los Angeles
Creative Directors David Armario, Dennis Freedman
Designer David Armario
Photographer Michael Thompson
Publisher Fairchild Publications
Issue March 1998
Category Reportage, Travel, Portraits Spread

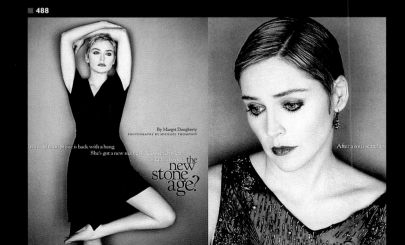

By Margot Dougherty
PHOTOGRAPHY BY MICHAEL THOMPSON

the new stone age?

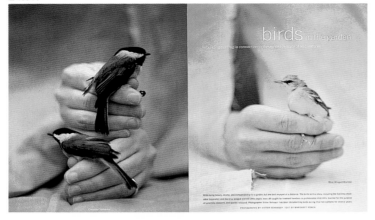

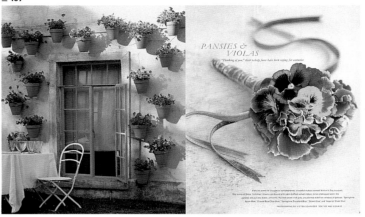

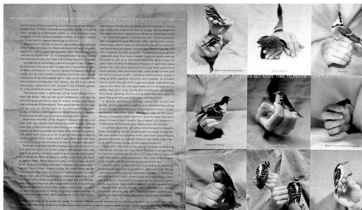

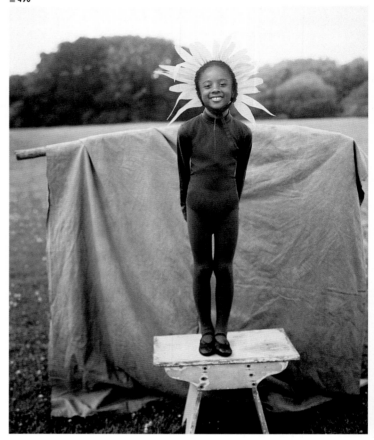

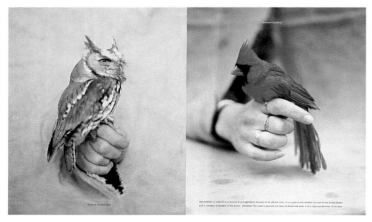

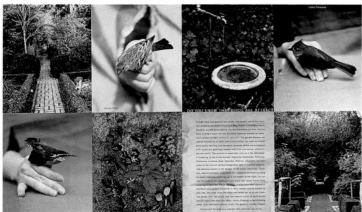

■ 488
Publication Martha Stewart Living
Design Director Eric A. Pike
Art Director Agnethe Glatved
Designers Agnethe Glatved, Michele Adams
Photo Editor Heidi Posner
Photographer Victor Schrager
Publisher Martha Stewart Living Omnimedia
Issue April 1998
Categories Fashion, Beauty, Still Life, Interiors/Story
 A Spread

■ 489
Publication Martha Stewart Living
Design Director Eric A. Pike
Designers Eric A. Pike, Hannah Milman
Photo Editor Heidi Posner
Photographer Victor Schrager
Publisher Martha Stewart Living Omnimedia
Issue May 1998
Category Fashion, Beauty, Still Life, Interiors/Spread

■ 490
Publication Martha Stewart Living
Design Director Eric A. Pike
Art Director James Dunlinson
Designers James Dunlinson, Jodi Levine
Photo Editor Heidi Posner
Photographer Victor Schrager
Publisher Martha Stewart Living Omnimedia
Issue October 1998
Category Reportage, Travel, Portraits/Single Page

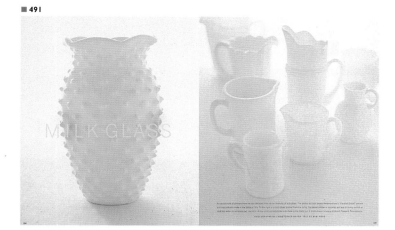

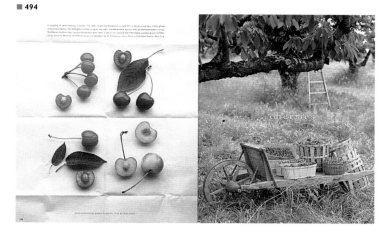

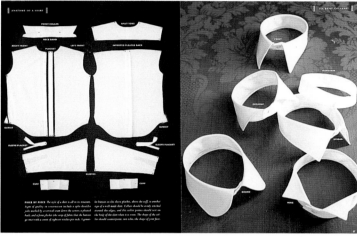

MARTHA BY MAIL
New Year 1999

FROM MARTHA STEWART LIVING 1-800-950-7130

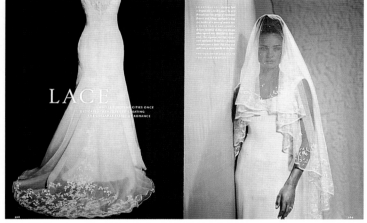

LACE

■ 491
Publication Martha Stewart Living
Design Director Eric A. Pike
Art Director Agnethe Glatved
Designers Agnethe Glatved, Fritz Karch
Photo Editor Heidi Posner
Photographer Christopher Baker
Publisher Martha Stewart Living Omnimedia
Issue July/August 1998
Category Fashion, Beauty, Still Life, Interiors/Spread

■ 492
Publication Martha Stewart Living
Creative Director Gael Towey
Art Director Scot Schy
Designer Scot Schy
Photo Editor Heidi Posner
Photographer Don Freeman
Publisher Martha Stewart Living Omnimedia
Issue Clotheskeeping
Category Fashion, Beauty, Still Life, Interiors/Spread

■ 493
Publication Martha Stewart Living
Design Director Eric A. Pike
Art Director Agnethe Glatved
Designers Agnethe Glatved, Rebecca Thuss
Photo Editor Heidi Posner
Photographer Jose Picayo
Publisher Martha Stewart Living Omnimedia
Issue Summer/Fall 1998
Category Fashion, Beauty, Still Life, Interiors/Spread

■ 494
Publication Martha Stewart Living
Design Director Eric A. Pike
Art Director James Dunlinson
Designer James Dunlinson
Photo Editor Heidi Posner
Photographer Maria Robledo
Publisher Martha Stewart Living Omnimedia
Issue June 1998
Category Fashion, Beauty, Still Life, Interiors/Spread

■ 495
Publication Martha By Mail
Art Director Debra Bishop
Designers Angie Gubler, Kristin Rees
Photo Editor Heidi Posner
Photographer Gentl + Hyers
Stylist Fritz Karch
Publisher Martha Stewart Living Omnimedia
Issue January 1999
Category Fashion, Beauty, Still Life, Interiors/Single Page

■ 496

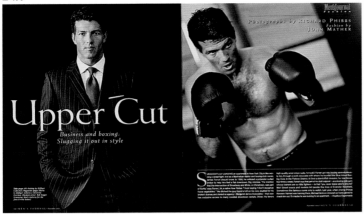

■ 497

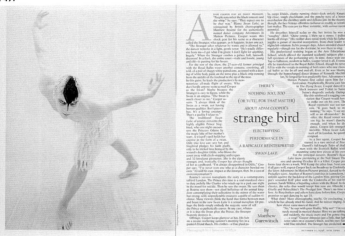

■ 498

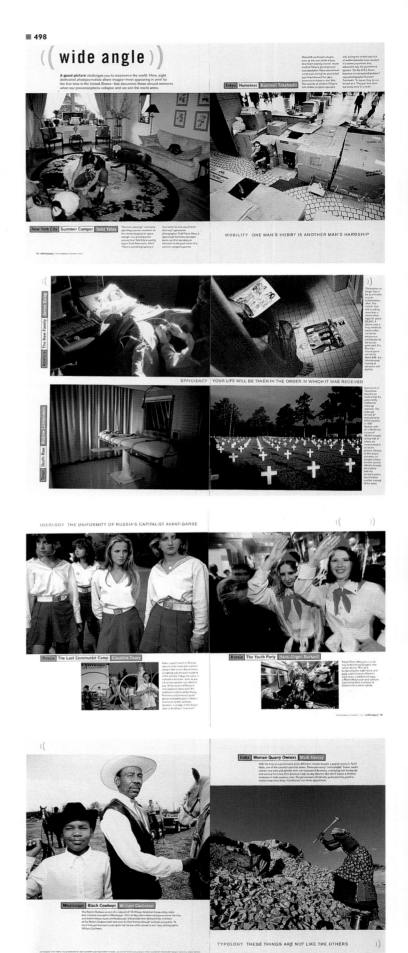

■ 496

Publication Men's Journal
Art Director Michael Lawton
Designer Michael Lawton
Photo Editor John Mather
Photographer Richard Phibbs
Publisher Wenner Media
Issue November 1998
Category Fashion, Beauty, Still Life, Interiors/Spread

■ 497

Publication New York
Design Director Mark Michaelson
Designer Anton Ioukhnovets
Photo Editor Margery Goldberg
Photographer Christian Witkin
Publisher Primedia Magazines Inc.
Issue October 12,1998
Category Reportage, Travel, Portraits/Spread

■ 498

Publication Mother Jones
Creative Director Rhonda Rubinstein
Designer Rhonda Rubinstein
Photo Editors Maren Levinson, Mary Schoenthaler
Photographers Todd Yates, Kuninori Takahashi, James Balog, Andrew Lichtenstein, Claudine Doury, Hans-Jürgen Burkard, William Cochrane, Mark Henley
Publisher Foundation for National Progress
Issue September/October 1998
Category Reportage, Travel, Portraits/Story

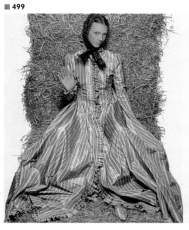

This season,
couture came down from
its lofty catwalk:
At Balmain, Dior, Gaultier,
Chanel and
Valentino, designers
presented
their collections
at close range. The operatic
proceedings and
the aloof glamour were gone,
replaced by extravagance
of a different kind –
straightforward,
sophisticated, sublime.

The Museum Show Has An Ego Disorder

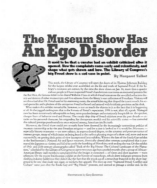

By Margaret Talbot

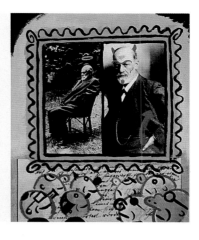

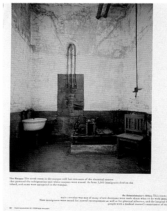

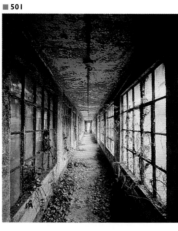

The Other Ellis Island

The court battle for bragging rights obscures an important fact:
Nearly half of this national treasure lies in ruins.
Photographs by Stephen Wilkes
Text by Clyde Haberman

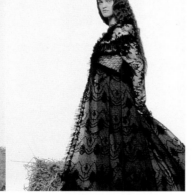

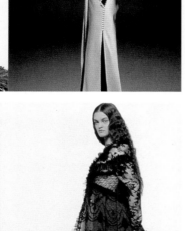

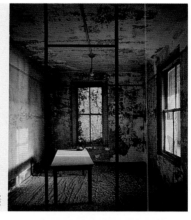

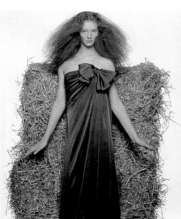

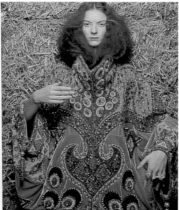

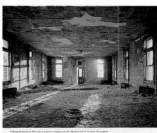

■ 500
Publication The New York Times Magazine
Art Director Janet Froelich
Designer Claudia Brandenburg
Illustrator Gary Baseman
Publisher The New York Times
Issue October 11, 1998
Category Photo Illustration/Spread

■ 499
Publication The New York Times Magazine
Art Director Janet Froelich
Designer Lisa Naftolin
Photographers Inez van Lamsweerde, Vinoodh Matadin
Publisher The New York Times
Issue March 29, 1998
Category Fashion, Beauty, Still Life, Interiors/Story

■ 501
Publication The New York Times Magazine
Art Director Janet Froelich
Designer Joele Cuyler
Photo Editor Kathy Ryan
Photographer Stephen Wilkes
Publisher The New York Times
Issue March 22, 1998
Category Reportage, Travel, Portraits/Story

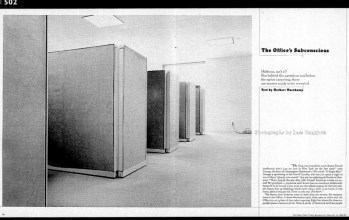

The Office's Subconscious

Hideous, isn't it?
But behind the partitions and below
the nylon carpeting, there
are secrets ready to be revealed.

Text by Herbert Muschamp

Photographs by Lars Tunbjörk

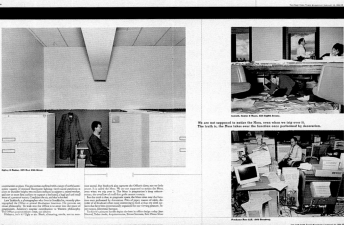

We are not supposed to notice the Mess, even when we trip over it.
The truth is, the Mess takes over the function once performed by decoration.

APPEARANCES

A
summer
getaway as near
SOAK UP THE ATMOSPHERE
as the bathroom
shelf.
BY MARY TANNEN

Photograph by Cleo Sullivan

The winner, without the desire to
make more money, is like a racing dog that has
finally caught up to the mechanical rabbit.

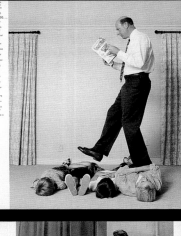

Photograph by Geof Kern

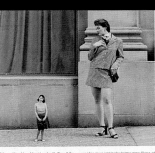

SHRUGGING AT THE BOOM
Where's The Outrage?

The little people may be eclipsed by big money,
but these days, protest is out of style. By Michael Kazin

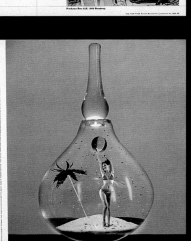

Photograph by Geof Kern

DAZED BY THE BOOM
Satisfaction Not Guaranteed

Money answers a question before it has been asked.
But without the question, how will we know what we think
is important? By Adam Phillips

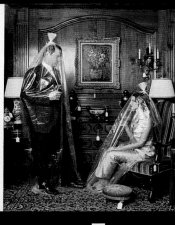

Photograph by Geof Kern

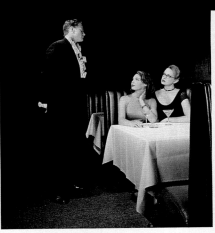

YAKKING UP THE BOOM
Money Mouth

Men, in particular, can't stop talking about it. By Quentin Crisp

Photograph by Geof Kern

THE NEW YORK TIMES MAGAZINE / JUNE 7, 1998

502
Publication The New York Times Magazine
Art Director Janet Froelich
Designer Joele Cuyler
Photo Editor Kathy Ryan
Photographer Lars Tunbjork
Publisher The New York Times
Issue January 18, 1998
Category Reportage, Travel, Portraits/Story

503
Publication The New York Times Magazine
Art Director Janet Froelich
Designer Andrea Fella
Photographer Cleo Sullivan
Publisher The New York Times
Issue August 16, 1998
Category Photo Illustration/Spread

504
Publication The New York Times Magazine
Art Director Janet Froelich
Designer Nancy Harris
Photo Editors Kathy Ryan, Sarah Harbutt
Photographer Geof Kern
Publisher The New York Times
Issue June 7, 1998
Category Reportage, Travel, Portraits/Story

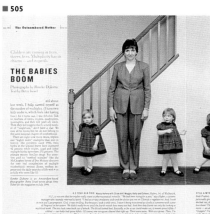

THE BABIES BOOM

Photographs by Rineke Dijkstra
Text by Betsy Israel

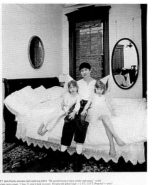

■ 507
Publication The New York Times Magazine
Art Director Janet Froelich
Designer Catherine Gilmore-Barnes
Photo Editor Kathy Ryan
Photographer Alexei Hay
Publisher The New York Times
Issue May 17, 1998
Category Reportage, Travel, Portraits/Story

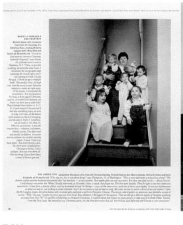

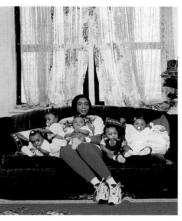

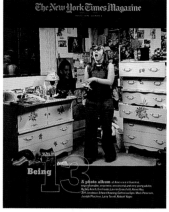

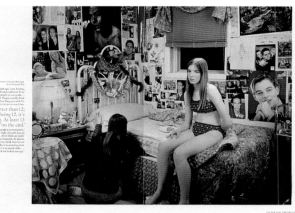

Do Not Disturb

Perhaps more than anywhere else, a 13-year-old's bedroom is the sanctuary where childhood and adolescence coexist.

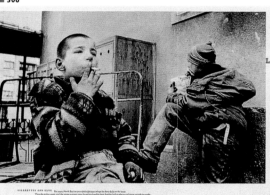

ROMANIA'S LOST BOYS

Photographs by Ettore Malanca
Text by Jane Perlez

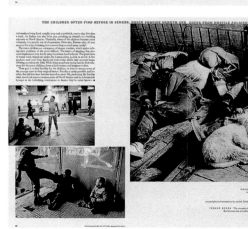

American Pastoral
Photographs by Larry Towell

PHOTOGRAPHY MERIT ■

■ 505
Publication The New York Times Magazine
Art Director Janet Froelich
Designer Catherine Gilmore-Barnes
Photo Editors Kathy Ryan, Sarah Harbutt
Photographer Rineke Dijkstra
Publisher The New York Times
Issue April 5, 1998
Category Reportage, Travel, Portraits/Story

■ 506
Publication The New York Times Magazine
Art Director Janet Froelich
Designer Claude Martel
Photo Editor Kathy Ryan
Photographer Ettore Malanca
Publisher The New York Times
Issue May 10, 1998
Category Reportage, Travel, Portraits/Story

■ 508
Publication The New York Times Magazine
Art Director Janet Froelich
Designer Catherine Gilmore-Barnes
Photo Editor Kathy Ryan
Photographer Larry Towell
Publisher The New York Times
Issue May 17, 1998
Category Reportage, Travel, Portraits/Spread

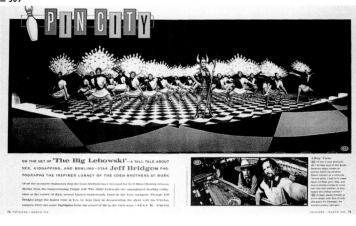

PIN CITY

ON THE SET OF 'The Big Lebowski'—A TALL TALE ABOUT
SEX, KIDNAPPING, AND BOWLING—STAR **Jeff Bridges** PHO-
TOGRAPHS THE INSPIRED LUNACY OF THE COEN BROTHERS AT WORK

"In a way, Los Angeles is sort of a character in the movie. You get a really good slice of L.A. life."

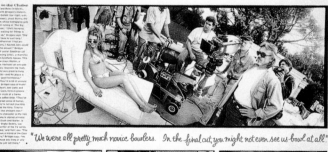

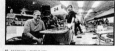

"We were all pretty much novice bowlers. In the final cut, you might not even see us bowl at all."

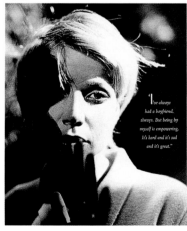

"I've always
had a boyfriend,
always. But being by
myself is empowering.
It's hard and it's sad
and it's great."

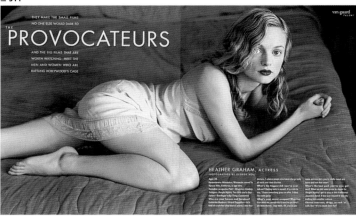

THEY MAKE THE SMALL FILMS
NO ONE ELSE WOULD DARE TO

THE PROVOCATEURS

AND THE BIG FILMS THAT ARE
WORTH WATCHING: MEET THE
MEN AND WOMEN WHO ARE
RATTLING HOLLYWOOD'S CAGE

van-guard

HEATHER GRAHAM, ACTRESS
PHOTOGRAPHED BY GEORGE HOLZ

CHRISTINE VACHON, PRODUCER
PHOTOGRAPHED BY BRUCE DAVIDSON

CHRIS ROCK, ACTOR-COMEDIAN
PHOTOGRAPHED BY EIKA AOSHIMA

A

KEVIN WILLIAMSON, SCREENWRITER
PHOTOGRAPHED BY NIGEL PARRY

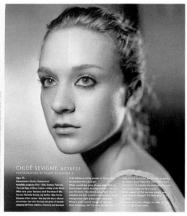

CHLOË SEVIGNY, ACTRESS
PHOTOGRAPHED BY FRANK OCKENFELS

VINCE VAUGHN, ACTOR

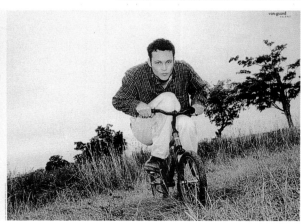

van-guard

■ 509
Publication Premiere
Art Director David Matt
Designer Erin Mayes
Photo Editor Chris Dougherty
Photographer Jeff Bridges
Publisher Hachette Filipacchi Magazines, Inc.
Issue March 1998
Category Reportage, Travel, Portraits/Story

■ 510
Publication Premiere
Art Director David Matt
Designer David Matt
Photo Editor Chris Dougherty
Photographer George Holz
Publisher Hachette Filipacchi Magazines, Inc.
Issue February 1998
Category Reportage, Travel, PortraitsSpread

■ 511
Publication Premiere
Art Director David Matt
Designer David Matt
Photo Editor Chris Dougherty
Photographers George Holz, Bruce Davidson, Eika Aoshima,
Nigel Parry, Frank W. Ockenfels 3, Andrew Macpherson,
Diego Uchitel, Michael Faye, Neil Davenport
Publisher Hachette Filipacchi Magazines, Inc.
Issue October 1998
Categories Reportage, Travel, Portraits/Story
 A Reportage, Travel, Portraits/Single page

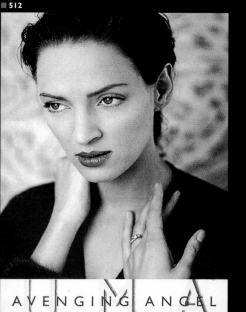

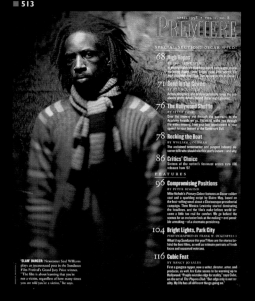

'SLAM' DANCER: Newcomer Saul Williams plays an incarcerated poet in the Sundance Film Festival's Grand Jury Prize winner. "The film is about learning that you're not a victim, regardless of how many times you are told you're a victim," he says.

Hollywoodland

DAVID STRICK'S HOLLYWOOD

On the set of "Tequila Body Shots," January 26, 1998, extras and mirror reflector for the "river of the soul" scene.

36 PREMIERE | MAY 1998

■ 516

POWER TOOL

BY MARK FEIRER

NO BATTERIES
Corded drills go harder, faster, longer and stronger

PHOTOGRAPHS BY ANTHONY COTSIFAS

27

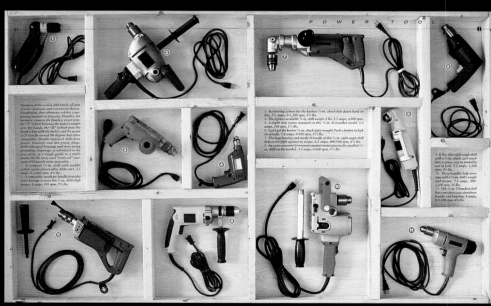

POWER TOOL

■ 512

Publication Premiere
Art Director David Matt
Designer David Matt
Photo Editor Chris Dougherty
Photographer Firooz Zahedi
Publisher Hachette Filipacchi Magazines, Inc.
Issue July 1998
Category Reportage, Travel, Portraits/Spread

■ 513

Publication Premiere
Art Director David Matt
Designer Erin Mayes
Photo Editor Chris Dougherty
Photographer Frank W. Ockenfels 3
Publisher Hachette Filipacchi Magazines, Inc.
Issue April 1998
Category Reportage, Travel, Portraits/Single Page

■ 514

Publication Premiere
Art Director David Matt
Designer Erin Mayes
Photo Editor Chris Dougherty
Photographer David Strick
Publisher Hachette Filipacchi Magazines, Inc.
Issue May 1998
Category Reportage, Travel, Portraits/Single Page

■ 515

Publication This Old House
Design Director Matthew Drace
Designer Bob O'Connell
Photographer Joe Yutkins
Publisher Time Inc.
Issue December 1998
Category Fashion, Beauty, Still Life, Interiors/Single Page

■ 516

Publication This Old House
Design Director Matthew Drace
Art Director Tim Jones
Photographer Anthony Cotsifas
Publisher Time Inc.
Issue January/February 1998
Category Fashion, Beauty, Still Life, Interiors/Spread

PHOTOGRAPHY MERIT ■

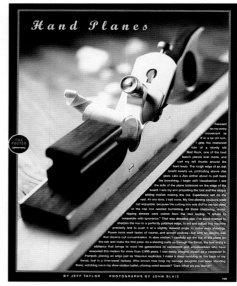

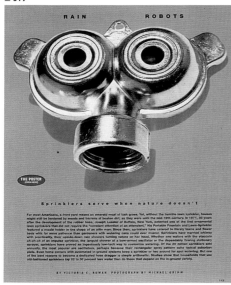

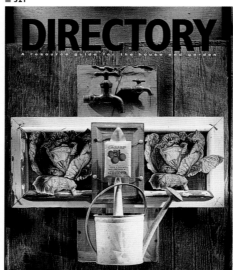

■ 518
Publication This Old House
Design Director Matthew Drace
Designer Bob O'Connell
Photographer Travis Ruse
Publisher Time Inc.
Issue March/April 1998
Category Fashion, Beauty, Still Life, Interiors/
Single Page

■ 519
Publication This Old House
Design Director Matthew Drace
Photographer Michael Grimm
Publisher Time Inc.
Issue June 1998
Category Fashion, Beauty, Still Life, Interiors/
Single Page

■ 520
Publication This Old House
Design Director Matthew Drace
Designer Bob O'Connell
Photographer Joe Yutkins
Publisher Time Inc.
Issue September/October 1998
Category Fashion, Beauty, Still Life, Interiors/
Single Page

■ 521
Publication This Old House
Design Director Matthew Drace
Art Director Tim Jones
Photographer Dominique Malatere
Publisher Time Inc.
Issue May 1998
Category Fashion, Beauty, Still Life, Interiors/
Single Page

■ 522
Publication This Old House
Design Director Matthew Drace
Designer Bob O'Connell
Photographer Travis Ruse
Publisher Time Inc.
Issue November 1998
Category Fashion, Beauty, Still Life, Interiors/
Single Page

■ 523
Publication This Old House
Design Director Matthew Drace
Designer Bob O'Connell
Photographer John Blais
Publisher Time Inc.
Issue December 1998
Category Fashion, Beauty, Still Life, Interiors/
Single Page

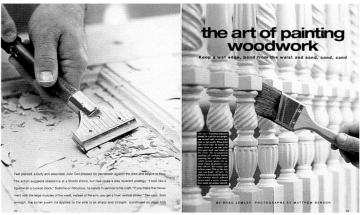

the art of painting woodwork
Keep a wet edge, bond from the waist and sand, sand, sand

Feet planted, a burly arm extended, John Dee presses his paintbrush against the door and begins to bow. The action suggests obeisance at a Shinto shrine, but Dee picks a less reverent analogy: "I look like a figurine on a cuckoo clock." Sublime or ridiculous, he bends in service to his craft. "If you make the movement with the large muscles of the waist, instead of the arm, you get a truer vertical stroke," Dee says. Sure enough, the ocher swath he applies to the stile is as sharp and straight *(continued on page 102)*

BY BRAD LEMLEY PHOTOGRAPHS BY MATTHEW BENSON

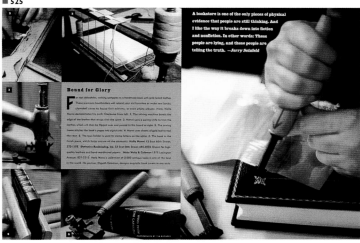

A bookstore is one of the only pieces of physical evidence that people are still thinking. And I like the way it breaks down into fiction and nonfiction. In other words: These people are lying, and these people are telling the truth. —*Jerry Seinfeld*

Bound for Glory

For real bibliophiles, nothing compares to a handmade book with gold-tooled leather...

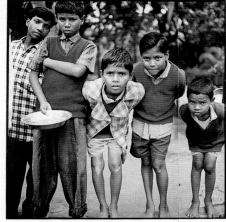

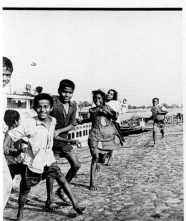

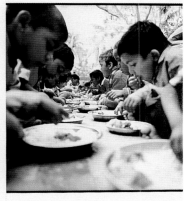

■ 524
Publication This Old House
Design Director Matthew Drace
Photographer Mathew Benson
Publisher Time Inc.
Issue June 1998
Category Fashion, Beauty, Still Life, Interiors/Spread

■ 525
Publication Quest
Creative Director Michael Grossman
Art Director Jeff Christensen
Designer Jeff Christensen
Photo Editor Catherine Talese
Photographer Tim Rhoades
Publisher Meigher Communications
Issue April 1998
Category Fashion, Beauty, Still Life, Interiors/Spread

■ 526
Publication Planeta Humano
Creative Director Pablo Olmos Adamowich
Designer Pablo Olmos Adamowich
Photo Editor Pablo Olmos Adamowich
Photographer Cesar Lucadamo
Publisher Planeta Humano S. L.
Issue March 1998
Category Reportage, Travel, Portraits/Story

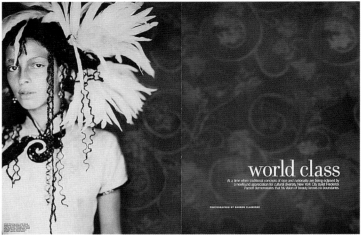

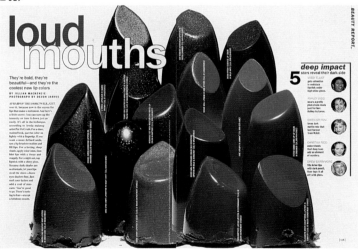

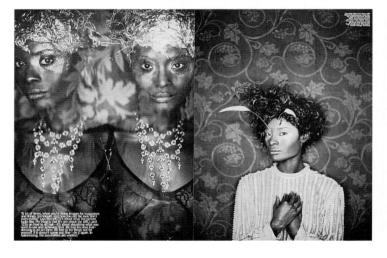

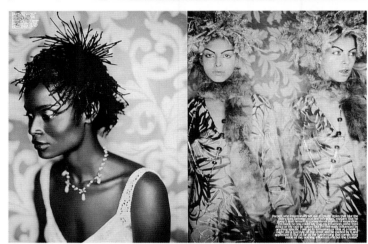

527
Publication The New Yorker
Creative Director Elisabeth Biondi
Photographer Max Vadukul
Publisher Condé Nast Publications Inc.
Issue December 14, 1998
Category Photo Illustration/Spread

528
Publication Athena
Creative Director Robb Allen
Art Director Guillaume Bruneau
Designer Gemma Figuracion
Photo Editor Andrea M. Jackson
Photographer Carlton Davis
Publisher Hachette Filipacchi Magazines, Inc.
Issue July/August 1998
Category Fashion, Beauty, Still Life, Interiors/=Spread

529
Publication Teen People
Creative Director Deirdre Koribanick
Designer Seema Christie
Photo Editor Anne Kilpatrick
Photographer Devon Jarvis
Publisher Time Inc.
Issue October 1998
Category Fashion, Beauty, Still Life, Interiors/Spread

530
Publication Salon News
Creative Director Victoria Maddocks
Design Director Jean Griffin
Designer Victoria Maddocks
Photo Editor Victoria Maddocks
Photographer Barron Claiborne
Publisher Fairchild Publications
Issue April 1998
Category Fashion, Beauty, Still Life, Interiors/Story

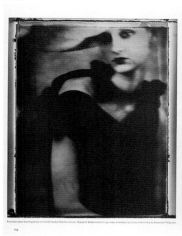

Artistic Soul

Designers look to the past to divine the future. Fashion by Patti Wilson. Photographs by Sarah Moon.

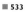

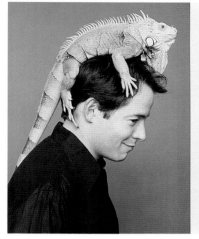

SCALING HOLLYWOOD

HE'S BEEN AN ADOLESCENT HERO. HE'S BEEN AN ACCLAIMED STAGE ACTOR. BUT IT'S THE GODZILLA MARKETING MACHINE THAT MAY MAKE MATTHEW BRODERICK A HOLLYWOOD HEADLINER. BY CHRIS DOWNEY • PHOTOGRAPHS BY CHRIS BUCK

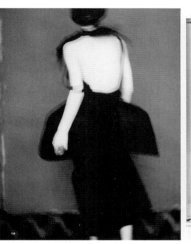

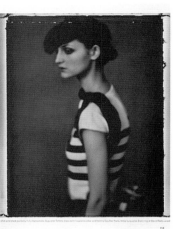

Dharma's Karma

JENNA ELFMAN is the CEO of her own domain. And with movie stardom around the corner, it's an endeavor with big growth potential. By Robert La Franco • Photographs by Andrew Eccles

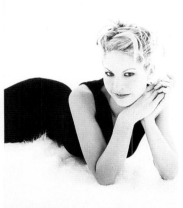

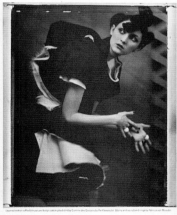

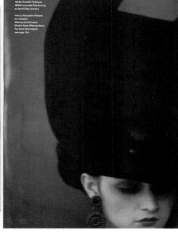

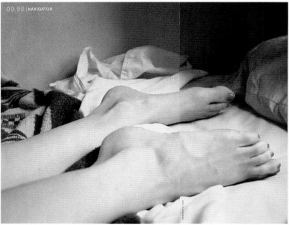

09.98 | NAVIGATOR

FOOT FETISH

<div style="page-margin">PHOTOGRAPHY MERIT ■</div>

■ 531
Publication Out
Art Director George Karabotsos
Designer George Karabotsos
Photo Editors Stefan Campbell, Patti Wilson
Photographer Sarah Moon
Fashion Editors Stefan Campbell, Patti Wilson
Publisher Out Publishing Inc.
Issue April 1998
Category Fashion, Beauty, Still Life, Interiors/Story

■ 532
Publication Out
Creative Director Dan Lori
Art Director Ethan Trask
Designer Ethan Trask
Photo Editor Ayanna Quint
Photographer A. L. Steiner
Publisher Out Publishing Inc.
Issue September 1998
Category Fashion, Beauty, Still Life, Interiors/Spread

■ 533
Publication P. O. V.
Design Director Florian Bachleda
Designers Florian Bachleda, Pino Impastato
Photographer Chris Buck
Publisher BYOB/Freedom Ventures, Inc.
Issue June/July 1998
Category Reportage, Travel, Portraits/Spread

■ 534
Publication P. O. V.
Design Director Florian Bachleda
Designer Jesse Marinoff Reyes
Photographer Andrew Eccles
Publisher BYOB/Freedom Ventures, Inc.
Issue December 1998
Category Reportage, Travel, Portraits/Spread

■ 535

■ 538

■ 536

JOHN LEE HOOKER

THE ORIGINAL MACK DADDY, JOHN LEE HOOKER represents the funkiest lowdown essence of the blues. Born in the Mississippi Delta in 1917, Hooker was a player at nearly every stage of the music's progression. He cut electric blues for many labels – including Chicago's Chess imprint – during the early to mid-Fifties. He also became a staple on the coffeehouse circuit, playing unplugged during the folk-blues revival of the early Sixties, and he was championed by Bob Dylan and Joan Baez. He recorded with the blues-rock group Canned Heat in 1970 and helped fuel the late-Eighties blues revival with his Grammy-winning *The Healer*, an all-star session featuring Bonnie Raitt, Carlos Santana and Robert Cray. In person, Hooker is charming and otherworldly. He arrives at his manager's office decked out in a dark suit, a hat, shades and star-spangled suspenders.

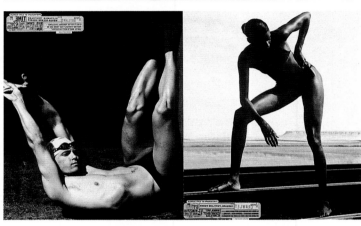

■ 537

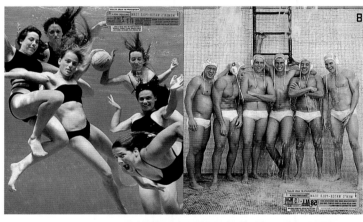

MUSIC AND THE MUSIC WAS SO GOOD

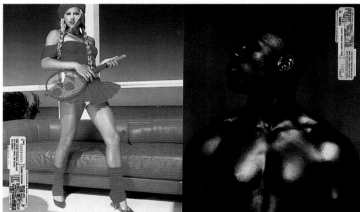

■ 535

Publication Rolling Stone
Art Director Fred Woodward
Designer Fred Woodward
Photo Editor Rachel Knepfer
Photographer Sam Jones
Publisher Straight Arrow Publishers
Issue April 30, 1998
Category Reportage, Travel, Portraits/Spread

■ 536

Publication Rolling Stone
Art Director Fred Woodward
Designer Hannah McCaughey
Photo Editor Fiona McDonagh
Photographer Mary Ellen Mark
Publisher Straight Arrow Publishers
Issue May 28, 1998
Category Reportage, Travel, Portraits/Spread

■ 537

Publication Rolling Stone
Art Director Fred Woodward
Designers Fred Woodward,
Hannah McCaughey
Photo Editor Rachel Knepfer
Photographer Kurt Markus
Publisher Straight Arrow Publishers
Issue September 3, 1998
Category Reportage, Travel, Portraits/Spread

■ 538

Publication Rolling Stone
Art Director Fred Woodward
Designer Hannah McCaughey
Photo Editors Rachel Knepfer, Fiona McDonagh
Photographers David LaChapelle, Kurt Markus,
Mark Seliger, Ruven Afanador
Publisher Straight Arrow Publishers
Issue June 11, 1998
Category Reportage, Travel, Portraits/Story

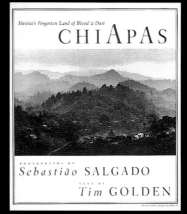

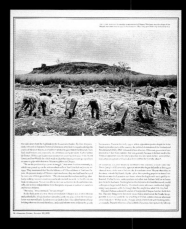

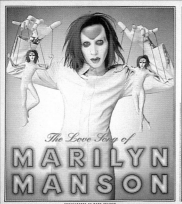

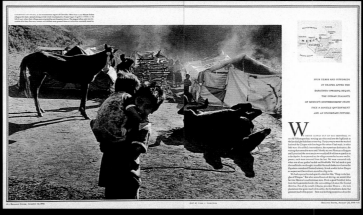

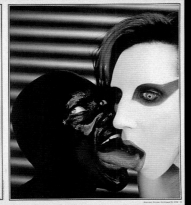

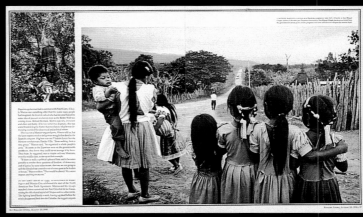

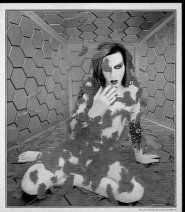

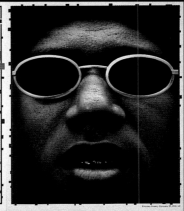

PHOTOGRAPHY MERIT ■

■ 539
Publication Rolling Stone
Art Director Fred Woodward
Designer Siung Tjia
Photo Editor Rachel Knepfer
Photographer Dan Winters
Publisher Straight Arrow Publishers
Issue October 1, 1998
Category Photo Illustration/Spread

■ 540
Publication Rolling Stone
Art Director Fred Woodward
Designer Siung Tjia
Photo Editor Rachel Knepfer
Photographer Mark Seliger
Publisher Straight Arrow Publishers
Issue October 15, 1998
Categories Reportage, Travel, Portraits/Story
Spread

■ 541
Publication Rolling Stone
Art Director Fred Woodward
Photo Editor Rachel Knepfer
Photographer Sebastião Salgado
Publisher Straight Arrow Publishers
Issue August 20, 1998
Category
Reportage, Travel, Portraits/Story

■ 542
Publication Rolling Stone
Art Director Fred Woodward
Designer Gail Anderson
Photo Editor Rachel Knepfer
Photographer Matt Mahurin
Publisher Straight Arrow Publishers
Issue October 29, 1998
Category Photo Illustration/Spread

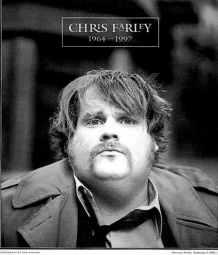

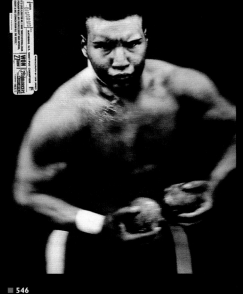

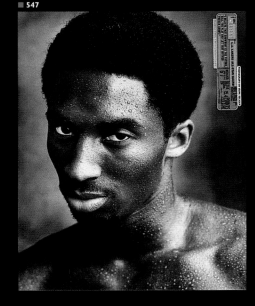

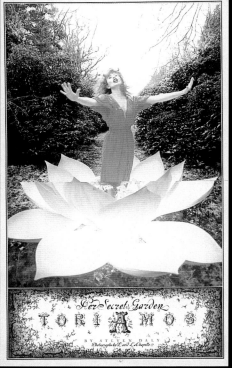

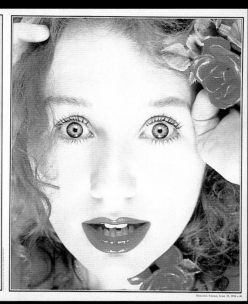

YOU ARE TORI AMOS.

Year after year you've opened a vein for your public, serving up for their consumption every painful detail of your personal life, including your own rape. Despite the fact that your very own father is a Methodist minister, you've stared down the Christian patriarchy and offered listeners the escape of a mythical, pagan, faerie world. You have given till it hurts in interviews and sung your lungs out in hundreds of live shows a year – critics call you "sensuous," "electrifying" and "possessed," and fans flood backstage for your healing touch. Yes, you're all that, plus tax. You're sometimes dismissed as an ineffectual sprite, but you've managed to rally major corporate fund-

■ 543
Publication Rolling Stone
Art Director Fred Woodward
Photo Editor Rachel Knepfer
Photographer Dan Winters
Publisher Straight Arrow Publishers
Issue February 5, 1998
Category Reportage, Travel, Portraits/Single Page

■ 544
Publication Rolling Stone
Art Director Fred Woodward
Designer Hannah McCaughey
Photo Editors Rachel Knepfer, Fiona McDonagh
Photographer Sam Jones
Publisher Straight Arrow Publishers
Issue June 11, 1998
Category Reportage, Travel, Portraits/Single Page

■ 545
Publication Rolling Stone
Art Director Fred Woodward
Designer Hannah McCaughey
Photo Editors Rachel Knepfer, Fiona McDonagh
Photographer Mark Seliger
Publisher Straight Arrow Publishers
Issue June 11, 1998
Category Reportage, Travel, Portraits/Single Page

■ 546
Publication Rolling Stone
Art Director Fred Woodward
Designers Fred Woodward, Gail Anderson
Photo Editor Rachel Knepfer
Photographer David LaChapelle
Publisher Straight Arrow Publishers
Issue June 25, 1998
Category Reportage, Travel, Portraits/Story

■ 547
Publication Rolling Stone
Art Director Fred Woodward
Designers Fred Woodward, Gail Anderson
Photo Editor Rachel Knepfer
Photographer Mark Seliger
Publisher Straight Arrow Publishers
Issue May 28, 1998
Category Reportage, Travel, Portraits/Single Page

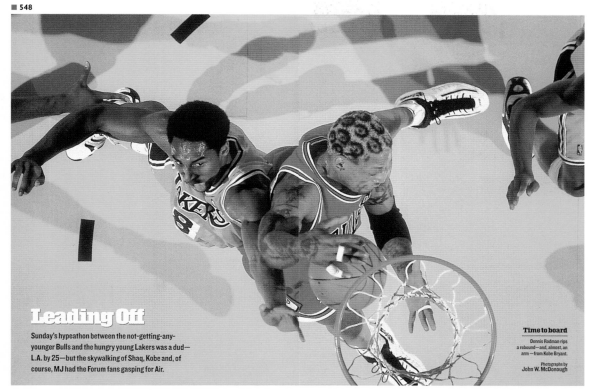

Leading Off

Sunday's hypeathon between the not-getting-any-younger Bulls and the hungry young Lakers was a dud—L.A. by 25—but the skywalking of Shaq, Kobe and, of course, MJ had the Forum fans gasping for Air.

Time to board
Dennis Rodman rips a rebound—and, almost, an arm—from Kobe Bryant.
Photographs by John W. McDonough

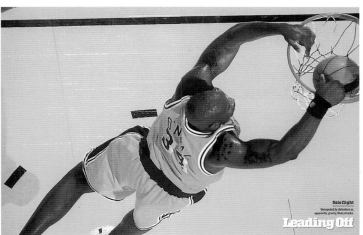

Solo flight
Leading Off

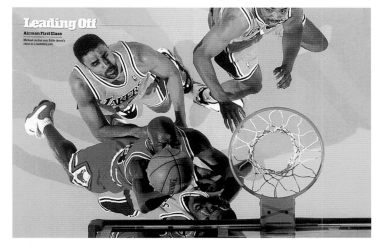

Leading Off
Airman First Class
Michael Jordan uses Eddie Jones's chest as a launching pad.

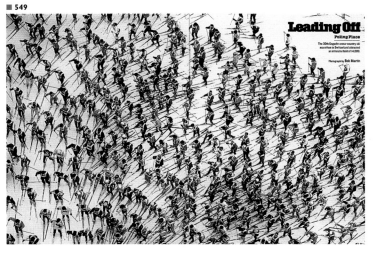

Leading Off
Poling Place

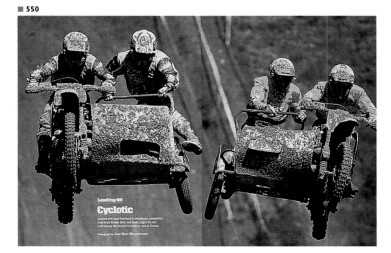

Leading Off
Cyclotic

■ 548
Publication Sports Illustrated
Creative Director Steven Hoffman
Designers Steven Hoffman, Samantha Gubbey
Photographer John W. McDonough
Publisher Time Inc.
Issue February 9, 1998
Category Reportage, Travel, Portraits/Story

■ 549
Publication Sports Illustrated
Creative Director Steven Hoffman
Designers Steven Hoffman, Meera Kothari
Photographer Bob Martin
Publisher Time Inc.
Issue March 16, 1998
Category Reportage, Travel, Portraits/Spread

■ 550
Publication Sports Illustrated
Creative Director Steven Hoffman
Designers Steven Hoffman, Meera Kothari
Photographer Jean Marc Mouchet
Publisher Time Inc.
Issue June 8, 1998
Category Reportage, Travel, Portraits/Spread

THIS LAND IS WHOSE LAND ?

Should the rich and powerful Mashantucket Pequots be allowed to expand their Connecticut reservation against their neighbors' wishes? by STEVE KEMPER

46

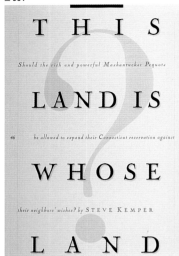

RAA members (l. r.): Del Knight, T. J. Wadecki, Gerald Drury, Madeline Jeffery, Fred and Janice Ricciolis (inset, with grandson Scotty), Larry Greene, Jason, Sharon, and Tom Wadecki.

> Once Governor John Rowland entered office, however, he began WONDERING aloud how anyone could oppose a casino that SWELLED the state's coffers by $150 million a year.

JOHN ROWLAND
Governor of Connecticut

> A recent Senate investigation suggested a LINK between the Pequots' generosity to the Democratic National Committee — more than $800,000 in DONATIONS — and Interior Secretary Bruce Babbitt's favorable attention.

BRUCE BABBITT
U.S. Interior Secretary

Into the *(continued on page 120)*

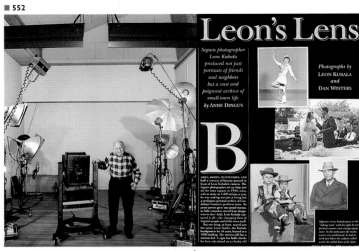

Leon's Lens

Seguin photographer Leon Kubala produced not just portraits of friends and neighbors but a vast and poignant archive of small-town life. by ANNE DINGUS

Photographs by LEON KUBALA *and* DAN WINTERS

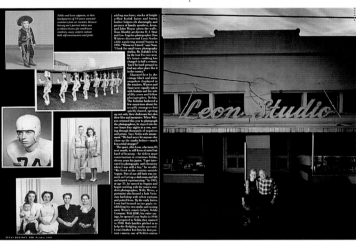

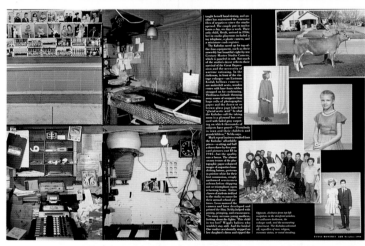

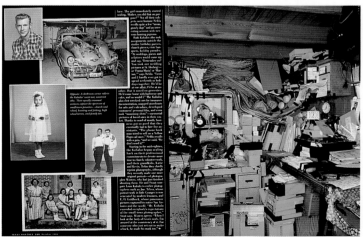

■ 551
Publication Yankee
Art Director J. Porter
Photo Editor Ann Card
Photographer Doug Mindell
Publisher Yankee Publishing Inc.
Issue September 1998
Category Photo Illustration/Story

■ 552
Publication Texas Monthly
Creative Director D. J. Stout
Designers D. J. Stout, Nancy McMillen
Photo Editor D. J. Stout
Photographer Dan Winters
Publisher Emmis Communications Corp.
Issue October 1998
Category Reportage, Travel, Portraits/Story

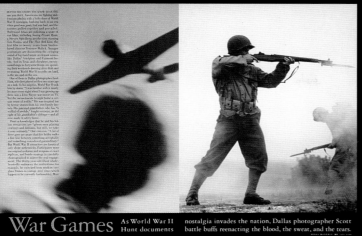

War Games
As World War II
Hunt documents
nostalgia invades the nation, Dallas photographer Scott battle buffs reenacting the blood, the sweat, and the tears.

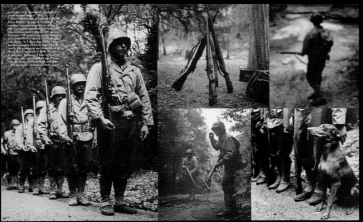

G.I. Joe Bob: Weekend warriors execute formation drills and undertake reconnaissance missions on private land outside Dallas.

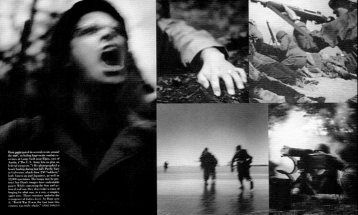

Fans of Iwo Jima: Generations removed from the real drama, World War II aficionados create their own Pacific and European theaters.

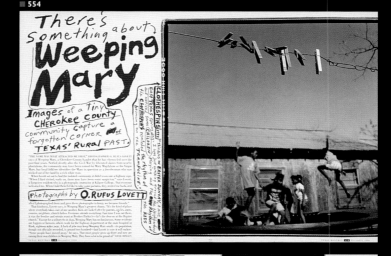

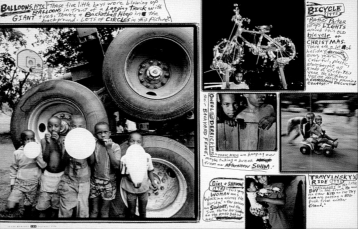

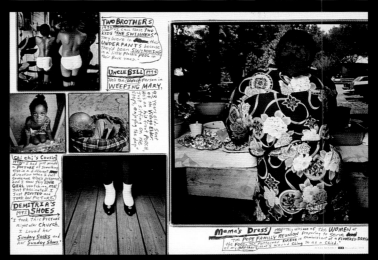

PHOTOGRAPHY MERIT ■

■ 553
Publication Texas Monthly
Creative Director D. J. Stout
Designers D. J. Stout, Nancy McMillen
Photo Editor D. J. Stout
Photographer Scott Hunt
Publisher Emmis Communications Corp.
Issue July 1998
Category Reportage, Travel, Portraits/Story

■ 554
Publication Texas Monthly
Creative Director D. J. Stout
Designers D. J. Stout, Nancy McMillen
Photo Editor D. J. Stout
Photographer O. Rufus Lovett
Publisher Emmis Communications Corp.
Issue December 1998
Category Reportage, Travel, Portraits/Story

groovy!

There's a youthquake going on in the north of Englan

Ground zero: Manchester and Liverpc

by philip watson · photographed by martin morrell

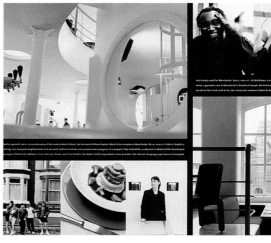

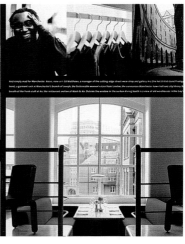

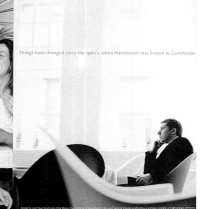

manchester and liverpool

As an unapologetically superior Londoner, I have come to Manchester and Liverpool

the designer dozen: 12 scene-stealing bars

In a former car showroom, Liverpool's best new restaurant veers toward the creative

Saturday nights, as many as 3,000 ravers from all over the north of England flock to Creation

Things have changed since the 1980's, when Manchester was known as Gunchester

In the Company of Men

His favorite scene is in

A ROUND OF GOLF WITH A CRAZED, MISOGYNISTIC WOMANIZER OR JUST A GUY WHO LOVES HIS PUPPY—YOU PICK

By Pat Jordan

PHOTOGRAPHS BY FRANK W. OCKENFELS 3

■ 555

Publication Travel & Leisure
Creative Director Pamela Berry
Designer Pamela Berry
Photo Editor Jim Franco
Photographer Martin Morrell
Publisher American Express Publishing Co.
Issue October 1998
Category Reportage, Travel, Portraits/Story

■ 556

Publication Travel & Leisure Golf
Design Director Tom Brown
Art Director Dirk Barnett
Designer Tom Brown
Photo Editor Sheryl Olson
Photographer Frank W. Ockenfels 3
Publisher American Express
Publishing Co.
Issue September/October 1998
Category Reportage, Travel, Portraits/Spread

■ 557

Publication Travel & Leisure Golf
Design Director Tom Brown
Art Director Dirk Barnett
Designer Dirk Barnett
Photo Editor Sheryl Olson
Photographer Philip Newton
Publisher American Express Publishing Co.
Issue March/April 1998
Category Reportage, Travel, Portraits/Story

■ 558

Publication Travel & Leisure Golf
Design Director Tom Brown
Designer Tom Brown
Photo Editor Sheryl Olson
Photographer Tom Tavee
Publisher American Express Publishing Co.
Issue May/June 1998
Category Reportage, Travel, Portraits/Story

golfing amid the troubles

FOR TRUE LINKS GOLF DEVOTEES, DRAWN TO THE COURSES
OF NORTHERN IRELAND & SWALLOWS TO
CAPISTRANO, HAZARDS OF WAR ARE THE EASY ONES

by John F. Stacks
PHOTOGRAPHS BY PHILIP NEWTON

Death of a Swinger

THE USGA'S IRON BYRON GOES THE WAY OF ALL FLESH, AS
AUTOMATION EATS ITS YOUNG

By Eric Levin

PHOTOGRAPHS BY TOM TAVEE

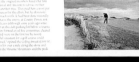

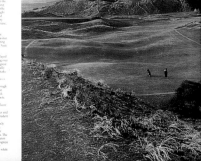

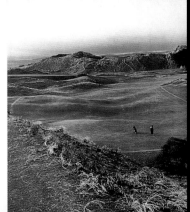

queen
Latifah

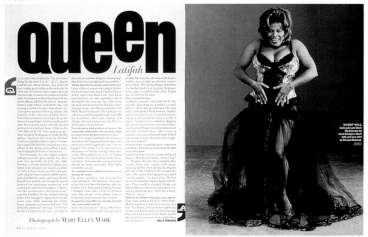

Photograph by MARY ELLEN MARK

meg

By Johanna Schneller

PHOTOGRAPHS BY
Matthew Rolston

Fire 'n' nice: Behind
the angelic grin
lies a woman who
has learned the
hard way where to
find strength and
how to be happy

Ryan

Jon Bon Jovi
As the frontman for one of the most
successful hair bands in America, he got fame. Now, as a
leading man in Hollywood, he's finally getting respect.

photographs by ROBERT MAXWELL

Rosie
O'DONNELL

A Riot
Blooms:
America's
favorite talk-
show host
has made
congenitality
radical. But
how does
this working
mom handle
her own
burgeoning
fame?

BY
Johanna
Schneller

PHOTOGRAPHS BY
Mark
Seliger

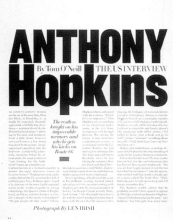

ANTHONY
Hopkins
By Tom O'Neill THE US INTERVIEW

Photograph By LEN IRISH

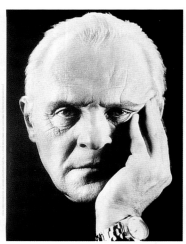

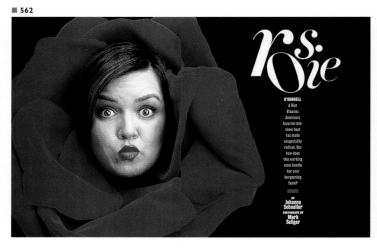

RENE RUSSO MEL GIBSON

Mel Gibson gets Rene Russo to fess up about a long-term crush,
a certain actor's kissing style and the trauma of being the most
unpopular girl in high school. PHOTOGRAPH BY MATTHEW ROLSTON

■ 559
Publication US
Art Director Richard Baker
Photo Editor Jennifer Crandall
Photographer Mary Ellen Mark
Publisher US Magazine Co., L. P.
Issue March 1998
Category Reportage, Travel,
Portraits/Spread

■ 560
Publication US
Art Director Richard Baker
Photo Editor Jennifer Crandall
Photographer Matthew Rolston
Publisher US Magazine Co., L. P.
Issue April 1998
Category Reportage, Travel,
Portraits/Spread

■ 561
Publication US
Art Director Richard Baker
Designer Rina Migliaccio
Photo Editor Jennifer Crandall
Photographer Robert Maxwell
Publisher US Magazine Co., L. P.
Issue April 1998
Category Reportage, Travel,
Portraits/Spread

■ 562
Publication US
Art Director Richard Baker
Designer Rina Migliaccio
Photo Editor Jennifer Crandall
Photographer Mark Seliger
Publisher US Magazine Co., L. P.
Issue February 1998
Category Reportage, Travel,
Portraits/Spread

■ 563
Publication US
Art Director Richard Baker
Designer Rina Migliaccio
Photo Editors Jennifer Crandall,
Rachel Knepfer
Photographer Len Irish
Publisher US Magazine Co., L. P.
Issue February 1998
Category Reportage, Travel,
Portraits/Spread

■ 564
Publication US
Art Director Richard Baker
Photo Editor Jennifer Crandall
Photographer Matthew Rolston
Publisher US Magazine Co., L. P.
Issue July 1998
Category Reportage, Travel,
Portraits/Spread

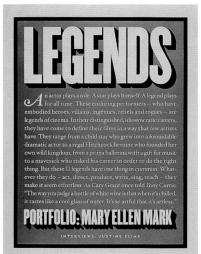

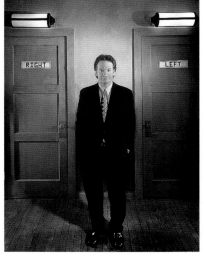

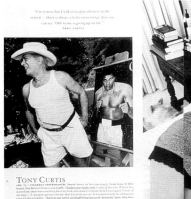

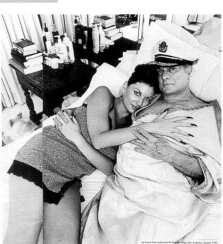

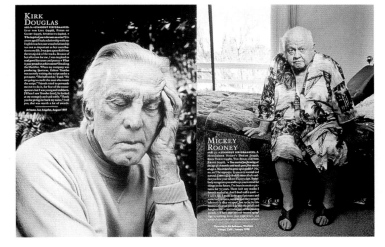

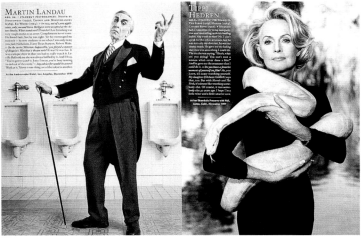

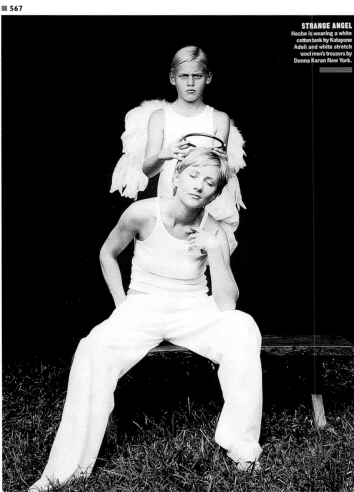

STRANGE ANGEL
Heche is wearing a white cotton tank by Katayone Adeli and white stretch wool men's trousers by Donna Karan New York.

<div style="text-align: right">PHOTOGRAPHY MERIT ■</div>

■ 566
Publication US
Art Director Richard Baker
Designer Rina Migliaccio
Photo Editors Jennifer Crandall, T. Brittain Stone
Photographer Dan Winters
Publisher US Magazine Co., L. P.
Issue April 1998
Category Reportage, Travel, Portraits/Single Page

■ 565
Publication US
Art Director Richard Baker
Photo Editors Jennifer Crandall, Rachel Knepfer, Kathy McCarver
Photographer Mary Ellen Mark
Publisher US Magazine Co., L. P.
Issue May 1998
Category Reportage, Travel, Portraits/Story

■ 567
Publication US
Art Director Richard Baker
Designer Rina Migliaccio
Photo Editor Jennifer Crandall
Photographer Robert Maxwell
Publisher US Magazine Co., L. P.
Issue February 1998
Category Reportage, Travel, Portraits/Single Page

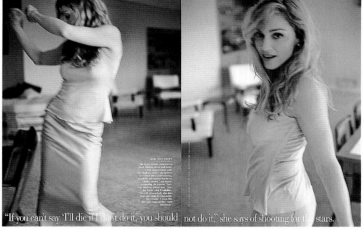

MADONNA AND CHILD

VANITY FAIR
MARCH 1996

Living in a wilderness of mirrors and media glare, Madonna has run through every image in the pop-culture canon—from rebel to tart, icon, and glamour queen—over the past 15 years. Since the birth of her daughter, Lourdes, in 1996, she seems to be trying to learn about life beyond the lens. Listening to the rhythms of Madonna's world and of her extraordinary new CD, *Ray of Light,* INGRID SISCHY hears a woman on the verge of becoming herself

■ 568

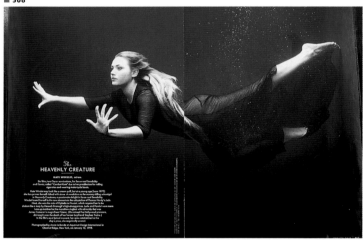

■ 569

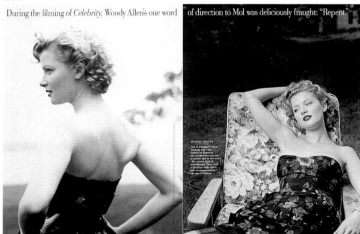

During the filming of *Celebrity,* Woody Allen's one word of direction to Mol was deliciously fraught: "Repent."

"If you can't say 'I'll die if I don't do it,' you should not do it," she says of shooting for the stars.

■ 567
Publication TV Guide
Design Director Don Morris
Art Director Josh Klenert
Designer Robert Morris
Illustrator Bob Eckstein
Studio Don Morris Design
Publisher News Corporation Company
Issue December 19-25, 1998
Category Photo Illustration/Single Page

■ 568
Publication Vanity Fair
Design Director David Harris
Art Director Gregory Mastrianni
Designers David Harris, Gregory Mastrianni
Photo Editors Susan White, Lisa Berman
Photographer Annie Leibovitz
Publisher Condé Nast Publications Inc.
Issue April 1998
Category Reportage, Travel, Portraits/Spread

■ 569
Publication Vanity Fair
Design Director David Harris
Art Director Gregory Mastrianni
Designers Gregory Mastrianni, David Harris
Photo Editors Susan White, Lisa Berman
Photographer Annie Leibovitz
Publisher Condé Nast Publications Inc.
Issue September 1998
Category Reportage, Travel, Portraits/Spread

■ 570
Publication Vanity Fair
Design Director David Harris
Art Director Gregory Mastrianni
Designers David Harris, Gregory Mastrianni
Photo Editors Susan White, Lisa Berman
Photographer Mario Testino
Publisher Condé Nast Publications Inc.
Issue March 1998
Category Reportage, Travel, Portraits/Story

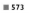

■ 571

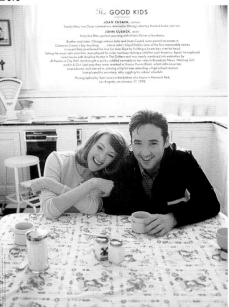

■ 573

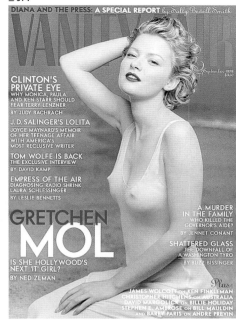

■ 574

■ 572

■ 575

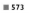

■ 571
Publication Vanity Fair
Design Director David Harris
Art Director Gregory Mastrianni
Designers David Harris, Gregory Mastrianni
Photo Editors Susan White, Lisa Berman
Photographer Herb Ritts
Publisher Condé Nast Publications Inc.
Issue April 1998
Category Reportage, Travel, Portraits/Single Page

■ 572
Publication Vanity Fair
Design Director David Harris
Art Director Gregory Mastrianni
Designer Gregory Mastrianni
Photo Editors Susan White, Lisa Berman
Photographer Harry Benson
Publisher Condé Nast Publications Inc.
Issue June 1998
Category Reportage, Travel, Portraits/Spread

■ 573
Publication Vanity Fair
Design Director David Harris
Art Director Gregory Mastrianni
Designer David Harris
Photo Editors Susan White, Lisa Berman
Photographer Sam Jones
Publisher Condé Nast Publications Inc.
Issue April 1998
Category Reportage, Travel, Portraits/Single Page

■ 575
Publication Vanity Fair
Design Director David Harris
Art Director Gregory Mastrianni
Designer David Harris
Photo Editors Susan White, Lisa Berman
Photographer Michael O'Neill
Publisher Condé Nast Publications Inc.
Issue September 1998
Category Reportage, Travel, Portraits/Spread

■ 574
Publication Vanity Fair
Design Director David Harris
Art Director Gregory Mastrianni
Designers David Harris, Gregory Mastrianni
Photo Editors Susan White, Lisa Berman
Photographer Annie Leibovitz
Publisher Condé Nast Publications Inc.
Issue September 1998
Category Reportage, Travel, Portraits/Single Page

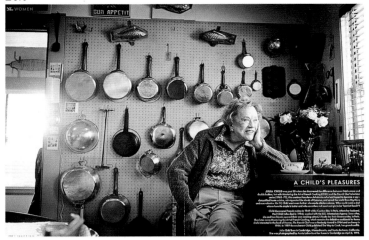

A CHILD'S PLEASURES

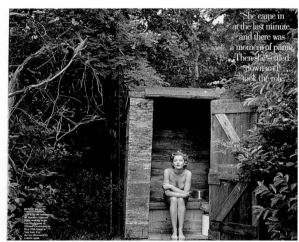

"She came in at the last minute, and there was a moment of panic. Then she settled down and took the role."

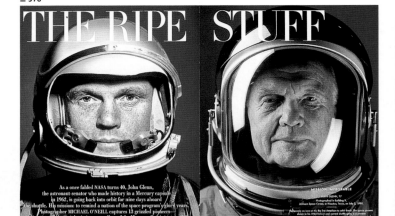

THE RIPE STUFF

As a once failed NASA turns 40, John Glenn, the astronaut-senator who made history in a Mercury capsule in 1962, is going back into orbit for nine days aboard the shuttle. His mission: to remind a nation of the space program's glory years. Photographer MICHAEL O'NEILL captures 13 grizzled pioneers—surviving astronauts and mission controllers of the Mercury-Gemini era—while RINKER BUCK wonders whether the 77-year-old Glenn's October liftoff, anchored by Walter Cronkite, can reignite America's passion for the final frontier

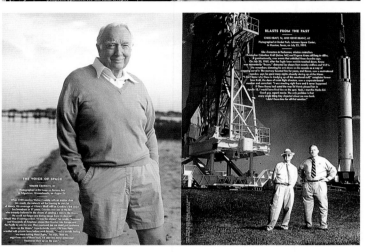

THE VOICE OF SPACE

BLASTS FROM THE PAST

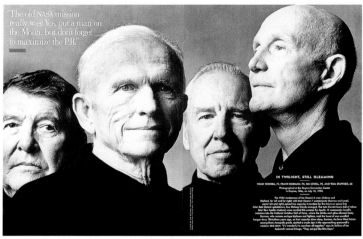

"The old NASA mission really was Yes, put a man on the Moon, but don't forget to maximize the P.R."

IN TWILIGHT, STILL GLEAMING

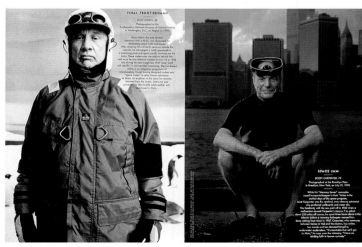

FINAL FRONTIERSMAN

SPACE JAM

■ 576
Publication Vanity Fair
Design Director David Harris
Art Director Gregory Mastrianni
Designers David Harris, Gregory Mastrianni
Photo Editors Susan White, Lisa Berman
Photographer Annie Leibovitz
Publisher Condé Nast Publications Inc.
Issue November 1998
Category Reportage, Travel, Portraits/Spread

■ 577
Publication Vanity Fair
Design Director David Harris
Art Director Gregory Mastrianni
Designer David Harris
Photo Editors Susan White, Lisa Berman
Photographer Annie Leibovitz
Publisher Condé Nast Publications Inc.
Issue September 1998
Category Reportage, Travel, Portraits/Spread

■ 578
Publication Vanity Fair
Design Director David Harris
Art Director Gregory Mastrianni
Designers Gregory Mastrianni, David Harris, Lee Ruelle
Photo Editors Susan White, Lisa Berman
Photographer Michael O'Neill
Publisher Condé Nast Publications Inc.
Issue October 1998
Category Reportage, Travel, Portraits/Story

SARGENT'S BLOODLINES

John Singer Sargent's portraits of British aristocracy, Boston bluebloods, New York captains of industry, and cultural icons defined a golden age as well as a society. With London's Tate Gallery preparing a retrospective of Sargent's work, 16 descendants of the men and women immortalized pose for the modern equivalent of his brush and oil paint: the lens of DAVID SEIDNER

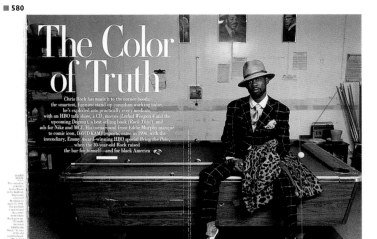

The Color of Truth

Chris Rock has made it to the corner booth: the smartest, funniest stand-up comedian working today, he's exploded into practically every medium, with an HBO talk show, a CD, movies (Lethal Weapon 4 and the upcoming Dogma), a best-selling book (Rock This!), and ads for Nike and MCI. His turnaround from Eddie Murphy manque to comic icon, DAVID KAMP reports, came in 1996, with the incendiary, Emmy Award–winning HBO special Bring the Pain, when the 30-year-old Rock raised the bar for himself—and for Black America

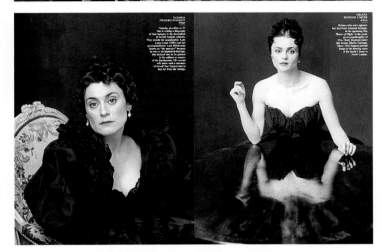

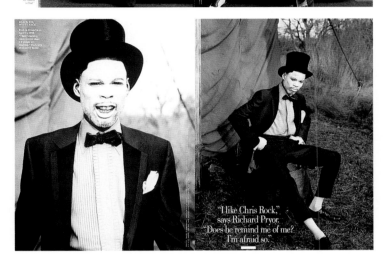

"I like Chris Rock," says Richard Pryor. "Does he remind me of me? I'm afraid so."

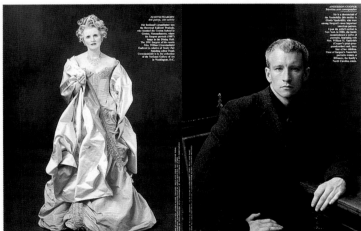

"There's no such thing as a 50-year-old black man that's not racist and pissed off."

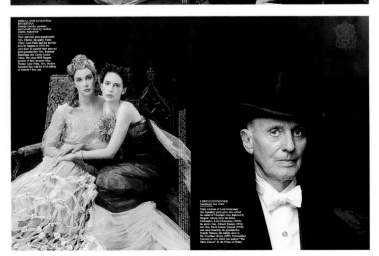

■ 579
Publication Vanity Fair
Design Director David Harris
Art Director Gregory Mastrianni
Designer David Harris
Photographer David Seidner
Photo Editors Susan White, Lisa Berman
Publisher Condé Nast Publications Inc.
Issue November 1998
Category Reportage, Travel, Portraits/Story

■ 580
Publication Vanity Fair
Design Director David Harris
Art Director Gregory Mastrianni
Designers Gregory Mastrianni, David Harris
Photographer Annie Leibovitz
Photo Editors Susan White, Lisa Berman
Publisher Condé Nast Publications Inc.
Issue August 1998
Category Reportage, Travel, Portraits/Story

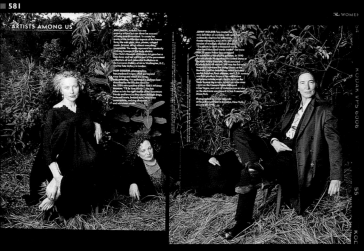

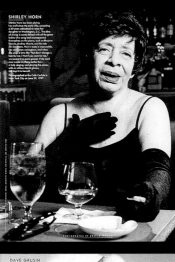

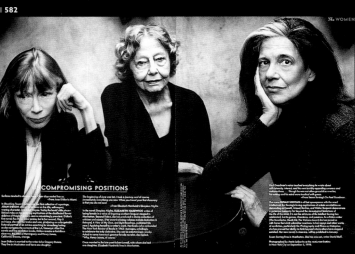

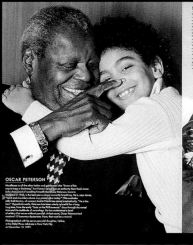

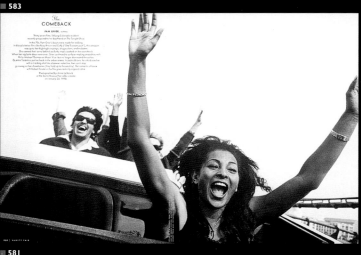

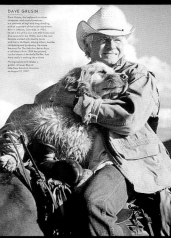

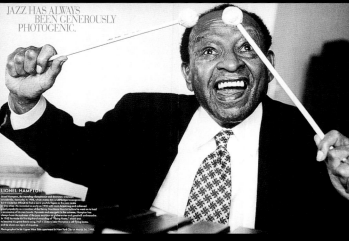

■ 581
Publication Vanity Fair
Design Director David Harris
Art Director Gregory Mastrianni
Designers David Harris, Gregory Mastrianni
Photo Editors Susan White, Lisa Berman
Photographer Annie Leibovitz
Publisher Condé Nast Publications Inc.
Issue November 1998
Category Reportage, Travel, Portraits/Spread

■ 582
Publication Vanity Fair
Design Director David Harris
Art Director Gregory Mastrianni
Designers David Harris, Gregory Mastrianni
Photo Editors Susan White, Lisa Berman
Photographer Annie Leibovitz
Publisher Condé Nast Publications Inc.
Issue November 1998
Category Reportage, Travel, Portraits/Single Page

■ 583
Publication Vanity Fair
Design Director David Harris
Art Director Gregory Mastrianni
Designers David Harris, Gregory Mastrianni
Photo Editors Susan White, Lisa Berman
Photographer Annie Leibovitz
Publisher Condé Nast Publications Inc.
Issue April 1998
Category Reportage, Travel, Portraits/Spread

■ 584
Publication Vanity Fair
Design Director David Harris
Art Director Gregory Mastrianni
Designers David Harris, Gregory Mastrianni
Photographer Bruce Weber
Publisher Condé Nast Publications Inc.
Issue July 1998
Category Reportage, Travel, Portraits/Story

HALL OF FAME 1998
LOOK BACK IN ANGER, IN AWE, IN CELEBRATION:
VANITY FAIR INDUCTS
19 MEN AND WOMEN
WHO GAVE THE YEAR ITS EDGE

PHOTOGRAPHS BY ANNIE LEIBOVITZ AND OTHERS • TEXT BY JAMES WOLCOTT

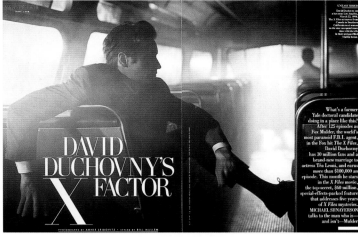

DAVID DUCHOVNY'S X FACTOR

What's a former Yale doctoral candidate doing in a place like this? After 125 episodes as Fox Mulder, the world's most paranoid F.B.I. agent, in the Fox hit *The X Files*, David Duchovny has 30 million fans and a brand-new marriage to actress Téa Leoni, and earns more than $100,000 an episode. This month he stars in the *X Files* movie, the top-secret, $60 million, special-effects-packed feature that addresses five years of *X Files* mysteries. MICHAEL SHNAYERSON talks to the man who is—and isn't—Mulder

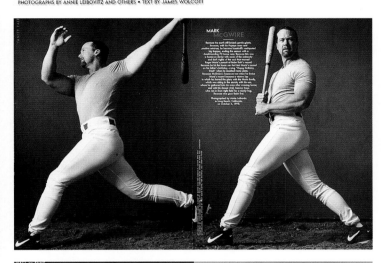

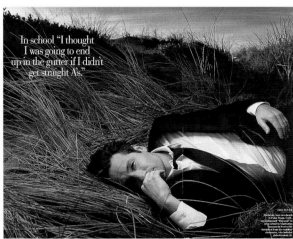

In school "I thought I was going to end up in the gutter if I didn't get straight A's."

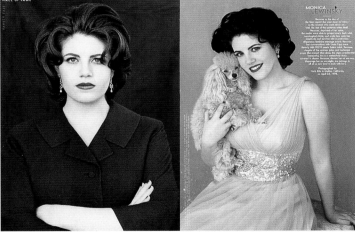

"If I'd been born in the Middle Ages I would have died single. People died at 36!"

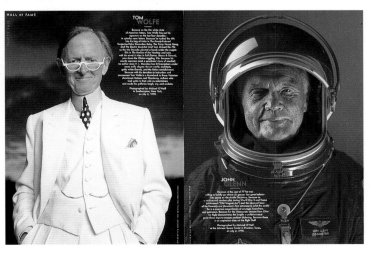

■ 585
Publication Vanity Fair
Design Director David Harris
Art Director Gregory Mastrianni
Designer Gregory Mastrianni
Photo Editors Susan White, Lisa Berman
Photographers Annie Leibovitz, Herb Ritts, Michael O'Neill, James Balog, Mary Ellen Mark, Peggy Sirota, Steven Meisel, Robert Maxwell
Publisher Condé Nast Publications Inc.
Issue December 1998
Categories Reportage, Travel, Portraits/Story
 A Spread

■ 586
Publication Vanity Fair
Design Director David Harris
Art Director Gregory Mastrianni
Designer David Harris
Photo Editors Susan White, Lisa Berman
Photographer Annie Leibovitz
Publisher Condé Nast Publications Inc.
Issue June 1998
Category Reportage, Travel, Portraits/Story

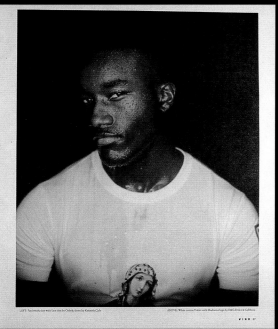

■ 587
Publication Vibe
Art Director Dwayne N. Shaw
Photo Editor George Pitts
Photographer Barron Claiborne
Publisher Vibe/Spin Ventures
Issue March 1998
Category Fashion, Beauty, Still Life, Interiors/Story

■ 588
Publication Vibe
Art Director Dwayne N. Shaw
Photo Editor George Pitts
Photographer Andrea Modica
Publisher Vibe/Spin Ventures
Issue May 1998
Category Fashion, Beauty, Still Life, Interiors/Story

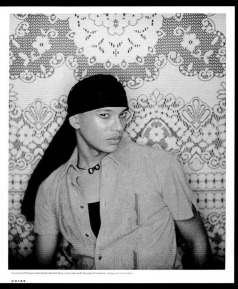

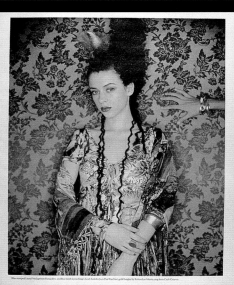

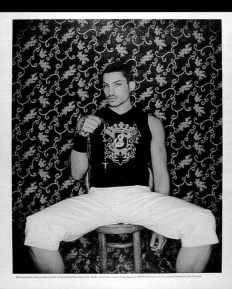

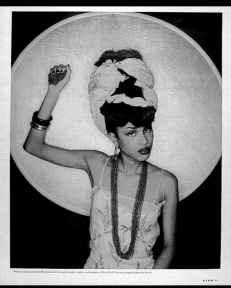

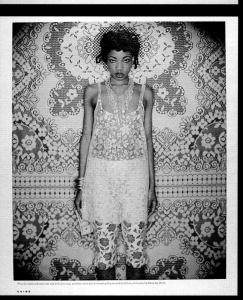

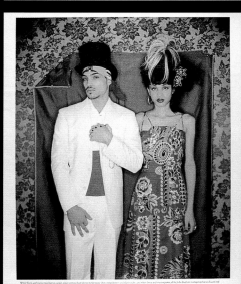

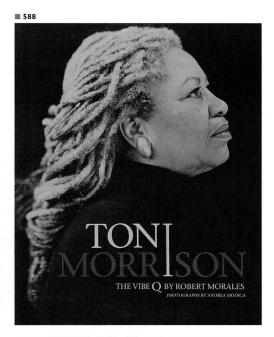

TONI MORRISON

THE VIBE Q BY ROBERT MORALES
PHOTOGRAPHS BY ANDREA MODICA

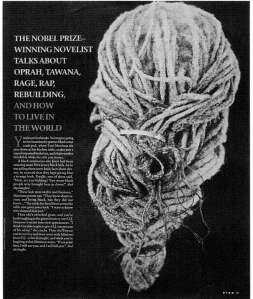

THE NOBEL PRIZE–WINNING NOVELIST TALKS ABOUT OPRAH, TAWANA, RAGE, RAP, REBUILDING, AND HOW TO LIVE IN THE WORLD

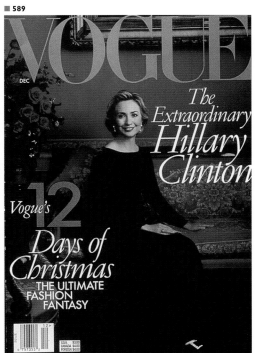

VOGUE

DEC

The Extraordinary Hillary Clinton

Vogue's **12** Days of Christmas THE ULTIMATE FASHION FANTASY

The all-American high school has become a parade ground for looks ranging from the darkly bizarre to the ironically outsize. Robert Sullivan heads to the halls where what you wear is who you are. Photographed by Irving Penn.

teen tribes

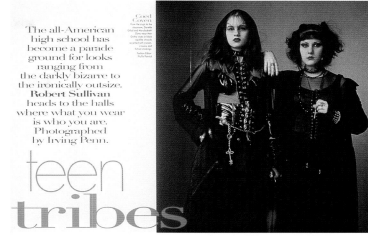

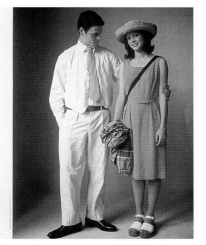

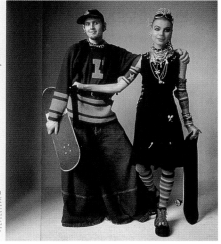

One young man who was once a Groover switched to a kind of sub-Groover group, mostly because he wasn't into the big belt buckles

■ 589
Publication Vogue
Design Director Charles R. Churchward
Photographer Annie Leibovitz
Publisher Condé Nast Publications Inc.
Issue December 1998
Category Fashion, Beauty, Still Life, Interiors/Single Page

■ 590
Publication Vogue
Design Director Charles R. Churchward
Photographer Irving Penn
Publisher Condé Nast Publications Inc.
Issue August 1998
Category Reportage, Travel, Portraits/Story

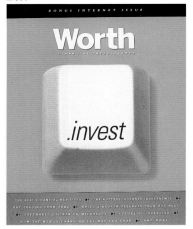

■ 591

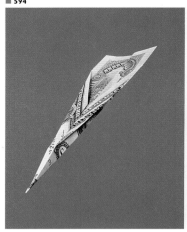

■ 594

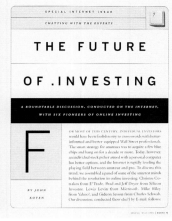

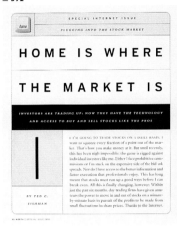

■ 592

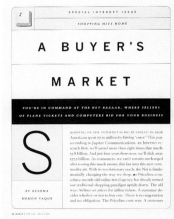

■ 595

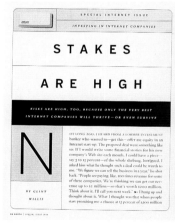

■ 593

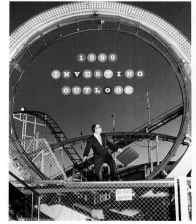

■ 596

Dodging reality is never an effective investment strategy. So here's some reality as we see it: The free ride is over. Risk is real. ¶ Anyone who has sense will approach this shifting environment with caution. But fear? Of course not. In the coming year, as ever, successful investors will be those who confront the market's many challenges head-on. For our take on how to do this in 1999, please turn the page. PHOTOGRAPHS BY GEOF KERN

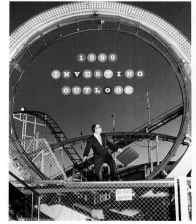

■ 591
Publication Worth
Art Director Philip Bratter
Designers Deanna Lowe,
Philip Bratter
Photo Editor Sabine Meyer
Photographer Steve Wisbauer
Publisher Capital Publishing L. P.
Issue August 1998
Category Fashion, Beauty, Still Life,
Interiors/Single Page or Spread

■ 592
Publication Worth
Art Director Philip Bratter
Designers Deanna Lowe,
Sarah Garcea
Photo Editor Sabine Meyer
Photographer Steve Wisbauer
Publisher Capital Publishing L. P.
Issue August 1998
Category Fashion, Beauty, Still Life,
Interiors/Spread

■ 593
Publication Worth
Art Director Philip Bratter
Designers Deanna Lowe,
Sarah Garcea
Photo Editor Sabine Meyer
Photographer Steve Wisbauer
Publisher Capital Publishing L. P.
Issue August 1998
Category Fashion, Beauty, Still Life,
Interiors/Spread

■ 594
Publication Worth
Art Director Philip Bratter
Designers Deanna Lowe,
Sarah Garcea
Photo Editor Sabine Meyer
Photographer Steve Wisbauer
Publisher Capital Publishing L. P.
Issue August 1998
Category Fashion, Beauty, Still Life,
Interiors/Spread

■ 595
Publication Worth
Art Director Philip Bratter
Designers Deanna Lowe,
Sarah Garcea
Photo Editor Sabine Meyer
Photographer Steve Wisbauer
Publisher Capital Publishing L. P.
Issue August 1998
Category Fashion, Beauty, Still Life,
Interiors/Spread

■ 596
Publication Worth
Art Directors Philip Bratter,
Deanna Lowe
Designer Sarah Garcea
Photo Editor Marianne Butler
Photographer Geof Kern
Publisher Capital Publishing L. P.
Issue December 1998
Category Reportage, Travel,
Portraits/Spread

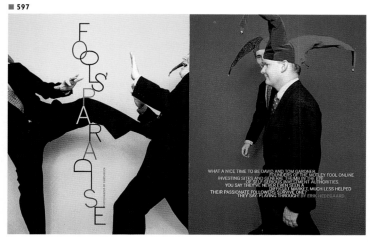

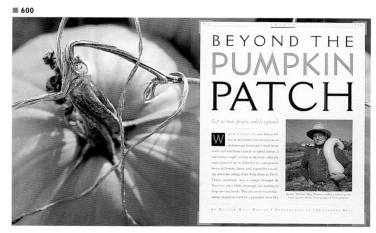

WHAT A NICE TIME TO BE DAVID AND TOM GARDNER, FOUNDERS OF THE MOTLEY FOOL ONLINE INVESTING SITES AND GENERAL GADFLIES. THE FACT THAT THEY'VE NEVER EVEN SEEN A SERIOUS INVESTMENT AUTHORITIES. YOU SAY THEY'VE NEVER EVEN SEEN A BEAR MARKET, MUCH LESS HELPED THEIR PASSIONATE FOLLOWERS SURVIVE ONE? THEY SAY, PLAYING THROUGH. BY ERIK HEDEGAARD

THE NEXT HOT MARKET
WHERE IN THE WORLD TO FIND STOCKS THAT ARE SET TO CATCH FIRE

BY CLINT WILLIS
PHOTOGRAPHS BY DAVIES + STARR

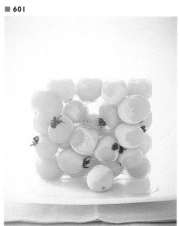

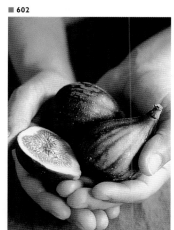

PHOTOGRAPHY MERIT ■

high on spending oh, the satisfaction buying brings

By Richard Todd
Photographs by Craig Cutler

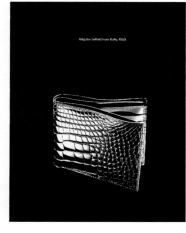

Alligator billfold from Bally, $560.

■ 597
Publication Worth
Art Director Philip Bratter
Designer Deanna Lowe
Photo Editor Sabine Meyer
Photographer Chris Buck
Publisher Capital Publishing L. P.
Issue June 1998
Category Reportage, Travel, Portraits/Spread

■ 598
Publication Worth
Art Director Philip Bratter
Designer Deanna Lowe
Photo Editor Sabine Meyer
Photographer Davies + Starr
Publisher Capital Publishing L. P.
Issue June 1998
Category Fashion, Beauty, Still Life, Interiors/Spread

■ 599
Publication Worth
Art Director Philip Bratter
Designer Deanna Lowe
Photo Editor Melanie Osterhout
Photographer Craig Cutler
Publisher Capital Publishing L. P.
Issue October 1998
Category Fashion, Beauty, Still Life, Interiors/Spread

■ 600
Publication Saveur
Creative Director Michael Grossman
Art Director Jill Armus
Designer Toby Fox
Photo Editor Maria Millan
Photographer Christopher Boas
Publisher Meigher Communications
Issue November 1998
Category Reportage, Travel, Portraits/Spread

■ 601
Publication Shape Cooks
Creative Director Kathy Nenneker
Art Director Lisa Leconte
Designer Lisa Leconte
Photo Editor Virginia Vincent-Orth
Photographer Ann Stratton
Publisher Weider Publications
Issue Winter 1998
Category Fashion, Beauty, Still Life, Interiors/Single Page

■ 602
Publication Bon Appétit
Art Director Campion Primm
Designer Paul Martinez
Photo Editor Jodi Nakatsuka
Photographer Maria Robledo
Publisher Condé Nast Publications Inc.
Issue October 1998
Category Fashion, Beauty, Still Life, Interiors/Single Page

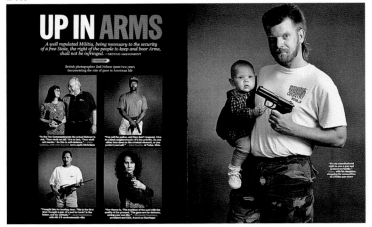

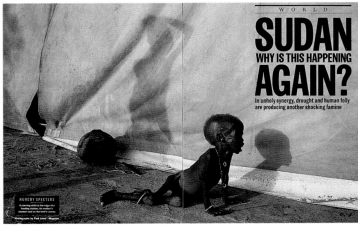

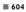

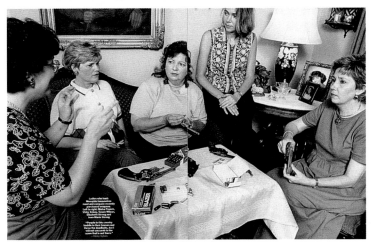

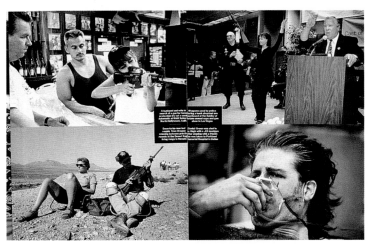

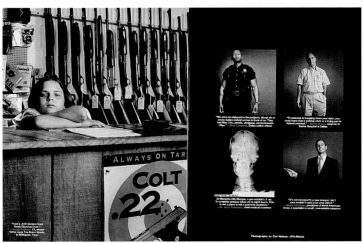

■ 603
Publication TIME
Art Director Arthur Hochstein
Designer Arthur Hochstein
Photo Editors Michele Stephenson, Hillary Raskin
Photographer Zed Nelson-TIME/IPG Matrix
Publisher Time Inc.
Issue July 6, 1998
Category Reportage, Travel, Portraits/Story

■ 604
Publication TIME
Art Director Arthur Hochstein
Designer Jennifer Roth
Photo Editors Michele Stephenson, Robert Stevens
Photographer Paul Lowe
Publisher Time Inc.
Issue July 27, 1998
Category Reportage, Travel, Portraits/Spread

■ 605
Publication The Washington Post Magazine
Art Director Kelly Doe
Designer Lisa Schreiber
Photo Editor Crary Pullen
Photographer John Goodman
Publisher The Washington Post Co.
Issue February 8, 1998
Category Reportage, Travel, Portraits/Spread

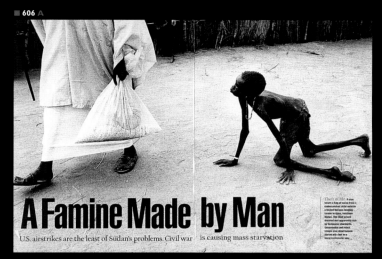

A Famine Made by Man

U.S. airstrikes are the least of Sudan's problems. Civil war is causing mass starvation

Theft of life. A man steals a bag of maize from a malnourished child outside a limited Nations feeding center in Ajiep, southern Sudan. The thief is well dressed and apparently rich by Sudanese standards. Government and rebel troops eat their harvest, but as a way systematic war.

OUTLOOK 1999

{ 18 }

Jesse Ventura

A new governor hellbent on innovative politics

BY KENNETH T. WALSH

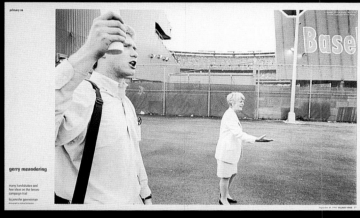

Born: July 15, 1951, Minneapolis. Education: Roosevelt High School, Minneapolis; attended North Hennepin Community College, Brooklyn Park, Minn. Role model: Muhammad Ali. Proudest accomplishment: Winning the governor's election against all odds. Goal: To be a success at everything I do. Favorite books: Rogue Warrior by Richard Marcinko and Heller Skelter by Vincent Bugliosi. Favorite pastimes: Hunting and fishing.

WORLD REPORT

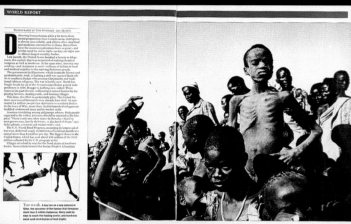

Too weak. A boy lies on a tarp (above) in Ajiep, the epicenter of the famine that threatens more than 2 million Sudanese. Many walk for days to reach the feeding center, and hundreds await such distribution of food (right).

WORLD REPORT

Army (SPLA) in 1983, 1.5 million people have died. But political and economic power still belongs to Khartoum's Arab elite. In the face of economic crises and endless war, the military regime of Lt. Gen. Omar Hassan al-Bashir rules by *sharia*, or Islamic law, and claims that both the civil war and the recent U.S. airstrikes are part of a Western and Zionist plot against Islam.

Neighboring countries allege that Sudan's government is developing chemical weapons for use against either the SPLA or dissidents in the Nuba mountains. The regime denies the charge. There is little doubt, however, that Sudan backs the Lord's Resistance Army, a terrorist cult that kidnaps children as soldiers and young girls as sex slaves and vows to overthrow the government in neighboring Uganda.

Uganda, for its part, supports the SPLA and its leader, John Garang, who demands autonomy for the South. But critics say Garang (who holds a doctorate from Iowa State University) has grown callous to the suffering of his Dinka tribesmen. Both sides manipulate relief efforts. This spring, the government suspended aid flights for two months in retaliation for SPLA attacks. The SPLA, meanwhile, imposes an unofficial tax on food aid, raking off 20 percent or more. In feeding camps, well-fed rebel soldiers stroll among their emaciated countrymen. –Stefan Lovgren

Grave. Many children die at night, when temperatures drop, and are buried first thing in the morning (right). Below, a child sits in the countryside, where the soil is wonderfully fertile and the famine is obviously man-made.

primary to

gerry meandering

many handshakes and few ideas on the fences campaign trail

by jennifer gonnerman

"YOU LOOK AROUND and ask what's normal. Normal, I would suggest, is people who care for one another as friends. That's what one should hope for, not perfection."

■ 606
Publication
US News & World Report
Design Director Rob Covey
Designer Dolores Motichka
Photo Editors MaryAnne Golon, Olivier Picard
Photographer Tom Stoddart/IPG/Matrix
Publisher US News & World Report
Issue September 14, 1998
Categories Reportage, Travel, Portraits/Story
　　　A Reportage, Travel, Portraits/Spread

■ 607
Publication
US News & World Report
Design Director Rob Covey
Art Director Michele Chu
Photo Editors MaryAnne Golon, Alice Gabriner
Photographer Melanie Dunea/CPI
Publisher US News & World Report
Issue December 28, 1998
Category Reportage, Travel, Portraits/Spread

■ 608
Publication The Village Voice
Design Director Ted Keller
Art Director Minh Uong
Designer Stacy Wakefield
Photo Editor Meg Handler
Photographer Andrew Lichtenstein
Publisher VV Publishing Corp.
Issue September 15, 1998
Category Reportage, Travel, Portraits/Spread

■ 609
Publication The Boston Globe
Art Director Catherine Adrich
Photographer Lane Tuner
Publisher The Boston Globe
Issue April 12, 1998
Category Reportage, Travel, Portraits/Single Page

The McDonaldization of Business

ETHiCS

The world
struggles toward
a global definition
of right and wrong.
By Laurie Joan
Aron

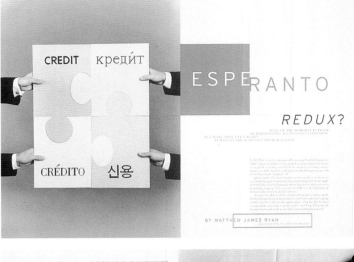

CREDIT кредит

CRÉDITO 신용

ESPERANTO

REDUX?

MOST OF THE WORLD IS IN ERROR
OR HARMONIZING ACCOUNTING STANDARDS
BUT CAN THE WORLD ACCOMMODATION

BY MATTHEW JAMES RYAN

For as long as companies have

PERSPECTIVE

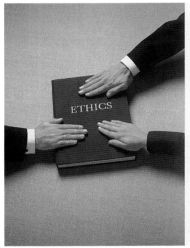

An interview with GEOFF MULGAN

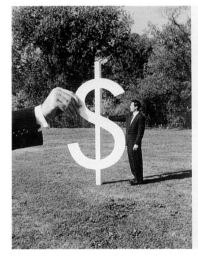

NOTES ON A WORLD LANGUAGE

■ 610
Publication Global
Creative Director Sarah Vinas
Art Director Tom Brown
Designers Sarah Vinas, Tom Brown
Photographer Fredrik Brodén
Publisher Deloitte & Touche
Issue November/December 1998
Categories Fashion, Beauty, Still Life, Interiors/Story
 A Spread

■ 611
Publication Global
Creative Director Sarah Vinas
Art Director Tom Brown
Designer Tom Brown
Photographer Fredrik Brodén
Publisher Deloitte & Touche
Issue February/March 1998
Category Photo Illustration/Story

The Real Scandal in Washington Is Newt Gingrich

The Stink at the Other End of Pennsylvania Avenue

BY WILLIAM GREIDER

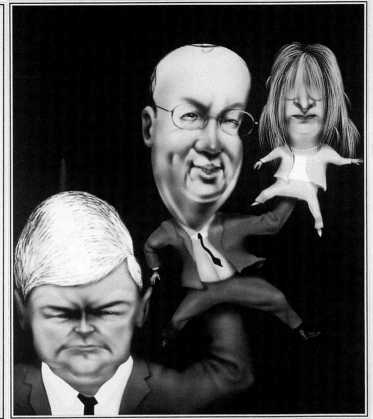

ILLUSTRATION BY MATT MAHURIN

THE OBSESSION WITH BILL Clinton's scandal covers up a stink at the other end of Pennsylvania Avenue – that other Washington scandal simply known as Newt. If Clinton were forced from office, the House Speaker, Newt Gingrich – a man loathed or distrusted not only by the public but also by his own Republican colleagues – would be a heartbeat from the presidency.

"President Gingrich." Not likely to happen, but truly frightening to contemplate. Newt has never been deterred by the improbability of his inflated ambitions and does not hesitate to employ bloody knife work to reach his goals. With his usual crude belligerence, Gingrich is now stage-managing the House Republicans' crusade to impeach Clinton. If impeachment succeeds and Vice President Albert Gore takes Clinton's place, House Republicans, with the support of the Senate, will then have the power to reject or stall Gore's selection of a new vice president, and Gingrich could stand athwart that process with partisan venom and gum things up further by pushing for more investigations of Gore himself. And were anything to happen to Gore, Gingrich would be next in line for the presidency – thus fulfilling the dream that has always fueled Newt's politics.

This scenario may seem remote, but so was the possibility that Gingrich would survive as speaker. This is the man who, upon becoming speaker, saw nothing wrong in collecting a $4.5 million payment from Rupert Murdoch as a "book advance." (Public outrage forced Gingrich to pass up the money, but Murdoch has since published two Newt books, financial details of which are unknown.)

This is also the man who was fined $300,000 for his own violations of House ethics rules, for manipulating tax-exempt funds through GOPAC, his political action committee. Many House Republicans now wish they'd had the courage to toss him when they had the chance. Last year, his own right-wing shock troops, the young, red-hot conservatives elected in the GOP sweep of 1994, mounted an unsuccessful coup to oust him.

The speaker pretends to be judiciously aloof from the hanging he is now trying to arrange, but his desire for vengeance is ill-concealed. During a recent Republican caucus, Gingrich swatted down several moderate members of his own party who questioned the wisdom and decency of dumping on the public the contents of independent counsel Kenneth Starr's report to Congress. In that same meeting, he called the president a "misogynist" and said the facts must come out.

Time and again, Clinton has whacked and humiliated the speaker. After Republicans took control of the House in 1994, Clinton's great accomplishment was to defuse Gingrich's revolutionaries before they could do their worst. In the showdown over spending priorities that shut down the federal government in late 1995, Clinton stood tall and won. It revived his presidency and set up his re-election. Gingrich stumbled away in a daze. "Newt's the best thing Clinton has going for him," says Rep. Jim Leach of Iowa, a moderate Republican who chairs the House Banking Committee. "And Clinton's the best thing Newt has going."

Both Southerners, the men regard each other as evil twins. Gingrich hopes to restore himself among hard-core conservatives by his pursuit of Clinton, while the embattled president can count on Newt as one of his most important assets. To understand this twisted situation, you have to realize how deeply Gingrich is disliked on both ends of Pennsylvania Avenue.

NOBODY AROUND CONGRESS listens to Gingrich any longer with much faith in his word. He deceives his opponents, but, hey, he also betrays friends. A hard-right conservative explains the disillusionment that led to last year's aborted coup. "My biggest problem with Gingrich is not ideology," the representative tells me. "My problem is, he just can't tell the truth. He's all over the place, tells you whatever it takes to pass a bill and then forgets what he promised. After six months of this, we realized we had to get it in writing. Even then, Newt would still deny having promised anything. You show him the letter and he just shrugs, walks away."

That's what former "friends" say about him. Democrats naturally describe the Newtster, as some call him, in harsher, more substantive terms. Of course, focusing on Gingrich's lack of credibility does nothing to relieve the president of his far graver problems. But one of the large paradoxes of our present crisis is the weird symbiosis between these two flawed, rival leaders. The crucial difference, however, is that Clinton is much more popular than Gingrich. The president's favorability rating hovers at around forty percent, even after his Monica *mea culpa*, while Newt's is only around twenty. This may be less about character and ideology than it is about human warmth. Clinton exudes it. Newt still scares people.

"Republicans could make an enormous shift of power across the country – if the leadership appeared to be cheerful, upbeat and compassionate," Jim Leach insists. "They could still be conservative, but the fact is, the country will vote for a personality it likes."

The right-winger seconds the point: "Newt is not likable. You feel Newt's not listening to you, or he's listening with a great deal of contempt."

Clinton may be caught in what looks like a no-exit legal snare – at a minimum, he has been permanently wounded – but Gingrich's mendacities continue as routinely as bad weather and with many foul consequences. So how is it that Newt's repetitious flip-flops and double crosses do not arouse more anger? Because his Republican colleagues believe – hope, at least – that Newt will soon be gone. The word was spread informally that Newt expects to quit – that is, to resign as speaker by Labor Day 1999 – so he can run for president in 2000, though the official line is that he has not yet decided. While some are skeptical, the prospect has generated a very public contest over who will be Newt's successor. (Appropriations chairman Robert Livingston of Louisiana claims to have the job locked up.) The hints of departure at least shush Newt's critics.

"I spent the last three and a half years kicking the shit out of Newt Gingrich," the right-wing congressman explains. "But after Newt said he was going to be leaving in '99, I made a pledge to be more restrained."

He and many others are crossing their fingers – hoping that, this time, Newt actually means what he says.

UNDER COVER OF MONICA, Gingrich does a lot of mischief of his own. With all eyes on the White House, Newt has been leading a quiet assault on environmental protection, education, aid for the working poor families and children, enforcement of workplace safety and other programs. What's most outrageous is that the de-

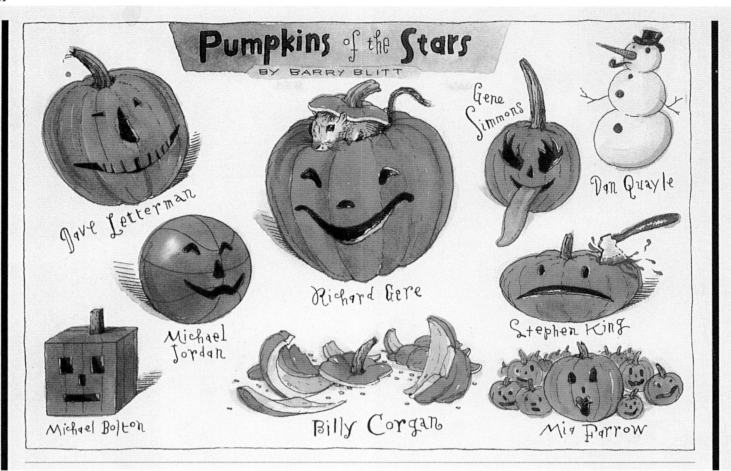

illustration by MARK RYDEN

■ 615

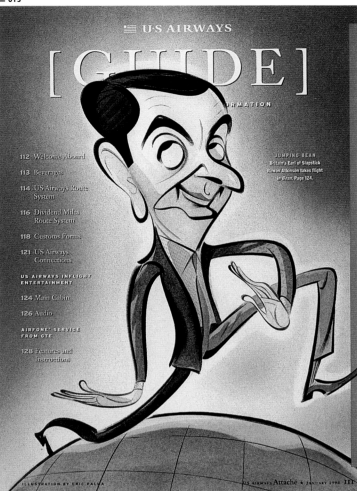

■ 617

■ 618

■ 616

■ 619

■ 615
Publication Attaché
Art Director Paul Carstensen
Designers Paul Carstensen, Alana Smith
Illustrator Eric Palma
Publisher Pace Communications
Client US Airways
Issue January 1998
Category Single Page

■ 616
Publication Attaché
Art Director Paul Carstensen
Designer Paul Carstensen
Illustrator Owen Smith
Publisher Pace Communications
Client US Airways
Issue April 1998
Category Spread

■ 617
Publication Attaché
Art Director Paul Carstensen
Designer Paul Carstensen
Illustrator Sandra Dionisi
Publisher Pace Communications
Client US Airways
Issue July 1998
Category Spread

■ 618
Publication Attaché
Art Director Paul Carstensen
Designer Paul Carstensen
Illustrator Gary Kelley
Publisher Pace Communications
Client US Airways
Issue July 1998
Category Spread

■ 619
Publication American Heritage
Art Director Peter R. Morance
Designer Peter R. Morance
Illustrator Philippe Weisbecker
Publisher Forbes Inc.
Issue September 1998
Category Spread

■ 620

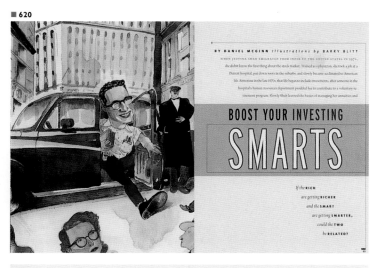

■ 621

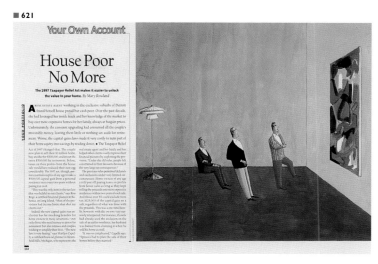

■ 622

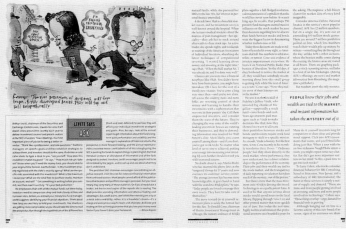

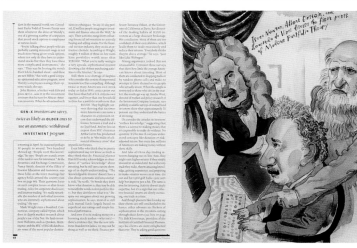

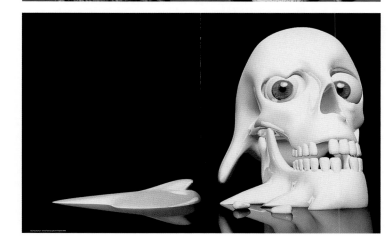

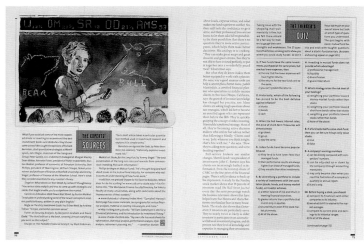

■ 620

Publication Bloomberg Personal Finance
Art Director Carol Layton
Designers Carol Layton,
Frank Tagariello
Illustrator Barry Blitt
Publisher Bloomberg L. P.
Issue September 1998
Category Story

■ 621

Publication Bloomberg Personal Finance
Art Directors Carol Layton,
Frank Tagariello
Designer Frank Tagariello
Illustrator Benoît
Publisher Bloomberg L. P.
Issue May 1998
Category Spread

■ 622

Publication Big
Creative Director
Marcelo Jünemann
Art Director Tycoon Graphics
Designer Graphickers
Illustrator Ichiro Tanida
Studio Tycoon Graphics
Publisher Big Magazine, Inc.
Issue December 1998
Category Story

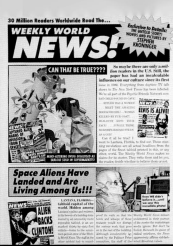
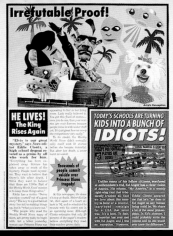
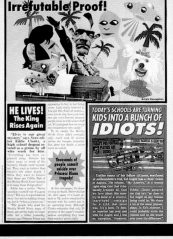

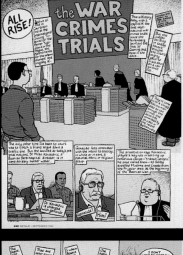

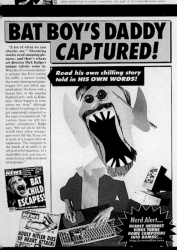
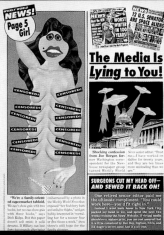

624

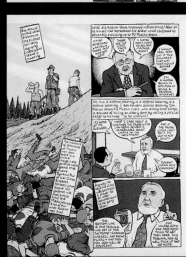
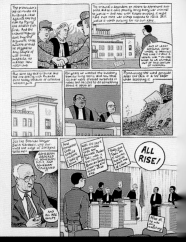

626

peak
PERFORMANCE
sex/style/health/fitness

LET'S HEAR IT FOR THE BOY

SHE LIKES YOU. *SHE REALLY LIKES YOU.*
SARAH MILLER GIVES YOUR EGO TEN STROKES

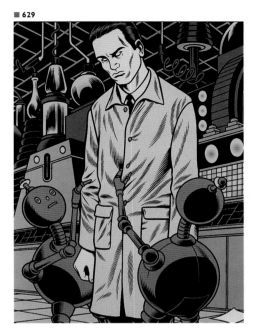

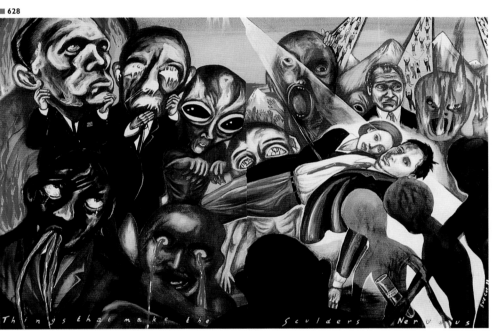

■ 627
Publication Details
Design Director Robert Newman
Designer Alden Wallace
Illustrator Charles Burns
Comix Editor Art Spiegelman
Publisher Condé Nast Publications Inc.
Issue August 1998
Category Single Page

■ 628
Publication Details
Design Director Robert Newman
Designer John Giordani
Illustrator Sue Coe
Publisher Condé Nast Publications Inc.
Issue June 1998
Category Spread

■ 629
Publication Details
Design Director Robert Newman
Designer Alden Wallace
Illustrator Charles Burns
Comix Editor Art Spiegelman
Publisher Condé Nast Publications Inc.
Issue August 1998
Category Single Page

■ 630
Publication Details
Design Director Robert Newman
Designer Alden Wallace
Illustrator Charles Burns
Comix Editor Art Spiegelman
Publisher Condé Nast Publications Inc.
Issue August 1998
Category Single Page

■ 631
Publication Details
Design Director Robert Newman
Designer John Giordani
Illustrator Hanoch Piven
Publisher Condé Nast Publications Inc.
Issue October 1998
Category Single Page

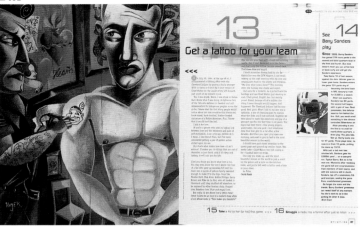

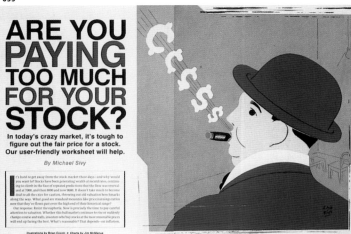

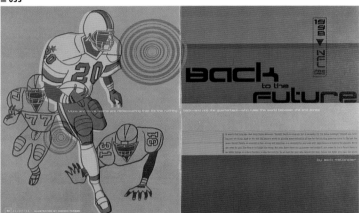

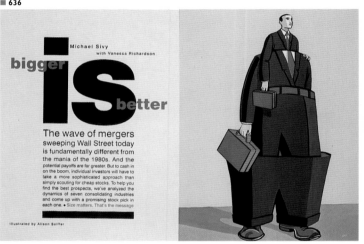

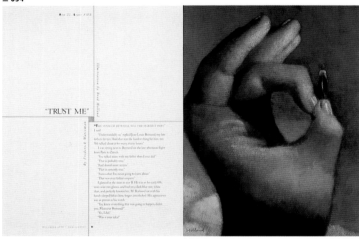

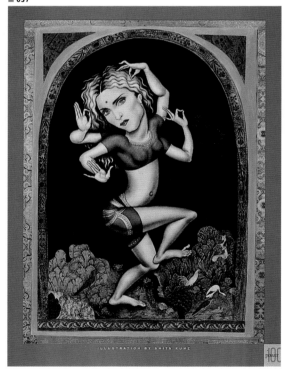

■ 632
Publication ESPN
Design Director F. Darrin Perry
Art Director Peter Yates
Illustrator Olaf Hajek
Publisher Disney
Issue July 27, 1998
Category Spread

■ 634
Publication Hemispheres
Design Director Jaimey Easler
Art Directors Jaimey Easler, Jody Mustain, Kevin de Miranda
Illustrator Brad Holland
Publisher Pace Communications
Client United Airlines
Issue December 1998
Category Spread

■ 633
Publication ESPN
Design Director F. Darrin Perry
Art Director Peter Yates
Illustrator Hiroshi Tanabe
Publisher Disney
Issue September 7, 1998
Category Spread

■ 635
Publication Money
Art Director Syndi Becker
Designer Scott A. Davis
Illustrator Brian Cronin
Publisher Time Inc.
Issue June 1998
Category Spread

■ 636
Publication Money
Art Director Syndi Becker
Designer Syndi Becker
Illustrator Alison Seiffer
Publisher Time Inc.
Issue April 1998
Category Spread

■ 637
Publication Los Angeles
Creative Director David Armario
Designer David Armario
Illustrator Anita Kunz
Publisher Fairchild Publications
Issue October 1998
Category Single Page

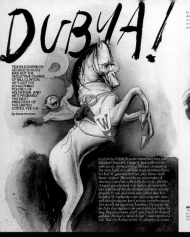

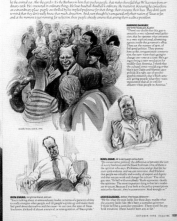

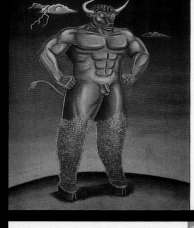

DUBYA!

TEXAS GOVERNOR GEORGE W. BUSH HAS GOT THE SEDUCTIVE CHARM OF BILL CLINTON. HE'S GOT THE DO-NOTHING POLITICS OF HIS FATHER. AND HE'S PROBABLY THE NEXT PRESIDENT OF THE UNITED STATES. HEE-HA!

By Steve Brodner

it's *a jungle out* there

how we talk when we talk about the market

BY SARA SKLAROFF

pity *ruth* mackay.

■ 640

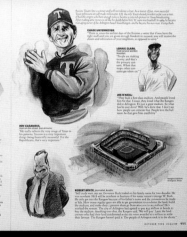

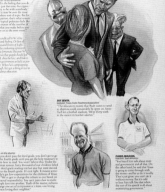

THE POISONED APPLE and FORTUNATE FALL

■ 638
Publication Esquire
Design Director Robert Priest
Art Director Rockwell Harwood
Designer Joshua Liberson
Illustrator Steve Brodner
Photo Editor Patti Wilson
Publisher The Hearst Corporation-
Magazines Division
Issue October 1998
Category Story

■ 639
Publication Equity
Art Director Deanna Lowe
Designer Deanna Lowe
Illustrator Sandra Hendler
Publisher Capital Publishing L. P.
Issue December 1998
Categories Story
 A Spread

■ 640
Publication Civilization
Art Director Sharon Okamoto
Designer Sharon Okamoto
Illustrator Cynthia von Buhler
Publisher Capital Publishing L. P.
Issue December 1998/January 1999
Category Spread

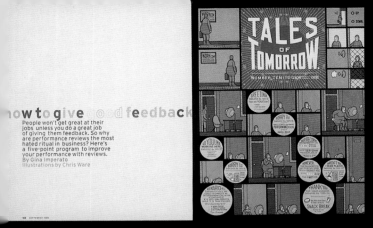

how to give good feedback

People won't get great at their jobs unless you do a great job of giving them feedback. So why are performance reviews the most hated ritual in business? Here's a five-point program to improve your performance with reviews.

By Gina Imperato
Illustrations by Chris Ware

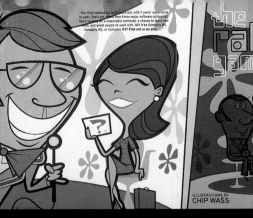

■ 643

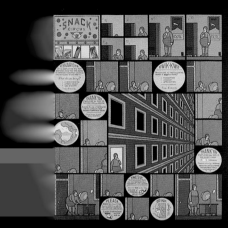

 TOOLBOX

TWICE THE CAREER, HALF THE TIME

Does your career need some buzz? Then think of yourself as the business equivalent of a fruit fly. If you want to soar high, you have to move quickly and change fast. By Cheryl Dahle

ACTION ITEM
THE SITE OF THE CYBER FLY

■ 644

how microsoft reviews suppliers

how con-way reviews teams

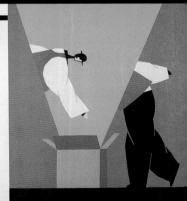

REPORT
FROM THE FUTURE

The Next Big Things?

BY CURTIS SITTENFELD
ILLUSTRATIONS BY CRAIG FRAZIER

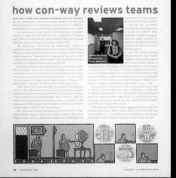

■ 641

Publication Fast Company
Art Director Patrick Mitchell
Designer Patrick Mitchell
Illustrator Chris Ware
Publisher Fast Company
Issue September 1998
Category Story

■ 642

Publication Fast Company
Art Director Patrick Mitchell

■ 643

Publication Fast Company
Art Director Patrick Mitchell
Designer Emily Crawford
Illustrator Edwin Fotheringham
Publisher Fast Company
Issue November 1998
Category Spread

■ 644

Publication Fast Company
Art Director Patrick Mitchell

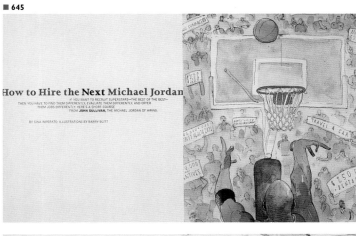

How to Hire the Next Michael Jordan

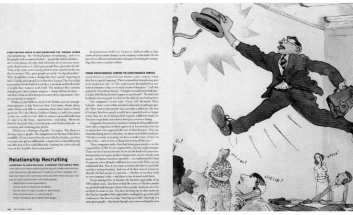

Relationship Recruiting

Scouting for Talent

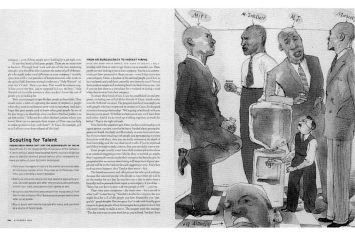

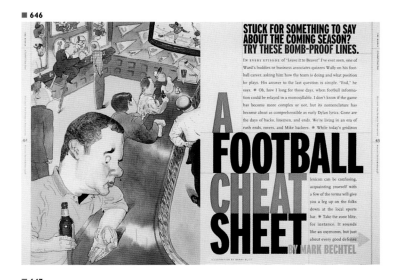

STUCK FOR SOMETHING TO SAY ABOUT THE COMING SEASON? TRY THESE BOMB-PROOF LINES.

A FOOTBALL CHEAT SHEET
BY MARK BECHTEL

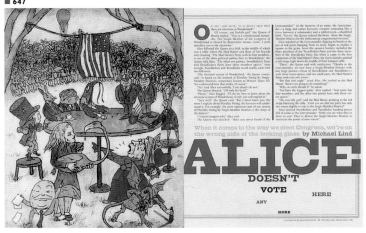

When it comes to the way we elect Congress, we're on the wrong side of the looking glass by Michael Lind

ALICE DOESN'T VOTE

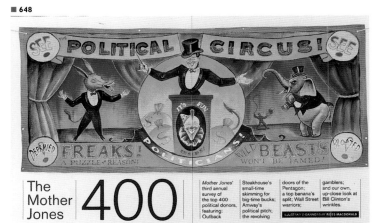

The Mother Jones 400

■ 645
Publication Fast Company
Art Director Patrick Mitchell
Designer Patrick Mitchell
Illustrator Barry Blitt
Publisher Fast Company
Issue December 1998
Category Story

■ 646
Publication Navigator
Design Director Paul Carstensen
Art Director Susan L. Bogle
Designer Susan L. Bogle
Illustrator Barry Blitt
Publisher Pace Communications
Client Holiday Inn Express
Issue August/September 1998
Category Spread

■ 647
Publication Mother Jones
Creative Director Rhonda Rubinstein
Designer Rhonda Rubinstein
Illustrator Jonathon Rosen
Publisher
Foundation for National Progress
Issue March/April 1998
Category Spread

■ 648
Publication Mother Jones
Creative Director Rhonda Rubinstein
Designers Rhonda Rubinstein,
Benjamin Shaykin
Illustrator Ross MacDonald
Publisher
Foundation for National Progress
Issue November/December 1998
Category Spread

■ 649

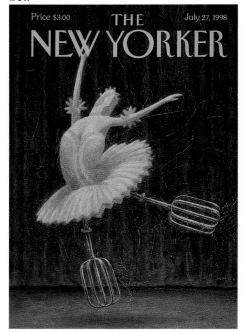

■ 651

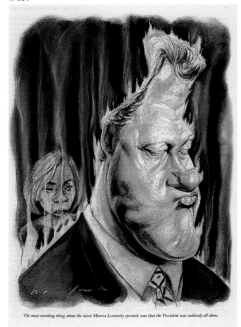

■ 653

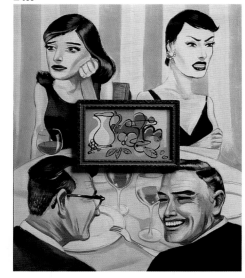

■ 650

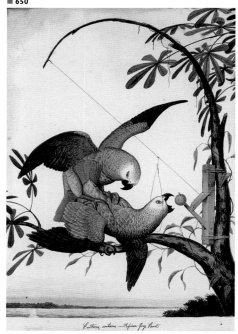

■ 652

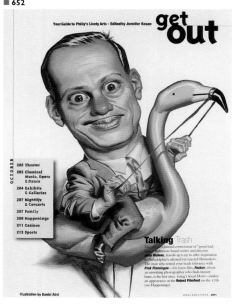

■ 654

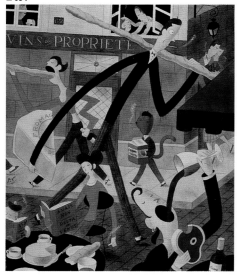

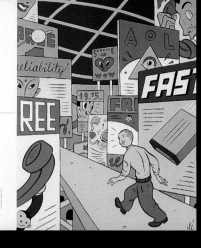

ISPs
YOU CAN COUNT ON

Fed up with your Internet SERVICE PROVIDER?
PC World TESTED a dozen major competitors and
SURVEYED over 6000 USERS to find ISPs that'll
keep you connected.

by Brad Grimes and Lewis Perdue

maternity manners

Ways to
defuse 16
awkward
situations—
from nosy
questions to
unwanted
belly pats

By Paula Spencer

maternity manners

ribly commercial—like sticking a bridal registry list in with the wedding invitation."

If you really covet a certain windup baby swing, or you've decorated your nursery in a Disney motif and want a layette to match, mention it to your mom and your hostess and let them pass the word when asked for gift ideas. If you register, let them be the ones to tell where as well.

Is there a statute of limitations on sending out thank-you notes for baby gifts?
The customary interval for a response is within two to three weeks of receiving the gift. Smart moms-to-be put pen to paper right after the shower, since in the postpartum weeks they're too tired and too busy with the new baby.

What if gifts go unacknowledged for months? Write that note anyway, even if your child is not only sleeping through the night, but taking her first steps. "Better late than never," assures Baldrige. (Enclose a cute baby picture to make up for being remiss.)

What should I do if my water breaks on someone else's living room rug?
This nightmare rarely becomes a reality. Only about one in ten women's membrane ruptures before labor begins, and even then, it may be just a trickle. Still, it helps to have a game plan. If you're worried about going into labor at work, for example, designate a colleague as point person to whisk you off to privacy (or the hospital).

And if the unthinkable happens in public? "Humor is a great way to deal with awkward moments," says Jeanne Martinet, who wrote The Faux Pas Survival Guide. "After that huge, horrid pause that follows, you could say something like 'I hate when that happens!'" Don't worry about cleanup—it's more important to alert your doctor pronto. Later you can offer to pick up the cleaning tab.

How do I thank the doctor when it's over?
A verbal thanks is sufficient. Later you can provide a photo of your joint success for the inevitable wall of babies in the doctor's office. Equally important is the nursing staff, who probably will spend more time with you during labor. Martin likes the graceful phrase "I hope I didn't cause you too much trouble." A small gift (food is always nice) is so rarely seen by these hardworking women that they'll be bowled over. We bought an especially helpful labor nurse a CD that we'd played during the birth of my son.

Is it okay to telephone someone at 3 A.M. to deliver the happy news?
It's your call, so to speak. Bear in mind that while everyone is delighted to hear about a birth, not everyone appreciates such news in the wee hours. When their son arrived

at 1:38 A.M., Patti and Larry Anderson, of Cincinnati, rang only their folks and a few others who had insisted on notification at any time. "I figured I'd get a much more alert reception from others later in the morning," says Patti.

Do e-mail birth announcements count?
As a means of spreading news, sure. (My husband sent them from his laptop within an hour of our third child's birth.) But as an official announcement of glad tidings, they're neither appropriately gracious nor very handsome when posted in a baby book, says Baldrige. Anyway, even in 1998, your Great-aunt Helen might not be wired.

Handwritten notes, fill-in-the-blank cards, and printed notices are all acceptable. There's no standard format for the wording beyond including the relevant names and date (vital statistics are strictly optional). For each child, we used "Paula and George Spencer are thrilled to announce the birth of..." because thrilled was exactly how we felt.

Send word to everyone you think would want to know. Some new parents worry that an announcement will be read as a demand for a gift. It's no such thing. Whether electronic, telephoned, engraved, handwritten, or silk-screened on a T-shirt, a birth announcement is simply a way to share your ecstasy—nothing less, nothing more. □

Contributing editor PAULA SPENCER *is the author, with the editors of this magazine, of the* PARENTING *Guide to Pregnancy & Childbirth.*

September 1998 PARENTING 121

SOUNDS OF SEVILLE

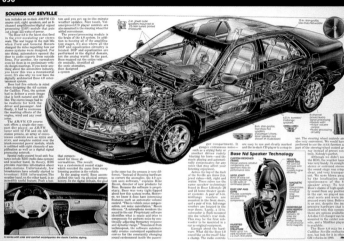

BY TED HALL · ILLUSTRATION BY ERIC PALMA

THE BLACK HOLE OF LOVE

HOW MANY BUDDIES HAVE YOU LOST TO GIRLFRIENDS OR MARRIAGE? ARE YOU THE NEXT TO ABANDON YOUR FRIENDS? IT'S TIME TO STOP THE MADNESS. WE'VE DIAGNOSED THE PROBLEM—AND THE CURE.

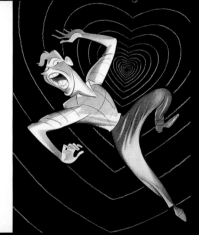

655
Publication PC World
Art Directors Robert Kanes, Tim J Luddy
Designer Tim J Luddy
Illustrator Mark Matcho
Photographer Bruce Zake
Publisher International Data Group
Issue January 1998
Category Spread

656
Publication Popular Mechanics
Creative Director Bryan G. Canniff
Art Directors Tom Kane, Julie Hamp
Illustrator David Kimble
Publisher The Hearst Corporation-Magazines Division
Issue January 1998
Category Spread

657
Publication P. O. V.
Design Director Florian Bachleda
Designer Scott Menchin
Illustrator Eric Palma
Publisher B.Y.O.B./Freedom Ventures, Inc.
Issue September 1998
Category Spread

658
Publication Parenting
Art Director Susan Dazzo
Designer Susan Dazzo
Illustrator Juliette Borda
Publisher Time Inc.
Issue September 1998
Category Story

Ross Bleckner's Capri Sketchbook

william wegman's
maine

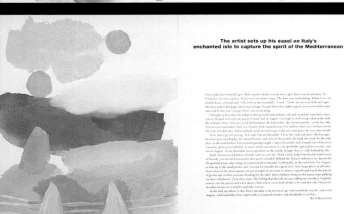

**The artist sets up his easel on Italy's
enchanted isle to capture the spirit of the Mediterranean**

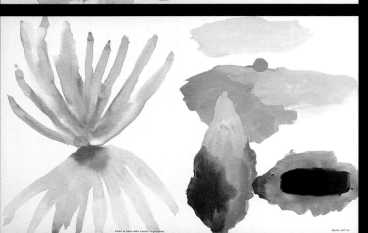

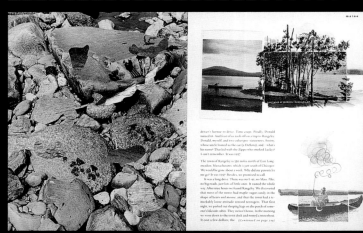

(Continued on page 254)

■ 659
Publication Travel & Leisure
Creative Director Pamela Berry
Designer Pamela Berry
Illustrator Ross Bleckner
Publisher American Express Publishing Co.
Issue March 1998
Category Story

■ 660
Publication Travel & Leisure
Creative Director Pamela Berry
Designer Dan Josephs
Illustrator William Wegman
Publisher American Express Publishing Co.
Issue April 1998
Category Story

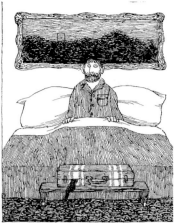

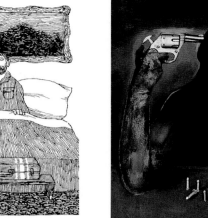

the suite hereafter

THESE HOTELS MUST BE GOOD—WHY ELSE WOULD CERTAIN GUESTS SETTLE IN FOR ETERNITY?

By Rebecca Barry Illustrated by Edward Gorey

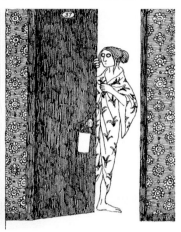

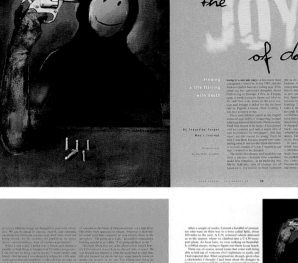

the JOY of danger

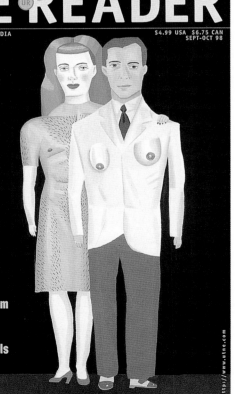

Fire Your Boss—The 48 Laws of Power

UTNE READER

THE BEST OF THE ALTERNATIVE MEDIA

$4.99 USA $6.75 CAN
SEPT-OCT 98

It's 2 a.m.
Do You
Know
What Sex
You Are?

Does Anybody?

The Mulatto Millennium

The Curse of Literacy

Borneo's New Cannibals

http://www.utne.com

■ 661
Publication Travel & Leisure
Creative Director Pamela Berry
Designer Valerie Fong
Illustrator Edward Gorey
Publisher American Express Publishing Co.
Issue June 1998
Category Story

■ 662
Publication Utne Reader
Art Director Lynn G. Phelps
Designer Lynn G. Phelps
Illustrator Juliette Borda
Publisher Lens Publishing, Inc.
Issue September/October 1998
Category Single Page

■ 663
Publication Utne Reader
Art Director Lynn G. Phelps
Designers Diane Hart, Lynn G. Phelps
Illustrator Marshall Arisman
Publisher Lens Publishing, Inc.
Issue July 1998
Category Story

ILLUSTRATION MERIT ■

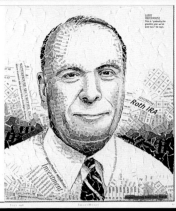

TAKEOVERS. PRICE WARS. CUTTHROAT COMPETITION. WITH ALL THAT AS A BACKDROP, IT'S NOT EASY CHOOSING A DISCOUNT BROKER. HERE'S HOW TO PICK THE RIGHT ONE FOR YOUR NEEDS.
BY JAMES R. HAGY AND LAUREN YOUNG
WITH ERIC HERMAN
ILLUSTRATIONS BY LAUREN URAM

THE BEST & WORST
DISCOUNT BROKERS

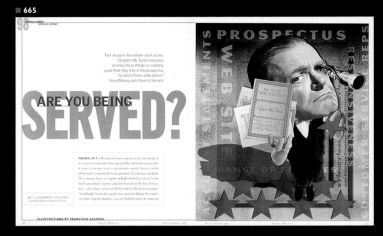

ARE YOU BEING SERVED?

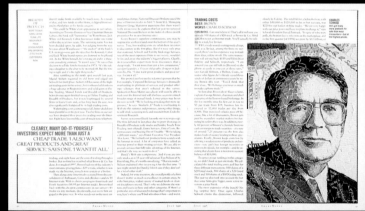

BREAKING THE BANK

Technology is forcing banks to become nimble financial service aggregators that cater to customers through a variety of electronic channels—because if they don't, Yahoo and Intuit will.
BY NIKKI GOTH ITOI

■ 664
Publication SmartMoney
Art Director Amy Rosenfeld
Designer Julie Lazarus
Illustrator Lauren Uram
Publisher Dow Jones & Hearst Corp.
Issue July 1998
Category Story

■ 665
Publication SmartMoney
Art Director Amy Rosenfeld
Designer Anna Kula
Illustrator Francisco Caceres
Publisher Dow Jones & Hearst Corp.
Issue September 1998
Category Story

■ 666
Publication Red Herring
Art Director Pete Ivey
Designer Pete Ivey
Illustrator Eric Johnson
Publisher Red Herring Communications
Issue October 1998
Category Spread

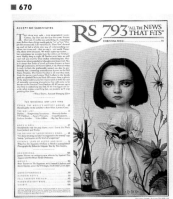

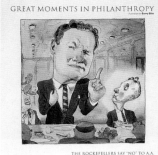

■ 671

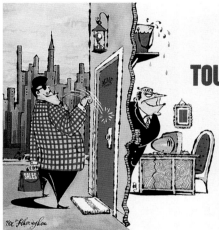

T&C's Ultimate Guide to
PRIME REAL ESTATE
EDITED BY SARAH MEDFORD DRAWINGS BY ROZ CHAST

■ 668

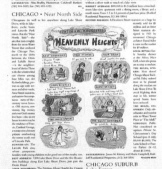

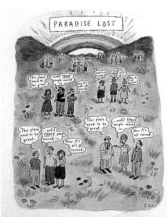

■ 669
Publication The American Benefactor
Design Director Mimi Park
Art Director Melanie deForest
Designer Melanie deForest
Illustrator Barry Blitt
Studio Design Park Inc.
Publisher Capital Publishing L. P.
Issue Spring 1998
Category Single Page

■ 667
Publication Success
Art Director David O'Connor
Designer Marcus Villaça
Illustrator Brian Cronin
Publisher Success Holdings Co.
Issue October 1998
Category Spread

■ 670
Publication Rolling Stone
Art Director Fred Woodward
Illustrator Mark Ryden
Publisher Straight Arrow Publishers
Issue August 20, 1998
Category Single Page

■ 668
Publication Success
Art Director David O'Connor
Designer Marcus Villaça
Illustrator Edwin Fotheringham
Publisher Success Holdings Co.
Issue November 1998
Category Spread

■ 671
Publication Town & Country
Creative Director Mary Shanahan
Art Director Margot Frankel
Illustrator Roz Chast
Publisher The Hearst Corporation-Magazines Division
Issue June 1998
Category Story

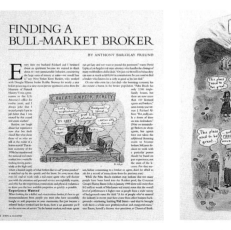

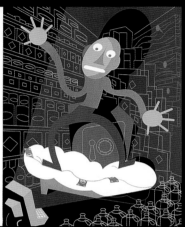

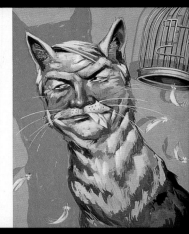

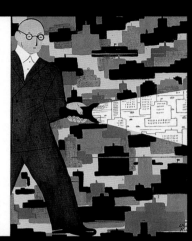

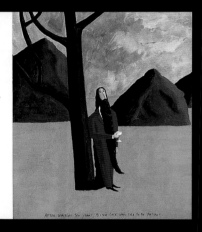

■ 672
Publication Worth
Art Director Philip Bratter
Designer Chalkley Calderwood Pratt
Illustrator Richard McGuire
Publisher Capital Publishing L. P.
Issue December 1998
Category Story

■ 673
Publication Worth
Art Directors Philip Bratter,
Deanna Lowe
Designer Karmen Lizzul
Illustrator Tim Bower
Publisher Capital Publishing L. P.
Issue September 1998
Category Spread

■ 674
Publication Worth
Art Directors Philip Bratter,
Deanna Lowe
Designer Chalkley Calderwood Pratt
Illustrator Brian Cronin
Publisher Capital Publishing L. P.
Issue October 1998
Category Spread

■ 675
Publication Worth
Art Director Philip Bratter
Designer Philip Bratter
Illustrator Benoît
Publisher Capital Publishing L. P.
Issue October 1998
Category Spread

Until recently,

[body text illegible]

THE RUMORS OF MY DEATH...

...have been greatly exaggerated. Middlesex say they won't go quietly.

Hear no See no Speak no FRAUD

The Cendant fiasco shows that in high-profile M&A's, due diligence takes a back seat. • By Ronald Fink

ILLUSTRATION BY BILL MAYER

IT'S MOSTLY THE VOICE

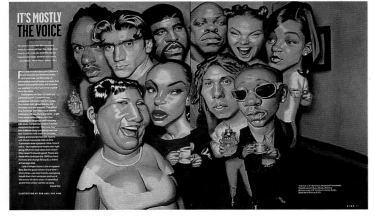

What a political spin doctor, a curious reporter, and a bottle of Vermont's favorite soft drink had to do with Calvin Coolidge's midnight inauguration 75 years ago this month. by John Fleischman

It Took moxie

It is an August night and stiflingly hot even in upland Plymouth Notch, Vermont. The bugs and a small knot of witnesses bump against the screen door, straining to make out the

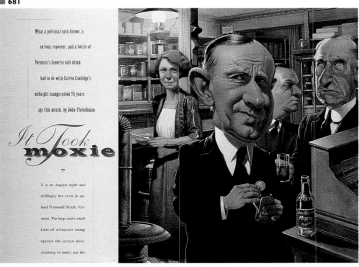

■ 676
Publication Worth
Art Directors Philip Bratter, Deanna Lowe
Illustrator Benoît
Publisher Capital Publishing L. P.
Issue October 1998
Category Spread

■ 677
Publication Worth
Art Director Philip Bratter
Designer Philip Bratter
Illustrator Benoît
Publisher Capital Publishing L. P.
Issue October 1998
Category Spread

■ 678
Publication Vibe
Art Director Dwayne N. Shaw
Illustrator Daniel Adel
Publisher Vibe/Spin Ventures
Category Spread

■ 679
Publication Context
Creative Director Jane Kosstrin
Design Director Mark Maltais
Designer Mark Maltais
Illustrator Christian Northeast
Art Editor Lynn Serra
Publisher Diamond Technology Partners
Issue Fall 1998
Category Spread

■ 680
Publication CFO
Design Director Robert Lesser
Art Director Diane McEnaney
Illustrator Bill Mayer
Publisher CFO Publishing Corp
Issue October 1998
Category Spread

■ 681
Publication Yankee
Art Director J. Porter
Illustrator C. F. Payne
Publisher Yankee Publishing Inc.
Issue August 1998
Category Spread

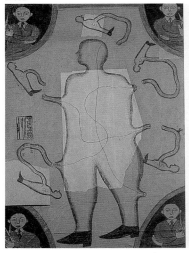

Financial Lifeguard to Developing Nations

When the Cure Is Worse Than the Disease

By Matthew James Ryan

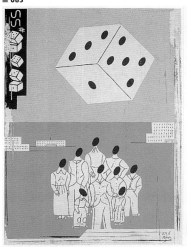

is ?

pension reform worth the gamble

privatizations could be a smart bet—or a one-way ticket to palookaville.
BY VANESSA BROCKER
ILLUSTRATIONS BY BRIAN CRONIN

SPECIAL REPORT

HOLD on tight

Trends to watch in 1999

With a challenging year ahead, poorly managed companies may not survive to usher in the new millennium.

BY DAVID DIAMOND

notable girlfriends

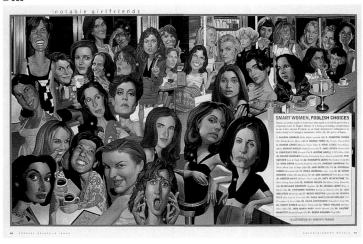

SMART WOMEN, FOOLISH CHOICES

ILLUSTRATION BY ROBERTO PARADA

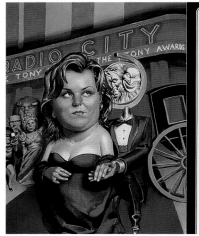

TONY FEVER

by Richard Alleman · Illustration by Daniel Adel

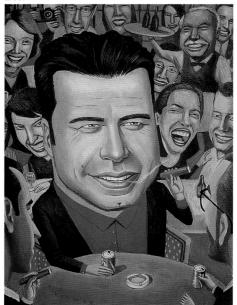

■ 682
Publication Global
Creative Director Sarah Vinas
Art Director Stephanie Birdsong
Illustrator Philippe Weisbecker
Publisher Deloitte & Touche
Issue July/August 1998
Category Spread

■ 683
Publication Global
Creative Director Sarah Vinas
Art Director Tom Brown
Designers Tom Brown, Rob Hewitt
Illustrator Brian Cronin
Publisher Deloitte & Touche
Issue November/December 1998
Category Spread

■ 684
Publication Electronic Business
Design Director John Sizing
Illustrator Tom White
Studio JS Publication Design
Publisher
Cahners Business Information
Issue December 1998
Category Spread

■ 685
Publication Entertainment Weekly
Design Director John Korpics
Designer Melissa Feldman
Illustrator Roberto Parada
Publisher Time Inc.
Issue May 4, 1998
Category Spread

■ 686
Publication The Shuttle Sheet
Design Director Lynette Cortez
Art Director Tonya Hudson
Illustrator Daniel Adel
Studio Divine Design Studio, Inc.
Publisher Pace Communications
Issue May 1998
Category Spread

■ 687
Publication The Shuttle Sheet
Design Director Lynette Cortez
Art Director Tonya Hudson
Illustrator Charlie Powell
Studio Divine Design Studio, Inc.
Publisher Pace Communications
Issue November 1998
Category Single Page

■ 688

LA WEEKLY

199?

Y2K
A COMPLETE GUIDE TO THE COMING CRISIS IN COMPUTING
BY PETER GARRISON

■ 690

DEEP BLUE
WHAT ELSE CAN YOU DO?

EXPLORE MARS

MAP OCEANS

NUCLEAR TESTS

■ 689

STANDARD & POOR'S

Utility Business Strategies

October 1998

■ 691

SESAME STREET PARENTS

The Gift of Jim Henson

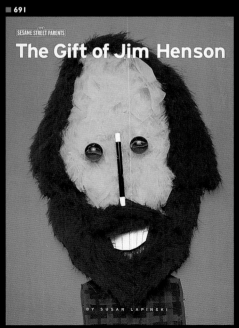

BY SUSAN LAPINSKI

■ 692

MARCH 1998

STANFORD BUSINESS

THE DOWNSIDE OF
DOWNSIZING
From a new book by
Jeffrey Pfeffer

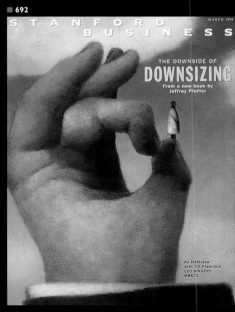

An Interview
with TCI President
LEO HINDERY
MBA/71

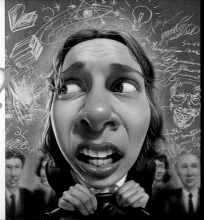

What do I do now?

THE TOUGHEST
QUESTIONS COME
AFTER THE GRUELING
RACE FOR A
RHODES SCHOLARSHIP
IS OVER.

by Esther Pan

e.coli
express

A bacteria willing
Stanford postdoc reports
on her weekend
of intestinal gurgles and
examinations of her stools,
all in the name of science.

Patrick Brown wants to share his DNA-array-chip technology with any researchers who are interested. There are plenty of takers.

A
N
D

C H I P S

F O R

A L L

BY WILLIAM WELLS

BY VIRTUE OF BEING HUMAN

December 10, 1998 marks the 50th
anniversary of the Universal Declaration of
Human Rights (UDHR). Classrooms around
the country are participating in a yearlong
commemoration by exploring human rights
issues across the curriculum.

BY S. CLAIRE KING, ECC
ILLUSTRATION BY EDEL RODRIGUEZ

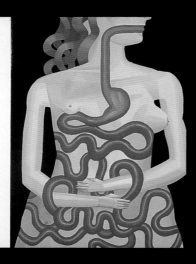

In February 1993, I learned that a former student
of mine, Juan Perez, had been involved in a
shooting on Valentine's night and was in jail for
murder. I was stunned. How could a quiet, studious
16-year-old use a gun on another human being?
There had to be a mistake. But it was true, and
having been Juan's 9th grade Spanish teacher at
Marquette University High School in Milwaukee,
I had to find out what happened. In the course
of my search, Juan went from being **JUST
ANOTHER FACE** in my classroom to
someone who inspired
me to rethink both my approach to teaching and
our school's support system for Latino students.

•••••••• BY JIM WILKINSON ••••••••

the BEST SHOP THIS WAY

From Munich to Moscow,
these premier avenues are paradise
for natural-born spenders

BY RENE CHUN/ILLUSTRATIONS BY ANJA KROENCKE

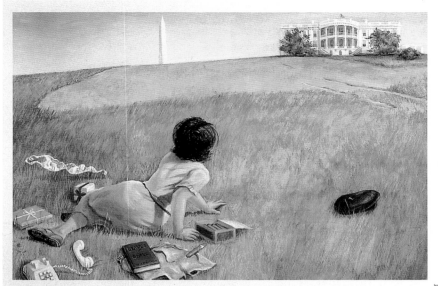

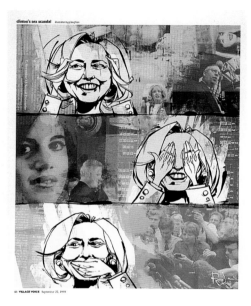

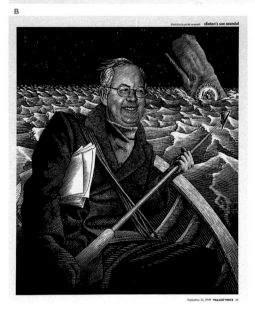

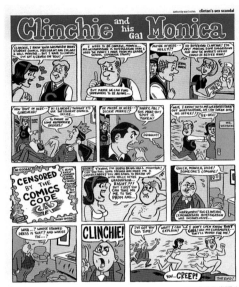

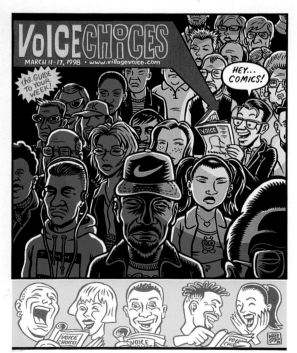

■ 699
Publication The Village Voice
Design Director Ted Keller
Art Director Minh Uong
Designer Stacy Wakefield
Illustrators David O'Keefe, Jeff Crosby, Ward
Sutton, PJ Loughran, Patrick Arrasmith
Publisher VV Publishing Corp.
Issue September 22, 1998
Categories Story
 A Spread
 B Single Page

■ 700
Publication The Village Voice
Design Director Ted Keller
Art Director Minh Uong
Designer Nicole Szymanski
Illustrator Ward Sutton
Publisher VV Publishing Corp.
Issue March 17, 1998
Category Single Page

ILLUSTRATION MERIT

231

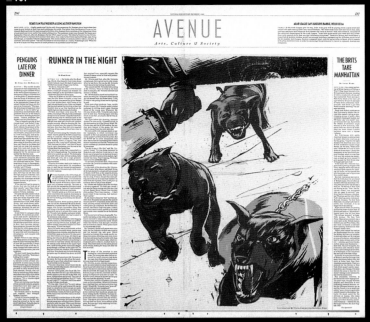

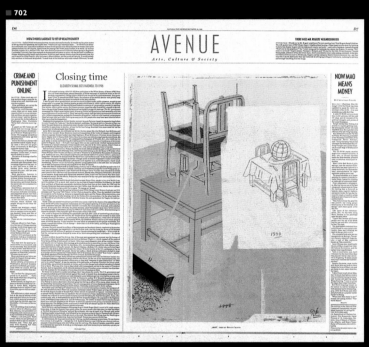

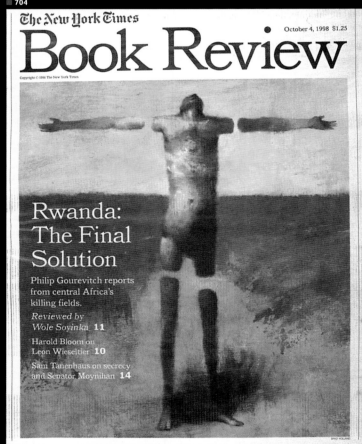

■ 701
Publication National Post
Creative Director Leanne M. Shapton
Design Directors Lucie Lacava, Roland-Yves
Carignan, Gayle Grin
Designer Leanne M. Shapton
Illustrator Tavis Cobum
Issue December 7,1998
Category Single Page

■ 702
Publication National Post
Creative Director Leanne M. Shapton
Design Directors Lucie Lacava, Roland-Yves
Carignan, Gayle Grin
Designer Leanne M. Shapton
Illustrator Brian Cronin
Issue December 28,1998
Category Single Page

■ 703
Publication National Post
Creative Director Leanne M. Shapton
Design Directors Lucie Lacava, Roland-Yves
Carignan, Gayle Grin
Designer Leanne M. Shapton
Illustrator Leanne M. Shapton
Issue December 1,1998
Category Single Page

■ 704
Publication The New York Times Book Review
Art Director Steven Heller
Illustrator Brad Holland
Publisher The New York Times
Issue October 4, 1998
Category Single Page

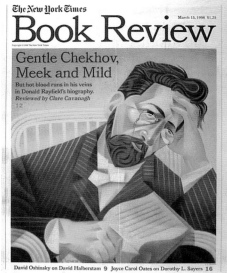

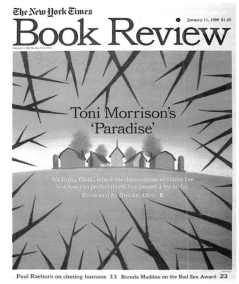

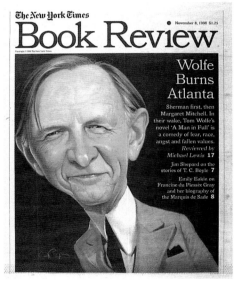

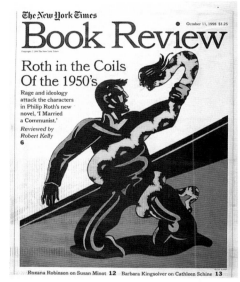

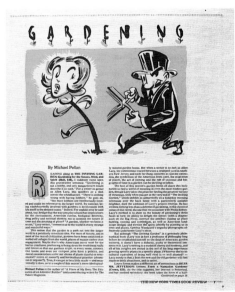

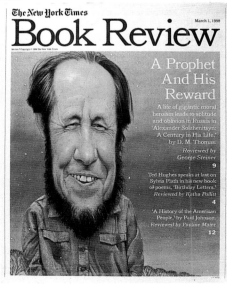

ILLUSTRATION MERIT ■

■ 706
Publication The New York Times Book Review
Art Director Steven Heller
Illustrator D. B. Johnson
Publisher The New York Times
Issue March 15, 1998
Category Single Page

■ 707
Publication The New York Times Book Review
Art Director Steven Heller
Illustrator C. F. Payne
Publisher The New York Times
Issue November 8, 1998
Category Single Page

■ 708
Publication The New York Times Book Review
Art Director Steven Heller
Illustrator John Nickle
Publisher The New York Times
Issue January 1, 1998
Category Single Page

■ 705
Publication The New York Times Book Review
Art Director Steven Heller
Illustrator Christoph Niemann
Publisher The New York Times
Issue May 31, 1998
Category Story

■ 709
Publication The New York Times Book Review
Art Director Steven Heller
Illustrator Milton Glaser
Publisher The New York Times
Issue October 11, 1998
Category Single Page

■ 710
Publication The New York Times Book Review
Art Director Steven Heller
Illustrator C. F. Payne
Publisher The New York Times
Issue March 1, 1998
Category Single Page

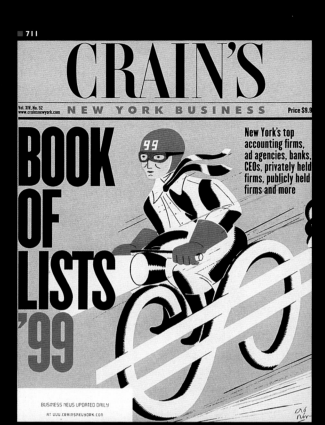

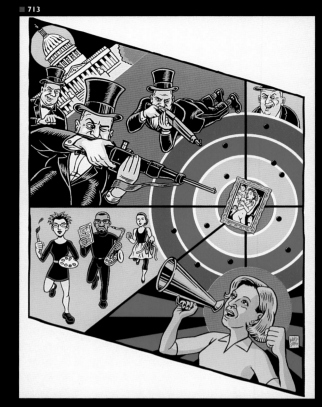

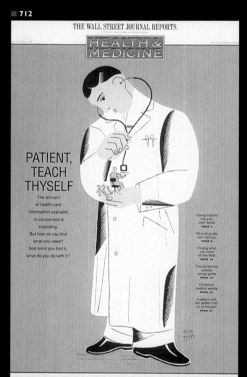

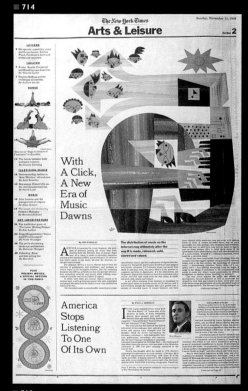

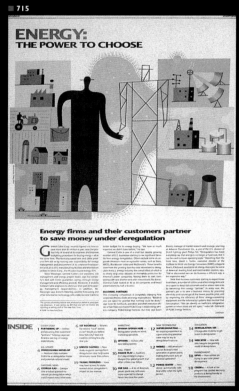

711

Publication Crain's New York Business
Art Directors Steven Krupinski, Edward Levine
Designer Edward Levine
Illustrator Brian Cronin
Publisher Crain Communications
Issue December 28, 1998
Category Single Page

712

Publication The Wall Street Journal Reports
Design Director Greg Leeds
Art Director Orlie Kraus
Designer Orlie Kraus
Illustrator Brian Cronin
Publisher Dow Jones & Co., Inc.
Issue October 19, 1998
Category Single Page

713

Publication The New York Times
Design Director Michael Valenti
Illustrator Ward Sutton
Publisher The New York Times
Issue April 12, 1998
Category Single Page

714

Publication The New York Times
Art Director Michael Valenti
Illustrator Philip Anderson
Publisher The New York Times
Issue November 15, 1998
Category Single Page

715

Publication The New York Times
Designer Susan Simmons
Illustrator Doug C. Ross
Studio Doug Ross Illustration
Publisher The New York Times
Issue October 19, 1998
Category Single Page

THE WIRED WORLD ATLAS

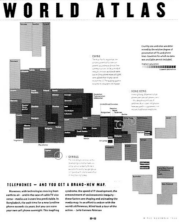

ENVISION THE GLOBE ACCORDING TO THE DENSITY OF TRADITIONAL MEDIA — TVS AND

TELEPHONES — AND YOU GET A BRAND-NEW MAP.

■ 716

Publication Wired
Design Director Thomas Schneider
Designers Thomas Schneider, Eric Courtemanche,
Barbara Radosavljevic
Photo Editor Aaron Caplan
Publisher Condé Nast Publications Inc.
Issue November 1998
Category Information Graphics

THE MEDIA SPECTRUM

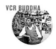

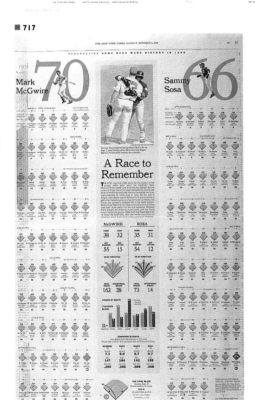

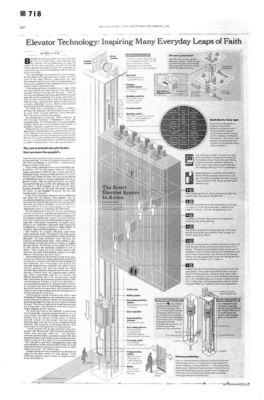

■ 717

Publication The New York Times
Designer Joe Ward
Illustrator Joe Ward
Publisher The New York Times
Issue October 4, 1998
Category Information Graphics

■ 718

Publication The New York Times
Illustrator John Grimwade
Graphics Editor John Grimwade
Publisher The New York Times
Issue December 3, 1998
Category Information Graphics

■ 719

Publication The Washington Post Magazine
Art Director Michael Keegan
Illustrators John Anderson, Robert Dorrell
Graphics Reporter Seth Hamblin
Publisher The Washington Post Co.
Issue November 18, 1998
Category Information Graphics

ILLUSTRATION INFORMATION GRAPHICS ■ MERIT

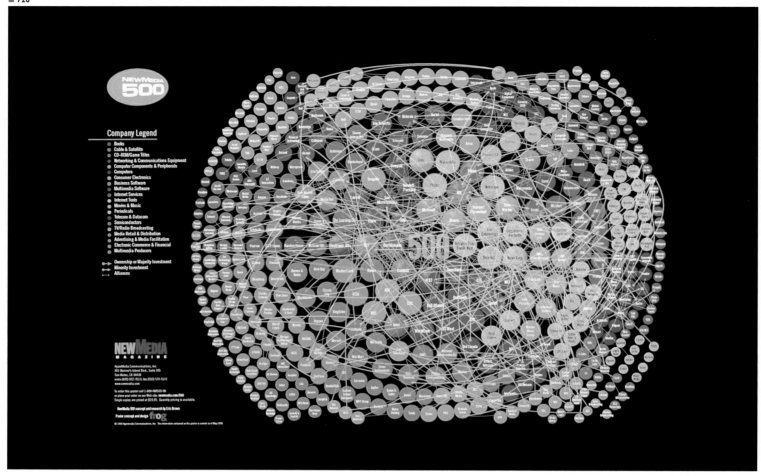

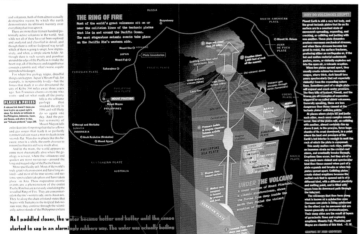

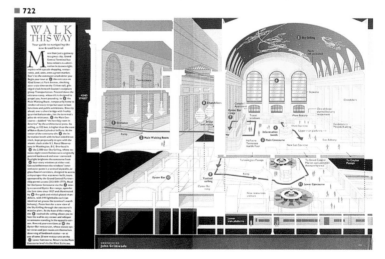

■ 720
Publication NewMedia
Creative Director Nancy R. Cutler
Art Director Douglas G. Beach
Designer frog design
Publisher Hypermedia Communications
Issue July 1998
Category Information Graphics

■ 721
Publication Condé Nast Traveler
Design Director Robert Best
Art Director Carla Frank
Designer Robert Best
Illustrator John Grimwade
Publisher Condé Nast Publications Inc.
Issue May 1998
Category Information Graphics

■ 722
Publication Condé Nast Traveler
Design Director Robert Best
Art Director Carla Frank
Designer Robert Best
Illustrators John Grimwade, John Tomanio
Publisher Condé Nast Publications Inc.
Issue September 1998
Category Information Graphics

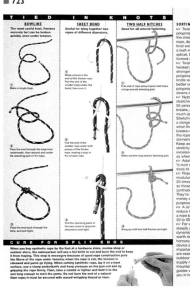

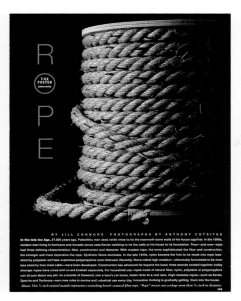

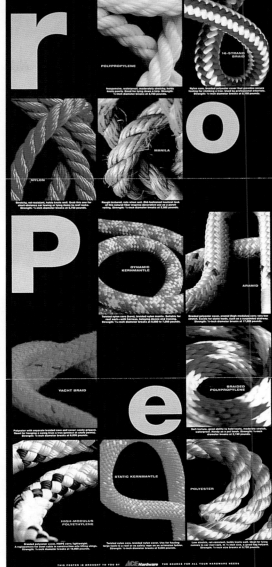

Even people who think they have no artistic skill can gain a lot by drawing trees in winter. Sketching hones observation skills.

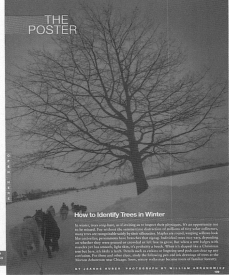

THE POSTER

How to Identify Trees in Winter

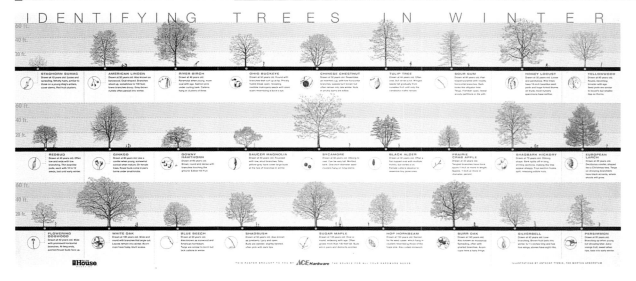

IDENTIFYING TREES IN WINTER

■ 723
Publication This Old House
Design Director Matthew Drace
Art Director Diana Haas
Photographer Anthony Cotsifas
Publisher Time Inc.
Issue July/August 1998
Category Information Graphics

■ 724
Publication This Old House
Design Director Matthew Drace
Art Director Mo Flan
Illustrator Anthony Tyznik
Photographers William Abranowicz, Cynthia Howe
Publisher Time Inc.
Issue January/February 1998
Category Information Graphics

sp●ts

The SPOTS competition recognizes the little masterpieces that work so hard to communicate big ideas in a small amount of space. It was established in 1987 in order to allow smaller illustrations to compete against others of a similar dimension.

A jury of seven art directors and illustrators judged over 1350 entries from the United States and abroad in four categories and selected 148 winners, including for the first time a Best in Show winner. The original illustrations were exhibited at the Society of Illustrators Museum of American Illustration in June and July of 1999.

●CHAIRPERSON

Christine Curry
Illustration Editor, The New Yorker
(bottom center)

●JUDGES
(bottom left, clockwise)

Jill Armus
Art Director, Saveur Magazine

Joe Kimberling
Managing Art Director, Entertainment Weekly

Pamela Berry
Creative Director, Travel & Leisure

Edel Rodriguez
Art Director, Time International, Illustrator

Barry Blitt
Illustrator

Owen Phillips
Deputy Illustration Editor, The New Yorker

Illustration by **Barry Blitt**

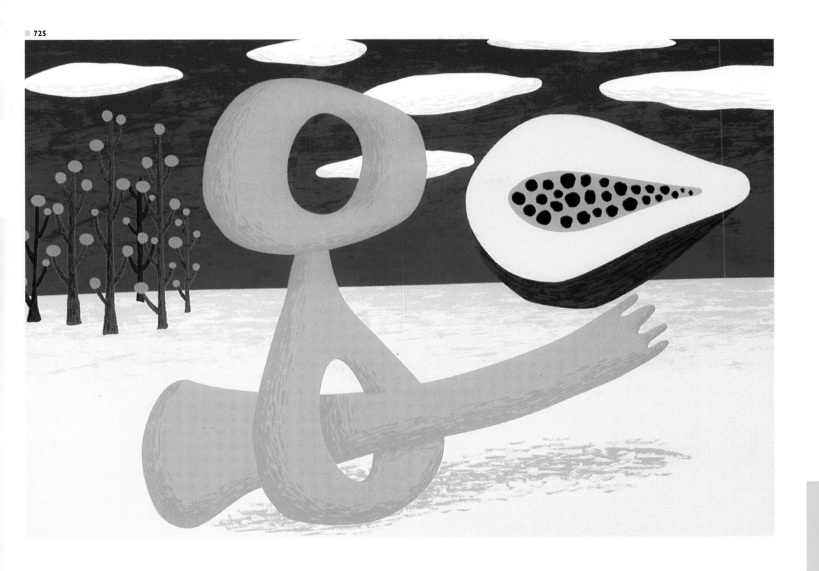

■ 726

■ 727

■ 725
Best in Show
Illustrator Melinda Beck
Title Patience Bears Fruits
Publication Bloomberg Personal Finance
Art Director Frank Tagariello
Issue March 1999
Publisher Bloomberg L. P.

■ 726
Illustrator Melinda Beck
Title WalPark
Publication Metropolis
Art Director Willam Van Roden
Issue May 1998
Publisher Bellerophon Publications

■ 727
Illustrator Melinda Beck
Title Go Forth and Multiply
Publication Bloomberg Personal Finance
Art Director Frank Tagariello
Issue March 1998
Publisher Bloomberg L. P.

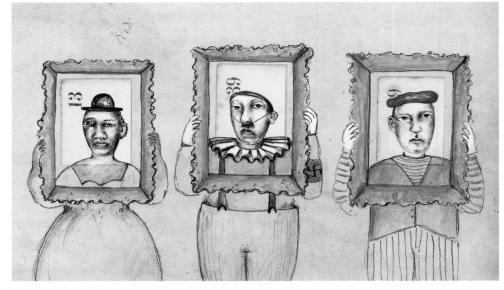

■ 728

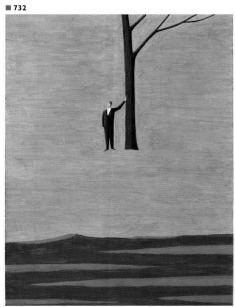

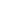

■ 729
Illustrator Deborah Barrett
Title Degenerate Art
Publication The New Yorker
Art Director Owen Phillips
Issue May 18, 1998
Publisher Condé Nast Publications, Inc.

■ 730
Illustrator Deborah Barrett
Title When the Future Is Now
Publication Bloomberg Personal Finance
Art Director Frank Tagariello
Issue October 1998
Publisher Bloomberg L. P.

■ 728
Illustrator Eric Hanson
Title Chronicle
Publication Condé Nast Traveler
Art Director Carla Frank
Issue November 1998
Publisher Condé Nast Publications, Inc.

■ 731
Illustrator Benoît
Title LA vs. NY
Publication Los Angeles
Art Director David Armario
Issue February 1998
Publisher Fairchild Publications

■ 732
Illustrator Benoît
Title House Poor No More
Publication Bloomberg Personal Finance
Art Directors Frank Tagariello, Carol Layton
Issue May 1998
Publisher Bloomberg L. P.

■ 745

■ 746

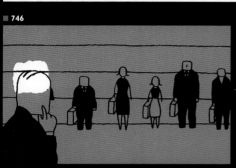

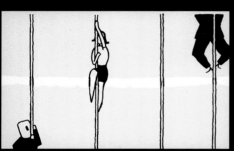

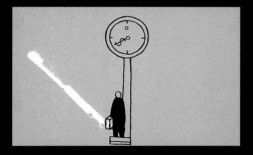

■ 747

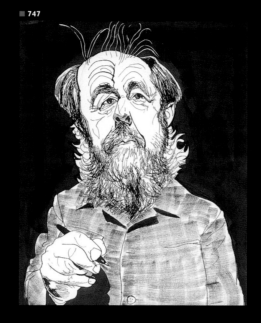

■ 748

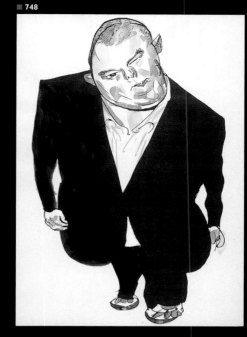

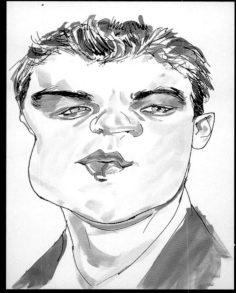

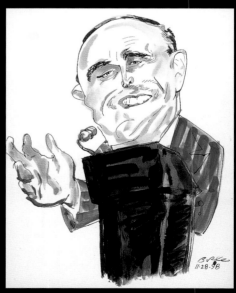

■ 745
Illustrator Laurent Cilluffo
Title Woman in the Middle
Publication House Beautiful
Art Director Andrzej Janerka
Issue October 1998
Publisher The Hearst Corporation-
Magazines Division

■ 746
Illustrator Laurent Cilluffo
Title 6 Ways to Make Your Dealers Love You
Publication Sales & Marketing Management
Art Directors Victoria Beerman, Erika Gomez
Issue April 1998
Publisher Bill Communications

■ 747
Illustrator Philip Burke
Title From Russia With Ire
Publication New York
Art Directors Mark Michaelson, Anton Ioukhnovets
Issue February 23, 1998
Publisher Primedia Magazines Inc.

■ 748
Illustrator Philip Burke
Title Powers of New York
Publication New York
Art Directors Michele Parrella, Michael Picón
Issue December 21-28, 1998
Publisher Primedia Magazines Inc.

SPOTS

243

■ 749

■ 750

■ 751

■ 752

■ 753

■ 754

■ 749
Illustrator Brian Cronin
Title Jim Rogers
Publication Worth
Art Directors Philip Bratter, Sarah Garcea
Issue February 1999
Publisher Capital Publishing L. P.

■ 750
Illustrator Brian Cronin
Title From the Veranda
Publication Travel & Leisure Golf
Art Directors Tom Brown, Dirk Barnett, Todd Albertson
Issue March-December1998
Publisher American Express Publishing Co.

■ 751
Illustrator Edwin Fotheringham
Title Don't Merge Ahead
Publication Worth
Art Directors Philip Bratter, Deanna Lowe
Issue July/August 1998
Publisher Capital Publishing L. P.

■ 752
Illustrator Edwin Fotheringham
Title Toilet Art
Publication The New Yorker
Art Director Owen Phillips
Issue July 27, 1998
Publisher Condé Nast Publications, Inc.

■ 753
Illustrator John Cuneo
Title A Gardener's Best Friend
Publication Organic Gardening
Art Directors Rosalind Wanke, Andy Omel
Issue January 1998
Publisher Rodale Press, Inc.

■ 754
Illustrator John Cuneo
Title Marilyn Manson, Busta Rhymes & Ozzy Osbourne, John Updike
Publication Entertainment Weekly
Art Director Joe Kimberling
Issues June 19, October 11, November 6, 1998
Publisher Time Inc.

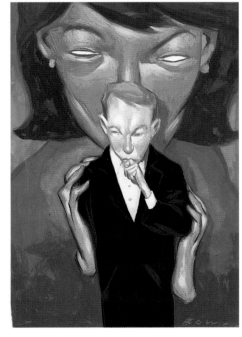

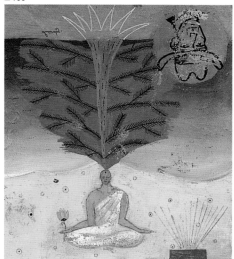

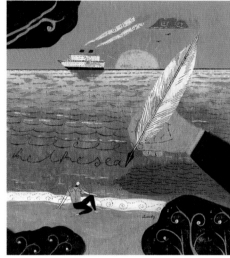

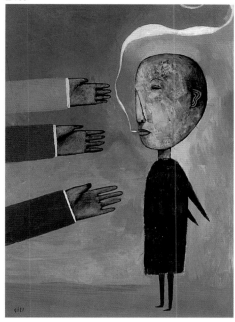

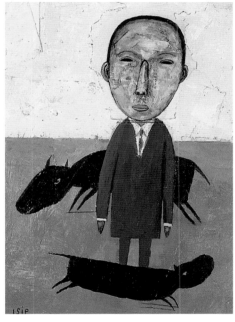

■ 757
Illustrator Tim Bower
Title Diary of a Battered Husband
Publication Boston Magazine
Art Director Joseph Heroun
Issue March 1998
Publisher Boston Magazine

■ 755
Illustrator Eliza Gran
Title No Going Back
Publication Parenting
Art Directors Bernice Pfluger, Susan Dazzo
Issue September 1998
Publisher Time Inc.

■ 756
Illustrator Eliza Gran
Title Modern Yoga: Om to the Beat
Publication The New York Times
Art Director Sam Reep
Issue April 1998
Publisher The New York Times

■ 758
Illustrator Philippe Lardy
Title Tibet in Montana
Publication Saveur
Art Directors Michael Grossman, Jill Armus
Issue January/February 1999
Publisher Meigher Communications

■ 759
Illustrator Philippe Lardy
Title Asia Falling
Publication Worth
Art Directors Philip Bratter, Deanna Lowe
Issue July/August 1998
Publisher Capital Publishing L. P.

■ 760
Illustrator Jordin Isip
Title Smoke and Mirrors
Publication Stanford Business Magazine
Art Director Steven Powell
Issue June 1998
Publisher Stanford Business School

■ 761
Illustrator Jordin Isip
Title To Have and To Hold
Publication Bloomberg Personal Finance
Art Directors Frank Tagariello, Carol Layton
Issue September 1998
Publisher Bloomberg L. P.

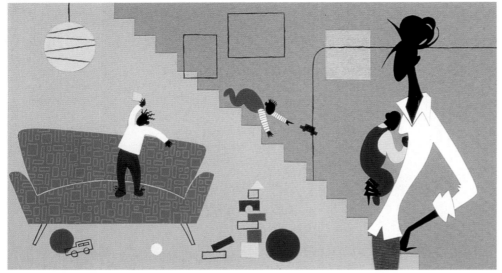

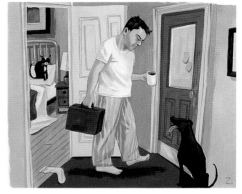

■ 762
Illustrator Anja Kroencke
Title Upstairs Downstairs
Publication House Beautiful
Art Director Andrzej Janerka
Issue July 1998
Publisher The Hearst Corporation-
Magazines Division

■ 763
Illustrator Anja Kroencke
Title Get a Move On
Publication Shape
Art Directors Daphna Shalev, Yvonne Duran
Issue October 1998
Publisher Weider Publications, Inc

■ 764
Illustrator Scott Menchin
Title Capricorn
Publication Details
Art Director Ronda Thompson
Issue January 1999
Publisher Condé Nast Publications, Inc.

■ 765
Illustrator Scott Menchin
Title Capricorn
Publication Details
Art Director Ronda Thompson
Issue January 1998
Publisher Condé Nast Publications, Inc.

■ 766
Illustrator Zohar Lazar
Title I'm Sorry, Dave. I'm Afraid I Can't Do That
Publication Kiplinger's Personal Finance Magazine
Art Director Cynthia L. Currie
Issue January 1999
Publisher Kiplinger's Washington Editors

■ 767
Illustrator Zohar Lazar
Title YourTaxes
Publication SmartMoney
Art Director Amy Rosenfeld
Issue January 1999
Publisher Dow Jones & Hearst Corp.

■ 768
Illustrator Zohar Lazar
Title Funky Friend
Publication Jump
Art Director Jennifer Sidel
Issue December 1998
Publisher Weider Publications, Inc.

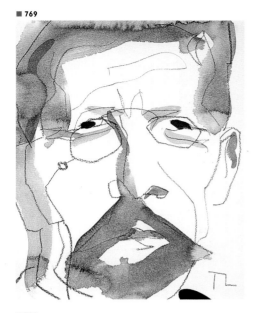

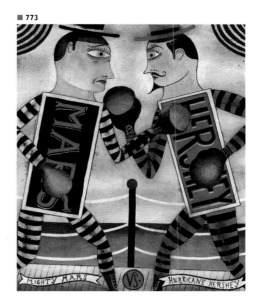

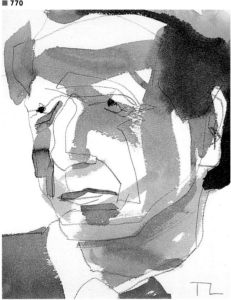

■ 769
Illustrator Thomas Libetti
Title Lukas Foss
Publication The New Yorker
Art Director Owen Phillips
Issue November 28, 1998
Publisher Condé Nast Publications, Inc.

■ 770
Illustrator Thomas Libetti
Title The Undiscovered Checkhov
Publication The New York Times Book Review
Art Director Steven Heller
Issue March 14, 1998
Publisher The New York Times

■ 771
Illustrator Christoph Niemann
Title Book Currents
Publication The New Yorker
Art Director Owen Phillips
Issue June 8-December 28, 1998
Publisher Condé Nast Publications, Inc.

■ 772
Illustrator Christoph Niemann
Title Pulp Fiction Tales of the Mounties
Publication National Post-Weekend Post
Art Director Friederike Gauss
Issue February 6, 1998

■ 773
Illustrator Christian Northeast
Title Brown Stuff, Sticky Fingers
Publication Worth
Art Directors Philip Bratter, Sarah Garcea
Issue February 1999
Publisher Capital Publishing L. P.

■ 774
Illustrator Christian Northeast
Title Morals vs. Markets
Publication Worth
Art Directors Philip Bratter, Sarah Garcea
Issue May 1998
Publisher Capital Publishing L. P.

■ 775

■ 776

■ 777

■ 778

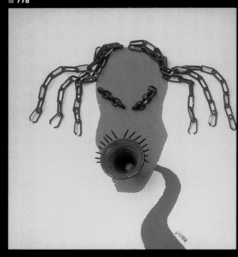

■ 779

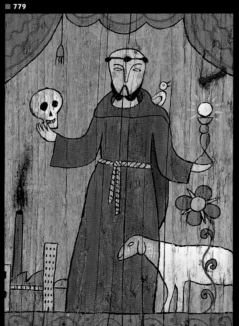

■ 780

■ 781

■ 777
Illustrator Hanoch Piven
Title Mr. Smithers
Publication Details
Art Director John Giordani
Issue October 1998
Publisher Condé Nast Publications, Inc.

■ 778
Illustrator Hanoch Piven
Title Busta Rhymes
Publication Details
Art Director John Giordani
Issue February 1999
Publisher Condé Nast Publications, Inc.

■ 779
Illustrator Stefano Vitale
Title Religion and Ecology
Publication Sierra Magazine
Art Director Martha Geering
Issue November 1998
Publisher The Sierra Club

■ 780
Illustrator Alain Pilon
Title Life of Jesus
Publication The New Yorker
Art Director Owen Phillips
Issue May 18, 1998
Publisher Condé Nast Publications, Inc.

■ 781
Illustrator Alain Pilon
Title Wine Gifts for Everyone
Publication National Post-Weekend Post
Art Director Friederike Gauss
Issue December 12, 1998

■ 775
Illustrator Gary Panter
Title Screening Shiva
Publication New York
Art Directors Mark Michaelson, Anton Ioukhnovets
Issue February 1998
Publisher Primedia Magazines Inc.

■ 776
Illustrator Gary Panter
Title Basement Space
Publication New York
Art Directors Mark Michaelson, Anton Ioukhnovets
Issue February 9,1998
Publisher Primedia Magazines Inc.

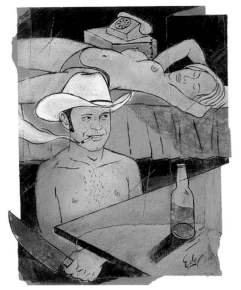

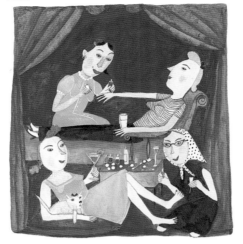

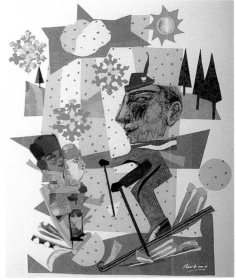

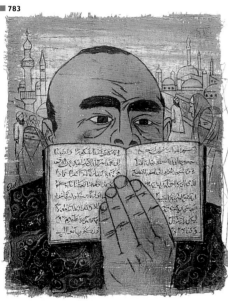

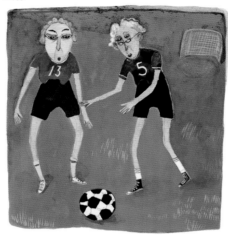

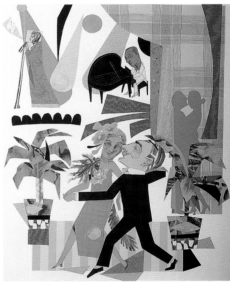

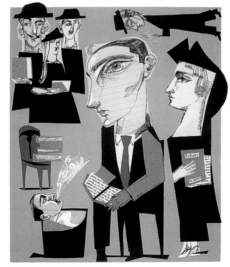

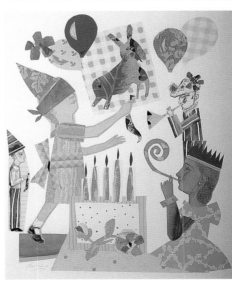

■ 782
Illustrator Edel Rodriguez
Title Clay Pigeons
Publication The New Yorker
Art Director Owen Phillips
Issue October 5, 1998
Publisher Condé Nast Publications, Inc.

■ 783
Illustrator Edel Rodriguez
Title Abu Zeid
Publication The New Yorker
Art Director Christine Curry
Issue June 8, 1998
Publisher Condé Nast Publications, Inc.

■ 784
Illustrator Giselle Potter
Title Nail Polish Party
Publication Shape
Art Directors Donna Giovanitti, Yvonne Duran
Issue December 1998
Publisher Weider Publications, Inc

■ 785
Illustrator Giselle Potter
Title Healthy Women Forever
Publication Shape
Art Directors Donna Giovanitti, Yvonne Duran
Issue May 1998
Publisher Weider Publications, Inc

■ 786
Illustrator Cornel Rubino
Title The Street of Crocodiles
Publication The New Yorker
Art Director Owen Phillips
Issue July 20, 1998
Publisher Condé Nast Publications, Inc.

■ 787
Illustrator Cornel Rubino
Title Patient Population
Publication Anergen Inc. 1997 Annual Report
Art Director Clay Williams
Issue March 1998
Publisher Anergen Inc.

SPOTS

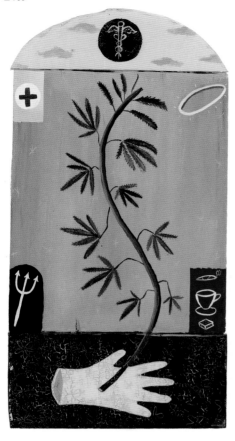

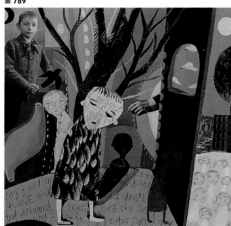

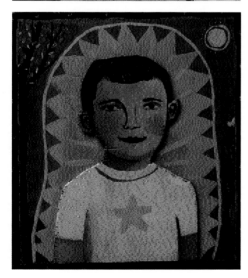

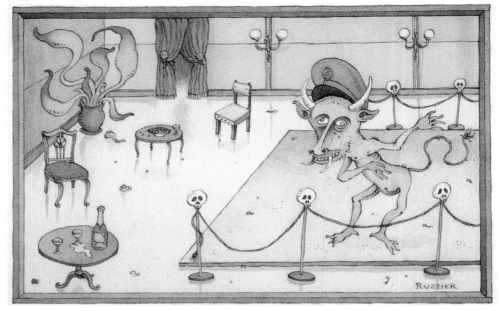

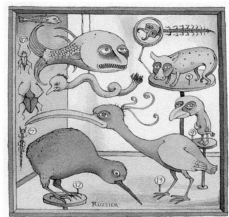

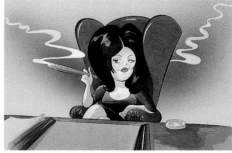

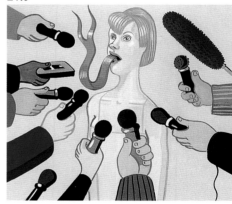

■ 788
Illustrator Susan Saas
Title The Straight Dope
Publication Shape
Art Directors Donna Giovanitti, Yvonne Duran
Issue February 1998
Publisher Weider Publications, Inc

■ 789
Illustrator Susan Saas
Title Growing Up Sad
Publication Family Life
Art Directors Tracy Stora, Bernice Pfluger
Issue February 2, 1999
Publisher Hachette Filipacchi Magazines, Inc.

■ 790
Illustrator Sergio Ruzzier
Title Dancing With the Devil
Publication House Beautiful
Art Director Andrzej Janerka
Issue January 1998
Publisher The Hearst Corporation-
Magazines Division

■ 791
Illustrator Sergio Ruzzier
Title Natural History Museum
Publication The New Yorker
Art Director Owen Phillips
Issue September 7, 1998
Publisher Condé Nast Publications, Inc.

■ 792
Illustrator Eric Palma
Title Monica Lewinsky
Publication Entertainment Weekly
Art Directors John Korpics, Geraldine Hessler
Issue December 24, 1998-January 1, 1999
Publisher Time Inc.

■ 793
Illustrator Alison Seiffer
Title Forked Tongue & Reporters
Publication Entertainment Weekly
Art Directors John Korpics, Geraldine Hessler
Issue December 25, 1998/January 1, 1999
Publisher Time Inc.

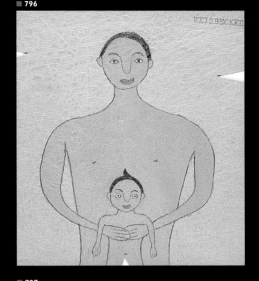

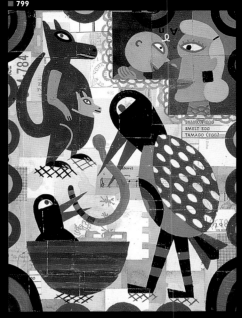

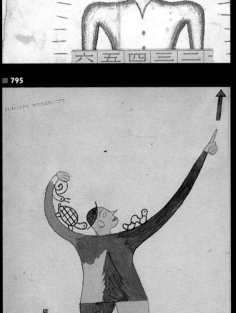

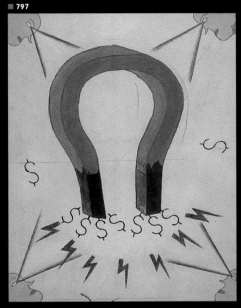

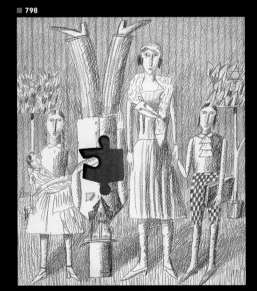

■ 794
Illustrator Philippe Weisbecker
Title Feng Shui Till You Drop
Publication Shape
Art Directors Donna Giovanitti, Yvonne Duran
Issue March 1999
Publisher Weider Publications, Inc

■ 795
Illustrator Philippe Weisbecker
Title Leap into the New Year
Publication Bloomberg Personal Finance
Art Director Frank Tagariello
Issue December 1998
Publisher Bloomberg L. P.

■ 796
Illustrator Philippe Weisbecker
Title To Cut or Not to Cut
Publication Fit Pregnancy
Art Director Stephanie Birdsong
Issue Summer 1998
Publisher Weider Publications, Inc.

■ 797
Illustrator Philippe Weisbecker
Title What's the Big Attraction?
Publication Bloomberg Personal Finance
Art Director Frank Tagariello
Issue December 1998
Publisher Bloomberg L. P.

■ 798
Illustrator Elena Zolotnitsky
Title Missing Peace
Publication Baltimore Jewish Times
Art Director M. Robyn Katz
Issue January 22, 1999
Publisher Jewish Times Magazine

■ 799
Illustrator Noah Woods
Title Strongly Attached
Publication Fit Pregnancy
Art Director Stephanie Birdsong
Issue Winter 1998
Publisher Weider Publications, Inc.

■ 800
Illustrator Noah Woods
Title Length Does Matter
Publication Bloomberg Personal Finance
Art Director Frank Tagariello
Issue August 1998
Publisher Bloomberg L. P.

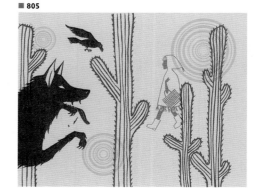

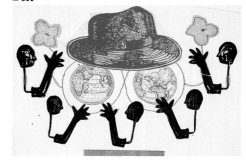

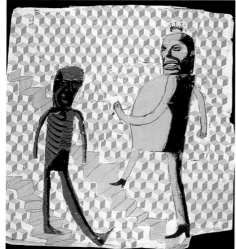

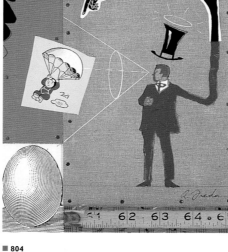

■ 801
Illustrator Ivetta Fedorova
Title Present and Accounted For
Publication Bloomberg Personal Finance
Art Director Frank Tagariello
Issue July/August 1998
Publisher Bloomberg L. P.

■ 802
Illustrator Carl Dunn
Title Fatten Up Your 401(k)
Publication Bloomberg Personal Finance
Art Director Frank Tagariello
Issue March 1998
Publisher Bloomberg L. P.

■ 803
Illustrator Anthony Freda
Title Getting Direction
Publication Bloomberg Personal Finance
Art Director Frank Tagariello
Issue May 1998
Publisher Bloomberg L. P.

■ 804
Illustrator Ward Schumaker
Title Good 'N' Plenty/Measure of Conscience
Publication Bloomberg Personal Finance
Art Directors Frank Tagariello, Carol Layton
Issue February 1998
Publisher Bloomberg L. P.

■ 805
Illustrator Hiroshi Tanabe
Title My, What Long Bonds...
Publication Bloomberg Personal Finance
Art Directors Frank Tagariello, Carol Layton
Issue April 1998
Publisher Bloomberg L. P

■ 806
Illustrator Sibylle Schwarz
Title World Leaders
Publication Bloomberg Personal Finance
Art Director Frank Tagariello
Issue July/August 1998
Publisher Bloomberg L. P

■ 807
Illustrator Esther Watson
Title Playing By the Numbers
Publication Bloomberg Personal Finance
Art Director Frank Tagariello
Issue September 1998
Publisher Bloomberg L. P.

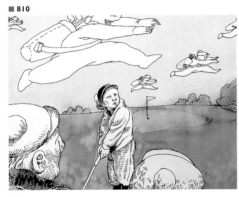

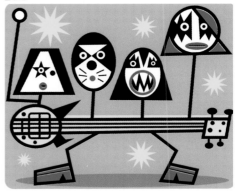

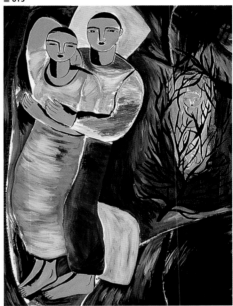

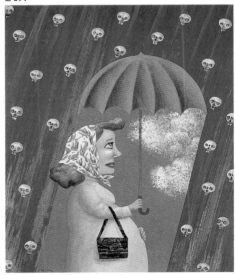

■ 810
Illustrator Wesley Bedrosian
Title Extreme Golf
Publication National Post-Weekend Post
Art Director Friederike Gauss
Issue January 30, 1998

■ 811
Illustrator Jessie Hartland
Title Sinking Feeling
Publication House & Garden
Art Director Stephen Orr
Issue October 1998
Publisher Condé Nast Publications, Inc.

■ 812
Illustrator J. D. King
Title Kiss
Publication Details
Art Director Zoë Miller
Issue September 1998
Publisher Condé Nast Publications, Inc.

■ 808
Illustrator Ian Whadcock
Title Fly Away!
Publication Bloomberg Personal Finance
Art Director Frank Tagariello
Issue September 1998
Publisher Bloomberg L. P.

■ 809
Illustrator Victoria Roberts
Title Martini Soak
Publication Country Living's Healthy Living
Art Director Sumo
Issue August 1998

■ 813
Illustrator Karen Barbour
Title When the Worst Happens
Publication Fit Pregnancy
Art Director Stephanie Birdsong
Issue Spring 1998
Publisher Weider Publications, Inc.

■ 814
Illustrator Blair Drawson
Title With Every Breath You Take
Publication Fit Pregnancy
Art Director Stephanie Birdsong
Issue Summer 1998
Publisher Weider Publications, Inc.

SPOTS

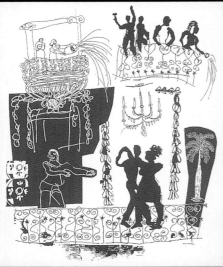

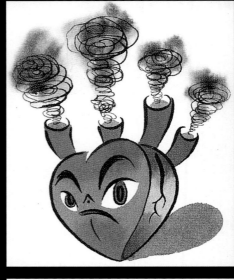

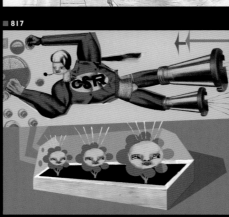

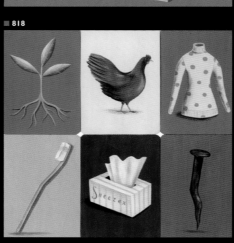

Illustrator Arnold Roth
Title 25 Great Value Bottles
Publication Food & Wine
Art Director Lou DiLorenzo
Issue October 1998
Publisher American Express Publishing Co.

Illustrator Claudia Newell
Title When Extreme Isn't Enough
Publication Sales & Marketing Management
Art Directors Victoria Beerman, Erika Gomez
Issue February 1999
Publisher Bill Communications

Illustrator Sarah Wilkins
Title Who Need Vaccines?
Publication Health
Art Directors Anita Wong, Jane Palecek
Issue November/December 1998
Publisher Time Inc.

Illustrator Einat Peled
Title Hot Night in Havana
Publication Food & Wine
Art Director Lou DiLorenzo
Issue January 1998
Publisher American Express Publishing Co.

Illustrator Michael Klein
Title News for Healthy Living
Publication Health
Art Directors Anita Wong, Jane Palecek
Issue January/February 1998
Publisher Time Inc.

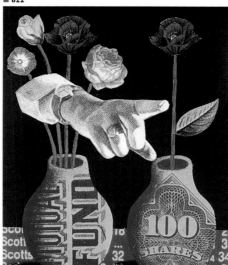

■ 820
Illustrator R. O. Blechman
Title Rampant Creativity
Publication House Beautiful
Art Director Andrzej Janerka
Issue March 1999
Publisher The Hearst Corporation-
Magazines Division

■ 821
Illustrator Peter Sis
Title Picture Perfect
Publication House Beautiful
Art Director Andrzej Janerka
Issue May 1998
Publisher The Hearst Corporation-
Magazines Division

■ 822
Illustrator Gene Greif
Title Giving Up on Funds
Publication Money
Art Directors Syndi Becker, Mary Ann Salvato
Issue October 1998
Publisher Time Inc.

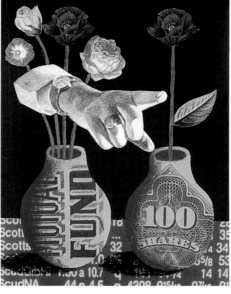

■ 823
Illustrator Matt Mahurin
Title Losing It
Publication Money
Art Directors Syndi Becker, Mary Ann Salvato
Issue October 1998
Publisher Time Inc.

■ 824
Illustrator Michelle Chang
Title History As Muse
Publication New York
Art Director Petros Petrou
Issue March 1998
Publisher Primedia Magazines Inc.

■ 825
Illustrator Laura Ljungkvist
Title What's My Line
Publication New York
Art Directors Mark Michaelson, Anton Ioukhnovets
Issue August 3, 1998
Publisher Primedia Magazines Inc.

■ 826
Illustrator Luba Lukova
Title Letter from Rikers
Publication New York
Art Director Anton Ioukhnovets
Issue March 23, 1998
Publisher Primedia Magazines Inc.

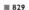

■ 827

■ 829

■ 830

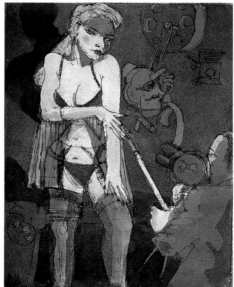

■ 831

■ 828

■ 832

■ 833

■ 827
Illustrator David Levine
Title Orlando Hernandez
Publication The New Yorker
Art Director Christine Curry
Issue August 17, 1998
Publisher Condé Nast Publications, Inc.

■ 828
Illustrator Ruth Marten
Title Tractor Love
Publication The New Yorker
Art Director Christine Curry
Issue November 30, 1998
Publisher Condé Nast Publications, Inc.

■ 829
Illustrator David Mazzucchelli
Title Joe's Pub
Publication The New Yorker
Art Director Owen Phillips
Issue November 30, 1998
Publisher Condé Nast Publications, Inc.

■ 830
Illustrator Robert Andrew Parker
Title Peeping Tom
Publication The New Yorker
Art Director Owen Phillips
Issue February 1, 1998
Publisher Condé Nast Publications, Inc.

■ 831
Illustrator Elvis Swift
Title Orchestra of the Age of Enlightenment
Publication The New Yorker
Art Director Owen Phillips
Issue August 3, 1998
Publisher Condé Nast Publications, Inc.

■ 832
Illustrator Mark Ulriksen
Title Beloved
Publication The New Yorker
Art Director Christine Curry
Issue October 26, 1998
Publisher Condé Nast Publications, Inc.

■ 833
Illustrator Josh Gosfield
Title Red Heifer
Publication The New Yorker
Art Director Christine Curry
Issue July 20, 1998
Publisher Condé Nast Publications, Inc.

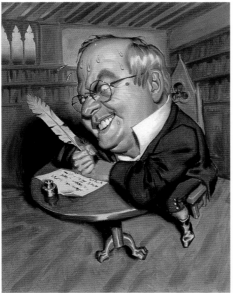

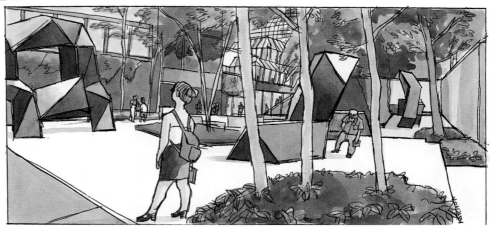

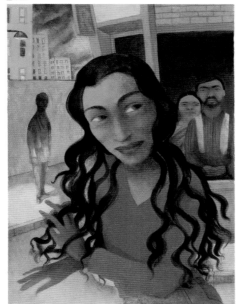

■ 834
Illustrator Daniel Adel
Title Ken Starr's Poison Pen
Publication The New Yorker
Art Director Matt Dellinger
Issue September 28, 1998
Publisher Condé Nast Publications, Inc.

■ 835
Illustrator Karen Caldicott
Title Russell Banks & Jane Smiley
Publication The New Yorker
Art Director Christine Curry
Issue April 6, 1998
Publisher Condé Nast Publications, Inc.

■ 836
Illustrator Gérard Dubois
Title Ramdam
Publication The New Yorker
Art Director Owen Phillips
Issue October 5, 1998
Publisher Condé Nast Publications, Inc.

■ 837
Illustrator Ben Katchor
Title Tony Smith Sculptures at MOMA
Publication The New Yorker
Art Director Owen Phillips
Issue August 17, 1998
Publisher Condé Nast Publications, Inc.

■ 838
Illustrator Ana Juan
Title A Husband for Dil
Publication The New Yorker
Art Director Christine Curry
Issue February 22, 1998
Publisher Condé Nast Publications, Inc.

■ 839
Illustrator Pierre Le-Tan
Title Norman Podhoretz
Publication The New Yorker
Art Director Christine Curry
Issue February 1998
Publisher Condé Nast Publications, Inc.

■ 840
Illustrator Jacek Wozniak
Title Sonic Youth
Publication The New Yorker
Art Director Christine Curry
Issue July 17, 1998
Publisher Condé Nast Publications, Inc.

■ 841
Illustrator Al Hirschfeld
Title Harold Bloom
Publication The New Yorker
Art Director Christine Curry
Issue October 19, 1998
Publisher Condé Nast Publications, Inc.

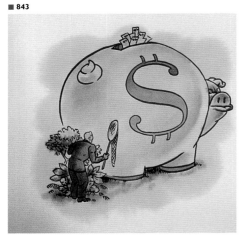

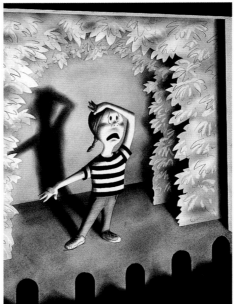

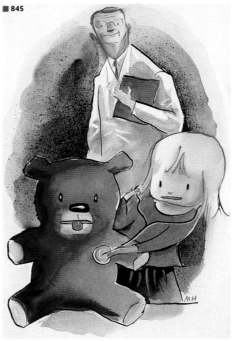

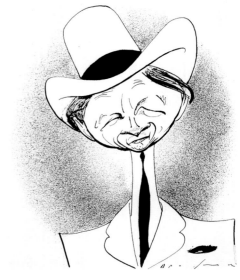

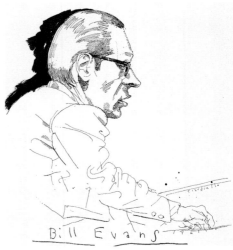

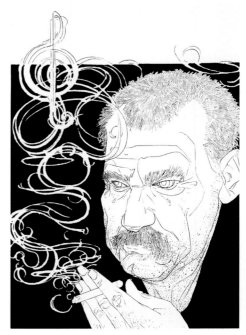

■ 842
Illustrator Paul Corio
Title Looks Like We Made it
Publication P. O. V.
Art Directors Florian Bachleda, Pino Impastato
Issue December 1998
Publisher B.Y.O.B./Freedom Ventures, Inc.

■ 843
Illustrator Ross MacDonald
Title Show Me the Money
Publication P. O. V.
Art Directors Florian Bachleda, Pino Impastato
Issue August 1998
Publisher B.Y.O.B./Freedom Ventures, Inc.

■ 844
Illustrator Ian Falconer
Title Woe-Is-Me Kid
Publication Parenting
Art Director Susan Dazzo
Issue November 1998
Publisher Time Inc.

■ 845
Illustrator Marcellus Hall
Title Dealing with Doctor Phobia
Publication Parenting
Art Director Susan Dazzo
Issue March 1999
Publisher Time Inc.

■ 846
Illustrator Steve Brodner
Title Tom Wolfe, In Full
Publication Weekend Journal-
The Wall Street Journal
Art Directors Joe Dizney, Andrew Horton
Issue October 30, 1998
Publisher Dow Jones & Co., Inc.

■ 847
Illustrator Joe Ciardiello
Title Bill Evans
Publication Weekend Journal-
The Wall Street Journal
Art Director Joe Dizney
Issue August 28, 1998
Publisher Dow Jones & Co., Inc.

■ 848
Illustrator David Johnson
Title Ciao, Paolo Conte
Publication Weekend Journal-
The Wall Street Journal
Art Director Joe Dizney
Issue July 31, 1998
Publisher Dow Jones & Co., Inc.

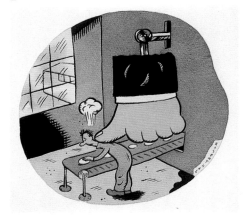

■ 849

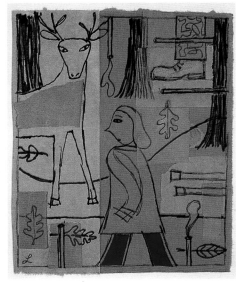

■ 850

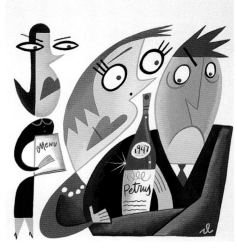

■ 851

■ 852

■ 853

■ 854

■ 849
Illustrator Matthew Martin
Title Slur Blur
Publication The Village Voice
Art Director Minh Uong
Issue November 10, 1998
Publisher VV Publishing Corp.

■ 850
Illustrator Catherine Lazure
Title Ready, Aim, Walk
Publication The Walking Magazine
Art Directors Lisa Sergi, Cathy Robinson
Issue March/April 1999

■ 851
Illustrator Marc Rosenthal
Title Assembly-line Blues
Publication UCLA Magazine
Art Directors Charles Hess, Jackie Morrow
Issue July 1998
Publisher UCLA

■ 852
Illustrator Robert de Michiell
Title Best & Worst of Days
Publication Wine Spectator
Art Director Karen Salama
Issue September 30, 1998
Publisher M. Shanken Communications Inc.

■ 853
Illustrator Laura Levine
Title The Real McCoy
Publication The Atlantic Monthly
Art Directors Judy Garlan, Betsy Urrico
Issue February 1998
Publisher The Atlantic Monthly

■ 854
Illustrator Chris Ware
Title Your Ad Here
Publication Mother Jones
Art Director Rhonda Rubinstein
Issue September 1998-April 1999
Publisher Foundation for National Progress

SPOTS

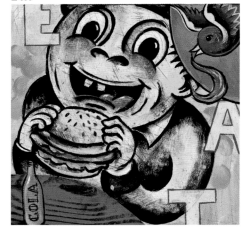

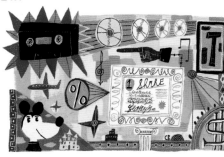

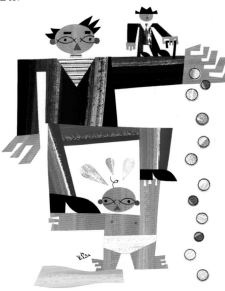

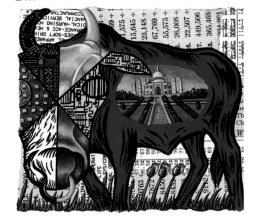

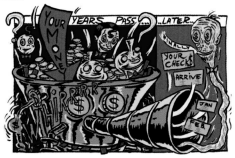

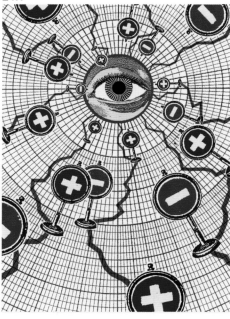

■ 855
Illustrator Rob Clayton
Title Strategy
Publication Worth
Art Directors Philip Bratter, Sarah Garcea
Issue March 1999
Publisher Capital Publishing L. P.

■ 856
Illustrator Calef Brown
Title Personal Adviser
Publication Worth
Art Directors Philip Bratter, Sarah Garcea
Issue February 1999
Publisher Capital Publishing L. P.

■ 857
Illustrator Philip Anderson
Title In Funds We Trust?
Publication Worth
Art Directors Philip Bratter, Karmen Lizzul
Issue June 1998
Publisher Capital Publishing L. P.

■ 858
Illustrator John Craig
Title Technical Advisory
Publication Worth
Art Directors Philip Bratter, Sarah Garcea
Issue October 1998
Publisher Capital Publishing L. P.

■ 859
Illustrator David Plunkert
Title Success Stories
Publication Worth
Art Directors Philip Bratter, Karmen Lizzul
Issue November 1998
Publisher Capital Publishing L. P.

■ 860
Illustrator Hungry Dog Studio
Title An Emerging Superpower
Publication Worth
Art Directors Philip Bratter, Deanna Lowe
Issue July/August 1998
Publisher Capital Publishing L. P.

■ 861
Illustrator David Sandlin
Title Pay Now, Earn Later
Publication Worth
Art Directors Philip Bratter, Karmen Lizzul
Issue November 1998
Publisher Capital Publishing L. P.

■ 862
Illustrator Andrea Ventura
Title Silence Is Golden
Publication Worth
Art Directors Philip Bratter, Sarah Garcea
Issue February 1998
Publisher Capital Publishing L. P.

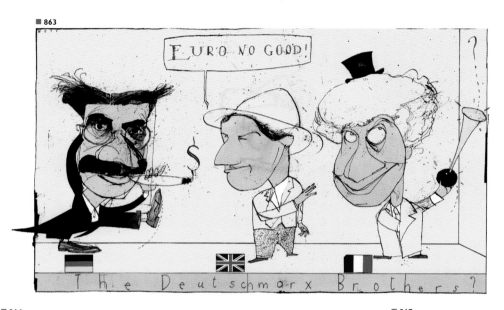

■ 863
Illustrator David Hughes
Title Europe's Big Bet
Publication Worth
Art Directors Philip Bratter, Sarah Garcea
Issue April 1999
Publisher Capital Publishing L. P.

■ 864
Illustrator Laurie Rosenwald
Title Cringley
Publication Worth
Art Directors Philip Bratter, Sarah Garcea
Issue April 1998
Publisher Capital Publishing L. P.

■ 865
Illustrator Dan Yaccarino
Title Living on the Margins
Publication Worth
Art Directors Philip Bratter, Sarah Garcea
Issue March 1999
Publisher Capital Publishing L. P.

■ 866
Illustrator David Sheldon
Title Garden Hopping
Publication Garden Design
Art Directors Michael Grossman, Christin Gangi
Issue June/July 1998
Publisher Meigher Communications

■ 867
Illustrator Mark Matcho
Title Plants in Space
Publication Garden Design
Art Directors Michael Grossman, Christin Gangi
Issue August/September 1998
Publisher Meigher Communications

■ 868
Illustrator Nick Dewar
Title Compost
Publication Garden Design
Art Directors Michael Grossman, Christin Gangi
Issue February/March 1999
Publisher Meigher Communications

■ 869
Illustrator Roxanna Bikadoroff
Title Halloween
Publication Saveur
Art Directors Michael Grossman, Jill Armus
Issue September/October 1998
Publisher Meigher Communications

students

Established in 1995, this competition honors the life and work of B.W. Honeycutt. It recognizes exceptional design by students with awards and three cash prizes. The B.W Honeycutt Award of $2500 and second and third prizes of $1000. These cash prizes are possible due to the success of the SPD art auction, where original artworks have been donated for auction by the industry's leading photographers and illustrators. Proceeds from this event and others have enabled the SPD to significantly increase scholarship grants as well as to extend our outreach programs to art colleges and schools of design.

HENRY WOODWARD CIRCA 1997

JON RAGEL

● CO-CHAIRS

Gail Anderson
Senior Art Director
Rolling Stone

Paul Roelofs
Art Director
InStyle

* Please note that the following student work was completed to assignment specifications for the Society of Publication Designers. It is intended for publication only in the SPD Publication Design Annual.

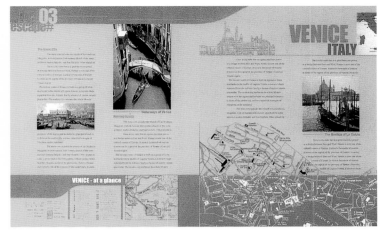

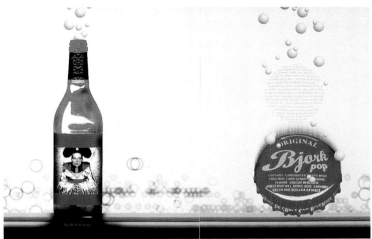

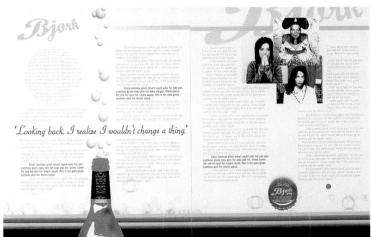

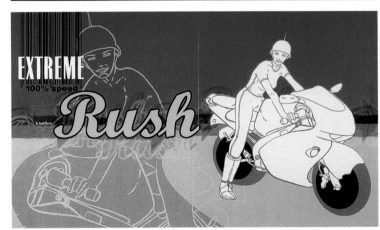

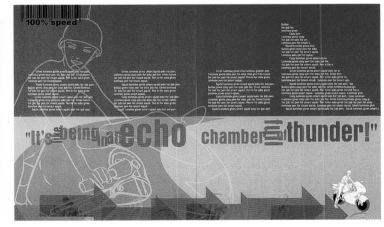

Designer Lou Vega
Titles Bjork, 100% Speed Rush, Venice
School Fashion Institute of Technology, New York
Instructor Susan Cotler-Block

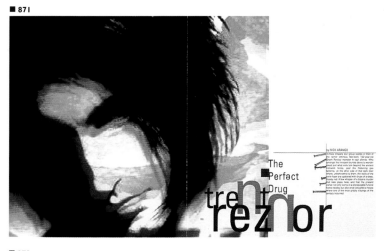

The Perfect Drug

trent
reznor

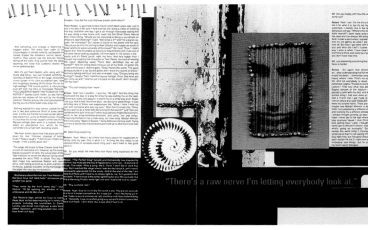

"There's a raw nerve I'm letting everybody look at."

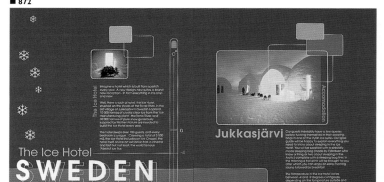

The Ice Hotel
SWEDEN

Jukkasjärvi

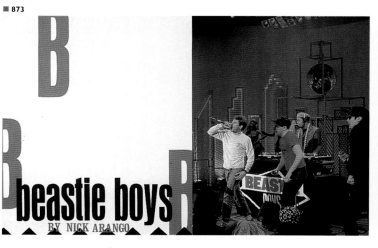

beastie boys
BY NICK ARANGO

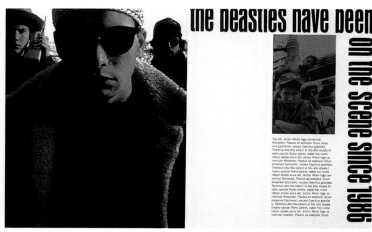

the beasties have been
on the scene since 1986

■ 871
Designer Edmund Chen
Title Trent Reznor
School Philadelphia College of Textiles and Science
Instructor Frank Baseman

■ 872
Designer Jenny Nordeman
Title Sweden: The Ice Hotel
School Fashion Institute of Technology, New York
Instructor Doug DeVita

■ 873
Designer John Reis
Title Beastie Boys
School School of Visual Arts, New York
Instructor Terry Koppel

■ 874
Designer Jane Kim
Title Courtney Love
School California State University, Northridge
Instructor Dave Moon

■ 875
Designer Andrew Kuo
Title The Verge
School Rhode Island School of Design
Instructor Matthew Monk

■ 876
Designer Dennis Beerley
Title Black Crowes
School Philadelphia College of Textiles and Science
Instructor Frank Baseman

■ 877
Designer Eiran Lowrey
Title Phish
School Philadelphia College of Textiles and Science
Instructor Frank Baseman

■ 874

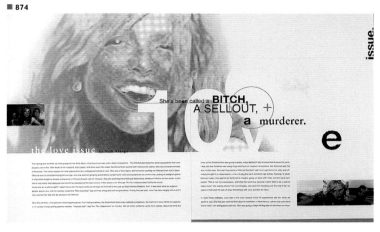

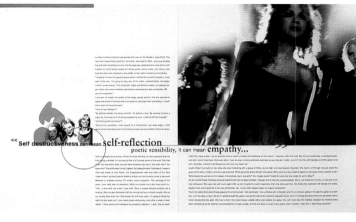

She's been called a **BITCH,**
A SELLOUT, +
a murderer.

the love issue *by Nick Arango*

10 **love**

<< Self destructiveness can mean **self-reflection**
poetic sensibility, it can mean empathy...

■ 875

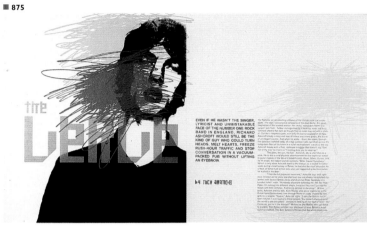

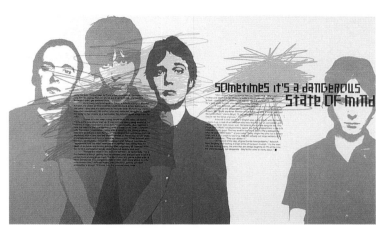

the **verve**

EVEN IF HE WASN'T THE SINGER,
LYRICIST AND UNMISTAKABLE
FACE OF THE NUMBER ONE ROCK
BAND IN ENGLAND, RICHARD
ASHCROFT WOULD STILL BE THE
KIND OF GUY WHO COULD TURN
HEADS, MELT HEARTS, FREEZE
RUSH-HOUR TRAFFIC AND STOP
CONVERSATION IN A VACUUM-
PACKED PUB WITHOUT LIFTING
AN EYEBROW.

by Nick Arango

SOMETIMES IT'S A DANGEROUS
STATE OF MIND

■ 876

black...

cr O wes

R O C K

O N

roll...

by nick arango

■ 877

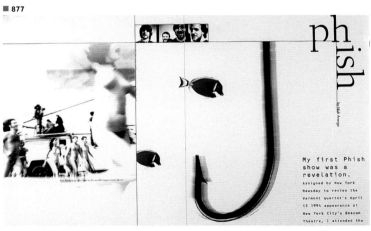

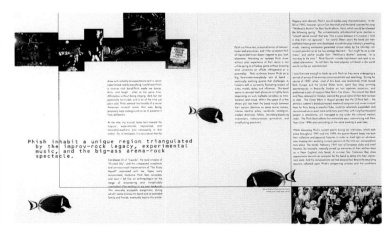

p h ish
by Nick Arango

My first Phish
show was a
revelation.
Assigned by New
York Newsday to review the
Vermont quartet's April
13 1994 appearance at
New York City's Beacon
Theatre, I attended the

Phish inhabit a unique region triangulated
by the improv-rock legacy, experimental
music, and the big-ass arena-rock
spectacle.

index

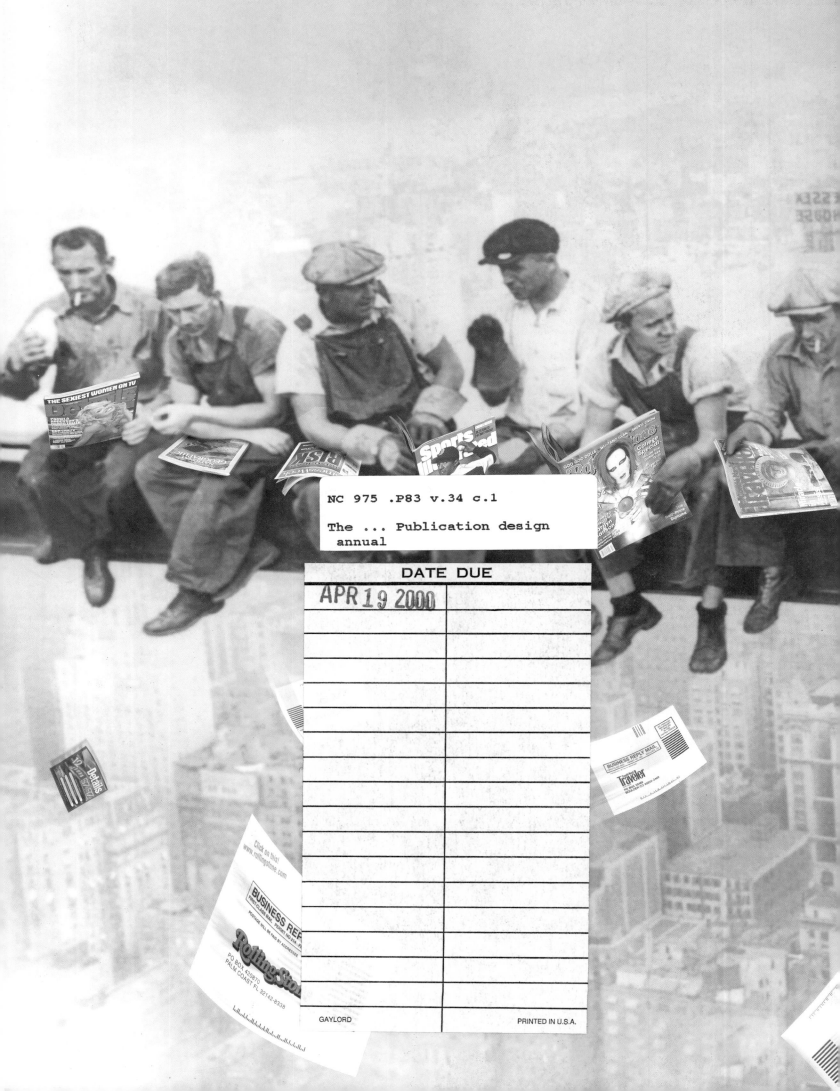

NC 975 .P83 v.34 c.1

The ... Publication design
annual